ACI 3807

Tempest and Shipwreck in Dutch and Flemish Art

Tempest and Shipwreck in Dutch and Flemish Art

Convention, Rhetoric, and Interpretation

Lawrence Otto Goedde

THE PENNSYLVANIA STATE UNIVERSITY PRESS
University Park and London

MM

Publication of this book has been aided by a grant from
The Millard Meiss Publication Fund
of the
College Art Association of America.

Library of Congress Cataloging-in-Publication Data
Goedde, Lawrence Otto.
Tempest and shipwreck in Dutch and Flemish art.
Bibliography: p.
Includes index.
1. Marine painting, Dutch—Themes, motives.
2. Marine painting—17th century—Netherlands—Themes,
motives. 3. Marine painting, Flemish—Themes, motives.
4. Marine painting—17th century—Flanders—Themes,
motives. 5. Allegories. 6. Shipwrecks in art.
7. Storms in art. I. Title.
ND1373.N4G6 1987 758'.2'09492 86–43030
ISBN 0-271-00487-8

To Ann
with hope and love

Contents

List of Illustrations

Preface

In recent decades the study of Dutch seventeenth-century art has increasingly focused on issues of meaning and purpose. The old concept of Dutch painting as primarily a faithful mirror of daily life in the Dutch Republic has been generally discounted or even entirely rejected, as scholars have broadened the scope of the questions they ask about the images. In many ways we see the paintings differently as a result of this research, which has explored such matters as the symbolic language of daily-life genre,[1] the role of history painting in Dutch art and society,[2] the functions of specific genres like pastoral and portraiture,[3] and the role of patronage.[4] And yet the nature and significance of the realism, of the mimetic accuracy, of Dutch art remains elusive.

The problem results in part from the lack of penetrating comment in seventeenth-century Dutch literature on the paintings now considered among the most distinctive achievements of Dutch civilization: realistic land- and seascape, still life, daily-life genre, and portraiture. A literature of art on the Italian model existed, but the classicizing theory on which it was based lacked critical concepts for dealing with these genres except in relatively disparaging terms. Art historians have, as a result, been compelled to look to the images themselves and to the broader history and culture of the seventeenth-century Netherlands for explanations of the realism that distinguishes so much Dutch art from contemporary Baroque imagery. In the process two views of Dutch realism have become polemically defined.

One, based on an iconographic method and associated most notably with E. de

Jongh, sees the vivid imitation of appearances in Dutch genre and still life as essentially a "schijnrealisme," an apparent realism, to use De Jongh's term.[5] The pictures, these scholars argue, are best understood in terms of the Horatian doctrine of the purposes of art, to instruct and delight.[6] Imitative accuracy delights and in doing so engages us in a moral content, our pleasure being heightened further by the necessity of deciphering the moral beneath an ostensibly daily-life occurrence. Taken to an extreme, this view of Dutch realism as a "gerealiseerde abstractie" (abstraction made real)[7] results in a disjunction between symbolic content and the imitative accuracy and calculated pictorial form on which the painters lavished so much attention. In its most reductive form, this approach turns evocative and often ambiguous images into moral pictograms.

Reacting against this development, Svetlana Alpers has urged an opposing view, reaffirming the older notion of the basically descriptive character of Dutch realism in contrast to what she sees as the narrative and literary nature of Italian art.[8] Alpers proposes that we seek in Dutch culture new analogies to the form and content of Dutch imagery, analogies that relate to the altered habits of thought about nature and man associated with the New Science. In her view Dutch pictures are most like camera-obscura projections, maps, images seen in the microscope, and even words on a printed page, that is, flattened, randomly framed, nonrhetorical structures of signs, whose purpose is to communicate information.[9] "Northern" paintings in her terminology are exactly contrary to the stagelike spaces and rhetorical purposes of "Italian" pictures, which aim at the affective engagement of the beholder in a fictive narrative.

While Alpers suggests potentially fruitful ways of considering the nature of Dutch art, the polarized categories in which she frames her discussion are inadequate to the complexity and variety of the pictures. Moreover, the specific analogies Alpers uses to explicate the pictures seem distinctly unsuited to the visual character of most Dutch paintings. In the case of her metaphor of "mapping" for Dutch landscapes, the paintings are unlike the abstracted forms of maps in ways that undermine the analogy.[10] Dutch landscapes, unlike maps, are spatially expansive, atmospheric, and often marvelously detailed. They are fictive worlds that resemble the world we see, and they invite our imaginative projection into their spaces in a way that can only be termed "Italian" in Alpers's scheme. Dutch landscapes are also unlike maps in frequently representing places that are at once imaginary and plausible. In some cases painters relocate identifiable buildings to invented sites, which seems especially subversive of the very nature of cartographic images. That such fictive locales should be believable and that seemingly accurate city views should be altered, apparently for compositional reasons, indicates the inadequacy of the model of scientifically neutral imagery like maps for Dutch landscape and for Dutch painting in general.

Neither Alpers's view of Dutch realism nor that of the iconographers encompasses the art. This is not to say that their approaches are without value, but that if exclusive claims are made for them, they become reductive. What seems to be required is an interpretive approach to the complex phenomena of Dutch realism that provides not a single, definitive interpretation for each painting, but

methods of responding to the varied visual forms and purposes of the images. Such an interpretive approach should be able to address two of the most revealing characteristics of this art—its selectivity and multiplicity of reference. It is increasingly clear that the realism of Dutch genre, still life, and landscape is not comprehensive and objective but selective and conventional.[11] Only some aspects of Dutch life and the countryside are consistently subjects of this art, while others are excluded, and still others are rare but not unknown. It is also increasingly apparent that while some realistic genre scenes and still lifes are explicitly metaphorical, many more are indirect and allusive in reference and patient of more than one interpretation. The subject matter of many genre paintings in particular is difficult to interpret even when easily recognized, because old iconographic patterns have been altered and recombined. Often obvious metaphorical references in traditional iconography, identifiable as symbolic intrusions into a realistic scene, have been suppressed in favor of a more thoroughgoing realism. In some cases, this paring down of iconography results in images that appear to be virtual records of daily-life occurrences or peasant customs, although the iconography is conventional and ultimately originates in allegorical and religious images. In many other cases the paintings seem to contain multiple visual allusions, puns, and quotations deriving from traditional iconography and referring to a wide cultural context, including scripture, literature, popular texts, proverbial expressions, and popular customs. These images often seem ambiguous because their iconography does not define a single moral message but offers multiple comments on the potential of the situation they depict. Genre paintings by Johannes Vermeer and Gerard TerBorch often display these qualities in particularly tantalizing form. Identifying patterns of selectivity and allusion thus becomes central to any attempt to penetrate the ways Dutch pictures communicated and why they were valued. While such an analysis is important in genre painting, it is even more fundamental to land- and seascape, in which the development of styles aiming at a thoroughly convincing realism excludes an obvious structure of symbolic details.

The present study proposes such an approach to interpreting Dutch landscape by focusing on one theme, the storm at sea, and by deciphering the patterns of convention and reference that inform individual pictures of that theme. The method is essentially iconographic and is deeply indebted to the research of De Jongh. It seeks, however, to give greater weight in interpretation to pictorial conventions of incident and expressive form and to identify analogous patterns of expression and meaning in the literary culture of the time. This approach to interpretation, moreover, depends in large measure upon the rhetorical tradition that shaped the ways people described both nature and images, a rhetoric that surely affected and was in turn shaped by the character of the pictures. In this study patterns of narrative incident and visual form become understandable not so much as illustrations but as pictorial articulations of structures of ideas, values, beliefs, and anxieties evident in contemporary life and thought. While each storm painting is arguably unique in its time and place and could be fruitfully studied through an intensive focus upon the painter and his personal responses to artistic traditions and to specific historical circumstances, this study considers paintings first as members of well-defined and extensive bodies

of images, sharing significant characteristics with many other works by a large number of artists. Interpretation proceeds by explicating an individual picture in relation to the conventions to which it conforms or from which it deviates, and in either case, through which it communicates.

Using this approach, the realism of Dutch stormscapes does not prove, on the one hand, to be a veil concealing the true moral content of the works. The pictures must be seen as possessing a content immediately accessible through their exploitation of conventions of narrative events and expressive form. Our analysis of these pictorial patterns, which both include and omit many aspects of human experience of the sea, respects both the realism of the pictures and the undeniable selectivity of that realism. In doing so, it offers a much more controlled and plausible access to the significance of Dutch storm paintings, including their metaphorical potential, than has been possible using a more strictly iconographic method. On the other hand, this approach does not discover in the realism of the paintings a documentary record of current events or even a catalogue of the full range of peril that men could and did experience at sea. The images are not usually illustrations of the great enterprise of Dutch seafaring but imaginative responses to it, and their realism serves an essentially rhetorical purpose, engaging our imaginations in the mortal dramas they depict.

Paintings of storm and wreck are at once vivid, convincing re-creations of the visible world and selective, conventionalized interpretations of that world. The traditional view that these images were a mirror of their time is thus not entirely off the mark, but they were an articulate mirror, revealing and confirming a dramatic vision of human existence in a tumultuous yet ultimately coherent universe.

Three technical points require further comment. First, while the broader history of Dutch marine art necessarily figures in this study at many points, my primary concern is the depiction of the storm at sea. This limited focus is potentially confusing because the development of tempest imagery, though inseparable from that of seascape in general, follows a somewhat different path. It originates later in Netherlandish art than seascape, and it relates to sixteenth-century traditions in different ways from seascape as a whole. My generalizations about the development of this subject refer to the storm at sea in art unless the larger context of marine art is specified.

A second point concerns the identification of a sea as stormy. The problem is that though a picture may depict no more than a strong breeze, the presence of waves and heeling vessels in a painting is often enough to indicate a storm for landlubbers. In general, my method for gauging the severity of the weather in a painting has been to pay attention to the vessels. Drastically shortened sail is a sure sign of rough weather since carrying full sail in high winds is not merely wasteful but dangerous to the ship. Though some Dutch seascapists were sloppy in matters of ship handling, many more were quite accurate indeed. Such mimetic faithfulness, by the way, strongly supports one of the main theses of this work, that painters expected an audience to inspect their images in considerable detail.

Finally, unless otherwise specified, translations are by the author.

Acknowledgments

*T*his book grew out of my work in the Department of Art History and Archaeology at Columbia University, and I am deeply grateful to the Columbia faculty, whose guidance and encouragement sustained me to the completion of that stage of the study: Anne Lowenthal, Howard McP. Davis, J. W. Smit, and especially David Rosand, whose pushing and pulling has much to do with the shape of my work. During his brief period on the Columbia faculty, John Walsh first suggested the idea for this study to me, and I have benefited from his continuing support and interest even at a distance. In reworking the material for publication I owe much to the encouragement and criticism of my colleagues at the University of Virginia, including Paul Barolsky, Keith Moxey, Roger Stein, and David Summers. Another colleague at Virginia, Mark Morford, not only corrected my translations from Latin but also generously and most helpfully reviewed the entire manuscript. I am also much obliged to J. W. Smit of Columbia University for criticizing my translations from Dutch.

From the beginning of my research I have been impressed by the generosity of many individuals who shared with me their insights, research results, photographs, and expertise. The following have in many cases taken considerable pains to help me, for which I am deeply grateful: Maryan Ainsworth, Alfred Bader, Jeremy D. Bangs, Marco Chiarini, Walter Gibson, E. de Jongh, J. Richard Judson, Jan Kelch, George Keyes, Janina Michalkowa, Teresa Pugliatti, M. S. Robinson, Lisa Vergara, Amy Walsh, and Sarah Elliston Weiner.

The extraordinary photograph archive and library of the Rijksbureau voor Kunsthistorische Documentatie in The Hague were essential to my research,

and I would like to thank J. Nieuwstraten and the staff, especially Gerbrand Kotting and Willem van de Watering, for their assistance and their forbearance with my at times inconveniently wide-ranging topic. I am equally indebted to the staff of the library of the Kunsthistorisch Instituut of the University of Utrecht for extending every courtesy in assisting my research. I also owe much to Robert Vorstman of the Nederlands Scheepvaart Museum for sharing with me his knowledge of Dutch marine art and seventeenth-century shipping.

The support and enthusiasm of Philip Winsor at the Pennsylvania State University Press has been essential to the publication of this project, and I am grateful also for the tactful and efficient editing of Cherene Holland.

My research and writing as a graduate student were partly supported by a Fulbright-Hays grant—and in connection with this grant I would like to express my appreciation to Joanna A. C. Wind, the director of the Netherlands America Commission for Education Exchange—and a fellowship from the Mrs. Giles Whiting Foundation. Publication has been supported by a grant from the Millard Meiss Publication Fund of the College Art Association of America.

Finally, I am deeply grateful to my wife both for years of encouragement and for the significant clarifications and economies that followed from her editing this manuscript.

I

Realism and Metaphor in Sixteenth- and Seventeenth-Century Land- and Seascape: The Problem of Interpretation

The tempestuous sea has always occupied a vital place in man's consciousness of the world and of himself. Apprehended as tragic circumstance and as deeply resonant symbol, it has been an unfailing source of metaphors for the vicissitudes of existence. The power of this experience has left its imprint on our most ancient literary traditions, and from Homer and Genesis onward the verbal evocation of the storm and exploitation of its emotional connotations have challenged and stimulated great literary talents. Yet only relatively recently, since the early sixteenth century, have painters treated the stormy sea with comparable intensity of feeling and fidelity to nature. And it is only since the beginning of the seventeenth century that the theme appears as a seemingly independent subject in painting, without an identifiable narrative from history or myth as the primary content of the image.

Such works as Jan Porcellis's *Stranding off a Beach* of 1631 (Fig. 1)[1] and Willem van de Velde the Younger's so-called *"Gust of Wind"* of about 1680 (Fig. 2)[2] exemplify this new artistic approach to the storm. In them ordinary, contemporary men and vessels, carefully observed in appearance and action, contend with the elements, whose forms and motions are likewise rendered with attentive naturalism and dramatic tension. Such pictures, first made in the seventeenth-century Netherlands, stand at the beginning of a European and American tradition of depicting tempestuous nature, a tradition persisting to the end of the nineteenth century and embracing such painters as Joseph Vernet, J. M. W. Turner, Gustave Courbet, and Winslow Homer. The numerous storm paintings of

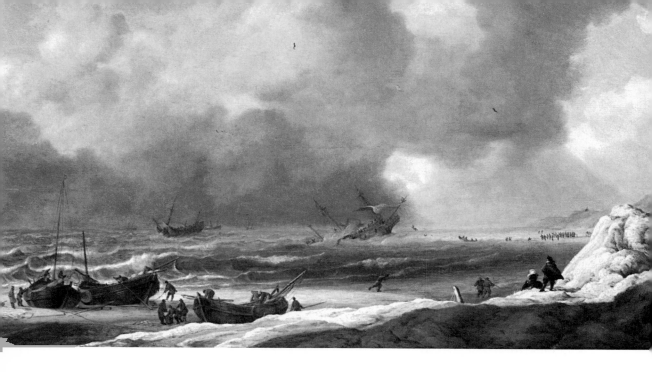

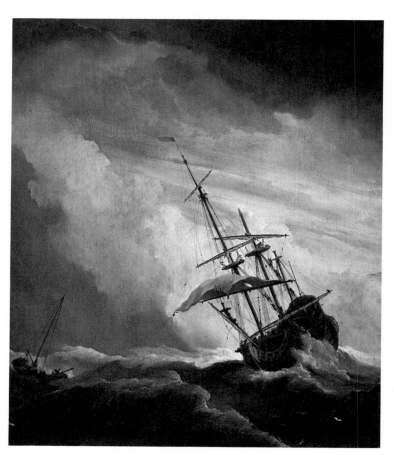

Above: FIG. 1. JAN
PORCELLIS. *Stranding
off a Beach.* 1631.
The Hague,
Mauritshuis

Left: FIG. 2. WILLEM
VAN DE VELDE THE
YOUNGER. *"The Gust
of Wind."*
Amsterdam,
Rijksmuseum

Opposite top: FIG.
3. WINSLOW HOMER.
Northeaster. 1895.
New York,
Metropolitan
Museum of Art, Gift
of George A. Hearn,
1910

Opposite bottom:
FIG. 4. J. M. W.
TURNER. *Snow
Storm—Steam-Boat
off a Harbour's
Mouth . . .* 1842.
London, Tate Gallery

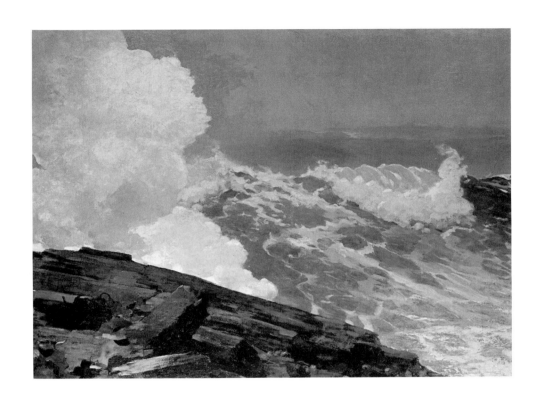

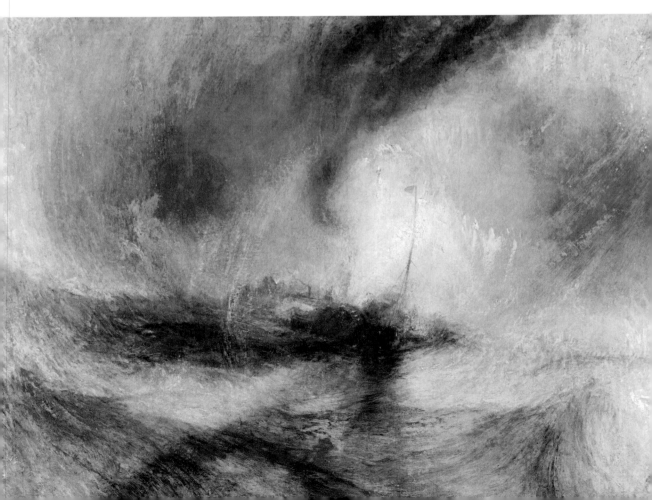

Dutch and Flemish artists were not merely ancestors of this typical Romantic subject but directly shaped the way these later painters approached the theme. Yet there is no mistaking a stormscape by Porcellis or Van de Velde for one by Turner or Homer, and the differences between the seventeenth-century and nineteenth-century versions suggest something more than the capacity of individual genius to transform its cultural heritage. Broad changes of attitude, of a view of the world and of man, seem to be implicit in the total elimination of man and in the viewer's unmediated confrontation with crashing waves in a Homer (Fig. 3),[3] something never encountered in a seventeenth-century view of a stormy coast. Similarly, the swirling forces engulfing human presence in a Turner (Fig. 4)[4] far exceed those subordinating vessels and figures to the tempest in Dutch pictures.

The concept and experience of the sublime demonstrably informs the images of later artists. This experience involves a direct encounter between man, or, more precisely, an individual intelligence, and the overwhelming forces and spaces outside the self, a confrontation experienced as a transcendence of human limitation in the face of the awesome and perilous otherness of the world.[5] Submergence of ships in a maelstrom, the elimination of the figures and vessels to create an immediate confrontation with the elements themselves, and a focus upon the shipwrecked and their broadly readable emotional responses are among the strategies artists adopted in the eighteenth and nineteenth centuries for rendering this kind of experience of the sea.

This is not, however, the experience and outlook that shaped the depiction of storms in the seventeenth-century Netherlands. While the vastness of the sea, the danger of the storm, and its surpassing violence formed the common ground of the pictorial responses of Porcellis, Vernet, and Turner, the value placed on man's role in relation to these natural phenomena shifted decisively between 1600 and 1800. In the seventeenth century, the storm, far from being a means of affirming our capacity for imaginative control of nature and deeply felt kinship with it, was wholly negative. It was cosmic disorder, manifesting discord in the basic structure of the elements. It was a ruthless enemy of individual and group, a token of all lawlessness and of all destructive forces in nature, in society, and in every man. Even seafaring itself was fundamentally suspect, for only a fool would place himself in such jeopardy—whereas for the Romantic sensibility, as W. H. Auden observes, "the sea is the real situation and the voyage is the true condition of man."[6]

In consequence of this change in values, particular artistic motifs—such as rocks beaten by the surf, waves, castaways in a boat, the ship on the high seas, and the sea itself—take on different emotional and metaphorical connotations in the course of the eighteenth century while remaining based in a constant human encounter with the world and a continuous artistic tradition. Thus both seventeenth-century and eighteenth-century viewers of tempest pictures would have found in the sea a majesty and vastness dwarfing human attempts at encompassment, but a statement such as Diderot's in meditating on a tempest by Vernet is virtually unthinkable for a contemporary of Porcellis or Van de Velde: "Tout ce qui étonne l'âme, tout ce qui imprime un sentiment de terreur conduit au sublime. Une vaste plaine n'étonne pas comme l'Océan, ni l'Océan tranquille comme l'Océan agité."[7] The strikingly different reactions of

a seventeenth-century beholder, the connotations, associations, and symbols such a beholder found in the storm pictures of the pre-Romantic age, are the subject of the pages that follow.

REALISM AND MEANING IN LANDSCAPE

The compelling realism of seventeenth-century storm scenes was a departure from the past whose importance to contemporary Netherlanders may be guessed from the intensity with which it was pursued and the popularity of the resulting images.[8] Pictures painted from the 1620s onward have long been celebrated for their verisimilitude, so much so that for most of the last 150 years the exact rendering of clouds and moist atmosphere, of waves and foam, and of the complexity of vessels and their tactics has been regarded as the primary content of the images.[9] Examining the pictures by Porcellis and Van de Velde mentioned above might indeed seem to corroborate this interpretation.

Porcellis (Fig. 1) depicts a typical stretch of beach and dunes on the Dutch North Sea coast. The day is somber in the aftermath of a storm still brooding darkly on the horizon. A shaft of sunlight falls on fisherman calmly tending their boats in the foreground, apparently heedless of the drama in the distance. There a knot of spectators also struck by light aid the rescue of castaways from a sinking ship, whose stern is already submerged and whose crew swings into the surf in hopes of reaching shore. She has grounded on the treacherous shallows, driven there by the storm, a fate threatening other nearby vessels dismasted and lying to in hopes of escape. Surveying the scene is a couple in the foreground at right, who reinforce the beholder's own activity and enhance the sensation of an immediately observed moment of seashore existence.

Van de Velde too renders his scene (Fig. 2) convincingly and dramatically. An English ship running before the wind, on a collision course with the drifting fishing boat at left, has seemingly just altered course to avoid the boat, producing the dramatic roll to leeward and perhaps causing the sheets to part on the foresail. The wild flapping of the sail, in which a rent is visible, will soon tear it to shreds. The ship has already lost the upper half of her main topmast and her whole topgallant mast and mizzen yard are missing. The wind is rising to a point where even her shortened sail will have to be struck, but for the moment she struggles onward, still answering to human control.

Both artists take pains to render the structures of their vessels as accurately as possible (Van de Velde's ship is identifiably English), and the tactics are what we would expect of seventeenth-century ship handling.[10] The subtly shaded gray clouds rendered by Porcellis, the gray-green and yellow clouds captured by Van de Velde, the heavy atmosphere, the swelling waves with foaming crests, the play of light, all suggest a direct study of these phenomena. The pictures are, indeed, triumphs of naturalism.

A number of other tempest scenes, however, such as a *Shipwreck* by Jan Peeters dating from about 1650 (Fig. 5),[11] suggest that something more than a

desire for verisimilitude motivated choices of incident and details. Peeters's more highly pitched color and light effects can be ascribed to the less sober naturalism of Flemish artists, but many Dutch seascape painters shared the disregard for historical precision that leads Peeters to combine a Dutch ship, a Turkish galley, and natives dressed in skins. Furthermore, if we examine Peeters's painting within the context of many contemporary shipwreck images, we find that the exotic location—implied by both the natives and Turks and the rocks—characterizes the great majority of Netherlandish shipwreck scenes. Surprisingly, it is the local Dutch beach in Porcellis's picture that is extremely rare in shipwreck images. If these artists intended to record contemporary reality, surely they would have selected more often the dangerous shallows off the coast of the Low Countries.

Van de Velde's picture is superficially a more immediate encounter with ordinary reality. Yet it too departs from exact reportage, for it adheres to a selective pattern in which ships on the open sea, however threatened, are nearly always depicted as still under human control. Very rarely in seventeenth-century tempest pictures are ships at sea portrayed lying to, trying to ride out the storm, or battered into helpless hulks. In such cases the vessels would be at the mercy of wind and wave, and this is exactly what these Dutch artists, in all but a few instances, avoid representing.

These and other patterns of narrative and form, which constitute a body of conventions deducible from the pictures themselves, are of fundamental importance to interpretation, for they demonstrate that artists produced and patrons purchased pictures of highly conventionalized, if also vividly naturalistic, character. The necessary conclusion is that Netherlandish stormscapes are not entirely faithful renderings of the visible world. Though perhaps somewhat obvious in itself, such a recognition raises more complex questions: If these images are not solely, or even primarily, transcriptions of visible reality, what was their meaning for a seventeenth-century beholder? If they do partly reflect the reality of seventeenth-century voyaging, to what extent does this shape their meaning? How does the deciphering of representational conventions lead to an understanding of that meaning? These questions directly affect the way we approach other issues, among them, the reasons for the popularity of these pictures. Why did so many people want to hang a scene of desperate peril and destruction on their walls? Are they the same reasons that motivated the popularity of the theme in the eighteenth and nineteenth centuries? These questions raise the larger issue of meaning in all landscape art: What did such images signify and how may we grasp this significance?

In Renaissance art from Giotto onward, landscape settings participate in many artists' figural narratives. Functioning both formally and thematically to reinforce dramatic structures, they serve to emphasize particular figures and to reflect or contrast with the mood of the story.[12] Seventeenth-century scenes of tempests descend from a particular branch of this tradition that includes depictions of such tales as Jonah and the whale, Christ asleep in the storm, and the shipwreck of Aeneas. In these images artists emphasize the tumult of the stormy seascape both to make it a convincing cause of terror and action and to amplify the vividly portrayed horror of the protagonists. The meaning of the

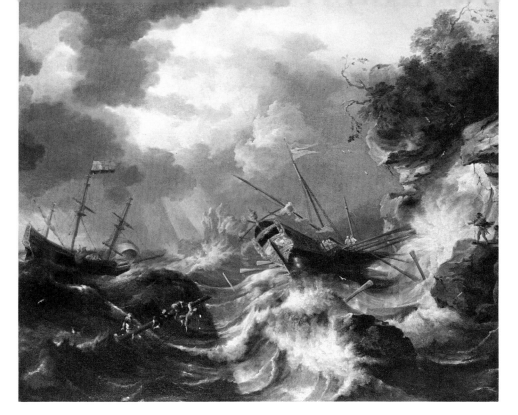

Above: FIG. 5. JAN PEETERS.
*Ships in Distress off a Wild
Coast.* Vienna,
Kunsthistorisches Museum

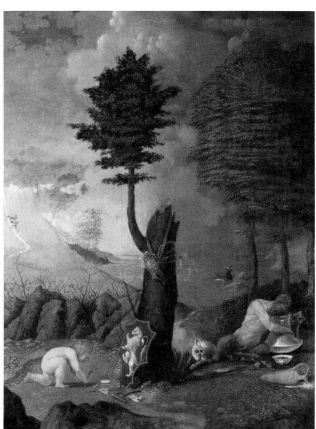

Right: FIG. 6. LORENZO
LOTTO. *Allegory.* 1505.
Washington D.C., National
Gallery of Art, Samuel H.
Kress Collection

seascape is thus readily accessible to us, for it resides—in large measure at least—in its consonant relationship to the figural drama or mood.

Interpretation is also relatively unproblematic in the related tradition of moralized landscape, such as Lorenzo Lotto's *Allegory* (Fig. 6), where natural things function overtly as metaphors. In this type of image the landscape usually reinforces the figural allegory, though the landscape component may possess much greater scope and expressiveness than in most narrative subjects.[13] Lotto, for example, divides his landscape into opposing sides, echoing and expanding the meaning of the figures: the industrious *putto* practicing the arts is associated with the rough high road, a living branch, and sunlight; the slothful, drunken satyr, with the easy low path, decay, and a storm sinking a ship. Here the juxtaposition of a steep hill and a low plain, or a dead branch and a storm, can refer to moral issues of thought and behavior by virtue of the semantic structure of the image, which organizes elements in a network of polar tensions and dialogic relationships.

Reading Lotto's allegory or understanding the role of the storm in a biblical narrative poses few difficulties, but a landscape such as we often find in the seventeenth century that consists solely of a view of mountains with a low river valley nearby, or that depicts only a vessel in a storm, provides far fewer indications of meaning. Such an image lacks both the iconographic cues identifying a narrative subject and the diagrammatic pictorial structure and mutually reinforcing symbols articulating a clearly moralized landscape.

Creighton Gilbert has suggested that a Renaissance landscape without an identifiable figural theme from literature is subjectless. By this he seems to mean that such an image is either a neutral genre scene or, as in the case of Giorgione's *Tempesta* (Fig. 24), one in which a natural phenomenon is actually the protagonist, the most significant actor in the image, with no further symbolic interpretation required or invited.[14] In Gilbert's view, there is no precise literary passage behind Giorgione's painting and no clear symbolism. The *Tempesta* thus approaches "pure landscape as we have it today," although it retains a link to literary culture in that it possesses the "tone of pastoral literature" in its ruins, the verdant glades and stream, and the nude young woman nursing a child.[15]

Gilbert's characterization of a landscape as "subjectless" points to a fundamental obstacle to our interpretation of landscapes that lack identifiable themes from literature. This is the widespread notion of "pure" landscape, which assumes that an image of nature lacking a citable reference to a text somehow has no subject or is value-free because it results from a neutral copying of the visible world. Whether such neutrality is possible is debatable, for, as Lisa Vergara observes, "Renaissance and Baroque landscapes—like all art—always express a theme, a shared strain of sentiment, or a set of values, no matter how trivial and regardless of whether human figures are depicted or not."[16] Certainly, the selective conventions discernible in Dutch storm pictures, and indeed in all seventeenth-century landscapes, demonstrate that something more significant than an indiscriminate or an "objective" imitation of nature occurs in these paintings. While any realistic image results from a process of selection, the persistence of conventional patterns among a large number of images further argues that this selectivity

reflects not just the idiosyncratic responses of individual artists but widely shared attitudes and concerns. Moreover, the idea that a depiction of a tempest could be neutral ignores the inherent power of the sea as metaphor as well as the relationship of these pictures to a rich body of well-known literary storms and to the realities of life in a seafaring nation on the violent North Sea. Far from offering detached reportage, tempest scenes arise from a cultural context in which the storm was charged with the most intense associations. Determining what those associations were and how the pictures express them are the fundamental concerns of this study.

The modern view that sixteenth- and seventeenth-century landscape was subjectless contrasts with recent efforts to find metaphorical content in landscapes, among them storm scenes. John Walsh, for example, writes of Porcellis's *Stranding off a Beach* (Fig. 1) that "it is clear that the sea brings disaster to some and prosperity to others; the picture seems to express the power of life and death that nature holds over frail mankind, together with the contrast of high ambitions brought to grief and modest ambitions rewarded. We can imagine these to be the meditations of the couple who look on in safety."[17] R. H. Fuchs similarly sees a disguised symbol of "life's uncertain voyage" in the situation Porcellis depicts in *Three-Masters Approaching a Rocky Coast* (Fig. 56), an image in which the tension between the vessels and the dangerous lee shore toward which the winds drive them remains unresolved.[18]

While these moralizing interpretations seem perfectly in accord with the situations depicted, there is little in these realistic portrayals themselves that dictates such readings, as Fuchs himself cautions. Neither the individual components nor the structures of the images depart from a high standard of realistic plausibility. And while the scenes are, in fact, carefully composed dramatic structures, they do not possess the clear semantic patterns of oppositions that characterize moralized landscapes such as Lotto's.[19] Furthermore, there is little in seventeenth-century discussions of landscape paintings to support metaphorical interpretations, a lack that has reinforced a belief in the compatibility of these pictures with the modern conception of pure landscape. The theorists of art who wrote most such descriptions reveal on the whole a limited conception of landscape, which was for them a concern distinctly secondary to the rendering of human action and emotion. As a result, entire categories of Dutch landscape are virtually ignored in the contemporary literature on art. Furthermore, most accounts of landscape at this time are limited to descriptive inventories of what is visible in the paintings, describing and praising those images largely in terms of variety and of accuracy in imitating nature.[20] Thus, while certain aspects of aesthetic theory will be important at later stages in our discussion, seventeenth-century theoretical texts offer little direct evidence for interpretations of the kind proposed by Walsh and Fuchs. In recognizing this, it should be kept in mind, however, that these texts betray almost no awareness of the connotations, values, and ideas that lie behind the conventions of landscape and the popularity these images enjoyed.

That a beholder would have expected and sought out metaphor in the straightforward realism of Dutch tempest paintings is nonetheless suggested by varied contemporary sources. One of the most intriguing examples is an

entry from a list of paintings belonging to the Oudezijds Huiszittenhuis in Amsterdam, an institution that distributed food and fuel to the needy.[21] Describing a painting probably by Jan Peeters (Fig. 7),[22] it reads, "Depicting a Shipwreck and thus like the origin of the poverty which is encountered in this house."[23] This passage is striking in part for its late date, 24 January 1787, long after the decline in interest in symbolic readings that some scholars believe took place in the mid-seventeenth century.[24] The entry is also remarkable for its apparent casualness and for its similarity to the interpretations of Walsh and Fuchs. Conveying the impression of a passing and perfectly ordinary explanation of the presence of the image in the institution, it suggests that twentieth-century metaphorical readings are not at all far-fetched.

At the same time, this brief text reveals the problems raised by this material. Because it is so closely bound to the particular location of the painting, it has a much more specific thrust than the generalized meditations on prosperity and ambition proposed by Walsh or on the uncertain voyage of life offered by Fuchs. This would suggest that metaphorical interpretations of more or less similar realistic images could very much depend on the circumstances in which a painting was seen. A picture on the wall of a prosperous bourgeois home might call forth somewhat different responses from a similar painting in a poor house.

Such considerations raise further questions. Not only do they indicate that interpretation was contextual and that it depended on the individual viewing the image, but they also suggest that the interpretive possibilities were mani-

FIG. 7. JAN PEETERS. *Ships Driving onto a Lee Shore.* Amsterdam, Rijksmuseum, on loan to the Amsterdams Historisch Museum

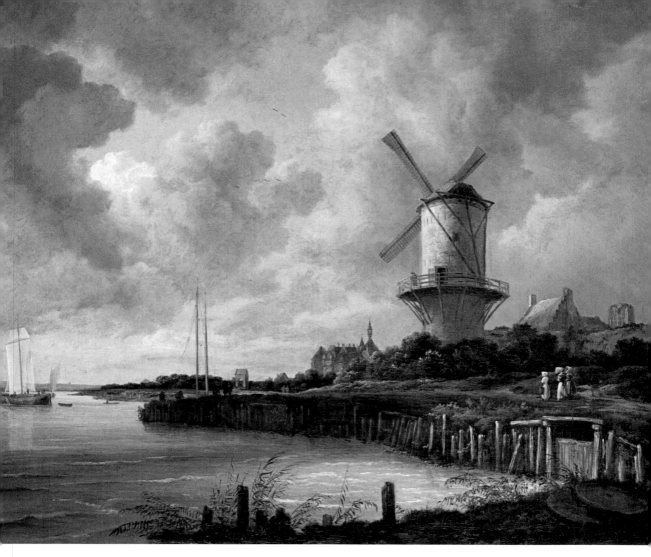

Fig. 8. Jacob van Ruisdael. *The Mill at Wijk bij Duurstede.* Amsterdam, Rijksmuseum

fold. That this was the case is implicit in the treatment in emblem literature of such motifs as the storm-tossed ship or a quite different landscape subject, the windmill. Emblems, a popular form of literature from the sixteenth through eighteenth centuries, combine a short, pithy phrase, a picture, and an explanatory text.[25] They offer important insights into seventeenth-century ways of thinking about images, for, in them, words and image were conceived as mutually reinforcing. A frequent goal of emblem writers was to place image and text in unexpected juxtaposition so as to reveal new associations and provoke thought in a way closely related to the conceits of metaphysical poetry. An article on Jacob van Ruisdael's *Mill at Wijk bij Duurstede* (Fig. 8) by Hans Kauffmann reveals the multiple interpretive possibilities that result from such an approach. Kauffmann cites more than a dozen emblematic interpretations of windmills, which play on every aspect of the mill and yield such diverse and contradictory metaphors as the restlessness of human life (the mill ceaselessly whirls and must be turned to face the wind) and the life-giving power of the Holy

Spirit (the mill does not move of itself but only with the wind).[26] The same multiplicity and inconsistency of interpretation mark the emblems on the sea and ships that Kauffmann also lists in connection with the boats in Ruisdael's painting.

A perusal of the emblem literature reveals the theme of shipwreck interpreted as the outcome of folly (daring great peril twice is foolishness; Fig. 9);[27] as unhappiness in marriage (at the beginning of a voyage one is deceived by fair sailing; Fig. 87);[28] as a drunkard's tongue (Fig. 10);[29] as anger and its consequences (Fig. 11);[30] as a model of life to be avoided ("a ship aground on a beach is a buoy in the sea"; Fig. 147);[31] and as the fickleness of fortune (Fig. 130).[32] If we consider in addition emblems of storm-tossed vessels on the open sea, of the stormy sea itself, and of ships in general, the myriad possibilities of meaning seem bewildering and pose a most serious problem for interpreting paintings. Furthermore, few guiding principles are apparent in these emblematic explications that can be transferred to reading paintings that lack texts. This problem is accentuated by the naturalism of many emblem illustrations, which are often directly based on compositions familiar from paintings. Like the paintings, they possess an internally consistent realism that may permit but does not appear to require a particular metaphorical interpretation.[33]

FIG. 9. Emblem from ROEMER VISSCHER, *Sinnepoppen*, Amsterdam, 1614

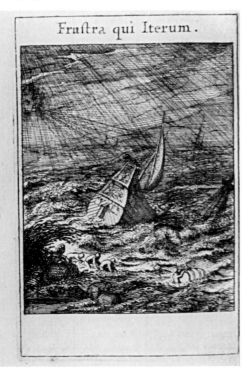

Infano Bachi *Thyrfus* quem perculit oeftro,
　　Claudicat ingenium, mens fugit uda mero:
Balba natat vox, offa tremor quatit, excidit amens.
　　Mars fubit, & calidis arma virumque canit:
Ilicet exiliunt ad jurgia Centaurêa,
　　Ad centaurêas exiliuntque neces,

FIG. 10. Emblem from MATTHEUS BROVERIUS VAN NIEDEK, *Zederyke zinnebeelden der tonge,* Amsterdam, 1716

Het Schip dat teghen rotfen flaet
Moet berften, en ten gronde gaet.

FIG. 11. Emblem from JOANNES A CASTRO, *Zedighe sinnebelden,* Antwerp, 1694

This use of images with explicatory texts to interpret paintings without texts—and the dilemmas it raises—are familiar from some of the most important studies of Dutch art in the last quarter-century. E. de Jongh and a number of other scholars who developed this method of interpretation have distinctly altered our apprehension of Dutch daily-life genre, still life, and portraiture. Instead of seeing in these pictures solely a mirror of their time, these scholars have found Dutch realism, however convincing its naturalism, to be pervaded by meanings that are expressed through a language of conventional subject matter and mutually reinforcing metaphorical details.[34] De Jongh has dubbed this characteristic impulse to render abstract concepts in terms of the observable world "schijnrealism" (apparent realism). The similarity of this concept to the so-called disguised symbolism of Early Netherlandish art reflects a continuous artistic tradition in the Low Countries, although in fifteenth-century paintings the metaphorical content of daily-life details usually relates to their place within an obviously religious image, transcending their ostensible mundanity.[35] What distinguishes the "apparent realism" of seventeenth-century Dutch imagery—and makes its significance less apparent to modern viewers—is its rendering of symbolic content entirely in terms of the ordinary observable world.

In their use of images with texts to interpret Dutch pictures, De Jongh and other iconographers have encountered difficulties that arise from the pre-scientific worldview that Marjorie Hope Nicholson characterizes as the "habit of thinking in terms of universal analogy," of finding correspondences in the Great Chain of Being.[36] From this point of view, all the world functions as a book of revelation, disclosing for those who would see divinely ordained pattern and meaning. This cosmology sanctions the obscurity of so many emblems and poetic conceits that involve what seem to us improbable connections between only slightly similar aspects of the world, for all reality is seen as ultimately a dense web of significant relatedness. Given this cosmology, the multiple, contradictory interpretations we find in emblems and other images with interpretive texts are appropriate and useful guides to paintings, but also sources of potential confusion.

De Jongh and other scholars, recognizing the inherent ambiguity of these sources, have sought to control the interpretation of a given image by identifying corroborating symbols in it that limit the scope of possible significance.[37] While especially helpful in understanding the daily-life genre scenes with which De Jongh has been most concerned, this method of interpretation has offered little help in explicating landscape. Aside from moralized landscapes, the pictures rarely contain the structure of mutually reinforcing symbols, whether in the form of objects, figures, or places, that we find in genre painting, and to a lesser extent, in portraiture and still life. De Jongh himself states that the concept of apparent realism must be applied to landscapes in a different sense from that of other images. Rather than possessing a disguised symbolic content, landscapes combine various natural and man-made elements in a plausible but fictitious composition.[38] In his view, landscape, of all seventeenth-century genres, most closely approaches the concept *l'art pour l'art,* which brings him very near the notion of pure landscape.

Given De Jongh's criterion of corroborating symbols as a means of controlling

interpretation, he properly restricts his discussion of meaning in landscape to images that are part of a pair or a series such as the elements or the seasons that can provide reinforcing symbols or a context that determines meaning. Such an approach, however, limits the range of our discussion too severely. Some landscape prints with interpretive texts exist to affirm the symbolic potential of individual images, and emblems and other sources, such as the inventory entry just mentioned, clearly indicate that landscapes could communicate in ways that go beyond both *l'art pour l'art* and the defined categories of the seasons. De Jongh himself, moreover, observes that seventeenth-century thinking about nature is pervaded by concepts of its fragility and of its capacity to manifest divine revelation.[39] Even moralizing metaphorical interpretations, however, are too limited for an understanding of landscape. The images themselves provide in their conventions and their expressive structures evidence of meaning not necessarily articulated in an emblem or indeed in any text.

It is, in fact, one of the weaknesses of recent iconographic study of Dutch art that scholars rely too exclusively on the interpretations of pictures with texts, forgetting that a painting and an emblem are different genres with different conventions and purposes. Having cited an emblem or group of emblems that corresponds to a motif in a painting, scholars often assume that these metaphors somehow explain the picture, despite the fact that the form and content of paintings are frequently more complex and evocative than the often condensed language of emblem illustration.[40] While De Jongh's studies of individual pictures are marked by a keen awareness of the multiple possibilities of symbolic interpretation and an erudite grasp of iconographic sources, he usually ignores those aspects of a symbolic motif and its visual context that cannot be explained by reference to images with texts. Thus the expressive implications for a symbolic motif of its formal treatment remain largely unexplored. Yet the size, prominence, clarity, and relation to other parts of the composition of such a motif surely modify its meaning.[41] It is striking how often an emblematic motif used to explain a painting is but one feature of a larger composition in which other motifs and the formal relationships of the pictorial structure have little to do with the emblem used as a source. It is clear that in such cases we must be willing to modify the meaning derived from the more limited context of an emblem icon in terms of the formal and thematic tensions of the entire image.[42]

AN APPROACH TO INTERPRETATION

The limited success of the strictly iconographic method of interpreting landscape derives in large measure from one of the primary—if unstated—goals of this research, that is, to arrive as closely as possible at a single explanation of a painting. De Jongh himself is fully aware that many images are inherently open to multiple interpretations and that contemporary taste and outlook found nothing amiss in this.[43] Indeed, ambivalence often seems to be the point. As De Jongh's method is applied, however, there is generally an emphasis upon corroborating symbols as a means of controlling—and, eventually, limiting—the pleth-

ora of possible readings, a method, as we have seen, that leaves most landscapes uninterpretable. If, however, we place less emphasis upon arriving at a single interpretation of a given image, we can still achieve considerable insight into how these pictures communicated to contemporaries by analyzing closely the narrative and expressive qualities of a group of related images and by locating those images within their contemporary culture.

Such an attentive reading of narrative and pictorial form reveals a characteristic essential to interpreting the pictures, that is, the generalized, conventional nature of storm imagery—a property shared by all Dutch landscape art. As we have seen in paintings by Porcellis, Van de Velde, and Peeters, and as we will observe in detail in Chapter 6, close attention to the narrative situations of vessels and human beings, the depiction of nature, and the dramatized pictorial structures in these images makes us aware that they abide by a surprisingly limited range of conventions, which possess consistent connotations and emotional associations. The rendering of reality in tempest pictures is thus selective, and this selectivity in itself discloses aspects of the images fundamental to interpretation. First, it allows us to dispense with the crippling concept of "pure landscape," as well as with the traditional view that the realism of Dutch landscapes is comprehensive and objective. Selective patterns of representation decisively contradict the concept that Dutch landscape consists of either a programmatic reproduction of the world or a value-free, objective recording of appearances on the model of scientific observation and description. The pictures display every sign of being imaginative constructs, products of the mind reworking experience and artistic tradition, rather than map-like or *veduta*-like reports of appearances.

The selectivity found in storm images not only confirms their imaginative content but also guides our effort to define and comprehend it. This convention-ality is an especially valuable guide for interpretation because it provides access to a level of content intrinsic to the images themselves. It is not an applied or exterior or concealed meaning. Rather, the patterns of selective representation that characterize storm scenes are themselves inherently interpretive, and they allow us to perceive a significance that is readable in what the artist chose for depiction. This is not to imply a necessarily conscious awareness of the content on either the artist's part or that of his audience. Even when followed thought-lessly, a convention or formula communicates meaning and can be analyzed for evidence of what contemporaries expected to see—or not to see—and what they found significant and worthy of representation out of all the multiple possibili-ties of existence. Indeed, an awareness of what is *not* shown is as important to understanding these patterns of representation as a definition of their character. What is omitted casts positive content into sharper relief, for it reveals the structure of choices, assumptions, and concerns shared by artist and patron.

In the case of stormscapes, an analysis of their selective realism allows us to see that, within the wide range of possibilities presented by actual storms, these highly naturalistic images offer a consistent and coherent interpretation of na-ture in an extreme mood and man's capacity *in extremis*. One example of this interpretive rendering is the depiction of men and their ships as frail and vulner-able and yet essential to the coherence of these compositions. Another is the rendering of natural violence in terms of polar oppositions reflecting for a con-

temporary fundamental patterns of antagonism in the four elements—earth, water, air, and fire. These polarities also serve to make the images comprehensive, including all possibilities of the universe, for the images are not simply negative but tensional, embracing the full potential of nature.

If a study of conventions reveals such overarching patterns of significance, it can also allow us to identify the preoccupations of a particular artist. In the case of Porcellis's *Stranding* (Fig. 1), for example, our awareness of conventional patterns allows us to recognize that this painter here avoids the exotic, foreign, and hyperdramatic. He transfers shipwreck from the conventional remote rocky shores to the local beach and depicts not a full storm but its aftermath, a more meditative and subtle moment typical of his work.

Our understanding of the implications of these conventions for contemporary beholders is enormously enhanced by an analysis of the ways tempest paintings correspond to and visually dramatize traditional and likewise conventional ideas about storms expressed in a literary tradition of narrative and symbolism. The relationship of storm paintings to poetry, drama, and scripture is in fact one of the central themes of this book. Chapters 2 and 3 discuss the development and character of the literary and pictorial traditions, which evolved in different ways but came in the seventeenth century to share several characteristics, most noticeably a highly rhetorical naturalism. As we will see in Chapter 2, the literary tradition in the West is ancient, and its characteristic narrative and symbolic treatment of the storm was familiar in one form or another to virtually every level of society in the sixteenth and seventeenth centuries. Embracing as it does several of the most familiar scriptural passages and numerous aphorisms and celebrated descriptive set pieces in classical literature, this rich verbal culture fundamentally formed a viewer's understanding of what he was seeing. Literature in the broadest sense—modern and classical drama and poetry, sermons, devotional writing, the Scriptures and the Church Fathers, the accounts of travelers, cosmological and meteorological treatises—can be read not only for the ideas and associations bound up with storms, conceptions that shaped the responses of beholders to these pictures, but also for insight into conventions that informed the imaginative syntheses of experience fashioned by artists.

In the vast majority of cases the relationship between tempest images and texts is not that of illustration, for the pictures rarely refer to specific passages or identifiable events. Nor is it possible to demonstrate the influence of a specific writer or text on an artist or picture. Storm images should rather be understood as visual analogues to literary storms, and their pictorial conventions as analogous but not identical to the conventions of literature. One such analogy is the highly dramatized rendering of the storm in both words and images in terms of conflict between absolutely opposing forces in nature, a conflict that exposes human beings to the limits of experience while placing them at focal points where oppositions meet. Such renderings necessarily involve narrative and a psychologically dynamic appeal to beholder and reader, and, indeed, verbal evocations of the storm belong to a tradition of rhetorical description descending from classical antiquity. In this tradition, it is conventional to present a detailed description that seeks to evoke the scene as though before the reader's eyes, thus drawing him psychologically into the account. This conventional verbal visual-

ization of disaster and horror, this placing of the sight of shipwreck and storm before the imagination, has a literally graphic parallel in the vividly detailed naturalism and careful staging of Netherlandish storm scenes. The pictures are intended, like texts, to grip the imagination, and their naturalism, however convincing, is basically rhetorical in purpose and effect.

The development of tempest painting outlined in Chapter 3 can be understood as the evolution of this pictorial rhetoric. In the course of the sixteenth century artists chose to render the storm at sea in new ways that permitted visual images to bear exactly the kind of emotional and temporal projection characteristic of classical and scriptural tempest narratives. It was a process in which older, more stylized patterns of representation were replaced by a new set of conventions that enhanced the naturalism and drama of the images. While the focus of the discussion is the Netherlandish tradition in the sixteenth and seventeenth centuries, developments in Italian land- and seascape deeply affected Northerners' vision of the stormy sea. Seventeenth-century Netherlandish painters were preoccupied with the interaction of man with uncontrolled nature, which is a theme rooted in and best understood in relation to Venetian art. We find, furthermore, significant changes in the rendering of these ultimately Venetian concerns in Pieter Bruegel the Elder's transformation of the Netherlandish pictorial tradition of veristic marine imagery. A history of storm painting embracing such national diversity, incidentally, leads us into unpathed waters, for the study of seascape has been constrained by the nationalist and temporal boundaries that have tended to divide most landscape studies. In view of the interwoven relationship of Dutch, Flemish, and Italian seascape production over two centuries, however, it is sensible to make this survey of the pictorial tradition as broad as possible.[44]

Another broadly analogous convention of literary and pictorial storms is the fundamental, indeed cosmic, opposition between the tempest and its alternative, fair weather and the resolution of storm and human distress in a calm harbor and secure happiness. While storm paintings themselves do not depict fair sailing or the outcome of the voyage, they intimate its existence in patches of blue sky and bursts of sunlight and in the very coherence of the images themselves. Thus, literature and art share conventions of verbal and pictorial rhetoric that dramatize the storm, that engage the reader's and beholder's imagination, and that articulate the ultimate concordance of a universe shaped by the love and strife of the four elements.

The appropriateness of finding in pictures an analogue to the rhetoric of literary tempests is confirmed by the highly rhetorical character of all descriptions of works of art in the seventeenth century, including rare but significant descriptions of Netherlandish storm paintings. As discussed in Chapter 5, these descriptions belong to a rhetorical tradition descending from classical antiquity called *ekphrasis*, which was a form of extended description that aimed at the vivid evocation of such subjects as people, places, buildings, and works of art, both real and imaginary.[45] Like their forebears in antiquity, the seventeenth-century authors of *ekphraseis* of paintings entered empathically into every detail of the pictures, imagining situations, emotions, locations, and weather phenomena. In

accounts of storm paintings, we find exactly the same patterns of dramatized incident and emotional affect characteristic of literary storms.

The validity of *ekphrasis*—and of the entire rhetorical approach to description—as the model for an analysis of tempest imagery is suggested by Svetlana Alpers's observation that "this kind of *ekphrasis*, with its narrative emphasis, was beneath rationalization for it represented the normal way in which art was then seen and described."[46] This engaged way of viewing, moreover, was sanctioned by the commonplace assumption that paintings ought to be read with the same narrative and psychological interest as literature by virtue of the principle of *ut pictura poesis*, that a painting is mute poetry, poetry a speaking painting.[47] There is every indication that the analogies we can draw between literary and pictorial tempests are firmly rooted in these fundamental conceptions about the nature of art and literature. Moreover, these analogies strongly indicate that we too should "read" tempest pictures closely. Such a participatory viewing of tempest pictures must bear a resemblance—to a substantial degree at least—to the spirit in which the paintings were conceived and looked at. Certainly the very accuracy with which the natural world and ships are rendered would suggest artists' and patrons' keen attention to such matters and call for our own attention as well. Although our reading of pictures is highly subjective and inevitably shaped by experiences and concepts foreign to the sixteenth and seventeenth centuries, some control can be achieved by using seventeenth-century descriptive literature for guidance.

The approach of participatory viewing has been fundamental to four recent studies of meaning in landscape in which this method is applied in somewhat different ways according to the character of the artists and works involved. These are an article on Jacob van Ruisdael's *Wheatfield* by R. H. Fuchs,[48] Lisa Vergara's study, *Rubens and the Poetics of Landscape*, which in part develops Fuchs's method,[49] and studies by H. David Brumble and Justus Müller Hofstede on Bruegel's landscapes.[50] It is striking that despite major differences in scope and purpose, all four studies arrive at two essentially similar conclusions as a result of their readings of landscapes. First, all find landscapes readable in terms of opposing principles manifest both in subject matter and form. These comprehensive polarities make the images generalized, universal, and typical statements about the world rather than topographically exact views of actual localities caught in an instantaneous moment. Second, all find parallels to the oppositional tensions and the typical, universal views of nature in literature, both ancient and contemporary. As we will see, the characteristics of tempest paintings fully conform to the results of these studies.

Both *ekphraseis* of storm paintings and the larger traditions of literary and pictorial stormscape disclose still another important aspect of this imagery for interpretation—the virtually constant presence of symbolism and moralization in the rendering of storms. In literature metaphor is itself a convention integral to the tradition of treating tempests and the sea: They that go down to the sea in ships see not just events at sea but the wonders of the Lord in the deep. In images as well, a good deal of evidence suggests that the tendency to metaphor was almost irresistible. The range and depth of contemporary responses to the stormy

sea and insight into the metaphorical potential of pictures of storm are evident in Chapter 5, which discusses both ekphrastic descriptions of pictures, in which the tempest is the occasion for metaphorical meditation, and a variety of sources combining images with explicatory texts, such as emblems, medallions, and prints with inscriptions. As we have already seen, the problem in reading similar metaphors in tempest paintings involves neither the appropriateness of interpretation nor a lack of source material. Rather, the issue is the application of this rich contemporary body of sea metaphor to images whose realism seems to require no single interpretation. It will become apparent in Chapter 5 that two components of the interpretive method proposed in this book are essential to resolving this dilemma—the analysis of conventional patterns of narrative and expression and the rhetorical model of *ekphrasis* for viewing pictures—and their value lies precisely in the access they offer to the principles of selection that underlie this realism and the opportunities they provide for observing the ways seventeenth-century viewers perceived metaphor in naturalistic images. It is most noteworthy in this connection that seventeenth-century sources like emblems, prints with inscriptions, and descriptions of paintings tend to make metaphorical interpretations of images precisely in accord with the artist's treatment of conventions of narrative incident, responding to the naturalism and affective form that the painter took such pains to make as vivid as possible. Our own interpretive meditations should similarly respect the intrinsic content of the pictures. Indeed, it is arbitrary for us to apply a single marine metaphor to a single feature of a painting without considering the usual conventional role of the feature and its specific rhetorical place in a given picture.

It also becomes apparent in studying interpretive sources that in many cases where a painting possesses a readily deciphered—and very typical—content in the dramatic events it represents, this content is open to a number of different metaphors, some of which may be obscure to modern viewers. In general, the code of incident and expression in a given Dutch stormscape—and probably in most Dutch landscapes—invites meditation and guides it but does not require or specify a single symbolic reading. Storm paintings, like most Dutch landscapes, are most emphatically not symbolic diagrams or puzzles with a single solution, but charged fields for the projection of thought and feeling. They are perhaps understood best by analogy to history painting.

Ultimately, the very existence of conventional patterns of representation in these images argues that they can be interpreted metaphorically. Of course, conventionality in storm paintings does not of itself prove a symbolic content corresponding to literary storms. Such conventions, however, manifest the same tendency of thought that underlies all symbolic interpretation in the seventeenth century, that is, a predisposition to seek in a situation or experience the typical and the general, that which fits a pattern of meaning. It is a habit of mind that functions in terms of a search for significant patterns and types in which microcosms, including man himself, mirror and reproduce the fullness of a purposeful creation. Conventionalized images do not just reproduce what happened or what it looked like to be there—storm scenes relate only very generally to actual history and real places—but make the experience intelligible. Considered in this way, convention in storm scenes can be seen to function essentially as a code that

permits the artist to re-create and the beholder to grasp an experience imagina-
tively, which in seventeenth-century terms involves metaphorical exegesis.

Thus, within the larger culture of the seventeenth-century Netherlands we
find a license and guidance for our interpretation of Dutch realism. While we
can never experience the paintings with the eyes of a seventeenth-century be-
holder, we have available to us in contemporary sources a literature of storm
that found meaning in mundane reality, attitudes toward depicting and reading
corresponding meaning in images, assumptions about the structure and scale of
the world, and a tradition of metaphorical interpretation of experience. The
culture of the sixteenth and seventeenth centuries in this way permits our
empathic entrance into these narratives of peril, disaster, and salvation and
allows us to read them with a body of ideas and associations in mind not unlike
those of the makers and buyers who prized paintings of the stormy sea and hung
them on their walls. It is within this more discursive approach to interpretation
that we may apply the metaphors of the emblem writers, recognizing that it is
not so much a matter of applying a single metaphor precisely to one picture as of
entering the value-system implicit in an image, which includes the possibility
of metaphor. The resulting view of the meaning of any one seventeenth-century
painting is not easily encapsulated in a phrase but reflects much more accu-
rately the character of contemporary understanding.

THE NETHERLANDS AND THE SEA

A further historical context that illuminates the imaginative re-creation of expe-
rience in tempest pictures is the reality of sixteenth- and seventeenth-century
seafaring and especially the enormous significance of the sea for the history and
culture of the Netherlands in these centuries.[51] The impact of seafaring on
Netherlandish life and thought, in fact, can hardly be overstressed, and its perva-
sive influence must be seen as shaping the associations and values with which a
Netherlander beheld an image of the tempest. The great enterprise of Dutch
seafaring was, moreover, a primary factor in the emergence of the storm and of
seascape in general as pictorial subjects.[52]

The geography of the Low Countries favored a maritime culture, for it is still a
land literally permeated by water, consisting in large part of the delta of the great
rivers Maas, Rhine, and Schelde, where they flow into the North Sea. Behind the
barrier dunes facing the menacing sea was a land of low-lying fields and bogs,
crisscrossed by numerous natural and man-made watercourses: rivers, streams,
canals, and drainage ditches. It was a land also of islands and inland seas, whose
aspect has been steadily altered by great reclamation projects that began in the
seventeenth century.[53] But at that time the islands of Zeeland had not yet been
linked to each other and to the mainland, and the Zuiderzee and Haarlemmer-
meer and dozens of smaller bodies of water and marshes still existed, giving the
land in contemporary maps a startlingly dissolved appearance. The process of
diking and draining, which had begun long before the seventeenth century, was

enough in itself to induce a special consciousness of the sea, especially as that element sometimes reclaimed its own in disastrous inundations.

The location of the Low Countries on the North Sea and the shortage of arable land made it a nation of fishermen, sailors, and traders. A principal foundation of Dutch prosperity was fishing, and especially the "great fishery" for herring in the North Sea. Furthermore, a location at a natural crossroads of European trade, where the traffic from the Baltic and the Iberian peninsula met that from the Continent via the great rivers and from the British Isles, offered Netherlanders the opportunity to develop rich and wide-ranging trading and shipping enterprises. In the fifteenth and sixteenth centuries, Bruges and later Antwerp were already the financial and trading centers of Northern Europe, and with the flight of labor and capital to the North Netherlands after the fall of Antwerp to the Spanish in 1585, there ensued an extraordinary growth in Dutch merchant activity.

By the mid-seventeenth century, Dutch traders were active from Russia to Brazil, from North America to Japan. If their search for profit and political advantage was sometimes disappointed, as in New Amsterdam and Recife, their enterprise in the East Indies was richly and enduringly rewarded. Dutch commerce, moreover, did not flourish solely in distant continents but achieved dominance in European waters, where the Dutch captured the carrying trade in such bulk goods as timber, grain, metal, salt, cloth, and even marble. It is revealing that Versailles was built with marble from Amsterdam. Perhaps the sheer scale of the enterprise generated in the small provinces of Holland and Zeeland is the most significant feature for a study like ours, for this expenditure of energy, wealth, and talent must have touched a large portion of the population that otherwise had no direct connection with seafaring.[54]

Dutch commercial success also resulted from such related aspects of this entrepreneurial energy as improvements in ship design and in navigation. Jan Jansz. Liorne, a shipbuilder in Hoorn, introduced the *fluit* or flute in 1595, an ocean-going ship distinguished by a rounded, swelling hull of relatively shallow draft, ideally suited to the shallow waters of the Netherlands and to carrying larger loads of bulk commodities than ordinary hull forms. Because the vessel was also capable of being handled by a smaller crew, it permitted the operating economies that enabled the Dutch to undersell their competitors and gain control of the carrying trade of Europe.[55] The Dutch also took the lead in cartography, and the sea charts first published by Lucas Jansz. Waghenaer in 1584–85 became so celebrated for their accuracy that English seamen continued to refer to books of charts as "wagoners" well into the nineteenth century.[56]

Dutchmen were keenly aware of these developments, just as they were conscious of the overriding importance of their naval power in resisting Spain for decades and of the role of seaborne trade in the prosperity that financed their revolt. The growth of national independence, a new national self-awareness, and seafaring were thus closely linked.[57]

Seafaring also penetrated the fabric of Dutch society through the *rederij* or part-ownership of vessels that prevailed in the North Netherlands, whereby individuals bought shares in ships as investments.[58] The *reders* were apparently often of modest means, even deckhands occasionally owning fractions of shares of the vessels they manned, a diffusion of ownership that spread both financial

losses and an interest in events at sea. This awareness was further stimulated by a large body of travel literature, the most important for our purposes being the accounts of the Dutch voyagers who broke the Iberian monopoly in the East and the Americas and explored northward for passage to the East.[59]

Jan Huygen van Linschoten's *Itinerario*, recounting his voyage to the Portuguese Indies, appeared in 1596 and was followed by a flood of this literature, often published in cheap pamphlet form. These writings are of the greatest interest in assessing the relationship of tempest images to the actual conditions of seafaring. The texts are often either extracts from logs and diaries, and thus direct records, or straightforward narratives expressing the immediate reactions of ordinary men without literary pretensions. The abundance and popularity of these accounts in the Netherlands confirm the availability to painters and their audience of accurate information about the actual conditions, rewards, and dangers of sailing.

Testing pictures against the realities of seventeenth-century seafaring as recounted in these sources, we again confront the fundamentally interpretive character of contemporary tempest imagery. We find that very few paintings illustrate the storms and wrecks recorded in the voyagers or other sources. While it is virtually certain that some tempest paintings represent real occurrences, very rarely can such an event be identified, and in these cases reality is apparently depicted almost entirely in terms of standard conventions, conforming to generalized patterns rather than emphasizing unique circumstances.[60] Moreover, this comparison with contemporary accounts reveals that rather than surveying the vicissitudes of seafaring, the pictures selectively portray human contention with the elements.

As in the cases of the other contexts in which we will study storm images, we encounter in the voyagers and the history of seafaring neither an exact correspondence with tempest paintings nor a means of explaining the pictures as illustrations of the great adventure of Dutch seafaring, but rather a means of entering into the imaginative world of artists and beholders, which was indeed marked by that adventure. And in the end this is the goal of our study, to draw upon the historical contexts that underlay and shaped a contemporary viewer's understanding of storm paintings and to identify the pictorial qualities that allow us to participate in that understanding.

2

Rhetoric, Weather, and Metaphor: The Storm at Sea in the Literary Tradition

Sixteenth- and seventeenth-century Netherlanders inherited an extensive body of writing on the tempestuous sea that was widely familiar in Renaissance Europe. This ancient literary tradition included verbal evocations of man's encounter with the tempest—accounts of narrative incidents, natural phenomena, and human emotional responses—as well as metaphorical interpretations of those experiences. Many of the most celebrated descriptions of storms occurred in biblical passages known to all levels of society, and numerous others were readily available in classical and modern texts that were familiar to any educated person of the time. Though repeated and elaborated over many centuries, these passages are marked by consistent and distinctive narrative techniques and metaphors that reflect a commonly shared worldview. Providing the fundamental structure of conceptions and categories through which the storm was experienced, this literature demonstrably shaped a seventeenth-century author's approach to this subject and surely informed a viewer's responses to images of the sea. Hence literary tempests must inform our own viewing as well.

The literary tradition comprises two main streams, classical and Christian, the latter formed from scriptural accounts of storms and the classical tradition as Christianized by the Church Fathers. For practical purposes, however, it is often difficult to identify which of these traditions, much less which particular passage, inspired a sixteenth- or seventeenth-century author because the narrative motifs and vocabulary of literary tempests had by this time become com-

mon cultural property. The extent to which this tradition permeated the consciousness of the literary elite and of the ordinary populace throughout Europe is revealed by the dependence of Renaissance accounts of storms on these classical and biblical literary precedents. Moreover, descriptions by Dutch voyagers such as Linschoten and Bontekoe, though less rhetorically ambitious, reveal the same propensity to interpret events at sea as direct manifestations of God's will that we find in "high" literature. We thus have available a stock of words and ideas about the storm that we can safely assume corresponds to those of a wide range of sixteenth- and seventeenth-century beholders and upon which we can draw for our own beholding and understanding.

THE CLASSICAL TRADITION
OF TEMPEST NARRATIVE

Although the classical component of this tradition embraces numerous descriptive passages, such accounts derive ultimately from Homer's accounts of two tempests sent by Poseidon and Zeus to assault the hero of the *Odyssey* (V.291–386; XII.403–25).[1] Of greater authority in the Renaissance, however, was Virgil's similar treatment of the tempest that scatters and destroys much of the Trojan fleet (*Aeneid* I.81–156).[2] In the seventeenth century Ovid's more elaborate account of a storm and shipwreck in the story of Ceyx and Alcyone (*Metamorphoses* XI.478–572)[3] was equally familiar, as was Seneca's extended treatment of the tempest that scourged the Greek fleet (*Agamemnon* 465–578).[4]

Tempest descriptions occur also in many other ancient texts known to the Renaissance. They not only remained a standard element of classical epic—perhaps reaching their ultimate development in that form in Lucan's *Pharsalia*, with no fewer than four lengthy storm scenes[5]—but were also an essential feature of romances such as Achilles Tatius's *Leucippe and Clitophon*.[6] Of equal importance to their elaboration and familiarity, descriptions of storms were basic exercises in the schools of rhetoric in antiquity, and in rhetorical theory they were regarded as suitable subjects for a *descriptio*. In this part of a declamation an author expanded the subject by vividly describing the sensory details of an event in such a way that the scene seemed to be present before the eyes of the hearer or reader, a quality referred to as *enargeia*.[7] Such rhetorical training underlies the pictorial vivacity of Lucretius's storm and wreck similes, as when he argues against a finite supply of atoms in the universe:

> I see no possible means by which [the atoms] could come together. Consider, when some great flotilla has been wrecked, how the mighty deep scatters floating wreckage—thwarts and ribs, yard-arms and prows, masts and sweeps; how sternposts are seen adrift off the shores of every land—a warning to mortals to shun the stealth and violence and cunning of the treacherous sea and put no faith at any season in the false alluring laughter of that smooth still surface. Just so will your finite class of atoms . . . be scattered and tossed about through all eternity.[8]

The closeness of the storm descriptions of Lucretius, Ovid, and Lucan is due to this shared tradition of rhetorical training and their use of a stock of declamatory formulas based on Virgil. Indeed, although authors after Virgil added new motifs to their accounts of storms, their basic dependence on his text is one reason for the difficulty in specifying classical models for a Renaissance storm narrative.[9]

We encounter many characteristics of these classical descriptions in Renaissance texts: Aeolus stirring up the winds; the battle of the winds and their combined assault from all directions on the vessel; the frightening darkness of the storm; clouds lit by lightning; the fury of the Sea God causing waves so monstrous they reach the mountaintops; high seas hurling ships to the stars, then to the sands of the abyss; the uselessness of the rudder; the battering of the hull and the loss of sails, yards, and masts; the shipwreck on a rocky shore; and the sailors' and passengers' despair, their laments and prayers, their struggles to survive, and usually their deaths. Every educated man—certainly every educated Dutchman—of the time was familiar with such literary storms, and for a description of a storm or a storm picture naturally turned to these familiar models. Thus out of the complex possibilities of recounting storms, certain events and descriptive features, first found in classical texts, became conventionalized.

It is not only specific elements from classical storms that influenced Renaissance texts, however, but the very style in which the storms are conceived and evoked. Classical accounts of tempests are notable for their strong narrative flow and their compelling rendering of weather phenomena and human responses so as to engage the reader psychologically. In this they reveal the close relationship of these descriptions to *ekphrasis* and confirm the influence of epideictic rhetoric on them.[10] The stormy sea is thereby associated in antiquity and the Renaissance with an emotionally charged and sensorily vivid style of presentation, which is overtly acknowledged in Samuel Purchas's marginal comments on William Strachey's "A true repertory of the wracke, and redemption of Sir Thomas Gates Knight," one of the texts that very likely inspired Shakespeare's *The Tempest*.[11] Purchas glosses the narration as "A terrible storme expressed in a patheticall and retorical description," and at a later point, "Swelling Sea set forth in a swelling stile."[12] Pathos and rhetoric indeed give Strachey's words great immediacy, as they were intended to:

> . . . a dreadfull storme and hideous began to blow from out the North-east, which swelling, and roaring as it were by fits, some houres with more violence then others, at length did beate all light from heaven; which like an hell of darknesse turned blacke upon us, so much the more fuller of horror, as in such cases horror and feare use to overrunne the troubled and overmastered sences of all, which (taken up with amazement) the eares lay so sensible to the terrible cries and murmurs of the windes, and distraction of our Company, as who was most armed, and best prepared, was not a little shaken. . . . For foure and twenty houres the storme in a restlesse tumult, had blowne so exceedingly, as we could not apprehend in our imaginations any possibility of greater violence, yet did wee still finde it, not onely more terrible, but more constant, fury added to fury, and one storme urging a second more outragious then the former; whether it so wrought upon our feares, or indeede met with new forces: Sometimes strikes [shrikes?] in our Ship

amongst women and passengers, not used to such hurly and discomforts, made us looke one upon the other with troubled hearts and panting bosomes: our clamours dround in the windes, and the windes in thunder . . . six and sometimes eight men were not inough to hold the whipstaffe in the steerage, and the tiller below in the Gunners roome, by which may be imagined the strength of the storme: In which, the Sea swelled above the Clouds, and gave batell unto Heaven. It could not be said to raine, the waters like whole Rivers did flood in the ayre. . . . What shall I say? Windes and Seas were as mad, as fury and rage could make them.[13]

In the seventeenth-century Netherlands, Joost van den Vondel's account of the storm in *Het Lof der zee-vaert* (*The Praise of Seafaring*) obviously belongs to the same tradition. Some of its verses are virtual translations of the storm in Seneca's *Agamemnon:*

. . . unexpectedly the wind sighs along the sandy shore. The clouds cover and ever more somberly extinguish the stars; the wind rises and covers and envelops the ocean with thick spray. It mixes sea and heaven together; it pours and showers. The East wind is against the West, the North against the South. Downfall thunderously denies uprising. The South Wind howls and rages; the North Wind cries. The breakers rage on the beach, on cliffs, and on shallows. Winter is unchained; the storms set free. They capture Aeolus; and he wonders whether Fate will brew a chaos of heaven, earth, and sea. The flood resists the wind; the careering winds sweep over the waves and make the surge roll. Where do you think my ship remains, driven by necessity, thrown into the mouth and jaws of death. One is hard at work with striking sail, pumping, bailing, with cutting, hammering, beating, with tying, climbing, untying. Now the ship is in danger from behind, now from before, now at the side. The sea forgets her limits, and Nereus, his ebb and flood. Now [the ship] hangs on a mountain, now the mast pierces the clouds; now Hell swallows it through the gulping of the vortices. One curses the longed-for land, although one fears the sea. The ship answers to neither rudder, steersman, nor compass: Art is conquered, as when the Janissary scum, fired with hate, heed no sultan, but foam at the mouth, threaten and defy, and stamp, and howl, and rage, until their appetite for vengeance is cooled with a pasha's blood. My Tiphys [helmsman] often must propitiate against his will the hearts of the water gods with the loaded goods and he lightens the cargo in need, and cuts away his masts, flings overboard willingly what he does not need, and struggles gropingly, and hears the ropes scream, observes no light in the heavens, and sees no fiery beacons. If light appears it is lightning, hurled by Jupiter into the deepest darkness of the night. Slowly day breaks, which lets him see that which would fill a stone heart with compassion: the disabled fleet, stricken, exhausted, stripped of sail and rigging, of rudder, rope, and mast; demolished, choked with sand, aground, on reefs and on rocky banks; despairing [castaways] who crave help desperately, and hang from rocks, or swim on a plank, one living, the other dead, soaked through, weak, and sick; and others rigid with fear, who are shrunken in and wait their last moments, and keep the vessel up by pumping, and still entreat assistance from afar with gunshots; and others, squeezed in their death-throes in a boat. Proteus help! It is a miracle that mortal men still scorn the plow and seek the sea-air.[14]

Considering these texts further reveals a still more fundamental affinity between the ancient and Renaissance passages, for essential to the rhetorical struc-

ture of both is the characterization of the storm through oppositional conflict. The storm itself is described in terms of antagonistic forces in Vondel's verses, for example, in the conflict of the four winds (ll. 270–72) and in the assault of wave against the shore and of the winds against the sea (ll. 273–78). Men experience the storm in extreme contrasts of situation and violent swings of mood— the ship now rises on a mountain of water, now plunges into the abyss (ll. 285– 87) and human beings are caught between the natural antagonists, horrified by the deadly peril represented by a coastline yet, ironically, fearful of their only escape, the open sea (l. 286).

In this literary tradition, such polarities offer us a measure of our place within the universe by portraying the storm as the situation in which all extremes of the world coincide. These storms thus surpass any human experience, for they are always more powerful, horrible, deadly, and terrifying than could ever be imagined. But polar oppositions also define the role of the storm within the larger structure of the universe. As we see in Vondel's account of the stormy sea, the existence of forgotten boundaries of the deep (l. 284) necessarily implies the existence of cosmic pattern and order. The same order is implicit also in the elemental discord that results when Fate seems to brew chaos from the ordinarily stable sky, earth, and sea, causing them to revert to the flux from which they were created (ll. 275–76). The sea possesses, of course, profound primordial resonance as symbol of all disorder and conflict, of all that is beyond man's physical control and imaginative comprehension and articulation. In part, however, it evokes our responses with such power because of the implied existence of an alternative possibility of concord and harmonious relationship, qualities at once antagonistic and complementary to the storm. Such tensions shape the classical tradition of tempest narrative, in which the alternation of storm and calm, destruction and prosperity, doom and salvation serves as a framework within which all narrative unfolds. Vondel is within this tradition when he evokes a calm at sea in the lines just preceding his storm (ll. 255–64) and immediately after the tempest recounts the pleasures of life on board in fair weather (ll. 339–45). Moreover, in the larger structure of his poem, Vondel guides us on a poetic voyage (in itself a classical conceit) that, passing through storm and distress, arrives in the harbor of Amsterdam to abundance and celebration in the home of the patron of the arts Roemer Visscher (ll. 457–79).[15]

The larger significance of this way of characterizing storms has been articulated by G. Wilson Knight in a study of Shakespeare's plays. Knight's thesis is that Shakespeare's work is fundamentally pervaded and unified by a tension between clusters of symbols centering on the opposition of tempests and music.[16] He observes that the antithesis in Shakespeare is not between order and disorder in any simple way, but between interacting forces or principles whose conflict and interplay lead to resolution. In this way even the tragedies become creative as they move from imagery of communal music to tempestuous discord to the restoration of harmony chastened and deepened by pain and strife. In this context the tempest, while "Shakespeare's intuition of discord and conflict . . . at the heart of existence," is still an element of a wider music permeating the whole world of matter, for the storm is essential to the texture of life and poetry.[17] It makes music possible. It is not simple negation but is interdependent

with concord and music in "reciprocal action and continual recreation."[18]

Knight recognizes that the unity of Shakespeare's drama results from a process of narrative that unfolds through the interactions of fundamental symbolic oppositions. His insight applies as well to the classical and Renaissance tradition of tempest description. While these texts are hardly ever endowed with the profound implications of *King Lear*, they are conceived and recounted through a similar structure of tensions that are at once oppositional, expressing the disorder and terrifying destructiveness of the storm, and unifying, each pole completing the sense of its opposite and providing a structure within which the entire narrative develops. Knight's recognition of an ordering principle of polar oppositions will prove extremely useful in discerning the conception of nature that guided painters of tempests in the seventeenth century, and it will help us especially to understand the implications of their rendering of the sea and weather. We find in tempest painting also a depiction of our place in the natural world analogous to the conception of a cosmos made up of forces in tension. In painting, men and vessels also participate in a dramatic process of conflicting forces, which dwarf and sometimes annihilate the human actors, but in which order is implied as men and ships sustain the coherence of the composition. Storm images, like texts describing storms, do not report weather phenomena or current events but articulate a dramatic conception of human existence.

Given the importance of fundamental polarities to these texts, it is clear that the storm in them is best understood in relation to its opposite found in both the *locus amoenus* of pastoral and the carefully tilled fields of georgic. These were the dominant modes of landscape description in classical and Renaissance literature, including that of the seventeenth-century Netherlands.[19] Like the literary storm, the *locus amoenus* was a highly conventionalized description following a pattern that derived ultimately from Theocritus and was deeply transformed by Virgil. But unlike storm narratives, pastoral poetry locates in landscape a vision of harmony between human action and thought and the life of nature. This setting is a "pleasance," the happy place where all desire is satisfied in perpetual springtime, a landscape combining varied trees shading a cool brook, fresh grass, and a carpet of flowers.[20] Extensive descriptions of the tempest and shipwreck do not form part of the conventions of pastoral; but in pastoral poetry seafaring is consistently referred to as one symptom—along with commerce in general and mining for gold—of the decline from the ideal oneness of man with nature in the Golden Age, with which the life of shepherds is so closely identified.[21] The Golden Age also figures in the ideal of rural life presented by georgic poetry, which in contrast to pastoral is concerned with agriculture. In georgic, seafaring and the perils of the sea, especially the storm, are always set in opposition, if only in passing, to the ideal life of industry, fertility, and harmony that a wise husbandman can experience in nature:

> Blessed is he who has been able to win knowledge of the causes of things. . . . He plucks the fruits which his boughs, which his ready fields, of their own free will, have borne; nor has he beheld the iron laws, the Forum's madness, or the public archives. Others vex with oars seas unknown, dash upon the sword, or press into courts and the portals of kings. (Virgil, *Georgics*, II.490–91, 500–504)[22]

Like Virgil, Horace exalts country life as against the perils of soldiering, sailing, and public life:

> Happy the man who, far away from business cares, like the pristine race of mortals, works his ancestral acres with his steers, from all money-lending free; who is not, as a soldier, roused by the wild clarion, nor dreads the angry sea. (*Epode*, II.1–6)[23]

This theme recurs repeatedly in the numerous Dutch georgics (called "hofdichten") of the seventeenth century.[24]

Moreover, the storm as a characteristic of a season and its corresponding human mood is frequently encountered in both pastoral and georgic. In the latter, the concern for reading weather signs as a means to a harmonious existence in nature sometimes leads to dramatic narratives of autumnal thunderstorms, such as that in Virgil's first *Georgic* (ll. 311–34):

> Why need I tell of autumn's changes and stars, and for what our workers must watch, as the day now grows shorter and summer softer, or when spring pours down in showers, as the bearded harvest now bristles in the fields, and the corn on its green stem swells with milk? Often, as the farmer was bringing the reaper into his yellow fields and was now stripping the brittle-stalked barley, my own eyes have seen all the winds clash in battle, tearing up the heavy crop far and wide from its deepest roots and tossing it on high; then with its black whirlwinds the storm would sweep off the light stalk and flying stubble. Often, too, there appears in the sky a mighty column of waters, and clouds mustered from on high roll up a murky tempest of black showers: down falls the lofty heaven, and with its deluge of rain washes away the gladsome crops and the labours of oxen. The dykes fill, the deep-channelled rivers swell and roar, and the sea steams in its heaving friths. The Father himself, in the midnight of storm-clouds, wields his bolts with flashing hand. At that shock shivers the mighty earth; far flee the beasts and o'er all the world crouching terror lays low men's hearts: he with blazing bolts dashes down Athos or Rhodope or the Ceraunian peaks. The winds redouble; more and more thicken with rain; now woods, now shores wail with the mighty blast.[25]

Thus, while extended accounts of storms at sea do not appear in these genres, the ideally hospitable landscapes of pastoral and georgic are consistently measured against the violent, hostile nature familiar from tempest narratives. These opposing conceptions of the relationship between man and nature formed, like nature and art or the city and the country, elementary structures of thought against which human experience could be evaluated and characterized.

COSMOLOGY, METEOROLOGY, AND METAPHOR

This Renaissance perception of life as pervaded by dramatic tensions has its roots in part in fundamental cosmological ideas that lie behind both the literary and visual imagery of the period. Centering upon the theory of the four ele-

ments, this worldview discovered universal order in a macrocosm that was linked by numerous correspondences to the multitude of microcosms that each reproduce its amplitude in small.[26] This concept, derived from classical antiquity, was expanded and ordered in a typically medieval systematization that remained a shared body of assumptions about the nature of the world and man's relation to it in the sixteenth and seventeenth centuries.[27]

As the seventeenth century progressed, the new cosmology of modern science began little by little to alter the Medieval-Renaissance cosmological consensus. It was a slow process, however, whose effects are but intermittently detectable outside an elite of well-informed scientists, philosophers, and men of letters until the second half of the century.[28] Constantijn Huygens, for instance, though deeply interested in the new learning and acquainted personally with scientists and philosophers such as Descartes, continued to think in terms of a universe of analogies. As late as 1675 he saw a divine lesson in a calm following a disastrous storm.[29] Even William Harvey, whose book on the circulation of the blood of 1628 is so striking in its factual, nonrhetorical tone, occasionally resorts to analogies with the cosmos to explain the circular motion of the blood from the heart. He finds that this circulation conforms to a pattern of circular motion that is visible also in the great world "in the same way as Aristotle says that the air and rain emulate the circular motion of the superior bodies; for the moist earth, warmed by the sun, evaporates; the vapours drawn upwards are condensed, and descending in the form of rain, moisten the earth again . . . and in like manner are tempests and meteors engendered by the circular motion, and by the approach and recession of the sun."[30] Even after 1700, science had only partly altered old habits of thought for the larger populace. The continued popularity of emblem books in the eighteenth century indicates that the inclination to find moral meaning in every aspect of the world had by no means vanished but was deeply ingrained, despite the loss of the cosmology that had sustained such interpretations.

The old worldview, which still held sway through most of our period, can best be apprehended through the theory of the elements—Earth, Water, Air, and Fire—as the basic components of all creation. In this theory we find a system of exactly the tension of antagonism and concord typical of tempest narratives.[31] Each element is composed of two of the four basic qualities, which exist as two pairs of polar opposites: dryness and moistness, and cold and heat. Because each quality is capable of combining with two of the others but is the opposite of the third, each element in turn is compatible with the two elements with which it shares qualities but absolutely contrary to the third. This system is more easily comprehended in a Pythagorean tetrad (Fig. 12), a diagram of this fundamental cosmological archetype that defines the structure not only of the whole cosmos but of every microcosm that reproduces in small the macrocosm.[32] In this conception the universe functions as an immense network of correspondences, so that the four elements are adumbrated or reflected in the microcosms of the four bodily humors, the four seasons, the four winds, the four ages of human life, all of which are pervaded by the same pattern of compatibility and polar opposition existing within the unity of the cosmos.[33]

These tensions between the opposing qualities themselves and between their

state of conflict and their concordance in other qualitative and elemental combinations are thus central to the worldview of the sixteenth and seventeenth centuries. Such tensions are indeed, as Knight remarks of storms, the very texture of existence. Moreover, the theory of elemental interaction, transmutation, and opposition was the basis of Renaissance meteorology, which derived primarily from Aristotle's *Meteorologica*, as Harvey's words testify.[34] In Aristotle's view, Earth and Water are the raw materials of weather on which Fire in the sun acts. The sun draws from water by evaporation a hot and moist vapor like elemental Air, while it causes a hot and dry "exhalation" to arise from the earth. As these Air-like substances rise and move they are modified by heat and cold (again the interaction of the four primary qualities is involved) to produce all weather, as well as earthquakes and a variety of astronomical phenomena.

In Renaissance thought, which followed classical and medieval authorities, weather was perceived as a strife between counterforces in the universe. When Vondel wonders "whether Fate will brew a chaos of heaven, earth, and sea," he reflects contemporary meteorological thinking about tempests, which envisioned the wind literally entering the sea, resulting in a confusion of the elements approaching primordial chaos.[35] This concept of the storm as a conflict between antagonistic elements is vividly pictured by Edmund Spenser:

> He cryde, as raging seas are wont to rore,
> When wintry stormes his wrathfull wreck does threat,
> The rolling billowes beat the ragged shore,
> As they the earth would shoulder from her seat,
> And greedie gulfe does gape, as he would eat
> His neighbor element in his revenge. . . .
> (*Faerie Queene* I.xi.21)[36]

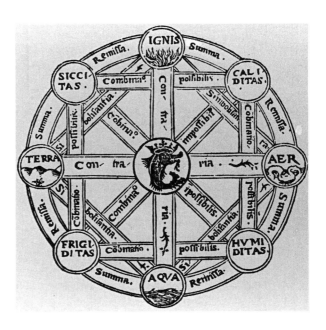

FIG. 12. Pythagorean tetrad, from Oronce Finé, *Protomathesis*, Paris, 1532

The drama and energy of this conception of the causes of weather are vividly expressed in a remarkable passage from Pliny the Elder's well-known *Natural History* (II.xxxviii.102–4), in which the "warfare between the elements" is not seen as simply destructive but as an integral aspect of an ever-changing yet coherent universe:

> This region below the moon [i.e., the realm of change] . . . blends together an unlimited quantity from the upper element of air and an unlimited quantity of terrestrial vapour, being a combination of both orders. From it come clouds, thunder-claps, and also thunder-bolts, hail, frost, rain, storm and whirlwinds; from it come most of mortals' misfortunes, and the warfare between the elements of nature. The force of the stars presses down terrestrial objects that strive to move towards the sky, and also draws to itself things that lack spontaneous levitation. Rain falls, clouds rise, rivers dry up, hailstorms sweep down; rays scorch, and impinging from every side on the earth in the middle of the world, then are broken and recoil and carry with them the moisture they have drunk up. Steam falls from on high and again returns on high. Empty winds sweep down, and then go back again with their plunder. So many living creatures draw their breath from the upper air; but the air strives in the opposite direction, and the earth pours back breath to the sky as if to a vacuum. Thus as nature swings to and fro like a kind of sling, discord is kindled by the velocity of the world's motion. Nor is the battle allowed to stand still, but continually carried up and whirled round, displaying in an immense globe that encircles the world the causes of things.[37]

Elemental interactions and tensions also caused and were mirrored in the changing cycle of the seasons, an association that manifests itself in landscape painting as well as in literature. The characteristics of the seasons in Renaissance thought derived, like meteorology, from classical culture as modified during the Middle Ages.[38] In pastoral poetry of antiquity and the Renaissance the correspondences believed to exist between the seasons and the cycles of human life and feelings were of central concern. Georgic poetry too has as a primary theme the relationship of man's occupations to seasonal change and his ability to read changing weather signs as a guide to abundance and prosperity within the larger movements of nature.[39] In this tradition storms both on land and sea take an assigned and understandable place in the sequence of seasonal development and are mirrored in human behavior and feelings.

The association of storms with seasons follows two distinct paths, both of which reflect the concept of polarities and harmonies among the elements. Winter as a time of storms is a commonplace of great antiquity. Deriving in part from the peril of navigation on the Mediterranean Sea during the winter months, it is one of the geographical and climatic factors whose impact on human behavior has been analyzed by Fernand Braudel.[40] But the storms of winter also possessed an imaginative appeal as the opposite of the fair weather and ripening abundance of summer. Then elemental fire and its qualities of heat and dryness are dominant, in contrast to their elemental and qualitative antagonists—water, cold, and moistness in winter.

Storms could also, however, characterize spring and fall or, more precisely,

the equinoxes, for then, as Lucretius explains, "the year's turning tide mingles cold and heat. . . . Then there may be a clash of opposites, and the air tormented by fire and wind may surge in tumultuous upheaval."[41] In antique and Renaissance cosmology all weather phenomena and the processes of seasonal growth and harvest, decay and renewal, arise from the cosmic tensions of compatibility and hostility between the elements. And in this process the tempest plays an integral role, both as the expression of elemental discord and as one extreme of a larger cosmic order oscillating between harmony and concordance and discord and violence.

The importance of this cosmology for the Renaissance understanding of storms, however, also resides in the conception of the universe as a structure of correspondences between the macrocosm and the many microcosms, including the "little world of man." In this system, all metaphors possessed a reality almost wholly foreign to our way of thinking. As Marjorie Hope Nicolson observes, "our ancestors believed that what we call 'analogy' was *truth*, inscribed by God in the nature of things."[42] In consequence, the many metaphors of tempest in the Western literary tradition that I will presently examine should not be understood as merely pleasing analogies but as identities grounded in the divinely ordained pattern of the universe.

Thus, when Shakespeare has a Gentleman report of King Lear that he is

> contending with the fretful elements;
> Bids the wind blow the earth into the sea,
> Or swell the curled waters 'bove the main,
> That things might change or cease;
>
>
>
> Strives in his little world of man to out-scorn
> The two-and-fro-conflicting wind and rain,
> (*King Lear* III.i.4–7, 10–11)

the strife between the elements manifest in an actual tempest and that between the passions in Lear's mind arise from imbalances and antagonisms echoing in the great world and the small world of man.[43] On a more prosaic level, Jacob Cats finds in the arthritic aching of his body on the approach of a storm not merely a metaphor in our sense but a genuine sympathetic link between the pains of the small world of our bodies and the turmoils of the universe.[44] It is this cosmology of correspondences that underlies and, for a Renaissance mind, validates the many metaphors of storm, seafaring, and shipwreck that we find in both the classical and Christian literary traditions. This cosmology made nature literally a revelation of divine purpose and meaning, and it justifies Roemer Visscher's dictum that "there is nothing empty or idle in things."[45]

METAPHORS OF STORM IN
CLASSICAL LITERATURE

The tempest in the classical literary tradition shared with pastoral the "inherent figural capacity . . . to encompass the great question of man's relation to the created order."[46] Ships and the tempestuous sea were thus endowed with an extensive range of metaphorical interpretations that still persisted in the sixteenth and seventeenth centuries.[47] These metaphors remained commonplaces for centuries; and, indeed, some retain their wide familiarity to this day.

Most often ships and storms were used as images of human life, especially of the suffering, turmoils, and disasters that men experience either as individuals or corporately in the state, armies, and crowds. Already in Homer we find the image of battle as a storm, a metaphor frequently elaborated in the classical tradition so that advance and retreat become like the waves, the noise of battle like their relentless breaking on shore, attacks from all directions like the assault of waves, and row after row of troops like the endless succession of waves.[48] Ovid reverses the metaphor and sees the waves attacking a ship as an army breaching city walls.[49] In an associated image defenders who resist attack are like rocks standing firm against the breakers, which in this tradition become emblematic of resistance and endurance.[50] Related to battle images are comparisons of crowds with the sea, also ultimately a Homeric image.[51] The vast numbers and unstoppable motion of a crowd are like the relentless waves; the emotions of the mob are swayed by every agitator's influence as winds work the waves; the noise of the crowd is like a storm breaking on a shore.

The tempestuous sea as image of the individual soul in the throes of profound emotion also originated in Homer.[52] Confusion, sorrows, insanity, and rage are all related to the violence of the moving sea, while the ship struggling in high seas is seen to resemble a soul in a state of high excitement or torn by conflicting emotions. Surrender of the rudder is like an individual's loss of self-control, and a man under the influence of wine is like a ship tossed helplessly in a tempest.

Love was the emotion most frequently described through storms and voyages, an image closely related to the comparisons drawn between the sea and the inconstancy, moodiness, and deceitfulness of women.[53] This association of the ever-changing sea with female unpredictability and love was made more readily in antiquity because of the dual role of Aphrodite as goddess of love and protector of sailors, invoked by Romans as *Venus marina*.[54] Erotic passion as a storm, the lover as a ship struggling in the tempests of passion, the follies of lovers and the suffering of unrequited love as shipwreck, the favor of the beloved as a safe harbor, jealousy as a storm, are all commonplaces in this tradition. And it is not surprising that marriage was likewise occasionally compared to a perilous voyage from which few return to port unscathed.[55]

The sea voyage of marriage clearly parallels the voyage of life, another broad category of nautical metaphors in which storms play a major role. The various stages of a sea journey allegorize the stages of life, and the parts of a ship or the members of her crew are individually interpreted as moral principles or aspects of personality.[56] The rudder, for instance, can stand for moral guidance in life; a

watchful pilot, sound philosophy; a steady helmsman in a storm, a wise man in the troubles of life; a safe harbor, the end of life's voyage in death or a haven in philosophy from the tempests of life. Such voyages of life, suitably Christianized, readily served for moralizing meditations in the seventeenth-century Netherlands. G. L. Boxhoorn, for instance, compares a richly laden ship lying to in a tempest to a virtuous man enduring the troubles of this life. The winds of the storm are God's Spirit, and the sails struck before their blast are a man's wandering thoughts. His sea anchor is Hope; the anchor cable is true Faith; his mainmast is love; and his rudder lashed into place is his heart and tongue restrained from rash or loose action.[57] Adrianus Valerius focuses his allegory on the skills and tools of a helmsman

> . . . who sails to far-flung lands, always takes sightings of cape and cliff and beach and seamarks of the sky, takes along azimuth and chart, compass, and everything that might serve him on the voyage, so that he might guide the ships and crew better and steer with God's help to a safe harbor. Oh man! See to it likewise for your precious soul that you do not fall into shipwreck due to sin![58]

Shipwreck may be due to folly but also to misfortune, which suggests the close relationship between the metaphor of the voyage of life and that of the turbulent seas of fortune.[59] Fortune, ceaselessly changing like the sea, is also subject like it to sudden alternations of auspicious favor with furious hostility. The mutability of fortune, in essence that of life itself, was a favorite theme in the Renaissance, and late in the seventeenth century a Dutch writer, Simon de Vries, still finds these time-worn concepts worth reiterating:

> Truly, the sea is the correct emblem of transience, being now still, then furious; now ebbing, suddenly again flowing. Everything on the entire globe is transient . . . it exists in a state of transience. . . . That our own life also and the state of our lives is very aptly compared to the sea is known to everyone. Let us then especially seek that we might, in all the pitching, heaving waves and dangers of the same, drop an anchor secured by Faith, by Hope, and by Love.[60]

The ship sailing the turbulent seas was also a common image of human community, particularly of the state.[61] This metaphor is easily suggested by the actual circumstances of the small society on board a vessel, cut off from all other human contact, and possessing a defined social structure with a complete hierarchy and tasks assigned according to rank and skill. It is a society in which the cooperation of all is essential to the survival of all. The focus in ship-of-state metaphors is generally on the helmsman and the quality of his control of the vessel, allegorizing the ruler and his government, and on the subordination of the crew to the captain and the fulfilling of each crew member's proper role in operating the vessel, exemplifying the conduct of the good citizen.

While not found in Homer, the ship of state appears about 620 B.C. in a poem by Alcaeus and was used by Plato and frequently by Plutarch and Cicero.[62] One of the most famous examples for the Renaissance, Horace's *Ode* I.14, known since Quntilian as an allegory of the ship of state, does not directly refer to this metaphor, but the traditional interpretation may well be correct.[63]

O Ship, new billows threaten to bear thee to sea again. Beware! Haste valiantly to reach the haven! Seest thou not how thy bulwarks are bereft of oars, how thy shattered mast and yards are creaking in the driving gale, and how thy hull without a girdling-rope can scarce withstand the overmastering sea? Thy canvas is no longer whole, nor hast thou gods to call upon when again beset by trouble. Though thou be built of Pontic pine, a child of far-famed forests, and though thou boast thy stock and useless name, yet the timid sailor puts no faith in gaudy sterns. Beware lest thou become the wild gale's sport! Do thou, who wert not long ago to me a source of worry and of weariness but art now my love and anxious care, avoid the seas that course between the glistening Cyclades![64]

The capacity of this subject matter to arouse both strong emotional identification with the fate of a vessel and suggest wider metaphorical reference is evident in Constantijn Huygens's well-known poem of about 1625, "Scheeps-praet, ten overlyden van Prins Maurits" ("Ship's talk, on the death of Prince Maurits"). In the guise of a simple lament by an ordinary sailor, Huygens exploits these commonplace metaphors as a means of articulating his own grief for his friend, concern for the national destiny, and patriotic pride in the vigor and resolve of Dutch seamen, who stand for the entire nation.[65]

THE CHRISTIAN TRADITION

The rhetorical descriptions and metaphorical interpretations of storms in classical antiquity perfectly complement the treatment of storms in scripture and patristic theology. Biblical storms include such familiar accounts as the tempest in Psalm 107:23–30; the storm sent by God in pursuit of Jonah (Jonah 1:4–17); the shipwreck of Saint Paul (Acts 27:13–44); and the storm on the Sea of Galilee calmed by Christ (Matthew 8:23–27; Mark 4:36–41; Luke 8:22–25). The tale of Noah's Ark and the Deluge (Genesis 7–8), while not strictly a storm, possesses many of the same elements as any account of disaster at sea.

While these scriptural texts do not recount the tempest with the rhetorical amplitude and pictorial precision of classical descriptions, they do contain vivid, emotionally moving details, such as the sailors who "reel to and fro, and stagger like a drunken man, and are at their wit's end" (Psalm 107:27); or the mariners who "were afraid, and cried every man unto his god, and cast forth the wares that were in the ship into the sea, to lighten it of them" (Jonah 1:5); or the centurion commanding "that they which could swim should cast themselves first into the sea, and get to land, and the rest some on boards, and some on broken pieces of the ship" (Acts 27:43–44). These details could be readily assimilated to the stock of classical tempest *topoi*. Some scriptural passages were identical with such standard classical motifs as the ship rising to the heavens and descending to the depths; or the laments and prayers of those on board; or the sudden halting of a deadly storm by divine favor.

Scriptural storm descriptions also exhibit the polarities I noted in classical and modern texts; indeed they provide several of the most compelling juxtaposi-

tions of natural violence with calm and of human terror and helplessness with joy and repose in a safe harbor (Psalm 107:28–30). Furthermore, in all these texts storms signify more than weather phenomena, for the storm and men's responses to it manifest the power and mercy of God or serve as tests of man's faith in those attributes.[66] Biblical storms are thus fundamentally metaphorical, and some are overtly so, as when Paul writes of shipwreck through lack of faith (I Timothy 1:19), and the Psalmist prays, "Let me be delivered from them that hate me, and out of the deep waters. Let not the waterflood overflow me, neither let the deep swallow me up . . ." (Psalm 69:14–15).

From early on the Church Fathers found it possible to reconcile the revelatory storms of scripture with the tempest and shipwreck metaphors of classical culture.[67] Augustine, for example, applies the voyage of life to his own journey to Christ.[68] We also encounter in patristic theology an identification of Christ with Odysseus, for in his voyage to eternity Christ was willingly nailed to the mast of his ship (mast and yard form a cross), just as Odysseus was tied to a mast to escape the Sirens.[69] Furthermore, the classical voyage of human life was reinterpreted as a ship with the cross of Christ as its mast, and her voyage to eternity was specifically compared to Odysseus's wanderings and sufferings.

In addition to Christian interpretations of the voyage of life, we also find in the Fathers the Ship of the Church, a metaphor derived from the classical Ship of State.[70] The Ship of the Church was identified with the Ark of Noah, which was seen as a prefiguration of the Church's saving mission in the stormy seas of this world, and with the *Navicula Petri*, Saint Peter's boat, from which Christ preached (Luke 5:3), and in which Christ saved Peter from drowning and calmed the sea (Matthew 14:24–33). Tertullian was the first to use the Ship of the Church metaphor,[71] and he was followed by numerous others, who expanded the image in lengthy allegories cataloguing every part of the vessel, her crew, and her voyages. In the version of Hippolytus of Rome, we find the customary identification of the mast and mainyard as the cross of Christ.[72] The steersman is Christ himself; the anchor is his law; the rudders are the Old and New Testaments; the sails are the Holy Ghost; the captain and sailors are bishops and priests. In the sea-voyage allegory of Clement of Rome, contrary winds are temptation, storms are false doctrine; reefs and shallows are persecutors; pirates are hypocrites; seasickness is purification from sin; shipwreck is sin; and the harbor is the City of the Great King.[73] From late antiquity the Ship of the Church was among the most familiar nautical metaphors and an especially important image in literature and art in the sixteenth and seventeenth centuries as both Roman and Protestant churches identified themselves with a vessel in the seas of doctrinal discord.[74] The *Navicula Petri*, moreover, had obvious appeal to the defenders of the papacy as heirs of Peter.

The image of the Christian community as a ship could also be inverted to serve as a satire on folly and vice. Such metaphorical vessels as the *Blauwe Schuit* (*Blue Boat*) and the *Schip van Sinte Reynuit* (*the Ship of St. Emptied-Out*, i.e., of drink or money) were manned by every sort of sinner, fool, and outcast.[75] Sebastian Brant's famous *Narrenschiff* (*Ship of Fools*) of 1494 is in every detail the opposite of the *Navicula Petri*.[76] She lacks helmsman, rudder, and anchor; she is driven restlessly and helplessly over the sea; and she has no goal, perhaps

the ultimate folly in an age when sea travel was uncomfortable, unhealthy, and highly risky. Her inevitable wreck is literally apocalyptic, for in Brant's conception the Ship of Fools is in the end an image of the followers of the Antichrist. Brant contrasts the wreck of the great ship of this folly-ridden community with the little boat of Saint Peter in which a remnant of the faithful persevere to salvation.

SIXTEENTH- AND SEVENTEENTH-CENTURY LITERARY TEMPESTS

We have already encountered several Renaissance texts that exemplify the pervasive influence of classical and Christian literary narrations and interpretations of the storm. The intense emotional identification with men and vessels and the vivid sensorial rhetoric for describing their fate in the grips of surpassing natural powers characterize Renaissance storm accounts as they had those of antiquity and scripture. The nature of the storm and of weather itself, man's place in relation to these phenomena, the kinds of incidents that befall man in a storm, even the vocabulary, depend on this cultural heritage, which also provided the fundamental metaphorical associations and the cosmology that gave those metaphors so vital a grip on men's imaginations. A few further examples will suffice to indicate the variety of storm accounts in Renaissance literature, but even more strikingly their typicality in their constant adherence to a relatively narrow range of incident and expression deriving from tradition.

Brant's recognition of the satirical possibilities of the voyage and shipwreck was followed by Erasmus in his colloquy "Naufragia" ("The Shipwreck"), a work of much greater cohesion and more acute irony than Brant's rambling moralizing.[77] Erasmus uses the storm and men's responses to it to satirize not only vanity and folly but more particularly the cults of the saints and the Virgin Mary, which he pointedly juxtaposes with animistic superstitions such as propitiatory offerings of oil to the sea. Against these practices stand the simple faith and silent prayer of a young mother with a baby and the faith of the narrator, who prays for deliverance to God directly and repents his sins in his heart. While the use of a shipwreck narrative for satirical purposes is novel, what is most striking for our discussion is the degree to which Erasmus in this well-known colloquy freely draws on the literary tradition for the description of the storm and the incidents occurring in it, taking some motifs from the classical tradition (for example, St. Elmo's fire, casting goods to the sea, the sufferings of the castaways, the sinking of the lifeboat) and others from the Christian (the undergirding of the ship and the hospitality of the rescuers on shore).

The striking dependence of Erasmus's "Naufragia" on traditional formulas is paralleled in François Rabelais's *Gargantua and Pantagruel* in a storm clearly inspired by Erasmus's colloquy.[78] Rabelais provides a serious description of the

raging sea worthy of his classical and modern sources,[79] as well as a typically robust satire on cowardice and superstition and on the conventional classical theme of the happy man, however humble, who watches a storm-tossed ship from the safety of shore: "Oh lucky devils, with one foot forever on dry earth and the other hard by. . . . The happiest mortal on earth is the humble cabbage-grower."[80] But even such satirical passages depend, of course, upon the standard accounts of sailors and castaways bewailing their fate, longing for shore, and praying frantically for deliverance.

Tradition similarly shaped the treatment of the storm in a very different body of writing—seventeenth-century Dutch religious literature addressed to seamen. Here we find inspiration coming not from classical culture but almost exclusively from scripture and the Fathers.[81] The essentially allegorizing character of these texts is apparent even in the title of a typical volume by Godefridus Udemans, a preacher of Zierikzee: *Spiritual Compass, that is Useful and Necessary Advice for all Sea-Faring and Voyaging People, in order to Avoid the Rock Cliffs and the Sand Bars of Sin and of the Wrath of God.*[82] Udemans, who dedicated the book (in 1617) to the Burgemeester and town officials and the whole fishery of Zierikzee, informs us in the preface that he intended it as a spiritual and practical guide for fishermen on extended voyages.[83] In reading Udemans's advice, it is especially striking to see how frequently he moves even in a single sentence from the vicissitudes of actual voyaging to metaphors of the voyage of life in the seas of this world. He simply takes for granted the identity between reality and metaphor, showing that for himself and for many and perhaps most of his readers, the storm and winds encountered in the real world are literally the manifestation of God's will. The winds are appointed by God not only to preserve and quicken living bodies and to make the seas sailable but also "to execute the judgments of God on man as it pleases him."[84] They that go down to the sea in ships truly do see the wonders of the Lord in the deep.

Udeman's text is revealing on two further counts. One is the ease with which he recounts different metaphorical interpretations, including some of radically different character, one after the other. In a short passage we move from the storm as an image of "the world set in uproar by the devil and evil men,"[85] to finding "in the ship lying and rolling in the sea . . . a figure of the struggling church of Christ on earth," which Udemans then proceeds to develop in a full Ship of the Church allegory.[86] Such a passage epitomizes the multivalence of symbols, for it is clear that these interpretations were not inconsistent from a contemporary point of view, nor did they exclude other interpretations.

Udemans's book is also striking in that he derived virtually all his metaphors and descriptive passages from traditional sources. Indeed, in two places he reveals the extent to which literature coincides with his experience of real storms. In one he is moved to observe that the storm in Psalm 107 needs no explanation to anyone familiar with the sea and ships "because the description is so lively and neat as though we saw the distress before our eyes."[87] Still more strikingly, in discussing the storm that afflicted the ship carrying Saint Paul to Rome, he remarks on the verisimilitude of the darkness that obscured the sun and stars for days, observing that

as in a heavy tempest, the water is covered as though with a thick darkness, as the learned poet [Virgil] put it in few words, saying of a certain tempest 'Ponto nox incubat atra' [Black night broods over the deep]. . . .[88]

This body of language provided Udemans and his contemporaries with the necessary imaginative framework of vocabulary and ideas within which they could articulate their experiences of the storm and locate the meaning of that experience.

Udemans's interpretations of real events at sea as signs of divine intention reflect a general propensity of the time, and one which had been powerfully reinforced for the Dutch by the defeat of the Spanish Armada in 1588.[89] Although this force had been aimed at England, all Protestant Europe anxiously awaited the outcome, and the Dutch as much as any because of their hopes for continued and increased English aid in their revolt against Spain. High winds drove the Armada into the North Sea, forcing it to return to Spain around the northern tip of the British Isles, suffering enroute considerable losses in storms off the Irish coast. Those storms and the gales that blew the Spanish into the North Sea tended to coalesce in the popular imagination, and these tempests were hailed by Protestants everywhere as miraculous, proof of divine favor for the Protestant cause.[90]

Fɪɢ. 13. Medallion (reverse): *Destruction of the Armada.* 1588. Amsterdam, Nederlands Scheepvaart Museum

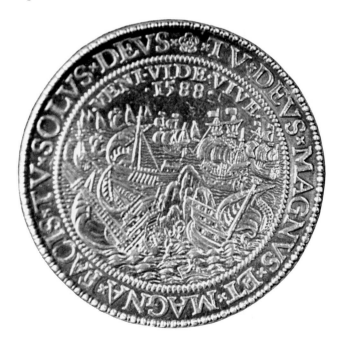

Dutch medallions of 1588 witness the confidence with which the hand of God was seen in the natural forces that defeated the Armada. One depicts two vessels from the Armada wrecking on rocks, accompanied by the texts, "Thou art great and doest wondrous things, Thou art God alone" (Psalm 86:10), and "Come, see, live" (Fig. 13).[91] Another medallion reveals the acceptance of contradictory metaphors at this time, for on the obverse we find the Armada's battle, with the legend "Flavit Yahweh [in Hebrew letters in a cloud with rays emerging] et dissipati sunt" ("Yahweh blew and they were scattered"), while on the reverse (Fig. 14) a church on a rock, representing the Hervormde Kerk, stands firm against stormy waves and winds that represent not God's power as on the obverse but that of the Spanish: "Allidor non laedor" ("I am struck but not damaged").[92]

In the Netherlands divine power was also commonly perceived in dike breaks and floods resulting from storms. In a prayer on the occasion of the inundation of 8 March 1625, Adrianus Hofferus, after nearly three pages of description, suddenly draws this lesson from the disaster:

> It is thoughtless sin that wounds us through the water, that raises the waves and their beating as high as mountains; the more sin infatuates us the more strongly the wind blasts; the greater sin grows, the higher flows the sea. It is sin which vexes us, which hunts us from the land.[93]

FIG. 14. Medallion (reverse): *Allegory of the Armada.* 1588. Amsterdam, Nederlands Scheepvaart Museum

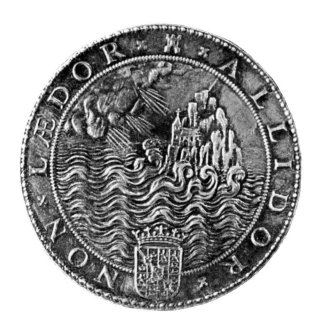

Constantijn Huygens likewise finds a direct revelation of the will of God in the improvement of the weather on a day of prayer decreed after the storm of 4–5 November 1675 caused dike breaks and floods in North Holland and Overijssel:

> On the still weather of the day of prayer 6 November 1675 after many days of storm
>
> The thunder, lightning, and storm of winds from all sides were horrifying to eyes and ears. Today it is suddenly still: Pray zealously, Fatherland; it seems that Heaven quiets in order to hear your prayer.[94]

This same habit of mind is evident in the Dutch voyagers, who saw God's will at work in their adventures, as Jan Jansz. Deutel explains in his introduction to Willem IJsbrandtsz. Bontekoe's famous *Journael* (1646):

> Now this description does not come from word-of-mouth . . . but from personal experience, relating the wonders that God has shown to the author himself and also to those who were with him. Because who will not marvel exceedingly when he reads how one man . . . was brought to a place of safety by the Lord's mercy through so many dangers and adversities, even those in which to hope for deliverance seemed like despair.[95]

Bontekoe himself relates his tales of an ordinary man experiencing extraordinary things with a straightforward, unadorned simplicity and piety that attribute his salvation to God alone. On reaching land after his ship has blown up literally underneath him and he has sailed with the survivors in an open boat for many days, Bontekoe thanks God on his knees, "because this day was the last after which the men were resolved to do in the boys and eat them. Here it appears that the Lord was the best helmsman, who led us and steered so that we reached land as was described."[96]

Scripture and the moralizing interpretations of preachers such as Udemans clearly inspired the voyagers' interpretations of tempest and shipwreck, which otherwise are generally sober and nonrhetorical, betraying no knowledge of the classical tradition. Bontekoe, for example, describes a storm this way:

> At six glasses in the night it began to blow so frightfully that to those who have never heard or seen it, it would seem impossible that the wind could produce such power. . . . The ship sank so low in the water due to the wind, as though the wind came directly from above, so that it seemed that the anchors on the bow came to the water; indeed, I thought the ship was sinking. Finally our main mast blew overboard and broke about three fathoms above the top deck, so that the ship rose again. We stood beside each other with our heads together but could not call or speak so that we could understand each other, to know who was on deck.[97]

Among the most frequent comments in the voyagers' accounts is that the storm, wind, rain, or waves were greater than anyone had ever seen or imagined, suggesting the lack of a sophisticated vocabulary for describing these experiences at length. Yet the impact of storm is communicated, perhaps because of this very simplicity, and it is noteworthy that although storms are called fright-

ful, horrible, and terrible, the voyagers never describe the storm in such a way as to suggest its sublimity. While we might attribute this to their less refined culture, it is another quality that their accounts share with those of the entire literary tradition, including the storm descriptions of such serious men of letters as Vondel. Even those on shore observing storms do not, in seventeenth-century accounts, experience sublimity, though such a location in the eighteenth and nineteenth centuries was one of the most conducive to this experience.[98] In recounting shipwrecks seen from shore, Jan Huygen van Linschoten responds with horror and intense sympathy for the plight of the castaways:

> ... the strength and endurance of the storm was a horror to hear for us, who stood on land, how much the worse for those in ships swarming on the sea, so that those twelve ships perished on the coast and cliffs around Tercera [in the Azores] alone, and not only on one side or place of the island, but in all corners and places, so that one heard nothing but lamenting, crying, and groaning, and shouting: there is a ship run to pieces on the cliff, and there another, and all the people drowned.[99]

And in the same storm, from the *vlieboot* the *Witte Duyve,*

> only fourteen or fifteen survived, and these with arms and legs half broken and disjointed ... the rest of the Spaniards and sailors, captain and owner, remained there [dead]. Whose heart would not weep at such a spectacle.[100]

This is much as Shakespeare's Miranda, more articulately but with equal empathy, suffers,

> With those that I saw suffer! A brave vessel
> Who had, no doubt, some noble creature in her,
> Dash'd all to pieces! O, the cry did knock
> Against my very heart. Poor souls, they perish'd.
> (*The Tempest* I.ii.6–9)

Thus, in the literary tradition both high and low, among literati imitating epic narrative and rhetorical *descriptio* and among hardworking, pious seamen raised on scripture, we find storms treated as occasions for intense emotional identification in a fashion that, as we will see, closely parallels the reading of pictures. It is, moreover, an empathic involvement that includes contemplation of the relationship of man to nature and a search for divine intention in the furies of nature and the resulting disasters that afflict men, as well as in the salvation beyond all hope that some find at sea. This widespread consciousness of the sea and storm, as we may reconstruct it from texts written in the sixteenth and seventeenth centuries and from the literature men read and imitated, also found a visual articulation and dramatization in these centuries, but this development proceeded in a radically different way from that of the literary storm.

3

"Swelling Sea Set Forth in a Swelling Stile": The Storm at Sea in the Pictorial Tradition

No pictorial heritage survives from antiquity comparable to the accounts of tempests in the classics, scripture, and the Church Fathers. Pictures of storms able like texts to evoke intense psychological responses are essentially an invention of the Renaissance. From the fourteenth century, artists in Italy and the Netherlands, working in traditions with somewhat different emphases, developed pictorial means for rendering the sea and ships with convincing realism. Only in the first half of the sixteenth century, however, did these traditions also become means of articulating poetic mood and heroic conflict through realistic land- and seascape.

In this evolution Netherlandish artists defined surprisingly long-lived compositional formulas for representing the tempest. But the expressive characteristics of the seventeenth-century storm scenes that are the focus of this study depend also upon decisive changes in style, subject matter, and the very conception of the act of painting itself, changes associated with the art of Leonardo da Vinci and the Venetians. Drawing on these Italian developments, sixteenth-century Northern artists endowed their images of storm with a new formal and thematic openness and dynamism that invited the psychological participation of the beholder.[1]

Apparently the first artist to realize the expressive potential of this subject and style was Pieter Bruegel the Elder. Bruegel gave the storm a visually compelling role in his art as an imaginative vehicle for his distinctive, skeptical view of human nature, society, and the world. Dramatizing the storm, he transformed earlier iconographic and metaphorical traditions to create images whose narra-

tive and expressive power permit essentially the same kinds of emotional projec-
tion and thematic resonance that animate literary storms.

 After Bruegel's death the unfolding development of storm imagery reveals a
consistent selection and refinement of expressive means that are best character-
ized as rhetorical. In the process, two distinctive modes of representing nature,
one naturalistic and the other theatrical, emerge. The tempest paintings they
inform, however, adhere to the same representational formulas and to a shared
rhetoric of oppositional conflict. As seascape developed into an independent
subject, the vivid depiction of elemental polarities and of the vividly realized
plight of men and vessels acquire an essential similarity to the patterns of
thought and expression characteristic of the literary tempests so familiar to all
levels of society. Like Bruegel's works, these seventeenth-century tempests are
not illustrations of texts but visual statements analogous in subject and rhetori-
cal expression to them.

THE MARINE ENVIRONMENT: TEMPESTS
IN THE NETHERLANDISH TRADITION

One of the main sources of the dramatized storm imagery of Bruegel and, more
generally, of Dutch and Flemish marine painting of the seventeenth century are
sixteenth-century Netherlandish scenes of danger, distress, and salvation at sea.
Although known from several paintings, they are most commonly found in
prints and book illustrations.[2] In these images similar compositions served for a
variety of subjects, such as the stories of Jonah cast to the whale, Christ asleep in
the storm, and Arion cast into the sea and saved by dolphins. The Deluge and
several legends of saints saving ships in storms required similar seascapes and
tempests. One composition frequently used for such themes shows a closeup
view of the ship and crew, while the storm is cursorily indicated. As we will see,
this remained the fundamental type for depicting figural narratives well into the
seventeenth century and served as the iconographic basis for the Drama on the
Deck, a thematic innovation of the eighteenth century. Jonah scenes of another
compositional type, however, provided the basic format for most seventeenth-
century storm paintings. This compositional structure, invented in the Nether-
lands and known in pictures from the circle of Patinir and his later followers
(Fig. 15), uses a high vantage point to place the storm-tossed ship bound for
Tarshish within a world panorama of estuaries, islands, and mountains. A whale
and a more or less naturalistic storm threaten the vessel as well.[3] The high
viewpoint characteristic of these scenes of storm was gradually lowered during
the early seventeenth century, and the artificial framework of landscape wings
disappeared too. But other elements, such as the rocky, mountainous coasts and
distant harbor cities, proved useful to the affective and metaphorical language of
seventeenth-century images. So too did the device of locating a center of sympa-
thetic identification—the ship—within the broad, threatening vastness of na-
ture. In a sense many later tempest paintings are Jonahs without a Jonah; even

FIG. 15. CIRCLE OF JOACHIM PATINIR. *Jonah Cast to the Whale.* Belgium, S. Simon Collection

the barrels in the water correspond to the earlier pictures, where they refer to goods cast overboard in an attempt to lighten the ship.

In these images of danger and salvation we also see the realism in rendering sea, ships, harbor, and shore that seventeenth-century artists used so successfully to amplify the emotional intensity of their images. This realism derives from the still-earlier Netherlandish tradition that produced such extraordinary achievements of verisimilitude as the *Voyage of St. Julian and Martha* and *The Prayer on the Shore*, illuminations by an Eyckian artist from the Turin-Milan Hours (Fig. 16).[4] Strong interest in the accurate rendering of marine subject matter is also evident in the second half of the fifteenth century in Master ₩⚹ 's series of eight ship engravings, a precedent for the printed sets of ship portraits by Bruegel and many later marine artists.[5] Master ₩⚹ 's prints, which were intended as a repertory of artist's models, include a shipwreck depicting a "baerdze" driven aground, her masts and rigging in disarray (Fig. 17).[6] As remote as the stylized rocks and waves are from seventeenth-century tempest images, the interest in rendering this situation locates this early print in a tradition culminating in such work.

Also within this tradition and closer to later handling of themes of storm and shipwreck is a small *Fleet in Distress* of about 1525–50 in the Museo Nazionale in Naples (Fig. 18).[7] This picture, by a follower of Herri Bles, lacks an identifiable

FIG. 16. *The Voyage of St. Julian*, from the *Très Belles Heures de Notre Dame* (destroyed portion). Formerly Turin, Royal Library

FIG. 17. MASTER W ✧. *Baerdze.* Engraving

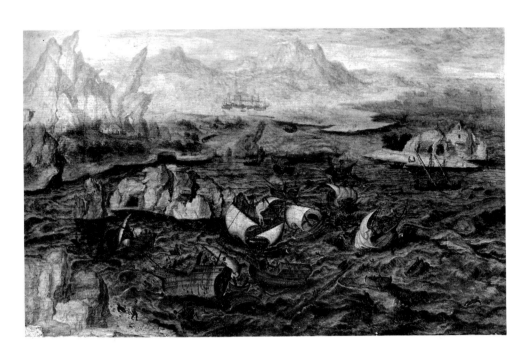

FIG. 18. FOLLOWER OF HERRI BLES. *Fleet in Distress.* Naples, Museo Nazionale

story, revealing already a feature of the Northern tradition important for subsequent artists, that is, the apparent self-sufficiency of this subject matter to sustain a painting. The main concern of the Naples picture appears to be the circumstantial description of the efforts of crewmen to chop away masts and sails and the struggles of castaways in lifeboats and clinging to wreckage. Here we find a body of motifs that recurs from the time of Bruegel onward. We also find in the Naples painting a dialogic tension in the contrast of stormy sea in the foreground and secure harbor in the distance that recalls literary tempests. The presence of this fundamental tension seems to be inherent in this tradition of depicting the sea from early in the sixteenth century. In landscapes by Patinir and his circle, we often find background seascapes divided into areas of dark clouds and rain showers over the open sea where ships sail, juxtaposed with a harbor view in fair weather.[8] This contrast plays a much larger role in a *Martyrdom of St. Catherine of Alexandria* (Fig. 19), where the storm (from which the lightning bolt destroyed her executioners) fills nearly half the background, sinking ships and looming menacingly near the port.[9] With such a compellingly moody setting, we seem to be on the verge of the turbulence and sweeping power of storms by Bruegel and his followers, by Porcellis, or by Van de Velde the Younger and their capacity to engage the beholder's own answering emotion. Such works are, in fact, firmly rooted in the Northern tradition, but the ultimate inspiration behind their dynamic rendering of nature and man's subjection to its energies comes from a different tradition: the art of Venice, where a separate tradition of depicting the tempest had developed in the early sixteenth century.

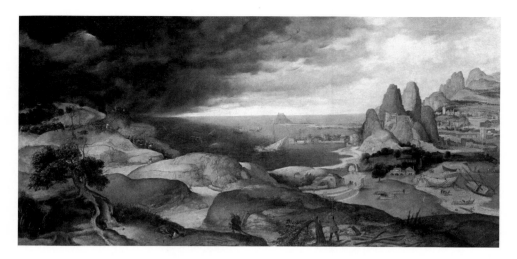

FIG. 19. ANONYMOUS NETHERLANDISH. *The Martyrdom of St. Catherine of Alexandria.* Washington, D.C., National Gallery of Art, Samuel H. Kress Collection

NATURE IN MOTION: THE DEPICTION OF TEMPESTS IN THE ITALIAN RENAISSANCE

Occasions calling for a painted tempest in fourteenth- and fifteenth-century Italian art were relatively infrequent, and with one major exception, tempestuous nature, which was distinctively subordinate to figural drama, was rendered by stylized, symbolic forms or by personifications. Thus Giotto's celebrated *Navicella* of about 1310 (Fig. 20), a mosaic formerly in the atrium of Old Saint Peter's, depicted the storm on the Sea of Galilee as two personifications of the winds, while the sea and ship showed little sign of responsive action.[10] As in all his work, Giotto emphasized emotion and corresponding behavior. While nature might echo, reinforce, and in the *Navicella* even cause feeling and action, the figures always predominate over the more abbreviated and stylized landscape. In part due to the wide influence of Giotto's painting, such stylized storms serving as a backdrop for human drama are typical of fourteenth- and fifteenth-century Italian painting.[11]

Before the early sixteenth century, one of the few parallels in painting to the pictorial vividness of classical storm narratives seems to have been Ambrogio Lorenzetti's fresco in the cloister of S. Francesco in Siena of about 1340 (Fig. 21).[12] Fragments of this scene, which depicted the missionary work in India and martyrdom in 1321 of Saint Peter of Siena and his companions, have recently been recovered. They reveal that the figural narrative dominated the pictorial field but that Ambrogio rendered the storm accompanying the martyrs' deaths with a naturalistic energy that strikingly foreshadows developments in later centuries, as so many aspects of his work do. In the surviving fragments of the background cityscape, we find a ship sinking in a harbor, overwhelmed by foaming waves that also curl and spray over the shore. Falling rain—so rarely depicted

FIG. 20. NICOLAUS BEATRIZET, after Giotto. *La Navicella* (reversed). Engraving

FIG. 21. AMBROGIO LORENZETTI. *The Martyrdom of St. Peter of Siena and His Companions.* Fresco fragment from S. Francesco, Siena

before the sixteenth century—and even hail are rendered, justifying Karel van Mander's comment that Ambrogio "was the first who knew how to depict tempest, rain, and similar things."[13]

A century later Lorenzo Ghiberti's enthusiastic description of this painting clearly stands within the tradition of classical *ekphrasis* in its close attention to the interrelated dynamics of nature and psychology and of image and beholder. In this passage Ghiberti first enunciates primary preoccupations of the entire Renaissance tradition of rendering storms:

> . . . after the decapitation of the monks there arises a storm, with much hail, flashes of lightning, and thundering earthquakes; it seems as if it were possible to see painted [there] heaven and earth in danger. It seems as if all were trying with much trembling to cover themselves up; the men and the women are pulling their clothes over their heads, and the armed men are holding the shields over their heads. The hailstones are so thick on the shields that they seem actually to bounce on the shields with the extraordinary winds. The trees are seen bending even to the ground as if they were breaking, and each person seems to be fleeing, everyone is seen to be fleeing. The executioner is seen to fall under his horse, which kills him; on account of this many people were baptized. For a painted story it seems to me a marvelous thing.[14]

Ambrogio's picture and Ghiberti's account of it remain isolated phenomena in Italian art, however, until about 1500, when we find a development crucial to a dramatic conception of landscape and the tempest: nature rendered not only in terms of realistic detail but also as an organic unity permeated by movement, by the process of growth and decay and seasonal change. While such a conception is most closely associated with Venetian art, the work of Leonardo da Vinci was fundamental to the evolution of this conception in northern Italy.

While any brief characterization of Leonardo's manifold work and thought is hazardous, it is clear that artistically and intellectually he was fascinated and profoundly disturbed by movement, change, and, in the end, time, for "with time everything changes."[15] He believed that "movement is the cause of all life,"[16] and this movement is closely bound up in Leonardo's thinking and art with water: "The cause which moves the humours in all kinds of living bodies contrary to the natural law of their gravity, is really that which moves the water pent up within them through the veins of the earth and distributes it through narrow passages." After elaborating this comparison of water in the earth to blood in the body, he continues, "thus within and without it goes, ever changing, now rising with fortuitous movement and now descending in natural liberty. . . . Rushing now here and now there, up and down, never resting at all in quiet either in its course or in its own nature, it has nothing of its own but seizes hold on everything. . . . So it is in a state of continual change."[17]

The motion, qualities, and effects of water form one of the largest parts of his writings, in which he closely studied the flow of water in rivers, eddies, and waves and the record of its past action in riverbeds, mountainsides, and traces of ancient seas.[18] Leonardo, moreover, emphasized gigantic weather phenomena involving water—storms, the deluge, and the destruction of the world in a cataclysmic flood—as subjects of the proper scope for the creative artist.[19] His

ekphraseis of these themes are among the most compelling in their intense observation of natural phenomena and human reactions.

For rendering the flow of water Leonardo developed a graphic language that permitted him to capture the dynamics of liquids in swirling and intertwining patterns—patterns which he also found in human hair, in plants, and in clouds, and which in their repetitiveness, tension, and sinuosity formally suggest continuous activity and organic vigor.[20] In a series of drawings illustrating an apocalyptic deluge (c. 1514; Fig. 22),[21] sheets filled to the edge with explosive torrents of water and cloud, Leonardo uses these same swirls rendered with the broken, open line and crumbled texture of chalk to depict the fury and darkness of the tempest.[22] These drawings and a still earlier *Storm in an Alpine Valley* (c. 1499; Fig. 23) are among the first images to make the components of landscape the primary actors in a dramatic confrontation that activates the pictorial space, drawing the viewer in through the interplay of light and shadow and dynamic forms.[23]

Leonardo's characterization of water itself remained little known to other artists. It is, however, intimately related to more widely influential aspects of his art that also activate pictures psychologically by requiring the imaginative participation of both artist and the beholder. His new handling of drawing as a sketch, a means of spontaneous, improvisatory personal expression exemplifies this quality in his work.[24] Still more important for landscape is his use of *sfumato*, whose tonal blurring of form unifies by creating a pervasive atmosphere and whose poetic suggestiveness, as lights emerge from shadow, compels the viewer to complete the sense of what is partially defined for him. Such openness of form perfectly complements the effects of ceaseless motion seen in Leonardo's drawings of storms and water.[25]

Leonardo's approach to form and its capacity for engaging the beholder in the tensions of pictorial space were essential to the development of a landscape style that could not only imitate nature's appearances but articulate her creative energies as well. The distinction between imitating *natura naturans* (nature's creating power) as opposed to *natura naturata* (nature as created fact) originated in antiquity. In Renaissance artistic theory and practice it was of central importance in developing the "modern conception of the creative, individualistic, and active character of artistic work."[26] Through this re-creation of *natura naturans* artists were to endow images of storm with the psychological dynamism and intensity that had long been characteristic of tempests in literature. Leonardo first achieved this, and his work surely influenced the development of a parallel approach to landscape in Venice.

While the exact relationship of Leonardo's art to Venetian painting remains difficult to define—indeed Giorgione's and Titian's approaches to tonalism differ from Leonardo's in being more coloristic and more involved with the texture of paint—Vasari was surely correct in asserting a link between them.[27] Kenneth Clark observes that the subjects described in Leonardo's *Trattato della pittura*— "how to paint a night piece, how to paint a storm, how to paint a woman standing in the shadow of an open door—show that he delighted in effects of light and shade of a strangeness and violence which Giorgione and his school were the first to attempt."[28] Furthermore, the Venetians shared Leonardo's atten-

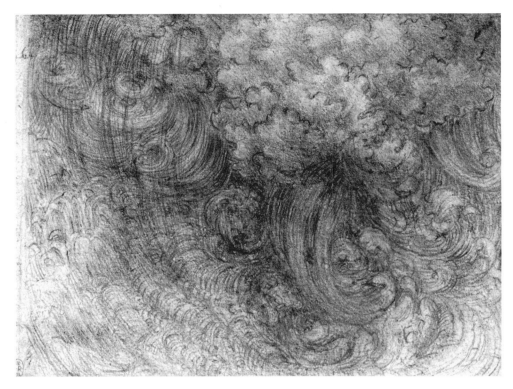

FIG. 22. LEONARDO DA VINCI. *The Deluge.* Windsor Castle, Royal Library, no. 12,383

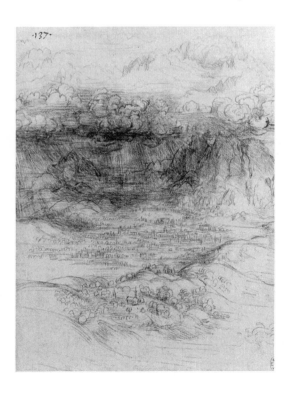

FIG. 23. LEONARDO DA VINCI.
Storm in an Alpine Valley.
Windsor Castle, Royal Library, no.
12,409

tiveness to movement and change in nature, endowing trees and even mountains with a swelling organic vitality, and rendering phenomena like storms, flowing water, and clouds as processes able at once to energize an image and to create or sustain an emotion or mood.[29]

Significantly, in Venice the major impact of Leonardo's thinking on these matters seems to have coincided with considerable interest there in the art of Hieronymus Bosch.[30] Pictures by Bosch were apparently known in Italy by shortly after 1500; several are known to have been available in Venice by 1521, including a "storm with Jonah swallowed by the whale," a "painting of a dream," and a "hell scene with a great variety of monsters," all in the collection of Cardinal Grimani, a friend of Giorgione.[31] Such typically Boschian subjects certainly offered the strange and violent effects of light and shade Leonardo describes. Moreover, Bosch's loose handling of paint and his rendering of flickering movements of fire and light give his paintings a formal openness that activates the beholder's responses, engaging him with the partially completed form and in the eerie moods of terrifying, fantastic dream worlds. In this his works closely parallel the formal and psychological character of Leonardesque and Venetian art.[32]

The subject of the most famous of Venetian landscapes, Giorgione's *Tempesta* (Fig. 24), continues to be as elusive as ever. It is beyond dispute, however, that the menace in the background of the brooding storm clouds and the flash of

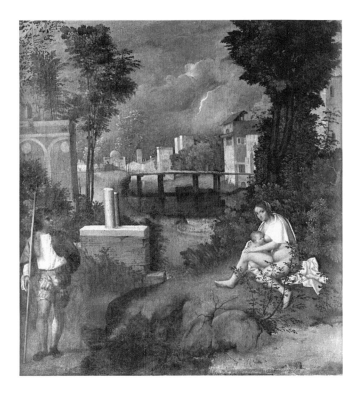

FIG. 24. GIORGIONE. *Tempesta.* Venice, Gallerie dell'Accademia

lightning (in itself among the most transient of visual phenomena) endows the tranquil foreground with a most poignant mood of seclusion and harmony, linking human existence with natural processes of nurture and growth and the passage of time.[33] Here nature, inhabited as always in Venetian art, seems at once to embrace man within its rhythms and to resonate with tensions fundamental to human existence, tensions between the urban and the pastoral, the civic and the intimately personal, turmoil and harmony.

Although seascape was not the independent tradition in Venice that it later became in the Netherlands, this characteristic preoccupation with rendering movement in nature and with evoking a broad range of affective moods in landscape results in the more frequent appearance of seascape in Venetian art than in Central Italian painting. Giorgione's *Tempesta* is not a seascape, of course. His name is associated, however, with a large, famous canvas of a marine tempest known as *La Burrasca,* though the exact extent and nature of his contribution remains problematic (Fig. 25).[34] Depicting three patron saints of Venice in a small boat who halt a large ship full of demons as they race to destroy Venice in a storm, the painting was much admired in the sixteenth century for the fury of its natural effects, as Vasari's descriptions attest.[35] Another vivid depiction of the sea occurs in Titian's great woodcut, the *Submersion of Pharaoh's Army in the Sea* of about 1514–15, where the swirling energy of water and rolling clouds are without precedent, except in the drawings of Leonardo.[36] Stormy seas also occur occasionally in the backgrounds of Venetian paintings, such as the small allegory of 1505 by Lorenzo Lotto (see Fig. 6).

These Venetian seascapes reveal a characteristic tendency not only to dramatize the natural world surrounding and interacting with men but also to allegorize the tempest. Even where the storm is already required as the setting of a literary or historical incident, moral and political connotations of exactly the kind we have encountered in the literary tradition may be found. Such an interpretive rendering of the storm already appears in a Venetian engraving of the late fifteenth century, in which a skeleton stands on the deck of a ship as it breaks up in a tempest (Fig. 26).[37] And in 1505 Lotto's painting uses the storm and shipwreck to allegorize vice. Such images are readily deciphered, but it has been plausibly suggested that Titian's woodcut of Pharaoh's defeat is also allegorical and represents the near-miraculous salvation of Venice, identified with the Chosen People, in its disastrous war with the League of Cambrai.[38] A political allegory relating to the same conflict has also been proposed for *La Burrasca,* which in depicting a story of divine protection of the city—and by implication, of its institutions—is inherently political.[39] In such vivid and suggestive images we find that both the dramatized naturalism and metaphorical potential familiar from literary tempests are integral to the Venetian pictorial tradition.

Such allegorical interpretations of tempests and imperiled ships were, however, typical of Northern European art as well. The Netherlandish tradition of realistic pictures depicting human helplessness and need for salvation in the tempest was paralleled by a body of explicitly emblematic imagery. This imagery allegorized civil and spiritual crises by means of ships wandering the seas, the threat of sea monsters, light in the darkness, and a safe harbor. The personal devices of celebrated princes and statesmen using nautical imagery to refer both

to individual ideals and political purposes are but one group of allegorized marine images available in the mid-sixteenth-century Netherlands.[40] Maurice, the Elector of Saxony, for example, took as his personal *impresa* the legendary barrel trick, whereby a wise captain could save his vessel by throwing a barrel or bale to a threatening whale to distract it from the ship (Fig. 27).[41] The motto, "His artibus" ("by these means"), refers to Maurice's use of cunning to maintain his position among more powerful neighbors, the Emperor and the Protestant princes of northern Germany, making the motif a political allegory of the ship of state.

A version of the ship of state was also chosen by Antonis Perrenot, Cardinal Granvelle, Philip II's most trusted, and most unpopular, representative in the Netherlands until 1564 (Fig. 28).[42] Granvelle commissioned numerous medallions in the 1560s and 70s that allegorize his ambitions as steersman of Philip's

FIG. 25. JACOPO PALMA IL VECCHIO and PARIS BORDONE. *La Burrasca.* Venice, Biblioteca dell'Ospedale Civile

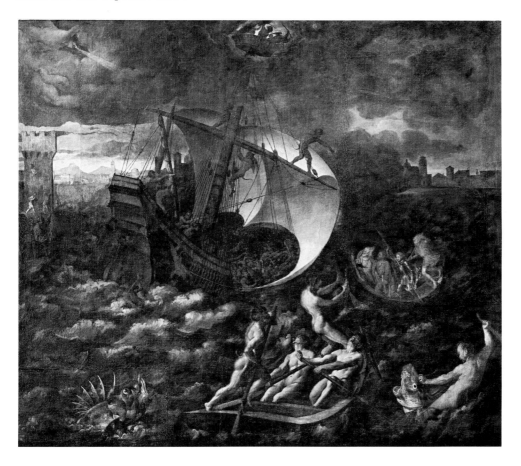

possessions in the Netherlands and Naples, depicting a ship in a tempest with the word "Durate" ("persevere"). This single word evokes Aeneas's call to his crew after the great storm scattered the Trojan fleet: "Durate et vosmet rebus servate secundis" ("Persevere and save yourselves for favorable circumstances"; *Aeneid* I.207).

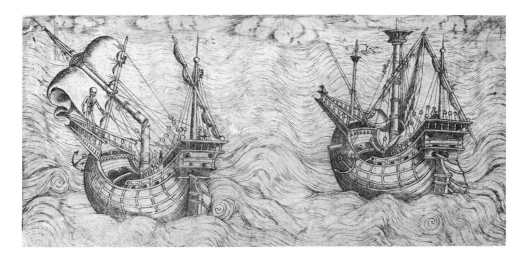

FIG. 26. ANONYMOUS VENETIAN. *Allegory of Shipwreck and Death.* Engraving

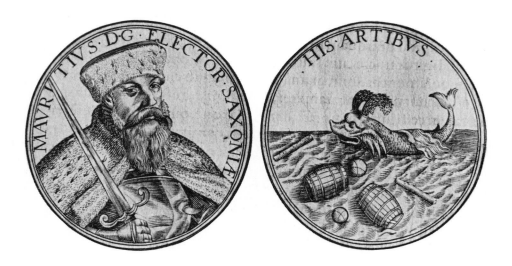

FIG. 27. Medallion of Maurice of Saxony. 1552. From J. Luckius, *Sylloge numismatum elegantiorum*, Augsburg, 1620

FIG. 28. Medallion of Cardinal Granvelle (reverse). From Gerard van Loon, *Beschryving der nederlandse historie-penningen*, I, The Hague, 1723

FIG. 29. Medallion of William of Orange. From Gerard van Loon, *Beschryving der nederlandse historie-penningen*

On the opposite side to Granvelle in the political and religious conflicts of the day was William of Orange, who took as his *impresa* the halcyon, a bird whose nesting period on a rock in the sea was a calm in the midst of the winter tempests (Fig. 29).[43] As depicted on a medallion of about 1570, the halcyon flies to its nest near a rocky coast, while the hand of God, stretching from a cloud before a light in the sky labeled "Christus," beats back storm clouds. The motto, "Saevis tranquillus in undis" ("tranquil in the raging waters"), would have suggested to contemporaries William's celebrated constancy in the face of controversy and repeated reverses in his attempts to spark and unite the rebellion against Spain.[44]

Fig. 30. Philip van Marnix van St. Aldegonde. Drawing in the *Album amicorum* of Abraham Ortelius. 7 March 1579. Cambridge, Pembroke College Library

Nautical symbolism also figures in the device of Philip van Marnix van St. Aldegonde, one of William the Silent's most trusted lieutenants and an important statesman and antipapal propagandist. His device (Fig. 30) depicts a ship sailing between rocks and a sea monster, but following a light in the sky that radiates from the name Yahweh in Hebrew and the constellation of the Little Dipper.[45] The motto, "Repos ailleurs" ("rest elsewhere"), makes the meaning of the picture clear: the ship of life, restlessly wandering the seas of this world and threatened by monsters and shipwreck, must, to survive, follow only the light of God.[46] Marnix, fervent Calvinist and translator of the Psalms, finds in the ship and her perilous voyage an appropriate image not only for man's spiritual quest but also for the active life in this world in which he was so deeply involved.

By the mid-sixteenth century, then, artists in both the Netherlands and Italy had evolved iconographies of storm and shipwreck that served in many contexts as background settings for monumental history paintings, as prints, and as personal and political allegories, and that functioned with a narrative vividness and symbolic reference approaching the tempests of literature. Yet the stormscape remained an infrequent subject in painting and was nearly always subordinate to figural action until Pieter Bruegel the Elder gave the sea and ships an important expressive role in his work.

BRUEGEL AND THE SEA

In the open-ended dynamism of Venetian form, Bruegel found the means of refashioning the Netherlandish iconography of the sea into a pictorial language of emotional and symbolic resonance. While it is difficult to determine whether Bruegel could have known Venetian marine images, it is clear that his landscapes generally possess deep affinities with Venetian art. Indeed, it is widely agreed that the landscape prints and possibly the drawings of Titian and Campagnola influenced Bruegel's depiction of nature both formally and thematically.[47] Such drawings as Bruegel's *Mountain Landscape with a Fortified City* of 1553 (Fig. 31) clearly depend on Titian and his circle for the vibrant, intertwining trees.[48] The long strokes of hatching that render shadowy atmosphere in trees and clouds and the swelling hills from which towers and walls seem to emerge organically likewise depend on Titian's graphic vocabulary. Woodcuts after Titian inspired the contrasts of light and shade dramatizing this landscape—the shadows cast by the walls lit from the rear are especially striking. And the dark clouds looming ominously over the mountains and the city, erupting suddenly into churning life near the center of the composition, unmistakably show Titian's inspiration. Bruegel's approach to the sea similarly reveals his absorption of this dynamic landscape style.

FIG. 31. PIETER BRUEGEL THE ELDER. *Mountain Landscape with a Fortified City.* 1553. London, British Museum

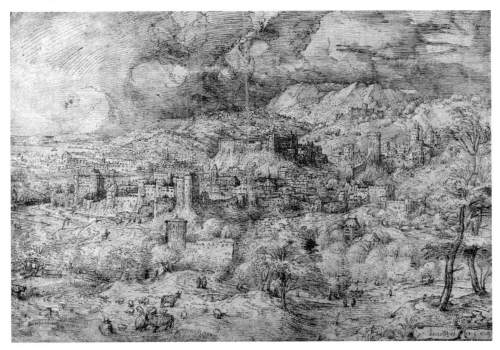

Bruegel's deep interest in the sea is much less well known than his close study of peasant life and his profound response to landscape. The sea, however, is central to the subjects of several of his paintings and designs for prints: *Christ Appearing to His Disciples on the Sea of Tiberias*, 1553 (Brussels, Collection of Charles de Pauw), *The Fall of Icarus* (Brussels, Musée des Beaux-Arts), *View of Naples with a Naval Battle* (Rome, Galleria Doria), and the engraving *A Naval Battle in the Straits of Messina*, published in 1561 (Fig. 32).[49] The close observation of vessels and naval tactics in these last two images of sea battles attests, moreover, to Bruegel's interest in and authoritative knowledge of ship types. He designed a set of eleven prints portraying in detail a variety of vessels of various sizes (Fig. 33).[50] More striking than the accuracy of his rendering is his concern with depicting the ships' responses to their environment, whether lying at anchor or sailing before a gathering gale. In contrast, the only precedents for this series, the engravings of Master ᴡ ⚹ and a group of similar Venetian engravings, possess little sense of the interaction of a sailing ship with wind and wave that almost makes a vessel seem alive.[51]

This particular sensitivity to the sea and ships reveals the general impact of the Venetian approach to landscape on Bruegel and is an important factor in the power of his highly personal approach to depicting tempests and shipwreck. Bruegel's insertion of ships wrecking and burning in the background of *The Triumph of Death* of 1562 (Madrid, Prado) functions as a minor amplification of

Fig. 32. Frans Huys, after Pieter Bruegel the Elder. *A Naval Battle in the Straits of Messina.* 1561. Engraving

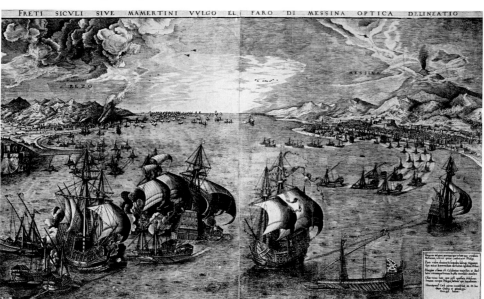

FIG. 33. FRANS HUYS, after Pieter Bruegel the Elder. *Two Mahonnas and a Four-Masted Ship Before a Looming Storm, with Arion and the Dolphins.* Engraving

a desert landscape filled with catastrophe and destruction.[52] More striking are the dark clouds looming ominously behind the vessels in a print from Bruegel's ship series that depicts three ships with Arion saved by dolphins (Fig. 33). This threatening weather suggests retribution for the sailors who cast Arion overboard, but it also hints ironically at rough sailing ahead for Arion himself.[53] Still more revealing are the storms Bruegel introduces into the iconography of two subjects in which the tempest had not previously appeared.

The first of these is his design for the engraving *Spes* (*Hope*) from the engraved series of the Seven Virtues, dated 1559 (Fig. 34).[54] In each print in this series, Bruegel depicts a female figure at center to personify the virtue and a variety of objects and events in a landscape to symbolize its qualities dramatically. In several designs of the series he alters or omits traditional attributes of the virtue, so that the print apparently depicts not the virtue itself but behavior or situations exhibiting very nearly its reverse: in the case of *Spes*, not hope in God or in salvation but the folly of hope in earthly things. The storm is just such an alteration, for in it the ship, a traditional attribute of Hope, actually does sink—leaving little room for hope—and a whale (shown in traditional guise as a giant fish) is about to pull from under Hope's feet the anchor on which she stands, her traditional symbol as a support and stay in the troubles of life.

Bruegel's attitude to symbolic content is clearly not that of an emblem maker. He expands such symbols as the ship dramatically, and he capitalizes on potential discrepancies in symbolism, most notably in the juxtaposition in the same space of the floating anchor and the sinking ship, one of which belongs to a symbolic, the other to a naturalistic, narrative mode of representation. The anchor, familiar symbol of Hope's stability, is thereby transformed into a disturbingly ambiguous sign, for if taken literally, it can only represent the opposite of its traditional meaning. That Hope is about to lose her anchor makes Bruegel's ironic purpose clearer. What is also striking, however, is that Bruegel deliberately makes a storm and shipwreck primary symbols of Hope, for in the icono-

graphic tradition they rarely appear as attributes of that virtue. Bruegel seems to
have been familiar with the unusual iconographic pattern seen in a Flemish
tapestry of about 1530 in Pittsburgh (Fig. 35).[55] In the middle distance behind the
allegorical figures in the foreground bellows-blowing wind gods assault a ship
and topple her masts, while in the far distance another ship sinks and a castaway
swims in the water. In *Spes* Bruegel renders these same disasters more naturalis-
tically, but also eliminates the vessel in which Hope rides (a sort of seagoing
triumphal chariot), leaving only shipwreck as a dramatized symbol of the virtue.
Such storms and shipwrecks are more typical of the iconography of *Fortuna* and
Occasio. Bruegel's *Spes* apparently conflates the figure of Hope on her anchor
and the figure of *Fortuna/Occasio,* who stands in the waves on a shell or on a
globe or wheel, sometimes accompanied by a storm sinking ships that symbol-
izes her sudden and destructive changes of favor.[56] This conflation is appropriate
to Bruegel's subtle subversion of the old iconography of Hope, for what we see
illustrated here is not trust in God's providence or in eternal life but the ineffec-
tuality of Hope in addressing the problems of this life both great and small,
whether shipwreck, imprisonment, household fires, or fishing, all things subject

FIG. 34. PHILIP GALLE (attributed), after Pieter Bruegel the Elder. *Spes.* Engraving

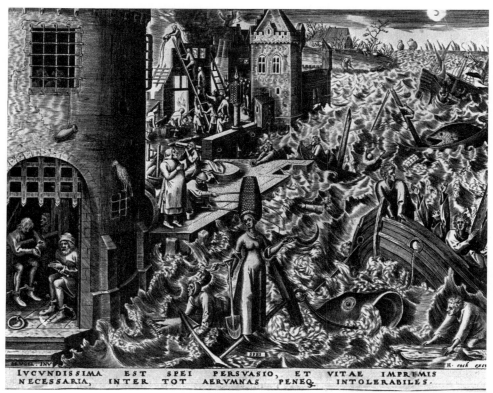

IVCVNDISSIMA EST SPEI PERSVASIO, ET VITAE IMPRIMIS
NECESSARIA, INTER TOT AERVMNAS PENEQ. INTOLERABILES.

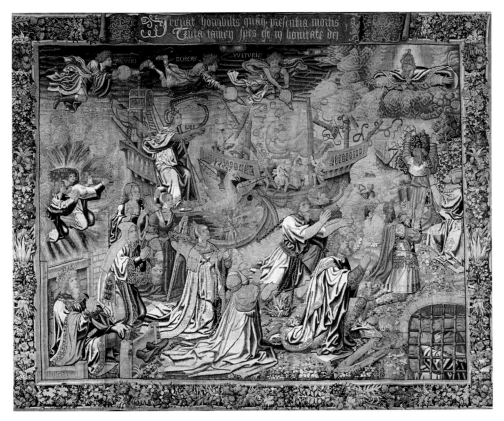

FIG. 35. *The Triumph of Hope.* Tapestry, Brussels. Pittsburgh, Museum of Art,
Carnegie Institute, Gift of the Heart Foundation

to fortune's mutability. The illusory nature of Hope in such things is suggested
in the peculiarly ambiguous text that accompanies the image:

> The persuasion of Hope is most pleasant and especially necessary for life among
> so many almost unbearable hardships.[57]

Bruegel's use of a storm in this context is an example of his distinctive intensifi-
cation of the pictorial vocabulary he inherited, for he depicts a storm that is
psychologically compelling both as a force overwhelming man and as a symbolic
agent destroying man's illusory hope in the transient things of the earth. Ampli-
fying this complex significance is the great fleet of ships sailing in favorable
winds on the horizon, further indicating the changeability of the world.

A storm similarly characterizes the nature of the world in *The Dark Day*
(Vienna, Kunsthistorisches Museum), dated 1565, one of a series of paintings
representing the months or seasons (Fig. 36).[58] Probably depicting March and
April, *The Dark Day* represents the rebirth of nature from the dead stillness of
winter. Particularly when contrasted with what was surely its pendant, *The*

Hunters in the Snow, The Dark Day is pervaded by dark moistness and stirring life, the landscape formed by long organic curves and colored by warm earth browns. As a manifestation of the cosmic process of growth and change, Bruegel introduces in the background a storm lashing a long coast and estuary, flooding orchards and fields behind dikes and destroying shipping all along the coast. This is nature in convulsion at a time of renewal, in opposition to the frozen mountains, sharply defined in the upper-left corner, still snow-shrouded in the grip of winter, echoing the cold, harsh mountains in *The Hunters in the Snow*.

Such a storm is apparently unprecedented in depictions of months or seasons, and its introduction here epitomizes Bruegel's expansion of the role of landscape in this picture cycle. Bruegel gives each season a vitally different personality, and in *The Dark Day* he uses the affective and associative power of the storm to transform the relatively static pictorial tradition.[59]

Bruegel's use of a storm as a sign of seasonal change has its roots in manuscript illumination, going back to small calendar pictures for February by Jean Pucelle dating 1323–26, showing rain falling on young plants.[60] The depiction of rain itself did not continue in the calendars of the fifteenth and sixteenth centuries, although February and March were sometimes characterized by gray skies. In the case of a sixteenth-century miniature for February in a calendar in Munich, the sky is even threatening with dark clouds (Fig. 37).[61] This miniature, like Bruegel's painting, depicts an estuary with a harbor town and shipping, reflecting a tendency to associate January, February, and March with river landscapes, ships, and fishing, probably because of the zodiacal signs of Aquarius and Pisces.[62] *The Dark Day*, however, seems to be the first image in which an actual storm characterizes a season. For this Bruegel was most likely inspired not only by his acute sensitivity to weather phenomena but also by traditional literary notions of winter as a time of storms and of the spring equinox in March, the transitional period from winter to summer, as a time of tempests.[63] These same associations doubtless led Bruegel to include a storm on the distant horizon in his design for the engraving *Ver (Spring)*.[64] In this drawing echoes of the rhetoric of literary storms also appear in the oppositions of calm, industry, and celebration in the foreground and tempest, destruction, and crisis in the distance. Similarly and more dramatically, the juxtaposition of tempestuous rebirth with icy stillness in the pairing of *The Dark Day* with *The Hunters in the Snow* gives visual form to the polarities animating both a universe based on the four elements and the textual tradition describing that universe.

But beyond these traditional ideas Bruegel found the tempest compelling in this new context, as in the *Spes*, for its affective capacity to express a characteristic insight: man's inescapable subordination to nature. As in many of Bruegel's landscapes, man is small within the world of *The Dark Day*. The artist chooses a high, distant viewpoint from which a given man or city or ship is visible only within an expansive context. His figures here as elsewhere are embraced and contained by nature, subject to its changing rhythms as they travel through it or go about the labors and celebrations of the seasons. The tempest in *The Dark Day* is the most violent statement in this series of pictures of man's place in nature and of the character of nature itself—vast, powerful, and in this phase of its cosmic rhythm of growth and change a force assaulting human presence in

FIG. 36. PIETER BRUEGEL THE ELDER. *The Dark Day.* 1565. Vienna, Kunsthistorisches Museum

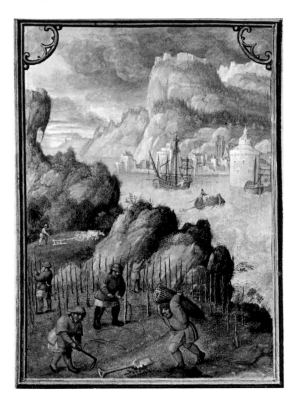

FIG. 37. *February.* From a manuscript calendar, cod. lat. 23638. Munich, Bayerische Staatsbibliothek

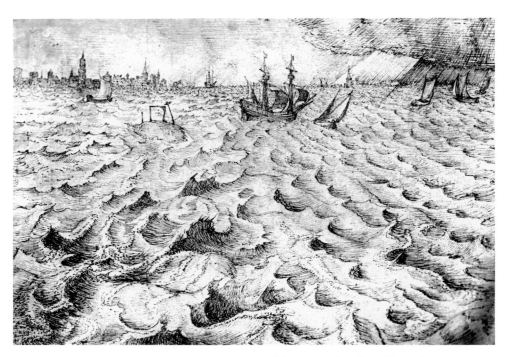

Fig. 38. Pieter Bruegel the Elder. *A View of Antwerp.* London, Home House Trustees Collection

the world, indifferently breaking dikes and engulfing vessels.

The seascape in *The Dark Day* is subordinate to a complex description of the world; in Bruegel's drawing *A View of Antwerp* of about 1565 (Fig. 38), the sea expands to fill a panoramic composition.[65] A broad expanse of moving water occupies the entire foreground without mediating framing devices, permitting a direct encounter with the repetitive yet varied forms of waves in constant motion. The restless energy of the sea contrasts with a city, stable and secure in the upper-left corner. The drawing does not depict the destructive storms of the *Spes* and *Dark Day* but just a localized squall, and the waves have a low chop suggesting, like the proximity of the harbor and the many small boats, the safety of local waters. Only the island with gallows and a torture wheel strikes an ominous note.[66] The association of the gallows with death is obvious, but only in this drawing is the motif set in the context of the moving sea, so that the unbounded waves in the foreground threateningly suggest the frailty of mortal life in the ceaseless dangers of this world. The significance of the gallows in a marine context is further suggested in an engraving by Joris Hoefnagel based on a design by Cornelis Cort, depicting a wrecked ship juxtaposed with a gallows (Fig. 101).[67]

The scope Bruegel gives to the sea in the *View of Antwerp,* and particularly the immediate confrontation of beholder with the waves, would seem to culminate in the famous *Storm at Sea* (Fig. 39) in the Kunsthistorisches Museum, Vienna, a picture attributed to Bruegel since the late nineteenth century.[68] Recent tree-ring analysis of the panels on which the storm is painted, however, indicate that the tree from which one panel was cut was probably felled between 1575 and 1585 at

the earliest. If this evidence is trustworthy—the technique and its statistical method are widely accepted—it would preclude Bruegel's authorship, since he died in 1569.[69] This technical data in turn would seem to make recent arguments for reattributing the work to Joos de Momper more plausible, at least in terms of date. Nonetheless, in view of features linking the *Storm* both to Bruegel's own work and to pictures by Jan Brueghel the Elder, we must consider the *Storm* to be a distinctly Bruegelian image. If not by Pieter the Elder himself—and its exact relationship to his work cannot at this point be specified—the picture extends and enriches motifs and formal devices in Bruegel's marine images in a manner that makes it appropriate to discuss within the development of his own work. If attributed to Joos de Momper, this fundamental link to Pieter Bruegel's work remains, for the few comparable stormscapes by De Momper (Figs. 42, 43) are directly dependent on Jan Brueghel's seascapes (Figs. 40, 41), which in turn rely on the works of Pieter the Elder. The Vienna painting likewise reveals a strong relationship to Jan's work and to the entire Bruegel tradition of depicting this subject.[70]

In the *Storm*, as in the *View of Antwerp*, we see vessels from an elevated viewpoint, but here it is a fleet of sixteen oceangoing ships instead of the primarily humble coastal boats in the drawing. All are diminutive in the pictorial field and scattered over the high waves of a vast plane of stormy water. The seemingly unbounded sweep of the sea beyond the picture frame results, as in the drawing, from the absence of repoussoir wings. Amplifying the understated tensions of the *View of Antwerp*, the artist organizes this tempest-filled space both thematically and formally around polarities. Inverting the proportion of light to dark in the drawing, the darkness of the *Storm* in places dominates the picture to the point of obscurity, making the small area of light in the upper left, corresponding to clear skies, more prominent and at the same time enhancing its smallness and remoteness. There is also a corresponding tension of near and far, with darkness and turmoil in the foreground and light and calm far away. Color reinforces this polarity: dark browns and dull greens in the area closest to us, creamy white and vivid blue farther from us. A lighter, greenish area in the dark, presumably the sun breaking through a rent in the clouds, illuminates a ship, two barrels, and a whale, depicted as a monstrous fish with gaping maw.[71] Suggesting perils from monsters of the deep, this threat may explain why the foreground vessels, especially the one at center, have crowded on so much sail. This group relates immediately and poignantly to the brighter light area in the upper left where the distant steeple of a large church and the masts of ships at anchor can be seen: land and a harbor city, the goal of a voyage and a place of safety and of calmer weather. The spire recalls the importance of towers as landmarks for sailors and the beacons lit in church towers during storms along the Netherlands coast. Such ports appear on the horizon in two of Bruegel's ship prints[72] and also in the *View of Antwerp*, where one appears in the upper left as in the painting. Unlike the harbor in the *View of Antwerp*, however, this port is remote and the ships are not making for it. It resembles much more the church tower and city visible to the right of center far off on the horizon in the *Dark Day*. Likewise silhouetted against a lightening sky, this church and harbor are placed just above a group of shipwrecks on the coast, creating unresolvable tensions between hope and disaster, safety and death, calm

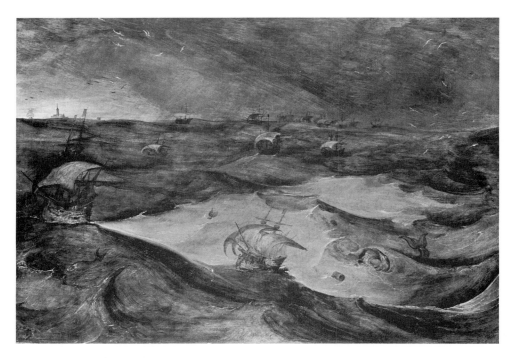

FIG. 39. Formerly attributed to PIETER BRUEGEL THE ELDER. *Storm at Sea.* Vienna, Kunsthistorisches Museum.

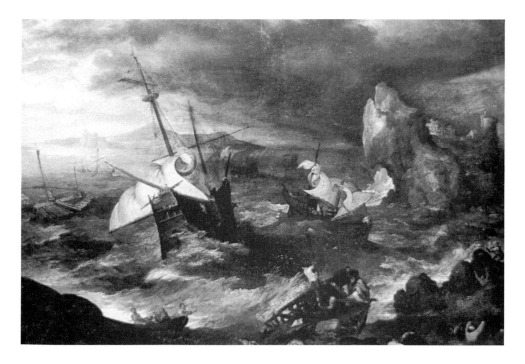

FIG. 40. JAN BRUEGHEL THE ELDER. *Shipwreck with Castaways.* German private collection

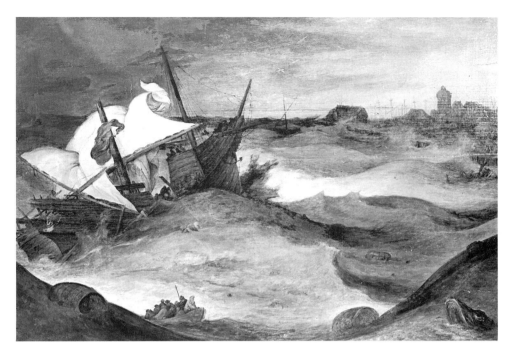

Fig. 41. Jan Brueghel the Younger (?). *Shipwreck on the Netherlands Coast.*
Vienna, Kunsthistorisches Museum

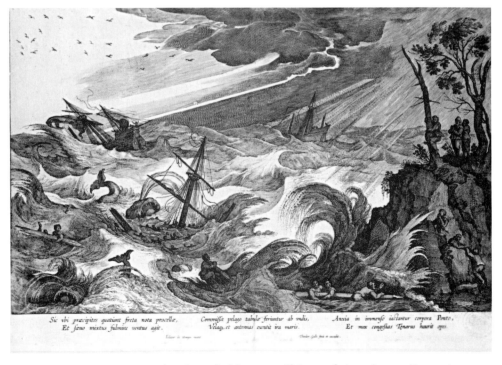

Fig. 42. Theodor Galle, after Joos de Momper. *Shipwreck in a Storm.* Engraving

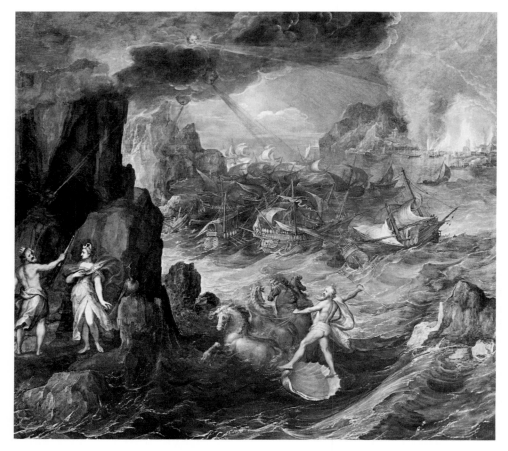

FIG. 43. Joos de Momper and an anonymous Flemish figure painter. *The Destruction of the Greek Fleet Returning from Troy.* Stockholm, Nationalmuseum

and storm, similar to those in the *Storm at Sea,* though as a subordinate theme in a larger composition.

These tensions are enhanced in the Vienna *Storm* by the instability of the whole composition, formed of interlocking curves and diagonals reinforced by the long sweeps of the liquid brushstrokes, inherently unstable forms suggesting constant motion.[73] The sense of flux is increased by a ship placed at the far left on the peak of a wave and at the juncture of important diagonals, attracting attention far from the center. The two wheeling flights of birds also serve to activate the composition. There is, in fact, nothing to stabilize the picture, nothing solidly vertical or horizontal except for the church and its roofline tiny and far away, and to the left of the tower, an equally tiny ship in pure vertical. With all sails set and filled with wind she sails alone toward the foreground, a token of the hope that this distant area of light represents. This motif also recalls the distant ships sailing in fair weather on the horizon of Bruegel's *Spes,* two of which are similarly seen from the bow with bellied-out sails.

This painting depicts not simply ships at sea in a storm but tensions of mortal danger and safety, present disorder and promise of order, tempest and calm.

Moreover, the remoteness of light, fair weather, and security from both the viewer and the vessels throws off the balance between the oppositions of the pictorial structure, greatly enhancing the tensions within the image. This inherent affective significance, readable in the situation of the vessels and in the pictorial structure, invites the beholder's empathic identification with the fate of the vessels and draws him into the depths of this storm-filled space.

This dramatic representation of the storm is a concentrated statement of characteristic themes and expressive devices in Bruegel's marine imagery, but it is also linked to Bruegel's art because it shares many features with the early seascapes of Bruegel's son, Jan Brueghel the Elder, dating to the mid-1590s. The basic compositional structure of distant, bright calm in one corner contrasting with the tenebrous storm filling the foreground appears in Jan's *Shipwreck with Castaways* (Fig. 40), in his *Jonah Delivered from the Whale* (Munich, Alte Pinakothek), and also in a *Shipwreck on the Netherlands Coast* (Fig. 41), possibly by Jan and certainly dependent on his work.[74] The sweeping vigor of the waves and the lack of framing structures in Jan's shipwreck scenes also resemble the Vienna *Storm*, as do the monstrous fish in the last two of these pictures. The link between these seascapes by Jan Brueghel and the Vienna *Storm* is significant because many other features of Jan's tempest pictures derive directly from the work of Pieter Bruegel the Elder.[75] The poses of the castaways in lifeboats and clinging to flotsam and jetsam in both the *Shipwreck with Castaways* and in the *Shipwreck on the Netherlands Coast* come from Pieter the Elder's *Spes*, and the decidedly old-fashioned ship with high stern and forecastle at the left center of the former is based on Bruegel's ship engravings. The view of the coastline with a harbor village in the latter painting also depends on the view of the coast in the *Spes*. The Vienna *Storm at Sea* thus belongs to a Bruegelian tradition of depicting the sea, and whatever the attribution or dating of the *Storm*, the painting should be considered in the context of this body of work. It may well derive from a lost work by Pieter the Elder.[76]

The *Storm at Sea* corresponds to literary descriptions of tempests not only in its dramatic presentation but in its openness to symbolic interpretation; and many readings of the picture have been advanced. While aspects of all these interpretations are valid, each such reading, as it lays claim to exclusive validity, remains unconvincing in large measure due to the expansive power of the picture. Ludwig Burchard, for example, basing his interpretation almost entirely on the whale, barrel, and ship, read the picture as "Bruegel's Parable of the Whale and the Tub."[77] While most scholars have accepted Burchard's view of the symbolism of the whole picture and of the barrel trick in particular, both are dubious. Burchard's reading of the whale-barrel-ship motif as human folly (the whale as foolish man chases a trifle and permits his true good, the ship, to escape) emphasizes the leviathan and makes it rather than the ships the protagonist, an unlikely object of the beholder's empathy.[78] Significantly the symbolism Burchard proposes is not that found in sixteenth-century sources; then the motif was read as referring either to the wise ruler who eludes monstrous powers threatening the ship of state or to the wise individual who discards worldly goods to save his soul.[79] Whichever interpretation of the barrel trick is favored, however, an interpretation based on a single feature in a much larger composi-

tion violates the expressive unity and scope of the image. The barrel trick here possesses a dramatized vitality and breadth of reference by its juxtaposition with another charged area of light and by the presence of an entire fleet in a stormy sea. Like the storm in Bruegel's *Spes*, this treatment of the symbol is dynamic and associative rather than emblematic.

Because the *Storm* can no longer be attributed to Pieter Bruegel, interpretive readings of the picture as symbolizing Bruegel's ethical and spiritual views or as an allegory of the current political situation must be set aside.[80] It is possible, however, to see that in the *Storm* what were symbols in other contexts become actors on a world stage in a drama of danger, struggle, and salvation. The barrel trick, for instance, was very likely on this artist's mind when he made the *Storm*, and yet it does not function here as a symbol inserted into a neutral setting, but itself participates in the tensions animating a turbulent image of the sea. Even so general an interpretation of this vessel as the ship of state seeking to escape chaos by cunning and reach the harbor of peace and prosperity is inadequate to her role in the painting because she is one of many vessels tossed by the tempest, nor is she sailing to the harbor. Her struggles are ongoing and relief is imminent neither in the restless sea nor in the far-off safety of the port. This ship, moreover, could be interpreted with equal validity and similar inadequacy as an individual struggling in the tempestuous waves of civic discord and spiritual disquiet. Yet this reading too must be broadened to include the other vessels.

Bruegel had long meditated on man's place in the cosmos in a variety of pictures, many of which were apparently reflections on the political and spiritual unrest of his time. The *Storm at Sea* may well derive from an image in which Bruegel was moved to use the commonplace iconography of the sea to express the perilous state of the Netherlands polity in the late 1560s. With the revolt of the Netherlands against Spain apparently shattered, the populace cowed by the Duke of Alva's Council of Troubles, and old civic institutions being trampled, superseded, or remade, an image of utter instability, ever-present peril, and remote security and peace could have seemed appropriate to the state of the times.[81] Yet Bruegel's work in general also moves beyond immediate topical references to broader issues of man's cruelty to man, the smallness of man's presence in the world, and a totally unromanticized view of nature and our relationship to it. The *Storm at Sea* belongs to this body of work, whether or not from the hand of Pieter Bruegel himself, as a meditation on issues of human capacity and limitation in the turmoils of existence. In this picture, as in the entire Bruegelian tradition, the tempestuous sea becomes a pictorial theme capable of functioning with an affective and metaphorical resonance foretelling the concerns of an enduring pictorial tradition.

TEMPESTS AS PROTAGONISTS IN
FIGURAL NARRATIVES: 1560–1660

Following Bruegel's death in 1569, his vision of the sea contributed significantly to the development of the tempest imagery that, with modifications, was to remain current to the end of the nineteenth century. Surveying this development into the seventeenth century, we see again the styles of Venetian and Netherlandish artists interact and fuse as artists explored the expressive possibilities of the theme. During the 1580s in particular, artists began to depict Jonah cast to the whale and several other subjects involving storms more frequently.[82] In a change of emphasis, however, they displayed greater interest in intensifying the confrontation of man and nature. This effect was not achieved by compositional changes but by dramatizing both the tempest and human reactions to it. Thus the formula developed in the first half of the sixteenth century employing a closeup view of ship, crew, and leviathan reappears in a design by Dirck Barendsz. of 1582, now known in an engraving by Jan Sadeler (Fig. 44).[83] Marten de Vos used the same composition in a series of drawings and prints begun in 1585 and culminating in a painting, dated 1589, formerly in the Kaiser Friedrich Museum, Berlin (Fig. 45).[84] Neither Barendsz. nor De Vos shares Bruegel's concern with ships caught in and diminished by the vast flux of elemental nature. Instead, these artists respond to the dramatic imperative of their subject, focusing on the emotions and actions of the terror-stricken crew. Both enhance the desperation of the figures by dramatizing not just the traditionally menacing Leviathan but also the elemental powers of sea and sky that cause their terror. Strong contrasts of light and dark in the swirling clouds and swelling waves suggest the intensity of the conflict and reveal the deep impression of both artists' Venetian training. Such expressive effects are distinctly reminiscent of *La Burrasca*, and even more strikingly so of Tintoretto's *St. Mark Rescuing a Saracen* (Fig. 46) of about 1562–66, a painting in which a similar affective use of diagonal forms, strong chiaroscuro, and spatially active figural poses energize the closeup formula for marine images.[85] Both *La Burrasca* and the *St. Mark* were on public view in the Scuola Grande di San Marco. Barendsz. probably knew both, and De Vos surely knew *La Burrasca*.

Growing interest in this ultimately Venetian conception of a natural world that intrinsically participates in human narrative is evident in the increasing number of storm images produced in the 1590s and in the rise of seascape as an independent genre in the same years. Although this attitude toward nature is also a basic feature of Bruegel's landscape imagery, the *Jonah*s of Barendsz. and De Vos have no apparent link to him. Their dominant concern continues to be expressive figural action; the storm is a vital element in the impact of their pictures, but its role remains subordinate to the human drama, as may be expected in tempest scenes using the closeup compositional type.

Such pictures with their figural emphasis had little direct influence on the development of the storm imagery that ultimately dominated the seventeenth century. Indeed, the maturing of storm and shipwreck as independent subjects and the rise of seascape itself were accompanied by a striking decline after about 1610 in the production of religious and historical subjects set in storms.

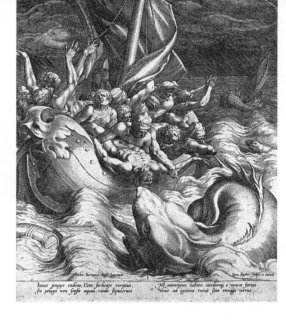

FIG. 44. JAN SADELER, after Dirck Barendsz. *Jonah Cast to the Whale.* 1582. Engraving

Such narrative images as Jonah cast to the whale, Christ asleep in the storm, and the shipwreck of Saint Paul would appear to be natural subjects for Baroque artists. Yet both in the North and in Italy depictions of these themes became markedly less frequent in the first third of the seventeenth century.[86] The same is true of classical histories and allegorical subjects set in tempests, which appear much less frequently after about 1610. The most impressive rendering of a classical storm theme after that date, Rubens's *Shipwreck of Aeneas* (Berlin-Dahlem, Gemäldegalerie; see Fig. 77), is identifiable as a specific historical subject only through the inscription on Schelte Adams Bolswert's engraving after the painting.[87]

A similar trend is apparent in the treatment of religious themes. Paul Bril's Jonah paintings and Jan Brueghel's pictures of both Jonah and of Christ asleep in the storm significantly influenced the compositions and expressive effects of the developing tradition of storm paintings; but the religious subjects of these paintings were almost completely ignored by later artists. When seventeenth-century history painters did treat these religious narratives, they turned for their models to the earlier compositions of Barendsz. and De Vos with their closeup views of struggling men. Such images were more appropriate to a biblical narrative than the storm paintings typical of their own period with their emphasis upon the power of nature and the desperate situation of the ship. Rubens's vivid *Jonah Cast to the Whale* of about 1618 in Nancy (Fig. 47)[88] and Rembrandt's *Christ Asleep in the Storm* of about 1633 in the Gardner Museum, Boston (Fig. 48), rely directly on these sixteenth-century compositions.[89] Simon de Vlieger, inspired by Rembrandt, was among the very few seventeenth-century marine artists to use this Barendsz.–De Vos composition.[90]

Only exceptionally did marine painters of this time set identifiable narrative figures in their typical storm scenes (Fig. 49).[91] When placed in the context of the enormous production of Netherlandish storm paintings in the seventeenth century, the few known literary subjects appearing in the new naturalistic storm-scapes of Porcellis and De Vlieger show how little demand there must have been

Fig. 45. Marten de Vos. *Jonah Cast to the Whale.* 1589. Formerly Berlin, Kaiser Friedrich Museum (destroyed)

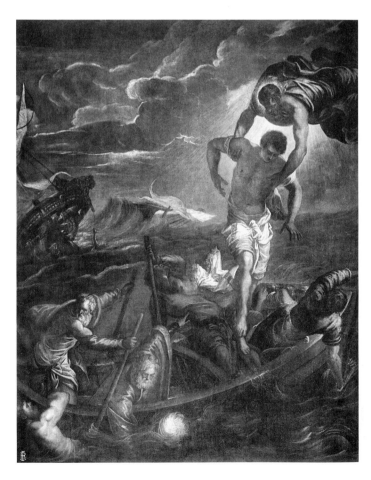

Fig. 46. Jacopo Tintoretto. *St. Mark Rescuing a Saracen.* Venice, Gallerie dell'Accademia

for these subjects. The depiction of nature itself and man's contention with it had become adequate to sustain an entire image, a fact borne out by the capacity of storm images to stimulate and sustain both emotional identification and symbolic meditation.

Figural tempest narratives of the Barendsz.–De Vos type testify to the growing interest in both the subject of the storm and a dramatic treatment of it in the period 1580–1610. Most important for the new storm images of the seventeenth century, however, was the application of this dramatic vision to the panoramic compositional type developed long before by Patinir (Fig. 15). In this type, the entire picture is composed within a horizontal format in which the vessel occupies the middle distance in a broad context of waves and rocky cliffs. From the sixteenth century to the present the congruence of this pictorial organization with our sense of the breadth of the world has made it the favored format for landscape. In images of storms it permits a fuller characterization of natural forces and a more vivid visualization of man's place in the expanse of the world than is usually possible in the vertical tempest scenes of the Barendsz.–De Vos type. The upright format, in contrast, echoing the orientation of the human figure and one of the principal axes of the sailing vessel, enhances and favors the dominance of human action.

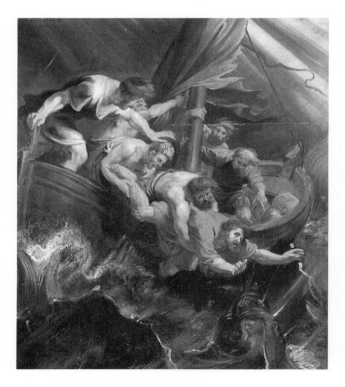

FIG. 47. PETER PAUL RUBENS. *Jonah Cast to the Whale.* Nancy, Musée des Beaux-Arts

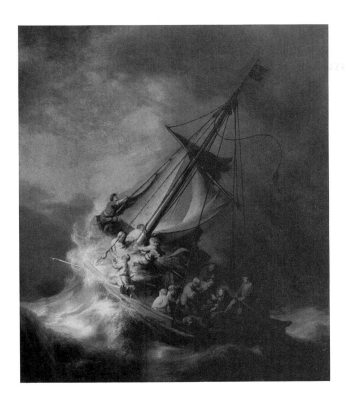

FIG. 48. REMBRANDT VAN RIJN. *The Storm on the Sea of Galilee.* 1633. Boston, Isabella Stewart Gardner Museum

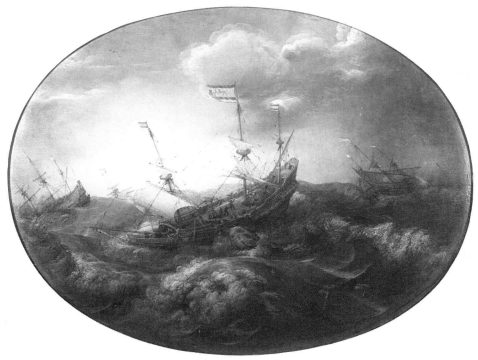

FIG. 49. ADAM WILLAERTS. *Jonah Cast to the Whale.* Greenwich, National Maritime Museum

The Patinir type of stormscape activated by Venetian light effects appears in the work of a number of artists around the turn of the seventeenth century. In Frederick van Valckenborch's almost phosphorescent *Shipwreck* dated 1603 (Fig. 50), the breadth of touch surely demonstrates his inspiration from Venetian painting.[92] Adam Elsheimer's *St. Paul on Malta* of about 1600 (Fig. 51) likewise depends on Venetian precedents for its multiple sources of illumination.[93] The most important paintings of the Patinir type for the rise of stormscapes, however, were those of Paul Bril in Rome. There, about 1588–89, Bril painted a fresco, *Jonah Cast to the Whale*, in the Scala Santa of the Vatican (Fig. 52), using a composition apparently invented by his brother Mattheus.[94] This design seems to have been well known. Bril repeated it at least three times on canvas, and Justus Sadeler engraved a version of it. Using a fantasy boat and monster very likely derived from Barendsz. or De Vos, Bril rendered these motifs in smaller scale within an extensive seascape. The scene is dramatized by the same Venetian chiaroscuro effects in water and clouds exploited by the earlier artists. Adding to the drama and expanding the space of the scene is a deep landscape vista characteristic of Bril: a few trees and bushes cling to steep cliffs topped by a ruinous watchtower; an arched bridge leads to the tower, and another bridge further inland leads to a town containing a circular domed building. While these landscape motifs ultimately derive from the northern panoramic tradition (e.g., Fig. 15), their immediate origins here are landscapes created by Netherlandish artists in the circles of Titian and Tintoretto, such as two shipwreck allegories designed by Cornelis Cort (see Figs. 101, 102).[95] Set within the broad horizontality of Bril's composition, these motifs exerted a lasting influence on the imaginations of younger artists, whose storm scenes, in turn, fundamentally shaped those of the seventeenth century in the Netherlands and Italy. The very persistence of Bril's type of coastline in two of the main categories that we will discover in seventeenth-century tempest painting indicates the basic importance of his example.

FIG. 50. FREDERICK VAN VALCKENBORCH. *The Shipwreck*. 1603. Rotterdam, Museum Boymans–van Beuningen

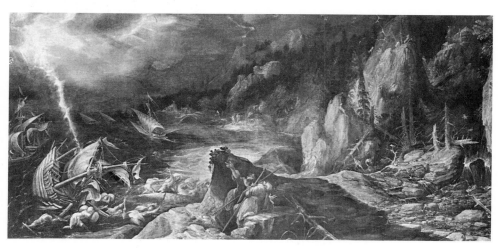

FIG. 51. ADAM ELSHEIMER. *St. Paul on Malta.* London, The National Gallery

FIG. 52. PAUL BRIL. *Jonah Cast to the Whale.* Rome, the Vatican, Scala Santa

DUTCH TEMPEST PAINTING:
RHETORICAL NATURALISM

In the 1590s the central figures in the development of marine painting in northern Europe were Jan Brueghel the Elder and Hendrick Cornelisz. Vroom. The tempest pictures of Paul Bril and Pieter Bruegel the Elder were apparently their models for specific motifs and also inspired their emotionally compelling ways of depicting the sea. The drama of sea and sky, light and shadow, ships and the elements, becomes in their images, as in the Vienna *Storm at Sea*, a subject sufficient in itself to sustain an entire picture, needing neither identifiable figural incident nor obvious allegorical attributes. The natural world in their works acts as a protagonist as important to the image as the human response represented by the ships and sailors.[96]

Jan Brueghel, Pieter the Elder's son, was a gifted artist in a number of genres, and such images as his *Shipwreck with Castaways* (see Fig. 40), a scene without an ascertainable narrative subject, typify his often astonishingly precocious compositions and choices of subject matter.[97] While dependent for poses and one of the vessels on his father's work, Jan turned for the scale of the vessels in the pictorial field, the cliffs and tower at right, and the waves and cloud forms to Paul Bril.[98] The general composition of light and dark and the contrast of stormy clouds and sea with calm clear weather in the upper left would seem to confirm that Jan knew the Vienna *Storm at Sea* or another picture like it. The contrast of dark, danger-filled sea with the calm safety of an anchorage found in that painting appears also in the closely related *Shipwreck on the Netherlands Coast* possibly by Jan (see Fig. 41).

Although Jan's pictures of shipwreck are rare, his storm scenes were probably more influential for Netherlandish artists than is generally recognized. Jan very likely provided the inspiration for the protruding, undercut rocks and the castaways in boats or clinging to rocks that are frequently seen in Northern stormscapes.[99] Jan's paintings differ from typical seventeenth-century storm scenes, however, in that they are constructed around the same oppositions informing the Vienna *Storm*—tempest and calm, violent open sea and secure harbor, darkness as danger and light as safety. These oppositions are either absent from or given a markedly different treatment in the seventeenth century.

More decisive for this new imagery was the contribution of Hendrick Cornelisz. Vroom, the central figure in the development of marine painting as a genre. None of Vroom's earliest storm pictures, presumably dating from around 1590, has been identified. The few by him that survive date from probably a little before 1600 to about 1610.[100] In them we find almost fully formed two of the four main types of storm image that emerge in the seventeenth century. One type, which I will call the Storm on the Open Sea, is known from a large fragmentary painting and from engravings by Petrus Kaerius (Fig. 53) and by Claes Jansz. Visscher after Vroom. It depicts several ships sailing on various courses in a tempest with no land in view.[101] This absence of land is a decisive departure from Bruegelian storm imagery, where land is always present and safety clearly implied. Vroom's new type possesses a distinctly different tone

Fig. 53. Petrus Kaerius, after Hendrick Cornelisz. Vroom. *Ships in a Storm.* Engraving

that derives from its rendering of awesome, totally hostile forces and ceaseless human struggle against them.

A second, long-enduring type of storm scene in Vroom's work, the Shipwreck on a Rocky Coast, is known from his *Ships in a Tempest*, datable before 1608 (Fig. 54).[102] Here Vroom again alters the thematic opposition of Bruegelian pictures in a way that has strong emotional connotations. Land is present in this type, but far from promising deliverance from the sea, it becomes something like a nautical *memento mori*, as two ships smash on a rocky outcropping in the middle distance and other ships struggle to set courses away from this fate. Light falls on the land as in the Vienna *Storm*, yet it appears not as a positive radiance but with a lurid glare that makes the peril of the rocks all the more vivid in the darkness of the storm.

Pieter Bruegel and Paul Bril provided the chief inspiration for Vroom's storm scenes. The ships struggling in the open sea strongly suggest closeup, lower views of the ships in the Vienna *Storm*, though whether Vroom knew that picture or another now-lost picture by Bruegel is impossible to say. The barrels and bales in the waves and spouting whales and monstrous Boschian fish certainly reveal the same Northern heritage upon which Bruegel built. Furthermore, there is no real precedent for the large, meticulously accurate ship in the center of each painting except in Bruegel's ship engravings. And Vroom constructs ships as authentic and up to date as those to be found there.[103]

The more dynamic bursts of light animating clouds and water and striking the rocks in the distance, however, recall Bril's *Jonah* (Fig. 52). So too does the size of

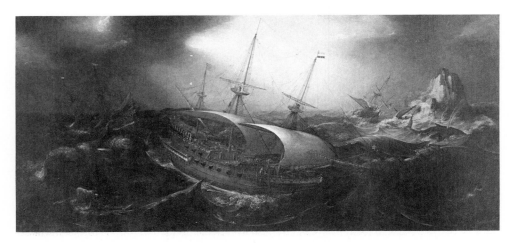

FIG. 54. HENDRICK CORNELISZ. VROOM. *Ships in a Tempest*. British private collection. Pendant to Figure 55

the central vessel in the pictorial field—neither so dominant as in the Barendsz.–De Vos compositional type nor so diminutive as in the Vienna *Storm*—and indeed Van Mander reports that Vroom worked with Bril in Rome. Vroom's altered use of light is central to the evolution of a new kind of storm imagery; the greater tension of light and dark that energizes his picture makes possible a richer and more ambiguous range of connotation than is available in the Bruegelian tradition. Like the land that causes shipwreck and yet promises safety from the storm, the light in Vroom's conception does not stand simply for fair weather. Though breaks in the clouds foretell that possibility, this light more significantly betrays the full scope of nature's fury and of the threatened or accomplished disaster; visually it both activates and unifies the conflicted elements.

This increased sensitivity to the evocative power of natural elements is qualified in Vroom's work by a schematic approach to seascape that closely parallels the late Mannerist style of Netherlandish landscape of the last decades of the sixteenth century.[104] Vroom's symmetrical compositions of almost equally spaced vessels, with the largest placed at center and parallel avenues into depth at each side, are comparable in conception to the even distribution of trees, rocks, and figures in landscapes by Paolo Fiammingho and Gillis van Coninxloo.[105] The consistent clarity of Vroom's vessels, no matter how distant from the foreground, corresponds to his formulaic treatment of many natural objects, including the sea itself. He renders brittle, smooth waves with long parallel planes tufted with stylized foam and rising to impossibly tall points. The strong local color and high horizon of these images reinforce the impression of a stylized diagram of the world, despite the relatively emphatic chiaroscuro and the sweeping curves of waves and clouds. As in many tempest images of all kinds made before 1620, Vroom's giant fish and whales—often recalling the conventional monsters on maps and globes—personify, rather than render through purely naturalistic means, the violence, mystery, and danger of the sea, further manifesting the overt artifice of his descriptions of natural disorder.

Vroom's innovative synthesis of the tempest imagery of Bruegel and Bril—in

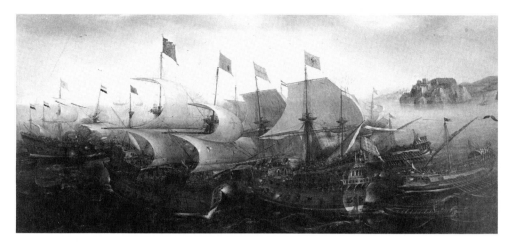

FIG. 55. HENDRICK CORNELISZ. VROOM. *The Battle of Cadiz.* British private collection

essence a synthesis of the Northern and Italian traditions—evidently made a strong impression in the Netherlands. By about 1615 a number of artists—including Jan Porcellis, Hercules Segers, Adam Willaerts, Cornelis Claesz. van Wieringen, and probably Andries van Eertvelt—were making pictures of sea storms in Vroom's manner.[106] During the second and third decades of the century Porcellis and Van Eertvelt in particular expanded the expressive reference of Vroom's compositional repertory, primarily by moving away from the stylization of his images. In the North Netherlands, Jan Porcellis modified the schemas of Vroom with an increasing naturalism marked by more varied techniques for rendering waves and foam and by an emphasis upon sky, atmosphere, and rich modulations of light as a means of communicating emotion. In the South Netherlands, in contrast, Van Eertvelt developed a more highly keyed, at times almost visionary, type of storm scene. This more overtly theatrical mode had wide influence, particularly in Italy.

Porcellis's interest in naturalism is evident in his earliest storm, one of a pair of seascapes in Hampton Court dating before 1612, in which the artist already modifies the ships, monsters, and flotsam and jetsam derived from Vroom with a gray, hazy atmosphere (see Fig. 120).[107] Although Porcellis could depict the most violent aspects of the sea—as seen in a painting of about 1620 in Greenwich depicting a ship with its mainsail blowing wildly in a strong gale (see Fig. 78)—he became increasingly interested in using nuances of clouds and light to create more subtle, shifting moods (Fig. 56).[108] This development, which required an increasingly precise observation and discriminating rendering of nature, is accompanied by the disappearance from his work of Boschian sea monsters. Drama, no longer fantastic, now resides solely in the interaction of sea, sky, and ships.

Porcellis also made major compositional changes to enhance his dramatization of nature and to articulate more clearly his insight into man's close but vulnerable interrelationship with the forces of this world. One such change was his lowering of the horizon, an enormously important development not only in

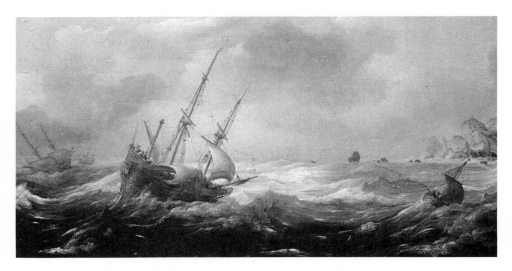

Fig. 56. Jan Porcellis. *Three-Masters Approaching a Rocky Coast.* Stockholm, Hallwylska Museet

his own work but for Dutch and Flemish land- and seascape painters for decades to come. Instead of viewing a panorama spread out below him, the spectator before such images encounters a world opening almost at his feet, extending his own space into that of the painting and engaging him by the accessibility of the fictive space. Equally important, the expansive area of sky made available by the lowered horizon permits the artist new scope for the rendering of movement and mood in clouds. Porcellis further accentuates the interplay of the natural elements by making his vessels smaller and by removing ships from the center of the visual field. Porcellis's vessels are not, as a result, by any means negligible, but they are more fully integrated into the embracing composition of waves, clouds, light, and land. This treatment of vessels was adopted by most Netherlandish artists of the following generation in depicting storms, and it became in particular for Porcellis's most important follower, Simon de Vlieger, a primary means of characterizing man's precarious place in the world.

More freely than any other Dutch or Flemish artist, Porcellis experimented with the developing formulas for seascapes and storms. In his *Stranding off a Beach* (Fig. 1) of 1631, for example, he departed from the typical wreck on a rocky coast in favor of an ordinary Dutch beach with fishing boats and dunes.[109] Though the choice by a Dutch artist of such a setting for a wreck seems an obvious one to us, few artists at that time imitated this beach stranding, a significant indication of the imaginative hold that pictorial formulas had in the seventeenth century. Porcellis's willingness to modify such schema is fully consonant with his new treatment of the natural world.

Porcellis's pictorial vocabulary permitted at once a dramatized rendering of the convulsive power of natural forces and a subtle discrimination of the distinctive properties of each. The result is a realism so convincing that the very limited number of formulas underlying the storm images of most subsequent artists has been until now largely unrecognized. This realism might also be called rhetorical realism, akin to that of the literary tempest, for each picture is

staged to engage the beholder's imaginative sympathy in a dramatic conflict whose intensity is heightened by verisimilitude. At the same time, the very coherence of the staging, of the compositional structure, expresses an essential concordance within nature itself and in man's troubled place in the world. Porcellis, in achieving this, first brought to full articulation the fundamental insight informing Bruegel's depictions of the sea.

The most important of Porcellis's followers was Simon de Vlieger, who transmitted to the next generation Porcellis's recognition of the expressive intensity that could be achieved through the closely observed description of weather and light. In the mid-to-late 1630s De Vlieger began producing his powerful shipwreck scenes (Fig. 57), in which the detailed depiction of castaways caught between raging waves and threatening cliffs may well reflect the more highly charged shipwreck scenes of the Flemish painter Bonaventura Peeters (Fig. 62).[110] The lack of signed, dated storms by either artist from the early and mid-1630s makes the actual direction of influence less than fully clear. In the 1640s this parallel development of their shipwreck scenes continued as both began amplifying the mood of paintings by crowning their cliffs with towers or ruins or other buildings characteristic of foreign cities. Figures along the shore in exotic clothing, who either observe the wreck or aid in the rescue of castaways, contribute further to the creation of an evocative atmosphere (Fig. 58; see also Fig. 79).[111]

Comparison of these artists' shipwreck scenes reveals the greater power of De Vlieger's pictures, which is due in part to his avoidance of the theatricality that characterizes Peeters's Flemish style. De Vlieger's lighting is less artificial, his rocks less bizarre, and the gestures of his castaways less operatic. This restraint is matched by a much more subtle control of the recession and atmospheric perspective that enhance our sense of the smallness of human beings in their final struggles on the rocks. Both Peeters and De Vlieger depict the complete submission of vessels to vastly superior natural forces and the vulnerability of those human beings who manage to reach shore or dare to offer assistance, but De Vlieger's simpler, more focused compositions, less busy with incident, convey the desperation of the situation with more concentrated and impressive force.

In De Vlieger's shipwreck pictures of the 1640s, we find, as in the general development of Dutch landscape, a larger proportion of the picture surface devoted to sky and a corresponding increase in height relative to breadth. The forces of the sky have become paramount actors in the drama of the storm, still further dwarfing the ships and men struggling in the breakers. While Porcellis initiated this expansion of the role of clouds, light, and weather, his picture formats, with notable exceptions, are generally long and low, emphasizing the breadth of the world, a trait shared by most land- and seascape of the 1620s and 1630s.[112] In De Vlieger's work the proportion of the image devoted to the sky changes from about the two-thirds typical of Porcellis (e.g., Fig. 1) to well over three-quarters (see Fig. 155).

De Vlieger's numerous shipwreck paintings inspired the tempest scenes of an impressive group of Dutch marine painters in the second half of the seventeenth century, including Allaert van Everdingen, Jacob van Ruisdael, Jan Theunisz.

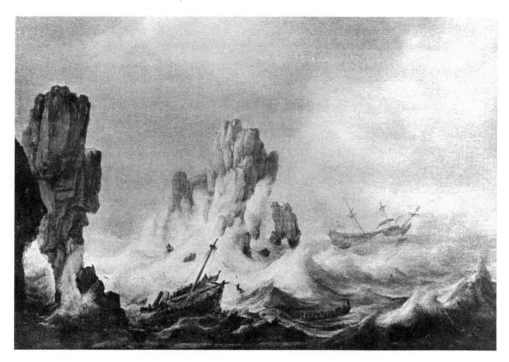

FIG. 57. SIMON DE VLIEGER. *Ships in Distress on a Rocky Shore.* Formerly Dresden, Gemäldegalerie

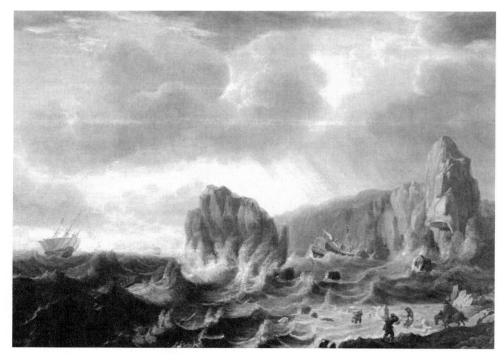

FIG. 58. SIMON DE VLIEGER. *Shipwreck on a Rocky Coast.* 1640. Greenwich, National Maritime Museum

Blankerhoff, Hendrick Dubbels, Ludolf Bakhuizen, and Willem van de Velde the Younger.[113] The dependence of these marine artists on thematic types and compositional formulas established by the 1630s is typical also of landscape painters later in the seventeenth century. Even so powerful a storm scene as Van de Velde's *"Gust of Wind"* (Fig. 2) is an expansion of a compositional scheme and pictorial vocabulary first articulated by Porcellis in his painting in Greenwich of about 1620 (Fig. 78).

Despite this typicality, Van de Velde's paintings (see Fig. 59), like those by Bakhuizen (Fig. 60), exemplify the fully developed expressive power of tempest imagery in the second half of the seventeenth century.[114] These are pictures at once meticulously accurate in detail and rich not only luministically but in coloristic effects as well, for the revival of stronger color in Dutch landscapes of the period is evident both in the ships themselves and in the pastel-hued clouds and mists surrounding the vessels. Visually compelling too are compositions arranged as though catching an ongoing struggle at a moment of crisis. These are, in sum, pictures whose compelling range of affective devices draws the

FIG. 59. WILLEM VAN DE VELDE THE YOUNGER. *Three Ships in a Gale.* 1673. London, The National Gallery

FIG. 60. LUDOLF BAKHUIZEN. *Ships Driving Aground in a Storm.* Brussels, Koninklijk Museum voor Schone Kunsten

beholder into the turmoil-filled fictional space in a way familiar from the dramatic storms of literature. And as in texts the viewer's encounter with a conventionalized range of situations and affect offer scope to equally familiar and conventionalized, though not the less meaningful, meditations on life, politics, religion, and personal emotions. It is a pictorial vocabulary whose intrinsic expressive power is evident in the fact that it needed only modest alterations to evoke sublimity when painted and viewed with another set of expectations and conventions in the eighteenth and nineteenth centuries.

Certain stylistic developments in Dutch seascape late in the seventeenth century may, in fact, foreshadow the sublime storms of the eighteenth century. Van de Velde's use of the vertical format—characteristic of the tendency to increase the height of landscape pictures during the last third of the seventeenth century—enhances our concentration on individual vessels, to which we respond almost as we would to individual figures (Figs. 2, 124). The vertical composition of images involves a resonance with our fundamental sense of the human body that is echoed by the upright axis of a ship. This format reinforces the expressive consequences of Van de Velde's revival of two other stylistic features of Vroom's generation of seascape: a focus on one or more vessels in the foreground and a return to strong local color in the ships and figures. A similar concern is discernible in storms by other painters late in the seventeenth century, notably Ludolf Bakhuizen (Fig. 60) and Aernout Smit.[115] In this concentration on the individual ships in the tempest, we very possibly see the beginning of a fundamental change in thinking about and visualizing the relation between man and stormy sea that leads to the imaginative experience of the sea as sublime and terrible. Experiencing sublimity involves, and in fact requires, an examination of and identification with internal human responses to overwhelming danger. These late seventeenth-century storm scenes seem to be among the first pictorial intimations of a turn toward this more personalized confrontation with the elements.[116]

Van de Velde and Bakhuizen carried this developing tradition of tempest imagery into the first decade of the eighteenth century, and their work fundamentally shaped the stormy seas painted by British artists during the following two hundred years. Turner's work is solidly rooted in the Dutch tradition.[117] The North Netherlandish storm types also influenced Vernet (see Fig. 68) and his numerous followers in the eighteenth century in France and England, most notably Philippe de Loutherbourg.[118] Vernet, however, significantly modified these Netherlandish sources by emphasizing a close description of powerful emotions in spectators and castaways confronted with grandiose, overwhelming natural forces and mortal peril. This interest in human emotional responses is related to the appearance in the mid-eighteenth century of a new type of storm image that focuses upon the drama occurring on the deck of a threatened ship. Such compositions stress individual figures and the variety of their feelings and actions in desperate peril, whereas seventeenth-century paintings define man's precarious place within the broad context of natural conflict and concord.[119]

These developments indicate a changing conception of the relation of man to the world that ultimately made possible the powerful tempest scenes of such diverse nineteenth-century painters as Turner, Géricault, and Winslow Homer. Transforming the theme of the storm, these artists broadened its implications in new directions and intensified in new ways its articulation of the confrontation of man and nature.

FLEMISH AND ITALIAN TEMPEST PAINTING: THEATRICAL AND VISIONARY STORMS

The naturalistic dramatization of ships and storms evolved by Porcellis was a distinctively Dutch phenomenon that contrasts sharply with the more theatrical characterization of tempests that developed in the Netherlands provinces that remained under Spanish control. There a visionary mode of rendering tempests first appears in the work of Andries van Eertvelt, a shadowy figure with few signed and dated works.[120] His earliest dated painting is an enormous storm with the wreck of a Turkish galley of 1623 (Fig. 61), though when Van Eertvelt began painting such storms, for which he became famous, is unknown.[121] This painting, like other early works (see Fig. 123), reveals a desire to heighten the beholder's response to the image by exaggerating and intensifying features of the styles of Vroom and Porcellis. Van Eertvelt's extraordinary flamelike waves are a highly mannered attenuation of wave forms in Vroom's work, and his composition reflects the same origin. Furthermore, the Turks and galley slaves who struggle against the storm are derived from Vroom's battle pictures.[122] On the other hand, the asymmetrical disposition of shafts of light and the more delicate and varied gradations within the areas of light recall Porcellis's pictures of about 1615–20, as do the less dry painting of the ships and the handling of details such as the sails. Van Eertvelt, however, with little regard for Porcellis's verisimili-

tude, elongates sterns and masts of ships to achieve sharper diagonal thrusts that enhance our sense of the vessels' responses to the elements. In his later tempest pieces he apparently eliminated the stylized waves, but he continued to paint essentially the same highly charged storm images, retaining the characteristic distortions of the ships, strong local coloring that emphasizes the struggling figures, and dramatic shafts of light that emphasize the inherently dialogic structure of the images.[123]

Van Eertvelt's seascapes, which exerted a lasting influence on marine painting in the South Netherlands, exemplify the general tendency of Flemish painting toward more overt theatricality and rhetoric, distinguishing it from the relative restraint and unidealized directness of most Dutch art. The tempests of Paul Bril, Frederick van Valckenborch, and Marten de Vos probably inspired this aspect of Van Eertvelt's work, particularly the enlarged scope of vessels and men in the compositions, which permits a more direct sympathetic identification than in most Dutch storm paintings of the 1620s. The diagonal thrust of vessels into the lower corners of some pictures suggests, moreover, an imminent bursting of the frame analogous to outward thrusts in Flemish history paintings such as Rubens's *Raising of the Cross*, now in the Cathedral of Antwerp.

In the South Netherlands, pictures affected by the more histrionic elements of Van Eertvelt's conception of the tempest nonetheless remain generally attached to observable reality and to the naturalistic mode evolved by Porcellis. The storm pieces of Bonaventura Peeters and his younger brother and pupil, Jan, exemplify this tendency, for although their storm scenes derive from Eertvelt's tempests, the theatrical element in their pictures is always restrained by the Dutch tradition of realism.

Bonaventura began producing his storms in the 1630s, using, like Van Eertvelt, high-keyed color effects and bursts of light breaking through thickly layered clouds to activate his compositions (Fig. 62; see also Figs. 72, 74).[124] Like Van Eertvelt also, he enhances the drama of his tempests by prominently featuring figural elements such as vessels struggling in the waves or dragging on shoals and crewmen striving frantically to save themselves while tossed among the rocks. This evocative mood is elaborated in rocks piled into distinctive, bizarre thrusting shapes, sometimes forming natural arches. These undercut, jagged forms standing against the battering of the elements suggest the endurance of the land in its conflict with the sea.

This Flemish mode of depicting tempests played an important role in marine painting in Italy, where Van Eertvelt himself traveled, as did two of his pupils, Kaspar van Eyck and Matthys van Plattenberg, called Platte-montagne (see Fig. 115).[125] A parallel Italian tradition of tempest imagery also emerged simultaneously to that in the Netherlands during the first three decades of the seventeenth century, though in Italy the theme never attained the popularity it acquired in the North and was not as frequently depicted. The few surviving Italian storm pictures from the first third of the century are strikingly similar to Flemish tempest scenes, sharing a notable concern for intensifying the violence of elemental discord, a willingness to disregard naturalism in deference to highly dramatized expressive effects, and an emphasis on figural elements in the foreground in the interest of a more immediate engagement of the viewer with

FIG. 61. ANDRIES VAN EERTVELT. *Storm with the Wreck of a Turkish Galley.* 1623. Ghent, Museum van Schone Kunsten

FIG. 62. BONAVENTURA PEETERS. *Ships Wrecking on a Rocky Coast.* Paris art market, 1962

the scene. The similarity between these traditions reflects the ultimate origin of these styles in the work of the expatriate Flemish artist Paul Bril in Rome, though Italian painters were very possibly aware of the storm scenes of Hendrick Vroom as well.[126] Like Van Eertvelt, Italian marine artists diverged from their Dutch counterparts in turning not to naturalism as a primary means of affectively engaging the beholder, but to expressive exaggerations of ship structures and to highly dramatized chiaroscuro contrasts.

The role of progenitor of the Italian tradition has customarily—and probably correctly—been assigned to Agostino Tassi, a specialist in both quadratura frescoes and landscape.[127] Although Tassi's earliest documented marine frescoes (as early as 1602) and storm scenes (1613–15) are lost, surviving marine frescoes dating from between 1613 and 1628 clearly reveal the origins of his seascape style in the work of Paul Bril and Adam Elsheimer, from whom he derived both his compositional structure and numerous details in his handling of figures, landscapes, and ships.[128] Bril's treatment of vessels, in particular, served as a model for Tassi, whose work shows a consistent preference for views of ships sharply foreshortened from bow or stern (Fig. 63). Seen at such angles, the tall, repeated lines of masts and crisscrossing yards are most decoratively intricate. Equally striking in these early fair-weather marines is Tassi's willingness to modify elements as he elongates masts and spars and exaggerates the upward sweep of sterns and the swelling curvature of hulls and sails.

Though none of Tassi's early storm scenes survives, a canvas attributed to Filippo Napoletano and datable around 1618–21 (Fig. 64) surely reflects their

FIG. 63. AGOSTINO TASSI. *Shipwreck.* 1635. Rome, Palazzo Doria Pamphilij

influence.[129] Such pictures by Tassi and Filippo Napoletano are direct models for the chiaroscuro effects and expressive linearity of Claude Lorrain's depictions of storms, an uncharacteristic subject for him (Fig. 65).[130] Surviving storm scenes by Tassi himself date from the mid-1630s. In them his characteristic elongation of ship forms and magnified swirls and bellying of sails are still more pronounced and accompanied by a much looser application of paint and a more sweeping treatment of waves and sky (Fig. 63).[131] Flickering contrasts of light and shadow add to the visionary quality of these images, in which small figures struggle amid the slashing and twisting forms of masts and sails and the surging flux of waves and clouds. The ships seem to turn into writhing participants in the chaos that surrounds frail humanity.

In these images Tassi intensifies the conflict between vessels and nature by the prominence he gives figures. Close to the viewer, shattered or struggling vessels loom large in the pictorial field and, along with castaways or figures scavenging flotsam and jetsam, often fill as much as a third of the foreground plane. Sometimes a row of figures forms a screen across the foreground on a spit

Fig. 64. Filippo Napoletano. *Ships in a Tempest.* Villa del Poggio Imperiale

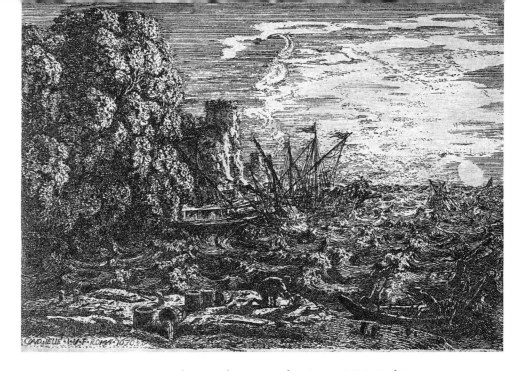

FIG. 65. Claude Lorrain. *Shipwreck on a Rocky Coast.* 1630. Etching

of land, a distinctive feature of the Italian tradition originating with Bril. Compared with Dutch storm scenes, Italian versions of this theme, like their Flemish counterparts, give relatively greater weight to figural drama, enhancing the impact of man's emotional and physical response to the storm and complementing the greater theatricality evident in the rendering of the natural world.

The theatrical approach continued to dominate Italian depictions of this subject during the second half of the seventeenth century, and it is then that the influence of the Netherlandish style becomes clearer. Pieter Mulier the Younger, the son of a Dutch marine painter and known in Italy as the Cavaliere Tempesta, combined both traditions in his prolific output. The storms of Eertvelt, Plattenberg, and Bonaventura and Jan Peeters supply the basic compositions, ship types, and use of flickering chiaroscuro and strong color contrasts, while the treatment of figures and coastlines derives from the Italian tradition (see Fig. 118).[132] Also of great importance to Tempesta was the work of Salvator Rosa. Although Rosa himself painted no tempest scenes, his dynamic rendering of nature in landscapes and coastal views deeply influenced Tempesta's conception of the storm as a pervasive force surging through the entire fabric of nature, intertwining vessels with the violence of the elements.[133] The dramatic vision of the sea articulated by Tempesta culminates, on the one hand, in the fantastic tempest scenes of Alessandro Magnasco and Marco Ricci, and their boldly painted, vibrating, at times almost spectral, pictorial worlds (Figs. 66, 67).[134] On the other hand, Tempesta also influenced a distinctly different later development of storm imagery in Italy and France in the tempests of Adrien Manglard in the first half of the eighteenth century and of Claude-Joseph Vernet from the late 1730s onward (Fig. 68).[135] Both French artists were interested less in the visionary potential of Tempesta's style than in his choice and manner of composing

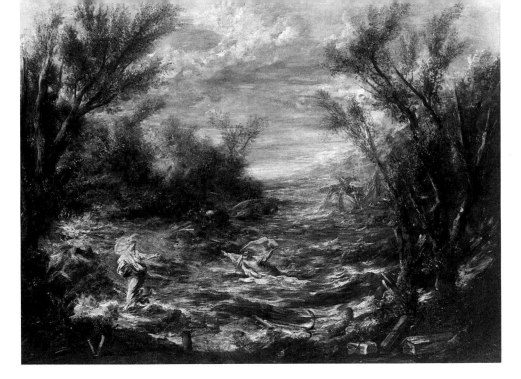

FIG. 66. ALESSANDRO MAGNASCO. *Christ at the Sea of Galilee.* Washington, D.C., National Gallery of Art, Samuel H. Kress Collection, 1943

FIG. 67. MARCO RICCI. *Tempest with Shipwreck.* Bassano, Museo Civico

grandiose natural effects. In this he provided a model for depicting in marine painting the wildness and sublimity that the eighteenth century prized in Salvator Rosa's landscapes and for which Vernet, in his seascapes, was so highly celebrated.

The visionary mode of Flemish and Italian storm imagery resembles the naturalistic Dutch mode in this adaptability to the new task of representing the sublimity that the eighteenth and nineteenth century regarded as inherent in the stormy sea. Despite the divergence of their expressive means, both modes aim at a visually vivid and emotionally compelling depiction of human action and natural violence, such that man's fate hangs in question amid elemental turmoil. In both modes this dramatized rendering corresponds to the verbal representation of storms in its vocabulary of thematic and formal polarities, in the evocation of human struggle, anguish, death, and salvation, and in the underlying order implicit in these coherent compositions. The pictures of both traditions can thus be read by analogy to the storms of literary representation, for while not dependent on texts, the images reveal the basic habits of thought and the conception of life and the world that underlie the written accounts. "Reading" the pictures is, moreover, the appropriate metaphor for beholding these works, in part because their rhetorical style of presentation encourages a process of close, empathic involvement in the fictive events they represent. But such a reading of images was also virtually normative in the seventeenth century because of the commonplace doctrine of the kinship of painting and poetry. The dramatic pictorial language of storm scenes thus functions within wider cultural contexts, and it is to these contexts that we must look for guidance in comprehending the ways such images acted as bearers of meaning for contemporary beholders.

FIG. 68. CLAUDE-JOSEPH VERNET. *A Storm with Shipwreck.* 1754. London, The Wallace Collection

4

Paintings and Interpretive Contexts: Pictorial Realism and the Realities of History

In tracing the development of tempest painting, we have seen the evolution of seventeenth-century images that reveal fundamental affinities with the more ancient literary tradition. Like storms in texts, these pictures exploit a vivid naturalism for the rhetorical purpose of engaging observers psychologically in a dramatically charged and coherent fictive world. In literature this rhetorical naturalism is entirely compatible with a metaphorical habit of mind that found in the sea and tempest divinely intended signs of the nature of the world and man's place within it. The existence in literary tempests of such metaphorical elements in comfortable association with verisimilitude must cause us to wonder to what extent pictures of storm are likewise informed by the metaphorical thinking implicit in the cosmology of Renaissance Europe.

The following chapters address this issue, seeking to discover what values and associations the engaged seventeenth-century viewer brought to images of storms at sea and what meanings and insights he found in them. To do so we will place these images within cultural and historical contexts that offer insight not only into the knowledge and concerns of contemporary viewers, but into the ways seventeenth-century beholders brought such concerns to bear on visual imagery as well. For this interpretive enterprise we will turn our attention from the evolution of the literary and pictorial traditions to focus on Dutch stormscapes from the 1590s and after—pictures by such artists as Hendrick Vroom, Jan Porcellis, Simon de Vlieger, Willem van de Velde the Younger, Jacob van Ruisdael, and Ludolf Bakhuizen—in which the visual language of the seventeenth-century Dutch tempest scene is most fully formed and articulate.

PICTURES OF STORM AND HISTORY:
IDENTIFYING THE PROTAGONISTS

To grasp the meaning of images of the sea and tempest for seventeenth-century Dutchmen requires an appreciation of the historical and cultural situation of the Netherlands at the time when the subject of the storm and the naturalism with which it was rendered gained such popularity. Placing these images in their historical context, however, immediately raises questions that require us to define their naturalism more precisely. Measuring these images against the actual events of seventeenth-century Dutch history and seafaring, we recognize how limited the reality is that they depict. In fact, despite their convincing mimetic accuracy, seventeenth-century storm paintings do not usually illustrate known ships in actual circumstances. Precision in portraying vessels often extends to defining their nationalities and a clear rendering of naval architecture, but more specific details that would identify a specific, historically identifiable ship are usually omitted. The nationality of a vessel is most easily ascertained from flags. It can also be deduced, however, from structural features and, with greater difficulty, from details of rigging.[1] Usually the nationality of ships is the artist's own, though this seems to have depended primarily on the painter's market. Van de Velde the Younger, for example, seems to have depicted primarily Dutch vessels in storms until he moved to England; thereafter his ships are mainly English.[2] A significant result of this practice is that by and large these images of storm and shipwreck show not one's enemies in danger but one's own countrymen, so that the ships even more strongly invite empathic identification. The ships themselves are usually accurately rendered, contemporary bottoms, their degree of precision reflecting the skill, expertise, and personal experience of the painter. Thus the vessels of Porcellis and the Van de Veldes are extremely accurate; those of less specialized painters like Jacob van Ruisdael or less gifted artists like Jacob Adriaensz. Bellevois possess varying degrees of plausibility.[3]

Although such indications of nationality and a general conformity to characteristics of seventeenth-century shipping are typical, the vessels in these images can only rarely be identified with real ships. Sometimes the name of a ship can be learned from the decoration of the tafferel or stern board, as in the case of Beerstraten's *Wreck of "De Zon"* (Fig. 69).[4] Even then her name, though readily deduced from her carefully displayed tafferel, is of little help in identifying the ship precisely since De Zon was among the most common names for Dutch shipping.[5] Similarly, a number of paintings depict bottoms bearing the arms of Amsterdam (see Figs. 7, 58), but *Amsterdam* or *Wapen van Amsterdam* were names frequently given vessels and thus of limited use in relating paintings to specific events.[6]

A small number of tempest paintings can be linked to historical circumstances with greater confidence. M. S. Robinson, for example, has suggested that several works by Van de Velde the Younger depict real events. Robinson thinks it possible that *The English Ship "Resolution" in a Gale* (Fig. 70) may represent an incident of 14 December 1669 described in the journal of Sir Thomas Allin,

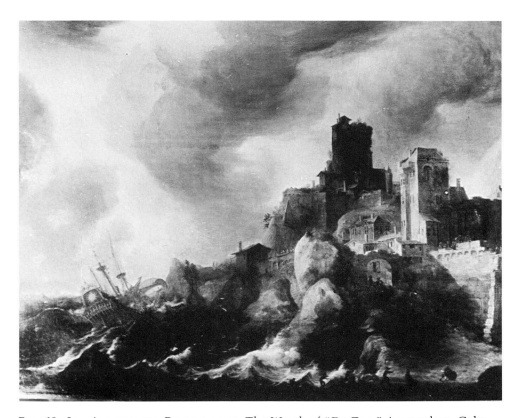

Fig. 69. Jan Abrahamsz. Beerstraten. *The Wreck of "De Zon."* Amsterdam, Gebr. Douwes, 1927

Fig. 70. Willem van de Velde the Younger. *The English Ship "Resolution" in a Gale.* Greenwich, National Maritime Museum

the English commander-in-chief in the Mediterranean.[7] He also relates a *Gale with Ships Wrecked on a Rocky Coast* to an actual disaster that occurred in December 1653, when a Dutch squadron that included the *Jupiter* (visible in the painting at left) was wrecked with its English prizes in a storm in the Gulf of Lions.[8] Both images would presumably have been commissioned to record these events. Other candidates for this class of historically specific images are pictures like Beerstraten's painting of ships with prominently displayed tafferel decorations, though none has been successfully identified. Hendrick Dubbels's *Wreck of the "De Liefde"* (Fig. 83), recognizable by the figure of Caritas on her tafferel, may depict another specific incident. The inscription at lower left, however, does not offer any clue to the exact circumstances.[9]

What is perhaps most striking about this group of pictures, aside from its smallness, is that the paintings are very nearly indistinguishable from those with no identifying attributes at all. In these images historical reality is depicted entirely within the conventions of the genre, the unique situation visualized in terms of generalized experience. This approach to history conforms to the representation of real historical events through typology and allegory that H. van de Waal discovered in contemporary Dutch history painting.[10] It reflects a habit of mind that searches out significance not in terms of historical specificity but in patterns of correspondences between the present and archetypal situations, a way of thinking that also underlies the symbolic reading of images.

This paucity of historical illustration in the surviving paintings is especially impressive when one considers the large number of wrecks that are described in the contemporary literature of exploration and travel and the dangers experienced daily on the stormy North Sea and among the treacherous shallows of Netherlands waters.[11] Even localized disasters brought on by storms, such as dike breaks and floods, are infrequently represented. The calm land- and seascapes painted by many of the same Dutch and Flemish painters who produced storm pictures show the same avoidance of historical fact. Though a well-known building may sometimes be more or less precisely rendered, these images of marvelous fidelity to the ordinary weather, light, and surroundings of Dutch coasts, harbors, and inland waters are only occasionally topographically exact views.

Calm seascapes, however, reveal a strong attachment to the Netherlands countryside completely unlike the exotic rocky coastlines typical of shipwreck scenes. In storm pictures it is clear that the settings, however convincing, were far from accurate accounts of contemporary reality. In them disaster hardly ever occurs in local waters off a typical Dutch beach (Fig. 1). Instead, ships sink and men die on ironbound coasts that would have been immediately identified by a Dutchman as foreign. So rare in painting is the sinking of a ship on a broad, flat Dutch beach with dunes that these few paintings can be seen as a variant type that never achieved widespread acceptance.

The rocky shores in shipwreck scenes are sometimes inhabited, particularly in those produced from the early 1640s onward. The setting is frequently the Mediterranean, as indicated by architecture and by the costumes of figures. The presence of a friar ministering to a castaway in De Vlieger's *Shipwreck with Castaways* in the Bader Collection, Milwaukee (Fig. 71), suggests a Mediterra-

FIG. 71. SIMON DE VLIEGER. *Shipwreck on a Rocky Shore.* Milwaukee, Alfred Bader
Collection

nean locale—though this and other paintings could also represent the northern
coast of Spain or Portugal. More distinctly Mediterranean is the city with an
obelisk in De Vlieger's *Shipwreck* in the Czernin Collection (Fig. 79). Similar
cities with partly ruinous stone walls, arched gates, round towers, large circular
structures, and a dense mass of buildings with tile roofs provide a southern
setting in numerous tempest paintings (Fig. 69). In others (Fig. 135, for example)
isolated mountains or ridges silhouetted on the horizon and harbor cities placed
in the middle distance suggest the topography of the Inland Sea.[12] Stone towers
on promontories (Fig. 72) are another distinctly Mediterranean feature, built to
provide safety for ships and local populations from pirate and corsair raids and
from Turkish attacks, particularly in Italy during the sixteenth century.[13] Occa-
sionally a painter gives one of these images a Levantine flavor by depicting
turbaned spectators on shore (Fig. 72), and Turkish galleys also appear in a
number of paintings (Figs. 5, 6). The galley itself is usually a sure sign of a
Mediterranean locale, since it was totally unsuited to the rough seas and change-
able weather of the Atlantic Ocean and North Sea.[14]

The choice of Mediterranean settings has partly to do with what Fernand
Braudel refers to as the Dutch "conquest" of Mediterranean trade in the late
sixteenth and early seventeenth centuries.[15] But the role of these locales is not
to report a current event but to create a plausible contemporary, yet remote,
setting for a disaster. This intent is evident from the vague locations of these
southern cities, which are rarely identifiable even as to country. In this regard
shipwreck images closely resemble most of the Mediterranean harbor scenes
that also became popular in the 1640s (Fig. 73). In these port views, ruins, round
arches, domed buildings, and details of costume likewise evoke Dutch shipping
in the exotic Southern and Eastern world, with little concern for topographical
accuracy.[16] These associations are conveyed by similar means in other contem-
porary images, such as Rembrandt's history paintings and etchings.

Many shipwreck scenes, however, are far removed from this romantic aura of
ancient civilizations and exotic peoples and customs, depicting instead wild

Fig. 72. Bonaventura Peeters. *Ships in Distress off a Mountainous Coast.*
Greenwich, National Maritime Museum

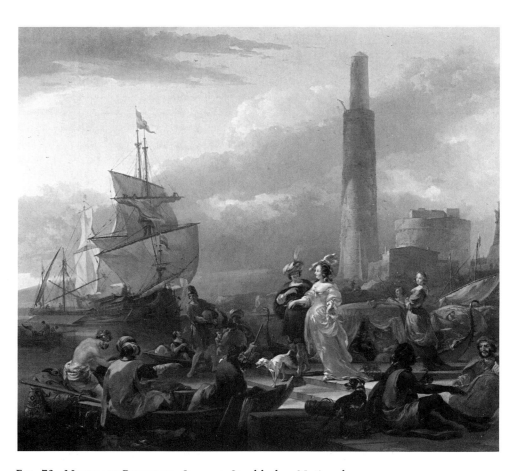

Fig. 73. Nicolaes Berchem. *Seaport.* Stockholm, Nationalmuseum

FIG. 74. BONAVENTURA PEETERS. *Shipwreck on a Northern Coast.* Dieppe, Musée Municipal

FIG. 75. SIMON DE VLIEGER. *A Threatening Shore.* Sale, Zürich, Koller, 1976

ragged shores of utterly barren rock or cliffs to which a few vines and stunted shrubs and trees cling, places remote from human aid. Most of these wild shores are deserted, but in a few paintings additional perils for the survivors are fore-shadowed by aborigines dressed in skins and feathers and carrying bows and arrows (Fig. 5). These figures are almost surely American Indians, whose reputa-tion for cannibalism, deriving from the earliest reports of the New World, re-

mained a popular conception well into the seventeenth century.[17] Wild beasts, notably lions and bears, occasionally inhabit the rocks too, reflecting another persistent fear in the accounts of the voyagers, as the human skeletons among the rocks in Bonaventura Peeters's *Shipwreck on a Northern Coast* (Fig. 74) witness.[18]

As in generalized Mediterranean settings, the exact locations of these desolate shores are uncertain. In some paintings, blasted pine trees suggest the Scandinavian or Baltic coasts, also important sources of Dutch trade in wood, metal, and grain.[19] This must be the location implied by the rocks in Peeters's scene (Fig. 74). In a few other paintings, as we have noted, natives suggest the Americas, but most shipwreck scenes contain no such localizing details. The unlikely combination of a Dutch ship, a Turkish galley, and natives dressed in skins in Jan Peeters's painting in Vienna (Fig. 5) exemplifies the lack of concern for geographical precision in these images. Such details of setting, unlike De Bry's illustrations or Albert Eckhout's paintings of Brazilian Indians,[20] do not function as ethnographic or historical reports of actual events, peoples, and places, though they are rooted in the popular awareness of voyaging. Rather, these figures have an affective purpose, signaling the place of disaster and mortal peril—and also of possible salvation—to be remote, unfamiliar, and, if inhabited at all, peopled by men with foreign and perhaps barbarian ways. In the situation of ultimate vulnerability depicted in these images, men are thrown on the mercy of the unknown.

The strange undercut rock formations with natural arches seen in many of these pictures (Fig. 75)[21] also do not illustrate particular coasts but serve rather to reinforce our perception of human weakness in the midst of elemental discord. Although bizarre rocks and cliffs exist in many places where the Dutch traded and explored (at Etretat near Le Havre, for instance, or on the coasts of Devon and Cornwall), no attributes appear in the paintings to identify them more specifically. The rocks seem to derive, in fact, not from topographical sketches but from formulas for rocky outcroppings and cliffs found in both the Northern and Italian landscape traditions. Their affective rather than topographical role is most evident in pictures where they acquire a potent, expressive presence, dominating the foreground and turning into towering masses topped by beacons, exaggerated in their size and isolation (Fig. 75). These and more naturalistic rocks convey through their angular, riven forms the erosive powers of their elemental antagonists, water and air. At the same time their firm stand against the crashing waves is an implacable resistance to the sea that becomes a terrible menace to the ships and men hurled against them. A sandy beach in a storm would prove as ruinous for a vessel as these rocks, and a hidden reef or sandbar is conceivably more frightening, but as visual experiences neither would be nearly so suggestive and manifestly threatening. Wild beasts seem superfluous to convey the deadliness of these shores.

For all the impressive precision of these pictures, whether in the delineation of a ship, a remote harbor or rocky coast, or the most subtle aspects of weather, their realism is selective and dramatized. The pictorial components are chosen not to render historical fact and topographical information but to evoke the beholder's empathy with the life-and-death struggles of men caught in the midst of universal antipathies in the remote places of the earth.

PICTURES OF STORM AND HISTORY: CULTURAL ROOTS OF REALISTIC SEASCAPE

To recognize that Dutch stormscapes are not records of historical events is not to cast them adrift from their historical context. Indeed, the origins of some of the most striking features of this art lie in a variety of interacting factors affecting Dutch social and economic life during the period between 1590 and 1620. The quite sudden appearance of the storm as an independent subject in the 1590s, the rapid evolution of naturalism in depicting the storm, and the sustained popularity of the subject are only explicable in terms of those developments in history and culture that together encouraged the appearance of seascape as a genre and the renewal of the Netherlandish tradition of realism.

The close relation between the rise of seascape painting and the tremendous growth of Dutch naval and merchant activity has long been apparent. The connection was first observed by Van Mander in his biography of Hendrick Vroom, where he comments: "En t'volck, ghelijck in Hollandt veel Zee-vaert is, begon oock groot bevallen in deze Scheepken te crijghen" ("And people began to take great pleasure in these ship pieces, since in Holland there is much seafaring").[22] The very period when marine painting developed saw the spectacular increase in Dutch commercial and naval power and the emergence of a national awareness and self-confidence closely linked to seafaring. Early marine paintings are in many cases public monuments to the prosperity and victory resulting from the policies of the ruling classes,[23] and the five admiralty boards, the town governments, the States General, and the Dutch East India Company were all early patrons of seascapes. The images of naval battles, arrivals of foreign dignitaries, views of bustling harbors, and pictures of Dutch ships in far-off places that these official bodies commissioned were closely tied to their members' civic and personal pride and ambitions.

A popular awareness of the importance of seafaring was also fostered by the appearance in the same years of the accounts of the Dutch voyagers that, as noted above, began with Jan Huygen van Linschoten's *Itinerario* in 1596.[24] The widespread knowledge of the perils of this nautical activity that this popular literature made possible must have contributed to the appearance and demand for paintings of Dutch ships tossed in raging seas and wrecking on wild coasts.

Yet Dutch naval and merchant exploits and their popular commemoration would not necessarily of themselves have produced a tradition of seascape painting. The Portuguese, for example, had a long, vigorous history of seafaring and discovery and possessed a vast commercial empire that reached across the Indian Ocean. Yet no tradition of Portuguese marine painting resulted. Even the existence of a popular Portuguese literature of shipwreck in the late sixteenth and early seventeenth centuries did not stimulate a pictorial response.[25] The rise of seascape in the seventeenth-century Netherlands also depended on a distinctive Netherlandish tradition of realistically rendering the sea and human activities connected with it—a tradition extending back, as we have seen, beyond Bruegel to Franco-Flemish manuscript illumination in the fifteenth century.

It is possible that an important factor in these years both in a renewed interest in this realistic tradition and in the development of seascape and storm imagery in the Netherlands was the positive value placed on landscape and the depiction of weather phenomena in the art theory of Karel van Mander. In his *Grondt der edel vry schilder-const,* published in 1604 — just at the time we have seen important experiments in sea-storm painting being initiated—Van Mander devotes an unprecedented entire chapter to landscape and includes an exhortation to paint all types of weather, with two stanzas devoted to storms.[26] Van Mander does not discuss marine painting per se, and indeed he apparently does not conceive of landscape without narrative figures as a self-sufficient genre. Nonetheless, his chapter on landscape probably fostered interest in this subject, and so stimulated the burgeoning contemporary development of a realistic landscape style. By the same token his recommendation of the storm as a subject to be studied from nature itself may well have served as an encouragement to, and justification for, a naturalistic rendering of sea and storm by Netherlands artists. Van Mander's favorable attitude toward such themes probably led him to support the efforts in seascape of his fellow citizen of Haarlem, Hendrick Cornelisz. Vroom. We know that he was instrumental in Vroom's securing an important commission early in his career, and the length of Van Mander's biography of Vroom in his *Schilder-Boeck* suggests that the author saw Vroom's marine art as one of the highlights of painting in Haarlem.[27]

In addition to the encouragement of Van Mander, the development of marine painting in the early 1600s was aided by a general impulse toward realism apparent in Northern art of the late sixteenth and early seventeenth centuries, despite the continued dominance of the late Mannerist style.[28] Indeed, elements of both styles often coexist in the same painting, and the minute accuracy of Vroom's ships within an artificial, stylized setting can be compared to landscapes by Gillis van Coninxloo or Jan Brueghel in which a realistically rendered tree or house is located within a schematic mannerist composition. Similarly, between 1595 and 1610 the virtuoso mannerist artists Hendrick Goltzius and Jacques de Gheyn the Younger produced drawings and prints that looked forward to the development of the realism that was to characterize Dutch landscape, genre, and still life of the 1610s and 1620s. Related to this is a renewed interest in the work of Pieter Bruegel the Elder. And Jan Brueghel's storm paintings are one manifestation of what was virtually a Bruegel revival at this time. The development of marine painting around 1610 is thus one aspect of a wider interest among Netherlandish artists in recording aspects of the world around them that results in the realism of Dutch land- and seascape. A seascape painter, Jan Porcellis, led the way in the 1620s in developing the monochrome landscape style that depended upon close, direct observation of the land and waters of the Low Countries.

Like the appearance of seascape as an independent theme, the emergence of this realism in Dutch painting issues from artists' responses to complex political and cultural developments in the Netherlands, and more broadly throughout Europe, in the decades from 1590 to 1620.[29] It is clear that the political and economic ascendancy of middle-class town oligarchies in Holland and Zeeland, the most important of the United Provinces, and the absence of church commis-

sions significantly changed both the patterns of patronage and the selection of artistic subject matter during these decades. Moreover, the military and economic successes of the new Republic and of its newly powerful rulers were fundamental to a buoyant, confident optimism in the early seventeenth-century Netherlands. This optimism seems to underlie a striking willingness at that time to experiment with new subjects, especially those drawn from ordinary life. Roemer Visscher's emblems based on familiar objects in the world,[30] Bredero's comic stage rendering of the vigorous life and often crude dialect and slang of town and country,[31] and Willem Buytewech's illustration of the element water by fisherfolk on a beach[32] are all related to the basic desire to address the immediate observable world that informs the new style of land- and seascape. The new national feeling may well also have contributed to this development, since a realistic art was regarded by many art theorists, especially Italians, as a distinctively Netherlandish characteristic, and some Dutch literary figures seem to have had strong convictions against the idealization and allegory of classical literature.[33]

Realism in Dutch art, including a growing attention to such natural phenomena as weather, is possibly linked also to an emergent strain of thought in the late sixteenth and early seventeenth centuries that found scientific explanations based on direct observation and rational, cause-and-effect descriptions more satisfying than metaphysical and ontological exegeses.[34] While no direct influence of the new science on a specific Dutch landscape painter of the early seventeenth century is known, the broad changes in values and in habits of thought that science presupposes may well have contributed to the ascendance of realism, if only as one of a number of contributing factors to alter men's way of looking at their world.

While the exact role of any one of these factors cannot be measured, the purpose of the realism seen in Dutch tempest pictures is not the neutral recording of phenomena analogous to scientific observation but the arousal of empathy analogous to the uses of realism in rhetoric. This use of realism requires considering the role of literature in shaping a seventeenth-century viewer's responses to these images and in guiding our interpretive efforts.

5
Paintings and Interpretive Contexts: Literature and Art

T he literary tradition surveyed in Chapter 2 makes it clear that a seventeenth-century viewer of tempest pictures brought to such images a vast body of classical and biblical associations, metaphorical connotations, and assumptions about the role of the storm within the very structure of the cosmos and the experience of daily life. Our use of this literary culture for interpreting seventeenth-century stormscapes depends, however, on our ability to determine how these images communicated to a contemporary beholder. For guidance we turn again to the literary tradition, considering now landscape in the theory of art, *ekphrasis* and rhetorical description, and the emblematic tradition. All are aspects of the contemporary verbal culture that can teach us not only what ideas were associated with storms and what rhetorical means were available to express them, but the principles and framework within which beholders discovered such ideas and metaphors in images.

LAND- AND SEASCAPE IN THE THEORY OF ART

The accurate and compelling rendering of nature that we find in tempest paintings accords with the fundamental conception of landscape in the Renaissance literature of art. In such texts landscape is described and praised primarily in

terms of this mimetic accuracy and affective power, for, as even Michelangelo granted, landscape can gladden you with all its multitude of details.[1] Precisely because of this pleasure in simple imitation as opposed to the ideal imitation found in history painting, theorists of art joined Michelangelo in according landscape a low place in the hierarchy of genres. Such theorists seemingly offer an appropriate literary source for insight into the content of landscapes, and of storm scenes in particular. Yet we find their usefulness is limited by a theory of subject matter that makes them indifferent to some of the most compelling aspects of Dutch land- and seascape paintings.

The storm and shipwreck do, however, have a role in the sixteenth- and seventeenth-century literature of art, in which they are recurrently cited as examples of the superior imitative power of painting, a conception rooted in the classical doctrine of the mimetic character of both the visual arts and poetry.[2] From the early sixteenth century, Italian theorists, writing *paragoni* of painting with other arts, mention the depiction of storms and marine subject matter among themes evincing the superior imitative powers of painting. Already in 1509 Francesco Lancilotti cites storms among celestial and meteorological phenomena that the artist should paint:

> Prima a pictar nel cel Giove, el tonante,
> La luna, el sol, le stelle, i dei e raggi
> Lucidi, che'escon dalle luce sante: . . .
> L'acqua di poi dove si riconoschi
> Pesci, nave, galee, grippi e liuti
> Con procelle e tempeste a'tempi foschi.[3]

This is basically the same list Vasari cites in a letter to Benedetto Varchi in 1548.[4] Sometimes Pliny's statement that Apelles "painted the unpaintable, thunder, lightning, and thunderbolts" was cited as support in this argument, which puts painting in competition especially with poetry.[5] Painting thus becomes capable of imitating the full range of weather phenomena, incidents, and emotions recounted in literature, as we see in Cristoforo Sorte's extended directions for painting a storm at sea in his *Osservazioni nella pittura* of 1580, which are clearly as much inspired by literary tempests as by his experience of Venetian painting.[6] Similarly, Gian Paolo Lomazzo, devoting an entire chapter to shipwrecks in his treatise on painting of 1584, writes a prescriptive *ekphrasis* that imitates and elaborates on passages in Ariosto's *Orlando Furioso*.[7]

Karel van Mander stands fully within this theoretical tradition when he recommends in his *Grondt der edel vry schilder-const* that painters imitate the phenomena of weather as Apelles had:

> Yet weather with high winds as when the sea and flowing streams are stirred up, is here excepted [from the rendering of reflections of clouds and sun in water as described in the previous stanza]. Now it astonishes me sometimes to think how Apelles' colors lightninged and thundered though they were so few, while we now have many more and purer [besides], more suited to depicting such uncommon things. Why then does the desire to imitate not stir us?[8]

The marginal note to this stanza reads:

> Apelles painted with just four colors as Pliny says, and he depicted lightning, thunder, and other such things; we who have so many colors must also desire to imitate nature in all things.

The text continues:

> Let then raging moist waves, whipped up by Aeolus' orders, imitate black thundery skies, monstrously ugly; and let crooked lightning bolts come flashing through the dark air of the tempestuous storm from the hand of the highest of the gods, so that all mortal, soul-bearing beings seem to be afraid of such a governing.

Van Mander's insistence on the importance of the imitation of nature, his description of the storm, and his assertion of its power to elicit the emotional response of all "mortal, soul-bearing beings" reflect a common concern of literary pictorialism. The author strives to achieve a heightened verbal rendering of the world that will vie with that of a picture, though here an imagined picture that he urges the artist to paint.[9]

Van Mander is, moreover, strongly influenced by literary models, notably the account of the autumnal storm in Virgil's first *Georgic:*

> The Father himself, in the midnight of storm-clouds, wields his bolts with flashing hand. At that shock shivers the mighty Earth; far flee the beasts and o'er all the world crouching terror lays low men's hearts. . . .[10]

Van Mander very likely encouraged Hendrick Vroom's early depictions of seascape painted at about the time Van Mander wrote these lines, but his words reveal little direct response to actual stormscapes by Vroom (Figs. 53, 54). The absence of a vessel in Van Mander's account in particular deviates from artistic practice.

Aside from the value ascribed to a mimetic accuracy and narrative energy capable of rivaling literature, the theory of art in the Netherlands, as elsewhere, reveals little about the content of tempest scenes. Nor does it deal with the connotations, values, and ideas that lie behind the most typical Dutch landscape subjects.[11] Moreover, as classicizing theory became increasingly rigid in the second half of the seventeenth century, even less value was placed on subjects that we consider to be among the most original contributions of Dutch art.

The writings of Samuel van Hoogstraeten exemplify this development. In a text published in 1678 he placed all seascape in the second of three levels of excellence along with landscapes of all kinds, night pieces, peasant and village scenes, architectural views, and what we would call genre painting.[12] Because these subjects are not on the highest level of art, he devotes little attention to the characteristics of actual paintings. In discussing marine painting, he goes so far as to recommend subjects from ancient Greek and Roman history and even from the ancient history of the northern peoples rather than the scenes typical of Dutch seascape.[13] His lack of enthusiasm for the immediate realism of Dutch

tempest scenes is evident:

> But if, replete with pleasures, you desire to see the furious sea from a safe shore, let the waves roll deeply and a dark cloud threaten the ships. Protogenes they say was a sea and ship painter until his fiftieth year; but let us remain on shore.[14]

In another passage discussing the representation of the seasons and different types of weather, he praises great storm scenes of the past—significantly, they are mostly histories such as *La Burrasca*[15]—and adds a poem on storms that begins on a favorable note:

> If you desire to depict a storm wind, bend the trees and let the branches play; let it rain; let the lightning strike boldly, and the mastless ship sink.

But the following lines make it clear that this is not really the best subject matter for art:

> That great misfortune [shipwreck] will harm no one. But I would rather see wanton nymphs bathe on a summer day in a crystal spring, and a beautiful palace glittering in the sun, the white clouds spread in the beautiful azure, and fine people enjoying themselves in a meadow. Because everything that pleases the eye in nature is also all that suits a painting best.[16]

In Gérard de Lairesse's *Groot Schilderboeck* of 1707 we find the classicizing taste for corrected nature in its extreme: wild nature in any form, including storms, is incomplete and deformed, unworthy of the learned artist.[17]

The positive value given in this theoretical tradition to depictions of the sea that capture the rhetorical energy and affective power of literary storms provided a favorable environment for the development of dramatized tempest imagery, as Lisa Vergara plausibly surmises in the case of Rubens.[18] Beyond this, however, the lack of congruence between the values of aesthetic theory and the work of numerous highly talented artists working in "low" genres limits the usefulness of the literature of art in interpreting Dutch land- and seascape.

READING PAINTINGS: *EKPHRASIS* AND INTERPRETATION

A more useful approach to analyzing the rhetorical character of tempest paintings and the ideas, values, and emotions they express involves a process of engaged, participatory "reading" of these images. Such a reading requires an imaginative entrance into their every detail, from the narrative struggles of men and vessels and the characterization of nature to the formal structure of the work. This method has been successfully used in analyzing seventeenth-century landscapes in two recent studies, those of R. H. Fuchs on Jacob van Ruisdael and Lisa Vergara on Rubens.[19]

Through a close examination of Ruisdael's *Wheatfield* (Fig. 76), Fuchs shows that "the entire semantic structure of the painting (which is a structure within the formal structure) seems to be built up from a series of visual contrasts between elements which, juxtaposed, express oppositions such as summer/ winter (or growth/decay), peace/turmoil, land/water, wild nature/cultivated nature (or nature/culture)."[20] Fuchs discovers this structure of oppositions by observing the division of the landscape into a low side with a meadow and beach and a higher side showing a field of grain. Three groups of trees and a fence also act as formal elements dividing foreground from background. Analyzing the content of opposing areas, Fuchs shows that these divisions are thematically significant. Thus one side is tranquil with a blue sky, while the other is stirred by looming rain clouds and windblown trees. Signs of past labor appear in partially harvested fields that complement figures at rest. Trees are autumnal on one side and lush and summery on the other, and the dark foreground is filled with wild plants, while the bright middle ground is dominated by ripening grain.

Fuchs's reading reveals that Ruisdael's landscape follows a pattern of oppositions that always represents two complementary sides of nature, defining general characteristics of the world rather than fragmentary, momentary appearances. Such generalized categories, which underlie and unify the realistic specificity of Ruisdael's painting, fully conform to contemporary habits of seeking out the general and typical in any experience. Fuchs goes on to propose that Ruisdael's painting depicts Nature in the World, likewise a generalized, universal category.

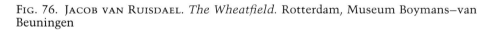

FIG. 76. JACOB VAN RUISDAEL. *The Wheatfield.* Rotterdam, Museum Boymans–van Beuningen

The Wheatfield would have been intended for contemplative viewing as a mirror of God's creation in all its fullness, a frequent theme of landscape descriptions in Dutch poetry.[21] Fuchs concludes that while such a landscape depends upon a careful and scrupulous observation of the world, it is also determined by a typical "code" of form and content that is intrinsically allegorical in that the comprehensiveness of the code manifests God's goodness.[22] Fuchs's recognition that Ruisdael characterizes nature in terms of polarities of generalized, universal categories, which recalls G. Wilson Knight's observations on the tempest in Shakespeare, and his conclusion that such images of nature function as revelations of divine meaning and purpose are especially relevant to this study.

Vergara's book on Rubens's landscapes further elaborates and refines an aspect of this interpretive method only suggested in Fuchs's article. Vergara demonstrates that the careful reading of details and their semantic relationships is essentially similar to, and can be validated by, the treatment of landscape in classical and contemporary literature. Vergara shows that the concept of *ut pictura poesis* allowed the landscape painter to share in the literary theory of genres, which are not only categories for organizing literature "but instruments for interpreting reality, aiding invention, and transmitting culture."[23] And she shows Rubens's awareness and exploitation of the conventions of the literary genres of pastoral and georgic and the Renaissance ideal of country life in the themes and expressive structures of his landscapes.[24] Rubens's landscapes can thus be seen as manifestations of his intellectual concerns and of his sense of the identity of his own creative powers with the processes of the natural world he depicts.

Vergara plausibly suggests that storms enter Rubens's work partly in response to the challenge to imitate and surpass both the rhetorical energy of tempest accounts in the literary tradition and the visual power of storm scenes by such predecessors as Titian.[25] She analyzes Rubens's *Shipwreck of Aeneas* (Fig. 77) as a composition possessing both a narrative movement from left to right, from storm and disaster to calm and salvation, and a rhetorical brilliance of description that successfully re-create and rival the character of classical narratives of storms, especially the storm in the *Aeneid*, to which the inscription on the engraving after the painting refers.

The Dutch and Flemish artists who painted sea storms were apparently not, like Rubens, intellectuals steeped in classical and Renaissance Italian culture. In consequence we know very little about their thoughts on painting aside from what we can deduce from their pictures. Yet the expressive character and content of typical Dutch and Flemish storm pictures are essentially similar to Rubens's *Shipwreck of Aeneas* and can be read following the principles of Vergara's study: the close, empathic scrutiny of theme and form and interpretation through the literary tradition. We shall see that these paintings too are characterized by a dramatic, emotionally compelling narrative presentation and a pictorial structure involving polar antagonisms and implying eventual resolution. It will prove much more difficult, however, to establish the kind of explicit connection between them and the literary tradition that Vergara makes in the case of Rubens's painting. Rubens self-consciously explored an ancient literary topic and reformulated its expressive possibilities to achieve the highest ends of

FIG. 77. PETER PAUL RUBENS. *The Shipwreck of Aeneas.* Berlin-Dahlem, Gemäldegalerie

his own art, whereas painters of Netherlandish tempests worked more consistently within and modified the conventions of an artistic tradition of dramatized naturalism. Their images adhere much more closely to standard conventions, to the codes of theme, form, and expression of the kind proposed by Fuchs for Ruisdael's *Wheatfield.* The resulting paintings are, like Rubens's, analogous in their modes of expression and content to tempests in the literary tradition, but this seems due not to conscious emulation as in Rubens's work but to values and assumptions common to a culture that the artists shared with virtually all levels of society, both literate and illiterate.

We might expect that contemporary descriptions of and comments on tempest paintings would be among the most useful sources for understanding the relationship of these images to their cultural context. Unfortunately, descriptions of the images are few, though this typifies all genres of Dutch paintings except portraiture and history painting. Furthermore, those descriptions we have must be understood not as unmediated responses to art but within the conventions of *ekphrasis,* that is, detailed, sensorily evocative description.[26] Revealingly, these texts read pictures in a way that corresponds to the basic method used by Fuchs and Vergara. Although none of them discusses formal expression as modern critics do, their reading of incident and emotion in an imaginatively participatory—and even expansive—way confirms the historical validity of such reading on our part. Moreover, these descriptive passages also support our decision to look at seventeenth-century pictures with the literary culture in mind, for they reveal the pervasive role of literary tradition both in shaping the ideas and emotions of beholders of storm paintings and in providing patterns for articulating those responses. The

authors assume that storms in literature and those in pictures are parallel expressions of thought and feeling, an assumption that we shall see they share with writers of emblems and very likely with most contemporary viewers of our storm paintings.

Literary culture strongly informs the two most impressive accounts of tempest paintings, poems by the Dutchman Joachim Oudaan, from a collection dated 1646. As observed in Chapter 2, all detailed tempest narratives in the classical tradition are closely related to *ekphrasis*, and Oudaan's descriptions exhibit the impact of these strongly rhetorical passages, as well as the conventions and preoccupations of *ekphrasis*. This becomes especially apparent if his poems are compared with storm paintings of the period. Although the title of Oudaan's set of poems, "Op Schildery, Teikening en Naelde-werk: ten Huise van Joffr. J.V.D.B." ("On Painting, Drawing and Needlework in the Home of Miss J.V.D.B."), implies that he is describing images in an actual collection, much that he narrates cannot be found in any Netherlandish storm scene, but rather reflects the conventional concerns of *ekphrasis*.

Oudaan begins the series with the poem "On a Thunderstorm by Porcellis," which seems to be based on a painting similar to *A Three-Masted Vessel in a Strong Breeze* in Greenwich (Fig. 78):

> The wind rises higher, the sail swells the rounder with it; be careful, helmsman, of the sheet; boasting brought many to submission, who, with their hearts full of pride, were ashamed to take in a reef when in distress. Here the waves are rough. Sailor and master's guest toil so hard they labor at the rudder and on the deck in order to break the beating waves on the bows if one could. The helmsman's pea jacket drowns, while a billow that beats on the stem leaps backwards and falls in round droplets, and makes the sailor's hair like the heads of water-dogs. A cloud comes from above, which, driven on and on by a beam wind, begins suddenly to pour; it splashes on board and pierces so much the more severely through the blue sailor's cap, through boots and rain jackets soaking to the skin. To which he [the helmsman] pays no heed, but cries (while the wind roars out so that it booms) the rudder is forced to leeward, the ship is on a low shore, push off, apply your strength. Yet a cool fellow usually sits on the main deck and watches the game although wind punishes and rainshowers beat; Porcellis likewise does not creep into the forecastle, but considers the storm calmly (in spite of water, rain, hail, and thunder), in order to examine in life this raging element, [an example] which you engrave in [your] thoughts.[28]

Oudaan's poem exhibits a specificity that suggests actual knowledge of Porcellis's work, and his close attention to the interaction of ship and crew with the elements seems appropriate to the artist's pictures. And yet his text diverges from any known work of the artist—and even from the properties of any painting—in ways that are surprising to us. Many of the features he treats could never be made visible or could only be inferred. Furthermore, he describes not a single image but a succession of unfolding incidents befalling a single vessel in a

way that cannot possibly be rendered in one still image: the waves beat upon the ship, the sailors toil against them, a cloud appears and rain begins, and the vessel is almost driven aground.

These affective aspects of Oudaan's text, though foreign to twentieth-century aesthetic theories, can be understood in the context of the approach to images found in *ekphrasis*, with its characteristic commitment to compelling narrative and emotional engagement. Features such as the drenching of the sailor's clothes and the helmsman's shouts, as well as the evocation of different actions, can be ascribed to what E. H. Gombrich calls "imaginative sympathy," an identification of the viewer's experience and emotion with situations depicted in narrative art that provides a temporal dimension to still images.[29] Arousal of this imaginative sympathy was a fundamental goal of *ekphraseis* of art works, which conventionally emphasize the extremely lifelike vividness of the images, so that even invisible elements such as water drops, damp hair, soaked caps, and the purely aural tumult of shouts and roaring wind are understood to be evoked by the power of pictorial art.[30]

The value placed on the artist's close imitation of nature as the means to enlist the viewer's empathy underlies the importance attached to the idea that the artist remained on deck observing and examining the storm. Indeed, the

FIG. 78. JAN PORCELLIS. *A Three-Masted Vessel in a Strong Breeze.* Greenwich, National Maritime Museum

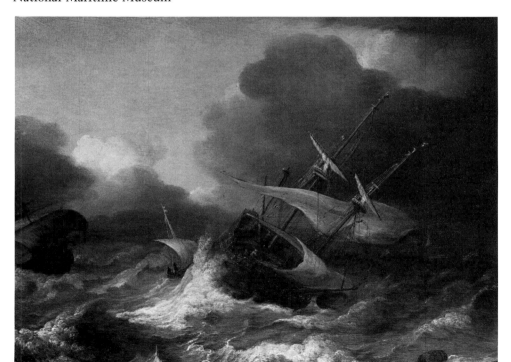

entire description of the discomforts experienced by sailors exposed to the storm underscores the painter's devotion to verisimilitude, for he too endures the elements and yet "does not creep into the forecastle, but considers the storm calmly . . . in order to examine in life this raging element." In fact, the artist's devotion to the imitation of nature in Oudaan's poem anticipates the actual practice of Ludolf Bakhuizen and Willem van de Velde the Younger, who had themselves taken out on the water in stormy weather to examine the elements firsthand.[31] Houbraken reports of Bakhuizen that he sought to bring from such a trip a "lively mental image" that would then guide his painting until he had satisfied this mental image. These activities prefigure and probably in some way lie behind Vernet's more celebrated daring, when in a storm he had himself tied to a mast. Vernet's purpose likewise seems to have been mimetic accuracy.[32]

As in the depiction of vessels and foreign ports and coasts discussed above, the purpose of this imitation of nature lies not just in verisimilitude. The capacity of such lifelike vividness to transcend the limits of still imagery and draw the viewer into the experiences depicted in a painting is a related *topos* of *ekphrasis* and appears in the first and final stanzas of another poem from Oudaan's collection.[33] Titled simply "On a Storm," it could be based on almost any example of the shipwreck type (see Fig. 79):

> The mere sight seems to embroil us also in the storm (so living is art); the murky light of the thickly clouded sun, spread so thinly, seems to excite us with inner anguish and heartfelt woe. Be calm, be calm, be calm tempestuous sea! Or through the cold uproar your anger will pull feeling with it.
>
> There splashes the ship (stained by slimy moisture and angry sand) deep in the abyss: no floating cork rose so lightly from land due to the strong wind, as though it were rising from the grave. Meanwhile the army of the raging winds roars together. Thus, the ship hits lightly on a lump of stone, and strikes and bursts into chips, and now fills with clouds, then a whirlpool, and always with people.
>
> The faint voice of the hopeless thus bursts out at the end: Lord, let it not splinter! Before you gave force to the winds by your divine words. Oh, let it be as in the winter when the Halcyon brings forth its young! Oh, bind this water-wolf before he smothers us! Oh Lord, before he buries the rushed boards of the shell, do help!
>
> Set aside, set aside, learned hand your artistic brush, baptized in tears. Your fine feather spreads and lays its strokes much too nobly to bear the pressure. And the higher the impression of grief rises, the deeper does the pain hurt. Your art removes not displeasure but gives it by the clear statement of danger.[34]

Again Oudaan's reading is noteworthy for the intensity of its emotional projection. His emphasis on the power of a work of art to "embroil us also in the storm" and on the capacity of the image to encompass all experience, even rendering something so invisible as the desperate prayer of the hopeless aboard the wreck, depends not on the direct observation of what the painter depicts, but on the traditional poetic concern with the mimetic powers of visual art and of words. These literary *topoi* seem to lead the poet far from the actual visual characteristics of the two storm pictures he describes; indeed he seems to be as

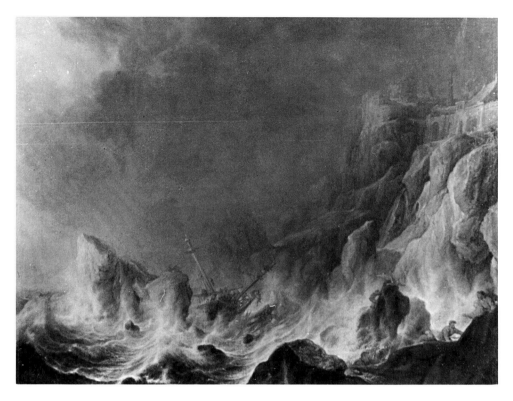

Fig. 79. Simon de Vlieger. *Shipwreck on a Rocky Coast.* Salzburg, Graf Czernin Collection

influenced by the storm descriptions of the literary tradition—Virgil, Ovid, Psalm 107, the shipwreck of Saint Paul in the Acts of the Apostles—as he is by the pictorial qualities of the paintings.[35] The way Oudaan empathically enters the images, reading details with imaginative sympathy, identifying with vessels and crew, and giving the incidents a narrative structure conforms not only to *ekphrasis* but also to the way tempests are recounted in other forms of the literary tradition. Linschoten's empathy for the victims of shipwreck on Tercera, cited above (page 45), is typical.

Oudaan's text reveals other characteristics that we noted in the literary tradition. In part, the force of his passages derives from an understanding of the world as made up of dynamic tensions in which both the actions of the elements and the feelings and activities of the men caught up in them unfold in a series of dramatic oppositions. Thus in describing Porcellis's painting Oudaan, who seems to delight in the existence and articulation of such contrasts, juxtaposes the almost frantic activity of the sailors and the storm in the first lines with the concluding self-possession of the painter, required of him to contemplate "this raging element." And in "On a Storm," the emotional force of the conflict between men and their ships and the storm is amplified through a series of juxtapositions—of present anguish and the hope of calm; of anger so intense it

FIG. 80. BONAVENTURA PEETERS. *A Ship in Distress off a Rocky Shoal.* Rotterdam, private collection, 1942

may cause numbness of feeling; of the ship thrown deep in the abyss, then rising high like a cork; of Halcyon and water-wolf; of high grief that imprints deep pain. Conflict and the possibility of resolution are inherent in the language of the poems as they are in the images of tempest and in the dramatic world that both poet and artists describe.

As in the literary tradition, there is in Oudaan's intense evocation of the storm no hint of uplift when confronted with the spectacle of natural forces that a later century would find sublime. Oudaan characterizes the tempest in "On a Storm" in metaphors of anger, rage, warfare, danger, and death. The depiction of this "water-wolf," a metaphor that summarizes all the others, provokes in viewers feelings of "inner anguish and heart-felt woe," grief, and pain.

The closest parallels to Oudaan's *ekphraseis* of tempest images are Arnold Houbraken's prose descriptions of tempest scenes by Bonaventura Peeters and Jan and Julius Porcellis.[36] Though dating from about sixty years later, the attitudes to the pictures and the storm seem to be the same as Oudaan's. Houbraken, like Oudaan, is preoccupied with the painter's fidelity to nature, but in the longest of three *ekphraseis* on storms, one describing a shipwreck painting by Peeters, Houbraken devotes more attention to the details of the painting itself than Oudaan had. It could well describe an actual picture by Peeters (Fig. 80), though a number of artists painted similar scenes:

> Bonaventura Peeters . . . painted seastorms and ships in danger of wreck due to all kinds of sad sea disasters. [He depicted] how Aeolus in wrathful spirit presses the clouds with his storm winds from four directions, and squeezes them so tightly that they burst out with an awful roar of lightning and thundering, with blow on blow batter the sails, masts, topmasts, and the hull of the sea ships, so that splinters fly about the ears of the sailors, who in this distress predict with oppressed lips their fated hour of death. Then again [he shows] how Neptune, dis-

turbed by the pride of the sea rocks, stirs up the brine, and from the immeasurable depths, comes ashore against them with his trident, spattering the highest peaks with foam; and how the ships fall into those breakers, jerked hither and yon, finally pound themselves to splitting; people and goods are brought into danger of perishing: a crowd of people appears on a single wreck breaking up; while others again seek to save their lives by swimming. Or also [he portrays] how the castaways on some populated beach relate their experiences with burdened shoulders, and beg for help, and so forth. He knew how to depict these and similar pitiful things so exactly in their appearances, and also how to paint air, water, cliffs, and beaches so naturally, that he was judged to be the best in his time in this way of painting.[37]

Again the author introduces elements, such as Aeolus and Neptune, that appear in no known image by Bonaventura but typify the literary tradition of storm description. These figures appear in the well-known storm narratives of Homer, Virgil, and Ovid, while sailors foretelling their doom are an almost universal feature of accounts of tempest.[38] The description of the ships in the breakers and of the castaways serves to emphasize another familiar convention, the artist's faithful imitation of nature and his ability through this imitation to move the spectator as if he were present. And like Oudaan, Houbraken characterizes the storm not as something to be sought out but as dreadful and perilous: Peeters depicts a sea that splinters and breaks, causing "sad sea disasters" and "pitiful things." The painter's rendering of nature is admirable, but nothing suggests admiration of the storm itself.

The debt to literature and the preoccupation with themes of mimesis and of nature and art in Oudaan's and Houbraken's descriptions do not, however, make their *ekphraseis* the less useful as a means of access to contemporary responses to paintings of tempests. As we have seen, the literary tempest informed nearly all seventeenth-century descriptions of real and fictional storms. Sermons, voyagers' accounts, poetry, all reveal its pervasive influence. Most literate viewers were as familiar as Oudaan and Houbraken with the storm narratives of classical culture, and virtually all beholders would have known the vivid storm passages in scripture. This widely shared culture fundamentally shaped the way a beholder of the time thought about storms in reality and must have informed that viewer's responses to images depicting tempests, as a number of seventeenth-century sources interpreting storm images reveals.

The method of describing that Oudaan and Houbraken used would have been sanctioned in the seventeenth century by the concept of *ut pictura poesis*.[39] This assertion of the essential kinship of poetry and painting was a commonplace of the culture and a license for the poet's attempt to communicate in words and even to excel the vital grasp of the world of visual art. In fact, this reading of the incidents in the images, directed at the psychological participation of the beholder and reader, seems to have been the normal way of viewing and describing art in the sixteenth and seventeenth centuries.[40] Vasari's *ekphrasis* of *La Burrasca* (Fig. 25), like Ghiberti's praise of Ambrogio Lorenzetti's *Martyrdom of St. Peter of Siena and His Companions* (see Chapter 2), shares Oudaan's interest in the imitative capacity of art and also his concern for a psychologically compelling narration:

In this scene is depicted a ship which is bringing the body of S. Mark to Venice; and there may be seen counterfeited by Palma a terrible tempest on the sea, and some barques tossed and shaken by the fury of the winds, all executed with much judgment and thoughtful care. The same may be said of a group of figures in the air, and of the demons in various forms who are blowing, after the manner of winds, against the barques, which, driven, by oars, and striving in various ways to break through the dangers of the towering waves, are like to sink. In short, to tell the truth, this work is of such a kind, and so beautiful in invention and in other respects, that it seems almost impossible that brushes and colours, employed by human hands, however excellent, should be able to depict anything more true to reality or more natural; for in it may be seen the fury of the winds, the strength and dexterity of the men, the movements of the waves, the lightning-flashes of the heavens, the water broken by the oars, and the oars bent by the waves and by the efforts of the rowers. Why say more: I, for my part, do not remember to have ever seen a more terrible painting than this, which is executed in such a manner, and with such care in the invention, the drawing, and the coloring, that the picture seems to quiver, as if all that is painted therein were real.[41]

This is very much the same process of projecting affective states of mind into the image that characterizes Constantijn Huygens's response to Rembrandt's *Judas Returning the Thirty Pieces of Silver* (Fig. 81):

Let all Italy come, and all that has come down of what is fine and worthy of admiration from earliest antiquity: the posture and the gestures of this one despairing Judas, leaving aside so many other figures [brought together] in a single painting, of this one Judas I say, who, out of his mind and wailing, implores forgiveness yet holds not hope of it, or has at least no trace of hope upon his countenance; that haggard face, the hair torn from the head, the rent clothing, the forearms drawn in and the hands clasped tight together, stopping the blood-flow; flung blindly to his knees on the ground in a [violent] access of emotion, the pitiable horror of that totally twisted body—that I set against all the refined art of the past. . . .[42]

Unlike Rembrandt's painting and most pictures described in *ekphraseis*, the seventeenth-century storm pictures Oudaan and Houbraken evoke are works in which the human beings are small and consequently not rendered with the same emotional detail as Rembrandt's Judas. Yet ships and men dominate their accounts and are read with the same emotional identification that Huygens brings to the figure in Rembrandt's painting. We have the impression that the writers have closely studied the vessels and crew and see them not as tiny, inconsequential staffage in objectively reported settings but as actors in continuing dramas of human contention with the elements, which are themselves highly charged protagonists. These readings accord completely with the actual rhetorical character of the pictures, which are purposefully staged to engage the viewer's emotional response. As we shall see below, vessels and human beings, though small, occupy crucial places in the expressive structures of the scenes and are rendered with great care and precision.

We also find the situations of ships in the images closely attended to in these ekphrastic readings. Thus Oudaan responds with differing associations and emo-

FIG. 81. REMBRANDT VAN RIJN. *Judas Returning the Thirty Pieces of Silver.* 1629.
English private collection

tions appropriate to the distinct situations represented in the two storm scenes. In
"On a Storm" an image of shipwreck leads to thoughts of man's helplessness and
his dependence on God when in the grip of these vastly superior powers, which
are, moreover, mostly inimical. On the other hand, his poem on Porcellis's paint-
ing warns of the danger of carrying too much sail in a storm (11.1–4). Pictures of
this kind typically depict not the ultimate vulnerability of the shipwreck but an
ongoing struggle to retain control of the vessel, an effort in which the amount of
sail can be a crucial factor.

Congruence with the textual tradition is also evident in the strong moral
overtones given to this admonition about the sails: pride, boasting, and shame
cause disaster in the tempest. Indeed, the first four lines closely resemble the
epigram of an emblem.[43] While Oudaan does not treat the entire narrative as an
allegory, he clearly sees the situation depicted in Porcellis's picture as capable of
teaching a lesson with implications reaching far beyond good and bad seaman-
ship. Oudaan's response to these images as emblematic bearers of moral con-
cepts reinforces the impression that in the seventeenth century moral lessons
were implicit in such a scene and were readily drawn and interpreted in a
number of ways.

It is also striking that the attitude toward verisimilitude in these *ekphraseis*
parallels the attitudes of the painters of sea storms as it is revealed from their
treatment of historical fact. These writers enlist specific detail for purposes very
like those of painters who render extremely precise but not historically identifi-
able ships or who evoke foreign ports through an accumulation of detail that
depicts no particular city. Such plausible but fictitious realism serves not only
to describe but to heighten readers' and viewers' experience, eliciting an essen-
tially dramatic response to a world where calm and storm, control and possible
disaster, live in dynamic tension. Within this context of compelling mimesis

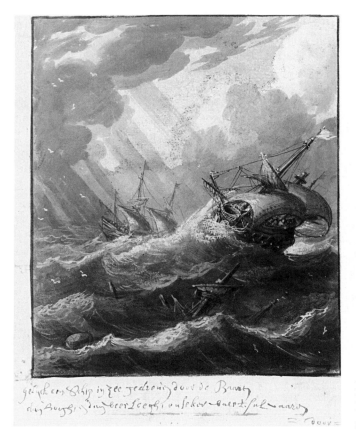

FIG. 82. BONAVENTURA
PEETERS. *Ships in a
Tempest.* Antwerp,
Stedelijk Prentenkabinet

and generalized reference, metaphors of the sea and ships seem completely consonant.

That the painters themselves understood tempest scenes in fundamentally the same terms as Oudaan and Houbraken is revealed by the closest things to comments on the pictures that we have by these artists. One is a poem by Bonaventura Peeters written by the artist himself on the front and reverse of a gouache drawing depicting ships in a storm (Fig. 82).[44] Apparently a meditation stimulated by Peeters's own picture, the poem sees the storm-tossed ship as a metaphor of human life with a specifically stoic comment on the pursuit of sensuality and adventure as leading to unrest and misfortune:

> Like a ship at sea driven by the waves, first high, then low, where it will sail in doubt due to the fierce sea tempest, so it goes with the condition of men, who are much more inclined to evil than to virtue, whereby they suffer nothing but torment, like sailors who go to sea to fight, who sometimes have pleasure from much captured booty, yet the voyage rarely turns out to their advantage, as mortal terrors full of a thousand horrors catch them by surprise at sea, and sorrows so press in that no one knows where deliverance will be: Behold whether life is other than misfortune, and whether it is not better to flee pleasure than to live here in little joy, which gives birth to much moaning. [For] then man dies peacefully, and hopes to gain after death the good of his soul by his salvation. Do not then risk

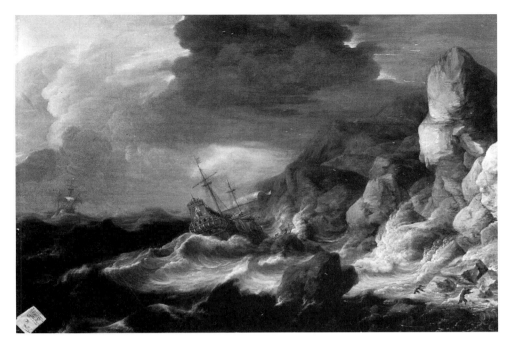

FIG. 83. HENDRICK DUBBELS. *The Wreck of "De Liefde."* Stockholm, Nationalmusem

your life too lightly in order to gain much; he who does so is not wise; one ought first to consider and take good advice in order to sail well, because there is too much at stake if one without reason commits oneself all too lightly to adventures. Woe to him who does so and suffers misfortune. It is still lovely weather when one can sail before the wind as long as one does not find a shoal which will split the ship.[45]

This poem is striking in part for its extreme conventionality: the description of the ship's plight and the moral drawn from it resonate with the entire verbal tradition. The presence of the inscription, moreover, gives the drawing an emblematic quality like that of Oudaan's poem on Porcellis's picture. But even more revealing for our purposes is the fact that the artist himself made such associations with his own image. The work of art clearly serves as a vehicle fo emotional projection and as an occasion for articulating fundamental wisdor and values. The image is neither neutral reportage nor a field of concealed symbols. Rather, like a poem, it is a means of rhetorically engaging the beholder (and the artist) in the struggles of ships on the high seas in a process of associative thought in which the choices that lead to the situation seen in the picture become moral metaphors.

The only comparable textual evidence of an artist's thoughts on such an image consists of two verses on a *cartellino* painted and signed by Hendrick Dubbels in the lower-left corner of *The Wreck of "De Liefde"* (Fig. 83).[46] While the picture may depict an actual event, the text does not refer to a specific situation; it is as generalized in character as the picture:

T gewelt der woeste
zee door stormen is
gedreven Verquist
veel, schadt de goedt
en breukeert veel
Om't leeven.

(The violence of the furious sea, [which] is driven by storms, wastes much, dam-
ages the good, and cleaves many from their lives.)

Here the painter—conceivably in his own words—directs our attention to essen-
tially those aspects of tempest scenes that are recounted with such rhetorical
amplitude in the passages we have just examined: the fury of the storm and the
fates of men and their vessels. And he characterizes the sea in the same terms of
dynamic destructiveness (wasting, damaging, and cleaving) and of extreme emo-
tion ("the violence of the furious sea"). The text again makes the picture em-
blemlike, and a metaphor seems to be intended. The storm damages "de goedt,"
which could suggest both material loss and moral conflict as well, a plausible
double meaning in a seventeenth-century context. As simple and brief as this
passage is, it serves almost as a synopsis of the longer accounts, and in its
generalized character provides both an epigrammatic summation of the signifi-
cance of the scene and wide latitude for further contemplation.

READING SYMBOLS: EMBLEMATIC
SOURCES AND THEIR ROLE
IN INTERPRETATION

Oudaan's poem on a storm by Porcellis and the inscriptions on Peeters's drawing
and Dubbels's painting draw more or less explicit moral lessons from the ways
in which human beings respond to the forces of nature. These symbolic readings
are striking for the way in which they explicate the situations themselves (as-
suming, as seems appropriate from the text, that the painting described by
Oudaan is typical of Porcellis's treatment of such a subject). The realistic re-
counting of the dynamism, danger, and losses experienced at sea assumes a
moral dimension, not an arbitrarily attached symbolism but one that seems
inherent in the picture itself.

Symbolic readings of realistic Dutch pictures have become a useful, if prob-
lematic, tool in the study of Dutch art. There is abundant evidence that the
symbolic interpretations in Oudaan's poem and Dubbels's inscription are as
appropriate to reading these scenes as the psychologically engaged viewing char-
acteristic of *ekphrasis*. Like *ekphrasis*, such interpretations are fundamental to
the context from which the paintings derive. Because of the conviction that the
world was an inherently meaningful cosmos, metaphor in the sixteenth and
seventeenth centuries was, as Marjorie Hope Nicolson observes, not experi-
enced as simile but as reality. Metaphor was inherent in the world as another

form of divine revelation, a book of nature written, like scripture, for human enlightenment and guidance.

Sea storms and shipwreck were especially susceptible to such interpretations partly because of this cosmology, which saw the origins of the storm in the very give-and-take of the most fundamental forces in the universe. In storms, the elements, ordinarily arrayed as patterns of concinnity and opposition, disturbingly resemble the original elemental conflict of chaos. The tempest was thus a particularly compelling object of symbolic speculation that reinforced the already immense evocative power of the aroused sea. The metaphors of storm in the classics and scripture, moreover, provided a broad range of models for such interpretations.

Realistic tempest images were interpreted symbolically in a number of contexts in the seventeenth century, such as the *ekphraseis* already discussed and the inventory reference to a picture by Jan Peeters (Fig. 7) as an allegory on the causes of poverty discussed in Chapter 1. These are, however, exceptional instances compared to the abundance of medallions and emblems on tempests.

EMBLEMS AND MEDALLIONS

Foremost among these interpretive sources are emblems, whose popularity increased steadily in the first half of the seventeenth century. Enormous numbers and varieties of emblem books were published in the Netherlands, both North and South, yielding an almost bewildering array of interpretations of tempest themes.[47] For our purposes we can group emblematic illustrations (referred to as icons) into two classes. One comprises overtly symbolic compositions in which a storm and vessels function as attributes of, or dramatized settings for, allegorical figures. Herman Hugo's emblem on Psalm 69:19 ("Let not the water-flood drown me, neither let the deep swallow me up") typifies such emblems (Fig. 84): An angel/cupid (divine love) pulls a child (the soul) to shore while a ship sinks in a raging storm in the background.[48] The epigram explains that the sea, the ship, and the winds are types for human life in this world, where the only salvation is Christ. Similarly, in an emblem by Florentius Schoonhovius (Fig. 85), a rocky shore in a tempest is an attribute of the figure of Fortuna, who dominates the foreground.[49] The lemma, "nihil ignavis votis" ("nothing by means of idle prayers"), is explained in a number of examples, including that of a helmsman in a storm who prays for safety but also eases the rudder and shortens sail to help bring about his own salvation: Fortune helps those who help themselves.

More revealing for this study are emblem icons of a second type, images virtually identical to storm paintings. While such emblems offer most suggestive possibilities for interpreting paintings, they possess several characteristics that qualify their direct application to realistic seascapes. In these emblems the icons often imitate paintings by known artists, as in Julius Wilhelm Zincgreff's emblem "Tempestate probatur" ("tested by the tempest") (Fig. 86) in which the illustration, a ship sailing close hauled in a storm, resembles contemporary paintings (cf. Fig. 131).[50] The epigram explains that one sees a man's virtue when he is tested by adversity, just as a pilot's skill is revealed not in a calm but in a storm. Such an interpretation is perfectly suited to a picture of a vessel sailing

Non me demergat tempeſtas aquæ, neq; abſor-
beat me profundum! Psal. 68.

11.

FIG. 84. Emblem from HERMAN
HUGO, *Pia Desideria*, Antwerp,
1624

Nihil ignavis votis.

EMBLEMA V.

Rebus in humanis noſtrum ſolamen opemque
Nil juvat ignavâ ſollicitare prece;
Audentes Fortuna juvo: conamina veſtra
Iungite, & hoc noſtrum præſto erit auxilium.

FIG. 85. Emblem from
FLORENTIUS
SCHOONHOVIUS,
Emblemata. Gouda,
1618

TEMPESTATE PROBATUR.

44

Aduersité esprouue.

Ce n'est pas en bonasse & sous un calme vent
D'vn aduisé nocher que se fait voir l'adresse;
Ainsi en temps contraire & plus grande destresse,
Que peut vn bonesprit, paroist euidemment.

Durch die zeit wird man probirt.

Im Sturmen wird des Schiffes Güte
Befunden, nicht zu guter zeit.
So wird in widerwertigkeit
Erforscht des Mannes sein Gemüthe.

M Lemma

FIG. 86. Emblem from J. W. ZINCGREFF, *Emblematum ethico-politicorum centuria,* Heidelberg, 1619

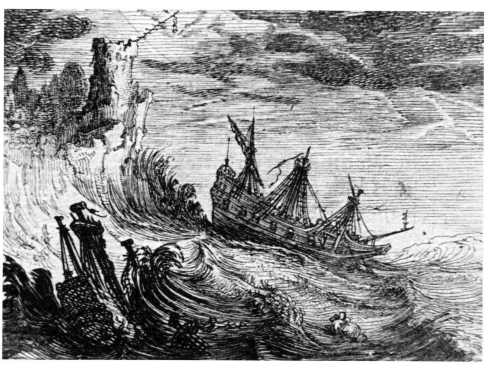

FIG. 87. Emblem from JAN JANSZ. DEUTEL, *Huwelijckx weeghschael,* Hoorn, 1641

onward in good order despite the tempest. The application of this specific meta-
phor to paintings, however, is complicated because Zincgreff goes on to offer a
further interpretation, asserting that the image represents the quality in adver-
sity of a ruler piloting the ship of state. Exactly the same icon, moreover, was
used some years later in a book by Bartholomeus Hulsius to allegorize a Chris-
tian's faith as it is tested in the troubles of this world.[51] Within a context
allowing multiple interpretations, apparently all of these were appropriate read-
ings of this motif, and all suit the character of the image.

Besides such multiple interpretations, modern viewers may face the problem
of the obscurity of some references. An example is Jan Jansz. Deutel's interpreta-
tion of an impressive illustration based on the shipwreck scenes of Bonaventura
Peeters (Fig. 87) as representing unhappiness in marriage.[52] Though the meta-
phor originated in antiquity, it is not likely that most twentieth-century viewers
would have thought of it on examining such an image. And in this we encounter
two important features of emblems that may not necessarily characterize a
given painting: Emblems are intended to stimulate associative thinking that
will penetrate riddle-like combinations of word and picture, and emblems are
contextual. In this case, the context, a book titled *Huwelijckx weeg-schael (The
Scales of Marriage)*, would very likely have been enough to prompt the meta-
phor, but a similar painting in a different setting might be as plausibly inter-
preted in a half-dozen other ways.[53]

While some genre paintings, still lifes, and portraits can be shown to incorpo-
rate emblematic motifs or virtually to be emblems, this is true of few seascapes,
and in those rare cases that exist we find exactly the structure of mutually
reinforcing symbols absent from ordinary storm scenes. An example of an
emblematic seascape is the painting *Lovers on a Stormy Shore* (Fig. 88) by an
anonymous Dutch artist working in the "gray" manner of Porcellis.[54] The image
divides into a stormy seascape on the left with a ship sailing into the wind and
clawing off the shore, and at right a rocky coast with three pairs of lovers in
various stages of dalliance, one of whom gestures at the ship (Fig. 89). The
women's loose garments with skirts cut at the ankles, the wide-brimmed hat

Fig. 88. Anonymous Dutch. *Lovers on a Stormy Shore.* Warsaw, Muzeum Narodowe

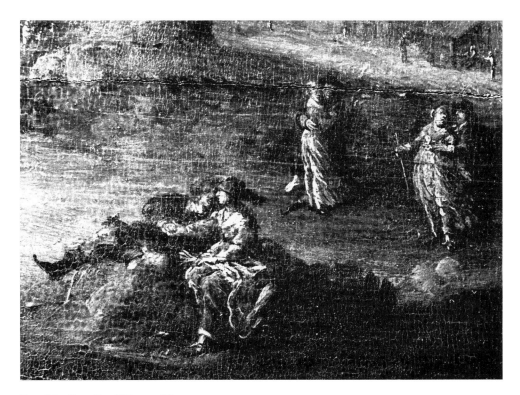

FIG. 89. Detail of Figure 88

worn by one, and the staff carried by another suggest that they are shepherd-
esses. While the men's costumes are more difficult to decipher, the turned-down
tops of their boots and the leggings (or bare legs?) between the tops of their boots
and knees also conform to conventions of pastoral illustration.[55] Behind them is
a Netherlandish village, but the rocky outcropping with a beacon is not local;
nor are the high mountains receding into the distance. The arrangement of these
elements on opposite sides of the long painting, which was probably an
overdoor, is clearly symbolic, and the ship in the storm surely signifies the lover
in the turbulent seas of passion. Unlike most emblems of this theme, however,
the painting depicts the perils of the beloved's disfavor: her beacon is not lit and
the ship is endangered by the rocks, a situation recalling Jan Harmensz. Krul's
epigram to an emblem on this theme (Fig. 90):

> Love is like a sea, a lover like a ship; your favor is the dear harbor, your disfavor is
> a cliff. If the ship is ruined (by disfavor) and comes to run aground, so is there no
> hope of landing safely. Show me with love's beacon the harbor of your favor so
> that I arrive out of the sea of love's fear.[56]

The juxtaposition of shepherds and a stormy sea is unusual in painting but not
inappropriate. Love is a pervasive theme in pastoral, and a parallel for the use of
this metaphor in a pastoral context can be found in Krul's "Meyspel van Cloris

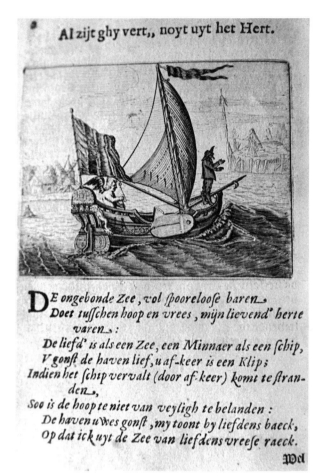

DE ongebonde Zee, vol spooreloose baren,
 Doet tusschen hoop en vrees, mijn lievend' herte
 varen:
 De liefd' is als een Zee, een Minnaer als een schip,
 V gonst de haven lief, u af-keer is een Klip;
Indien het schip vervalt (door af-keer) komt te stran-
 den,
Soo is de hoop te niet van veyligh te belanden:
 De haven u wes gonst, my toont by liefdens baeck,
 Op dat ick uyt de Zee van liefdens vreese raeck.

FIG. 90. Emblem from JAN HARMENSZ. KRUL, *Minnebeelden*, Amsterdam, 1634

en Philida," in which the shepherd Cloris, in despair at Philida's displeasure, compares himself to a ship driven to shore and smothered by angry waves.[57]

The resemblance of this painting to the illustration chosen by Deutel as symbolizing unhappy marriage (Fig. 87) is intriguing. Both depict ships near rocky coasts with beacons and both deal with the theme of love. One might be tempted to read all paintings combining imperiled ships and beacons as allegories of love. Before doing so, however, it is necessary to recognize that in both cases it is the context that makes the meaning of the ship in the storm clear, and for most of these paintings such contexts do not exist.

More suggestive for our purposes is the congruence between the situation represented in each image and the metaphorical reading. In contrast to the ship in the painting, Deutel's ship is virtually doomed, a distinction appropriate to the difference between despair in courtship and in marriage. Such a precise correspondence between symbol and image seems to be a general (though by no means universal) characteristic of emblems. The emblems of a ship in a storm by Zincgreff and Hulsius are further examples of this. Occasionally emblems may take this attention to detail even further, narrating the circumstances de-

picted in an image in a way that resembles *ekphrasis* and conventional storm narratives. Deutel, for example, seems to respond to the vivid naturalism of the illustration and provides a long description of orders being given from striking the topsail, to manning a pump, to dropping a sea anchor (to try to keep the ship from drifting toward the rocks), and finally the command to leave everything to the mercy of God.[58] This passage, recalling the poems by Oudaan, corresponds to the imaginative entry into an image typical of *ekphrasis.*

A few emblems that give similar detailed readings include features in their icons that are not ordinarily present in paintings of the same type. C. P. Biens's emblem on Psalm 37:5 ("Commit thy way unto the Lord, and put thy trust in him, and he shall bring it to pass") (Fig. 91) is illustrated with a completely up-to-date scene of a ferry sailing in a fresh breeze that recalls scenes by Porcellis and De Vlieger.[59] It is differentiated from the paintings, however, in one detail—a passenger holding onto the mast. The accompanying epigram explicitly reads this passenger's actions and emotions, which result from fright at the motion of the boat, and the amused responses of the experienced crew, who know that the heeling of the vessel is perfectly normal and necessary to reach the goal of the voyage. In Biens's text all of this is understood to illustrate a man who has no trust in God's providence amid the terrors of this life. Here, while the ship of life in the seas of this world is a commonplace, the specific interpretation depends upon a significant detail not otherwise found in contemporary images. Thus, while emblems provide fascinating insights into the ways symbolism could be read in images and into emotions evoked by a particular subject, interpretations found in them can only be applied to tempest paintings with considerable circumspection. In particular, emblems suggest that a symbolic reading must suit the specific incidents depicted in a painting and that, where multiple interpreta-

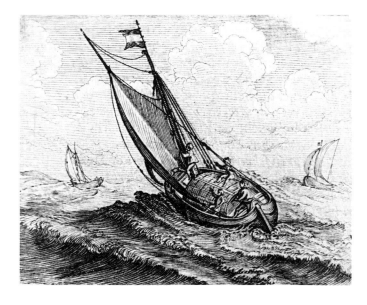

FIG. 91. Emblem from C. P. BIENS. *Handtboecxken der christelijcke gedichten,* Hoorn, 1635

tions are possible, our own can rarely go beyond those underlying meanings that are shared by all the specific interpretations.

Medallions, which closely resemble emblems in character, offer another, somewhat neglected source of interpretations for seventeenth-century art. Like emblems, medallions juxtapose an aphoristic phrase and image whose meaning derives from their interaction; only the explanatory epigram typical of emblems is absent. A wide range of marine themes is found on medallions and, as we saw with pieces struck in the mid-sixteenth century, they are of great interest as evidence for the widespread familiarity of this subject matter and its capacity to address major issues facing prominent individuals and the state.

In medallions, as in emblems, the interpretation of a ship or storm depends primarily on the context, the specific purpose of the medallion. An example is a very fine piece of 1672 commemorating the murders of Johan and Cornelis de Wit by a mob in The Hague (Fig. 92).[60] Depicting on the obverse portraits of the two men and on the reverse two ships wrecking on cliffs in a storm, it allegorizes the brothers' fate in the storms of political strife as the text, "Una mente et sorte" ("of one mind and fate") makes clear. The ship of state also appears in varying guises on medallions, where it is used to illustrate a number of concepts. In a piece struck in 1606 (Fig. 93) depicting a boat in a storm with the crew all working at a variety of tasks to save it, the text "Servat vigiliantia concors" ("harmonious vigilance protects") indicates the virtues of unity in the state.[61] The reverse reminds the beholder of the importance of trust in divine providence with Christ's words to the disciples on the sea of Galilee, "Modicae fidei quid timetis?" ("What do you fear, you of little faith?"). A medallion of 1647 (Fig. 94) shows a ship flying the Dutch flag sailing a sea studded with rocks, a course clearly requiring the qualities defined in the motto "Timide ac prudenter" ("cautiously and also prudently").[62] A long text like an emblem epigram on the reverse explains that the image refers to the perils of rash action in the peace negotiations at Münster now that the Eighty-Year War is drawing to a close.

Medallions with marine subjects also allegorize the opposites of storm and peril, celebrating the power and prosperity of the United Provinces, as in a medal (Fig. 95) struck to commemorate the fortunate state of the Dutch at the time of the Twelve-Years' Truce (1609).[63] On the obverse we find a milkmaid milking a cow in a fenced yard, probably references to De Nederlandse Koe (the Dutch cow) and De Hollandse Tuin (the Dutch garden), potent political symbols in the seventeenth century.[64] The reverse depicts a Dutch ship sailing a calm sea and, like the obverse, symbolizes the prosperity of the nation, as their mottoes also indicate: on the obverse "Avidi spes fida coloni" ("the sure hope of the thrifty farmer"), and on the reverse "Verrit turbida nauta aequora" ("the sailor sweeps the restless seas"). Prosperity also figures in a medallion depicting on the obverse a figure representing Amsterdam supported by Virtue and Trade; on the reverse we find an allegorical figure of the River IJ with a Victory floating overhead, while in the background ships sail into the harbor of Amsterdam.[65] Dating from 1612, the piece is a celebration of the power and prosperity of the city, as the texts make clear: on the obverse "D'Eerwaarde deugt haar rechter arm beschut: de coopmanschap haar slinker onderstut" ("Honorable virtue sup-

FIG. 92. Medallion of JOHAN AND CORNELIS DE WITT (reverse). 1672. Amsterdam, Nederlands Scheepvaart Museum

FIG. 93. Medallion: *The Concord of the State.* 1606. Amsterdam, Nederlands Scheepvaart Museum

ports her right arm; trade supports her left"), and on the reverse "Vier Burgemeesters eel en vroom van stam regeerden 'tvolck en scheepryck Amsterdam" ("four Burgomasters of noble and distinguished stock rule the people and ship-rich Amsterdam").

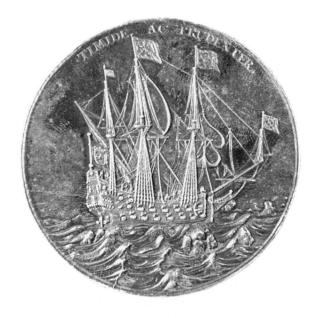

FIG. 94. Medallion: *The Ship of State in Perilous Waters*. 1647. Amsterdam, Nederlands Scheepvaart Museum

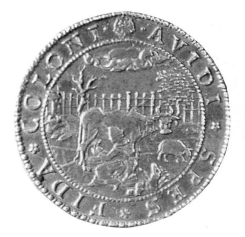
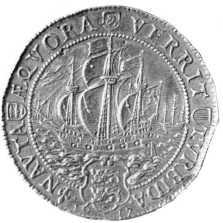

FIG. 95. Medallion: *The Prosperity of the Netherlands*. Obverse: *The Netherlands Cow in the Garden of Holland*. Reverse: *Sailing Ship*. 1617. Amsterdam, Nederlands Scheepvaart Museum

PRINTS WITH INSCRIPTIONS

Prints can also function in an emblemlike way, as we see in an engraving, perhaps by Robert de Baudous, dated 1613, allegorizing "s'Lands Welvaren" ("the prosperity of the land") through a view of the harbor of Amsterdam filled with ships and boats flying flags with the arms of the Dutch provinces (Fig. 96).[66] The dedicatory text explains that the picture symbolizes through ships the prosperous state of the United Provinces.[67] This use of ships for an iconography of prosperity probably underlies most paintings depicting Dutch harbors with bustling shipping made in the seventeenth century. Ludolf Bakhuizen made this

significance explicit in his etched views of Netherlands shipping of 1701, which he prefaced with an allegory of the mercantile power of Amsterdam. The accompanying text echoes the recurrent Dutch celebration of seafaring as the source of national security, prosperity, and the spread of true religion:

> Thus they build here on the [River] Y rich in shipping / The centerbeam of the state and cities / For the benefit of the community and the members / Of the East India Company / So one brings pearls from far-flung lands / There Christ's teaching is taught, established, and planted.[68]

Such prints with inscriptions form another source of evidence for the symbolic interpretation of storm scenes, but unlike other subjects in Dutch art in which paintings are reproduced in prints with metaphorical commentary, no allegorical prints based on typical Dutch and Flemish tempest paintings are known to me. Prints depicting other types of storm images do, however, shed light on possible interpretations of tempest and shipwreck and the intellectual associations stimulated by images of storm.

Two of these prints interpret storms as an autumnal season sign. One, an engraving titled *November* by Jacob Matham after Jan Wildens (Fig. 97), clearly belongs to the labors-of-the-months tradition and seems to depend on Bruegel's idea of dramatizing the season with a storm.[69] The text portrays the tempest as at once part of the cosmic cycle and a disturbance that threatens a discordant junction of opposites:

> Behold the Pleiades disturb the whole sea in the month of November, and a fierce wave carries off the imperiled ship; seeing which, you would say, "Who has joined together such discordant elements?" In this one place are heaven and black hell.[70]

Another engraving depicting *Autumn*, by Robert de Baudous after Cornelis Claesz. van Wieringen (Fig. 98), belongs to a series of four prints allegorizing the seasons not in terms of traditional labors but through the activities of ships.[71] The print, titled *Autumn*, does not depict a full storm, and the inscription is fully in accord with the image, associating the scene not with disaster but with a sense of the exhilaration of running before a freshening gale and of national pride in the hardiness of Dutchmen:

> Batavians, those water folk, exult to voyage on the high seas and to spread rank upon rank of sail to the North Wind.[72]

That Van Wieringen's otherwise realistic design could be interpreted as Autumn is significant, for it suggests the possibility that storm scenes could be read as embodiments of the conflicts between opposing elemental forces that traditionally produced seasonal storms. This interpretation also suggests that some Dutch storm paintings may have been pendants to calm seas or even to landscapes in a group of four seasons or in a summer/winter pairing, though no such set has survived. Storm scenes could also conceivably have been read as dramatized symbols of the element water, as in Reinier Nooms's etching *L'Eau* from a series of four elements (Fig. 99).[73] Each print renders one element as part

FIG. 96. *s' Lands welvaren.* 1613. Engraving. Brussels, Koninklijke Bibliotheek Albert I

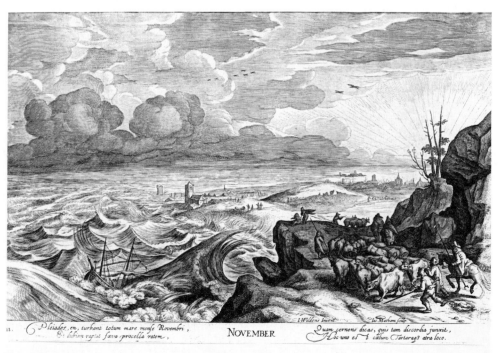

FIG. 97. JACOB MATHAM, after Jan Wildens. *November.* Engraving

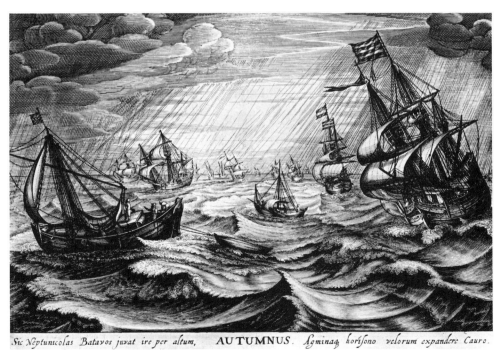

Sic Neptunicolas Batavos juvat ire per altum, **AUTUMNUS**. *Agminaq; horisono velorum expandere Cauro.*

FIG. 98. ROBERT DE BAUDOUS, after Cornelis Claesz. van Wieringen. *Autumn.*
Engraving

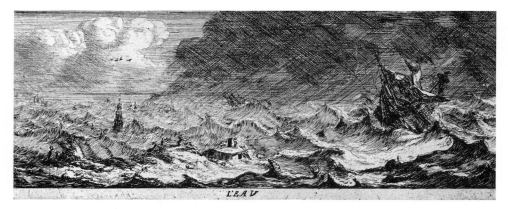

Fig. 99. Reinier Nooms, called Zeeman. *L'Eau.* Etching

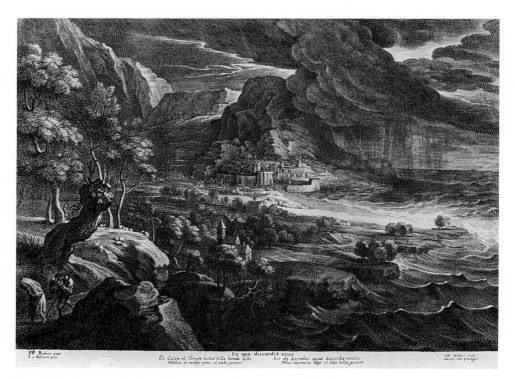

Fig. 100. Schelte Adams Bolswert, after Peter Paul Rubens. *A Storm over a Coastal City.* Engraving

of a land- or seascape in which it dominates its fellows. Unleashed elemental water manifests itself in a storm that, besides sinking a ship, floods the earth in the form of a Dutch countryside and fills the air with water in the form of driving rain.

The capacity of such images to evoke the fury of this elemental strife is suggested by the text that accompanies the engraving after Joos de Momper's design for a scene of shipwreck (Fig. 42). This print also belongs to a season

series and again illustrates autumn with a storm.[74] Interestingly, the text is not a metaphorical interpretation but a verbal counterpart to the horrific incidents represented in the engraving. To achieve this end, the poet enlists the familiar rhetoric of extreme anger and violent assault and destruction used for storms in the *ekphraseis* just discussed and in the literary tradition. Indeed, two lines of the poem paraphrase Ovid's *Tristia*:

> Thus when furious storms shake the known seas and the wind mixed with lightning drives [the waves], the hull entrusted to the sea is beaten by the waves and the angry sea shakes sails and yards. Troubled bodies are tossed about on the immense sea, and soon the underworld drinks in the heaped-up wealth.[75]

This poem suggests that for at least some viewers the meaning of a storm image resided primarily in its capacity to arouse an empathic identification with human beings caught in a cosmic conflict, with no more specific metaphor sought or required. But it should also be noted that the intensity of human identification with natural forces and the basis of this identification in a cosmology of correspondences made metaphorical interpretation an easy and almost habitual step.

The conflict of the elements in a storm figures prominently also in the inscription to Schelte Adams Bolswert's engraving after Rubens's *Storm Over a Coastal City* (Fig. 100). Here, however, elemental discord is interpreted virtually as an emblem of civil strife:

> "See whither discord [has led on] citizens"
> Fire and water confuse heaven and earth, waging "wars, dreadful wars" amid the clouds. But when discord vexes minds that are in disagreement they wage wars that are yet more harmful to others and themselves.[76]

The text was added by the publisher Marten van den Enden, though surely with Rubens's approval, and it indicates to us the kind of associations a storm breaking over a city could possess for an educated beholder.[77] The title paraphrases a line from Virgil's first *Eclogue* ("En quo discordia civis / produxit miseros"— "see to what point civic discord has led wretched country folk"), a context perhaps suggested to the author by the shepherd watching over his flock in the middle distance at left. The understated contrast between this figure, who embodies an ideal harmony with nature, and the tempest-lashed city and lowlands echoes vital issues of Virgil's *Eclogue*, in which civil war, which has resulted in the displacement of farmers, forms the background of the dialogue between a farmer and a shepherd.[78]

Although this image little resembles typical Dutch tempest scenes—its closest parallel in seventeenth-century Northern art is perhaps Rembrandt's *Stormy Landscape* in Braunschweig[79]—it is of special interest to us because of the way symbolism is perceived in the vigorous naturalism of the scene. A depiction of a breaking storm and of a city lead to meditation on civil strife in the little world of human polity as an echo of discord in the great world manifest in the storm. While other readings and associations are not excluded (the picture almost illustrates the autumnal storm in Virgil's first *Georgic*), the metaphor in this inscrip-

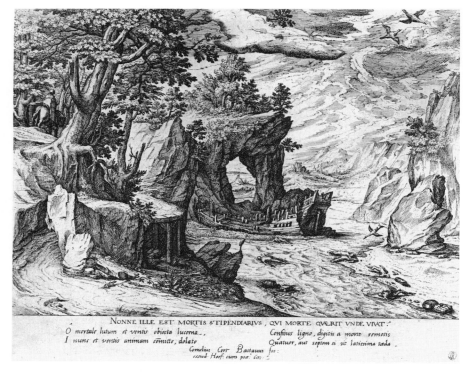

FIG. 101. JORIS HOEFNAGEL, after Cornelis Cort. *A Wrecked Ship in a Rocky Cove.* Etching

tion is not arbitrary. It conforms closely to the inherent content of the image and is justified by the conception of meaningful correspondences between microcosm and macrocosm.

The humanist culture that informs the inscription to Bolswert's engraving also marks two etchings dating about 1590 by Joris Hoefnagel after drawings by Cornelis Cort, probably of the 1570s. In inscriptions on these prints, shipwreck elicits the commonplace metaphor of the ship of human life suffering the storms of Fortune, although the interpretation reflects specifically neostoic ideas.[80]

A Wrecked Ship in a Rocky Cove (Fig. 101) is not a scene of catastrophe but a meditation on its aftermath.[81] The splintered hull of a ship is juxtaposed with one of the bizarre rocks with natural arches that become so common in seventeenth-century storm pictures. To the right bodies and cargo drift ashore; on the left a man on horseback rides along a wooded trail. This contrast between the safety and danger of modes of travel seems to fit the title of the inscription, a fairly standard attack on the folly of seafaring: "Nonne ille est mortis stipendiarius, qui morte quaerit unde vivat?" ("Is he not a tributary of death, who by death seeks his livelihood?") But the text goes on to imply the identification of all human beings with the sea voyager:

> O mortal clay and lamp exposed to the winds, "go now and entrust your life to the winds, trusting in rough-hewn wood, four fingers removed from death or seven if it be the thickest board."[82]

Seen with reference to this text, the natural arch of rock framing a gallows and

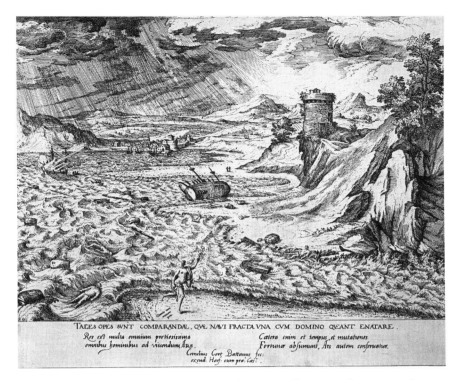

FIG. 102. JORIS HOEFNAGEL, after Cornelis Cort. *Ships Wrecking on a Coast.*
Etching

the wreck become emblems of man's mortality within the realm of nature.

A specifically stoic perspective on this pessimistic vision of life is offered by the companion print (Fig. 102), which depicts sea disasters in process—one ship is burning, another wrecked, corpses and flotsam and jetsam fill the breakers. In the foreground an allegorical figure of *Nuda Virtus* runs from the sea; she carries a staff of olive branches intertwined with a snake, symbols of Minerva and wisdom and of Mercury and art and science as well; and she wears an oxen skin, symbol of labor.[83] Representing the highest levels of humanist aspiration, she stands for true values that, in contrast to material possessions and worldly power, triumph over the blows of fortune symbolized by sea disasters, as the inscription reveals:

> Such wealth is to be gotten, which is the sort that could swim away together with its owner from a shattered ship. Art is by far the most precious thing of all for all men for living [well]. For both time and the changes of fortune consume the rest; art, however, is preserved.[84]

The lesson is driven home by the phrase inscribed near the figure of Virtue: "Omnia mea mecum porto" ("I carry my all with me"). Virtually no seventeenth-century tempest painting possesses visual features that would specifically encourage a reading as a humanist allegory of this kind. Nonetheless, Bonaventura Peeters's poetic meditation on his drawing of a ship in the storm (Fig. 82) reveals that stoic philosophical conceptions could well be applied to the seventeenth-century pictures.

PAINTINGS WITHIN PAINTINGS

The paintings within paintings that appear in many Dutch genre scenes also demonstrate the way seventeenth-century viewers read paintings as bearers of symbolic content. As normal decorations of an interior, paintings within paintings can be explained in purely realistic terms, but in at least some cases these pictures also comment on and even warn against the activities taking place in the rooms they decorate.[85] Seascapes, for instance, appear in a number of paintings that show a woman receiving, reading, or holding letters.[86] In these images they usually refer to the unquiet sea of love, a metaphor as widely known in the seventeenth century as in antiquity. De Jongh, who first observed the significant function of these seascapes, has suggested that the vessels in the pictures refer directly to the emotional states of the women in the paintings. In one interior by Dirck Hals (Fig. 103), for example, we find a smiling woman with a letter juxtaposed with a calm seascape, while in another (Fig. 104) we see a disappointed woman tearing up a letter and kicking the scraps. Near her is a more dynamic marine picture, though it is not, as De Jongh proposes, a storm, since the boats in the picture are sailing close-hauled into a fresh breeze. While the greater movement of the ships may reflect the woman's turbulent feeling, the picture in the picture is not truly a storm of love. The reference to the seas of love seems plausible, but a precise reading of mood through the seascape seems untenable.

FIG. 103. DIRCK HALS. *A Woman with a Letter.* 1633. Philadelphia Museum of Art, John G. Johnson Collection

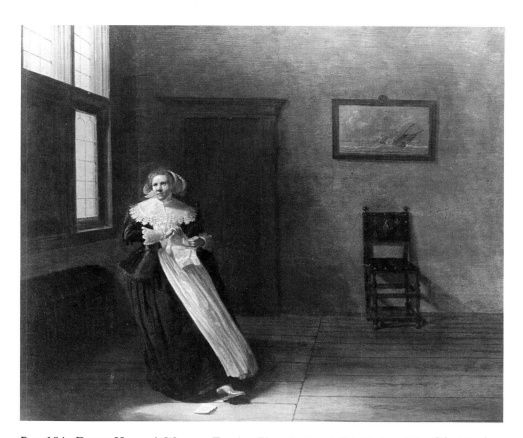

FIG. 104. DIRCK HALS. *A Woman Tearing Up a Letter.* 1631. Mainz, Mittelrheinisches Landesmuseum

In Vermeer's *The Letter* (Fig. 105) we again find a scene of fair-weather sailing above the woman and her maid.[87] The momentary and only partially accessible psychology of the exchange between the maid and mistress—knowing confidence suggested on the part of the former, questioning hope on that of the latter—reveals none of the distress depicted in Hals's picture. Again the dynamism of the seascape must refer to the general turbulence of a love affair, which may include both joy and loss. Interestingly, the maid in Gabriel Metsu's *Woman Reading a Letter* (Fig. 106) lifts a curtain partway up from a truly tempestuous seascape.[88] Here the picture of a storm seems completely out of keeping with the calm delicacy of the lady's mood as she reads her letter. The storm may suggest her hidden emotion, or perhaps it refers to her lover's sufferings, though in the pendant painting (Fig. 107) he is shown writing in no evident emotional upheaval. It seems most likely that the picture is meant to refer to the variety of emotions all lovers experience, not those of this particular moment. Still less clear is the significance of the painting on the wall behind the lover, apparently an Italianate pastoral landscape, though if taken as a pendant to the storm, this scene may well refer to the alternating emotional states experienced by lovers.[89]

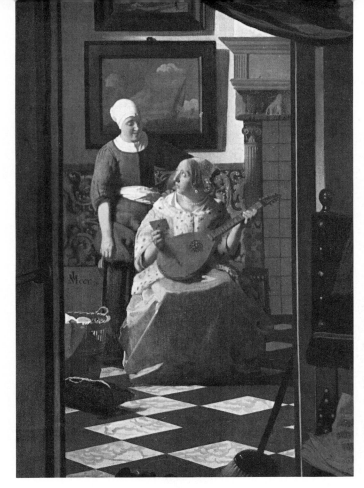

FIG. 105. JOHANNES
VERMEER. *The Letter.*
Amsterdam,
Rijksmuseum

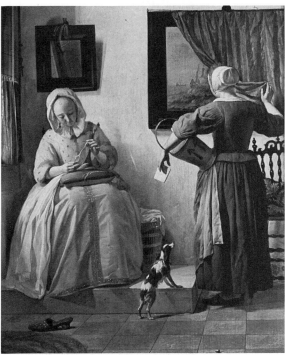

FIG. 106. GABRIEL METSU.
Woman Reading a Letter.
Blessington, Sir Alfred Beit
Collection

Given the contextual approach to metaphor typical of seventeenth-century sources, storm paintings within paintings suggest different connotations when placed in genre scenes depicting upper-class people indulging the senses with food, drink, music, and amorous dalliance. In a *Merry Company* by Isack Elyas of 1620 (Fig. 108), a chimney piece depicting the Deluge warns against the overindulgence of the five senses. These are represented by the celebrants at the table, from whom the portrait pair at right hold themselves aloof.[90] Anthonie Palamedesz. makes the same point with a painting of a ship in a storm in his *Musical Company* (Fig. 109) of 1632 in the Mauritshuis.[91] Palamedesz.'s picture is less overtly symbolic than that of Elyas: His figures do not so clearly allegorize the Five Senses, and the pictures on the wall are ordinary land- and seascapes. The potential for the abuse of pleasure is present in this gathering, however, and the storm warns against it by recalling metaphors of drunkards as helpless ships in a storm and of shipwreck as the end of those living dissolute lives.[92]

Slightly different connotations attach to the shipwreck scenes on the chimney pieces in two pictures by Jan Steen, *The Oyster Meal* and *"Soo gewonnen, soo verteert"* (*"Easy Come, Easy Go"*) (Fig. 110).[93] The statue of Fortuna standing before the seascapes in each is pointedly juxtaposed with the thoughtless sensual indulgence of the group at the table. The perils of such pleasures, which are ultimately subject to the fickleness of fortune, are also readily suggested by the

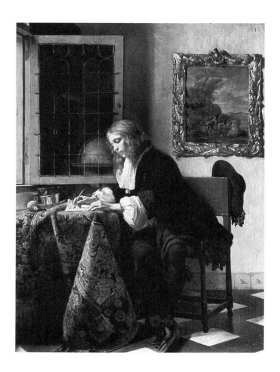

Fig. 107. Gabriel Metsu. *Man Writing a Letter*. Blessington, Sir Alfred Beit Collection.

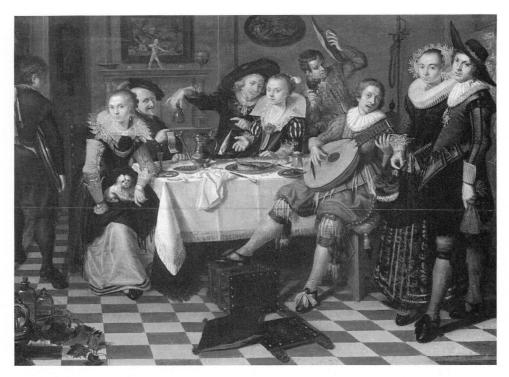

FIG. 108. ISACK ELYAS. *Merry Company.* 1620. Amsterdam, Rijksmuseum

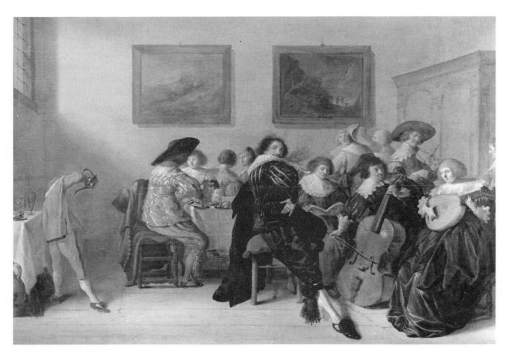

FIG. 109. ANTHONIE PALAMEDESZ. *Musical Company.* 1632. The Hague, Mauritshuis

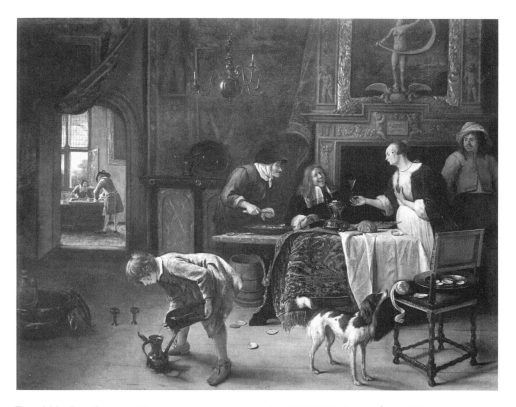

FIG. 110. JAN STEEN. *"Soo gewonnen, soo verteert."* 1661. Rotterdam, Museum Boymans—van Beuningen

tempest scene behind the statue in which one ship wrecks but the other, though partially dismasted, sails on. In *The Oyster Meal* Fortuna's ball (symbolizing her instability) rests on a death's head, a further warning of the transience and futility of such pleasures, while in the other scene, Fortuna stands directly on a die, referring to the backgammon game visible in a farther room at left and the folly and waste of such pastimes.

A storm scene conveys similar warnings in Jan van Bijlert's *Prodigal Son Among the Whores*, illustrated here by a copy in Leipzig (Fig. 111).[94] The themes of Steen's paintings and of *The Prodigal Son* are clearly related iconographically. Here, as in Steen's paintings, the youth's wasteful indulgence of his lusts leaves him subject to the mutability of Fortune, which is allegorized in a pair of sea-scapes. At left we see fair sailing in a calm seascape corresponding to his time of wealth. At the right, however, mortal peril of wreck is seen in the storm scene that foreshadows his downfall, which is visible in a doorway at right through which he is being driven into a bleak, stormy landscape. The deceptive beauty of the sea and the pleasure of sailing, as well as its ability to turn to deadly menace, were frequently likened in emblems to fortune and to the transience of sensual pleasures. The storm painting here is very close to an actual painting attributed to Jan Porcellis, *Three-Masters Clawing Off a Rocky Coast* (Fig. 112).[95] Of inter-

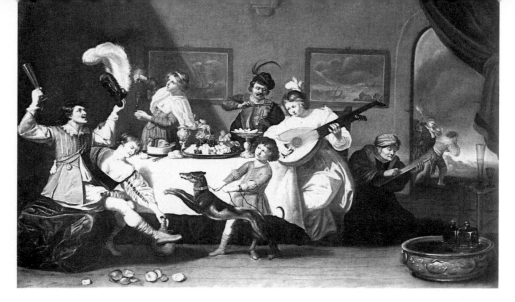

FIG. 111. Copy after JAN VAN BIJLERT. *The Prodigal Son Among the Whores.* Leipzig, Museum der bildenden Künste

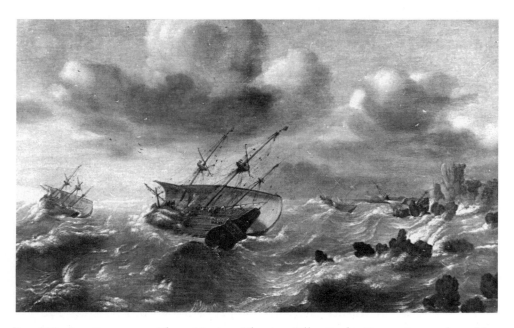

FIG. 112. JAN PORCELLIS. *Three-Masters Clawing Off a Rocky Coast.* Amsterdam, M. Wolff, before 1940

est in itself because so few paintings within paintings of any subject can be precisely recognized, this identification strikingly bears out an aspect of symbolic readings that we have repeatedly emphasized, the tendency of the symbolism to suit the circumstances depicted in the image being interpreted. In this case the nearly catastrophic fall of the Prodigal Son is paralleled by ships desperately threatened but not yet beyond hope.

FIG. 113. GABRIEL METSU. *A Musical Party.* The Hague, Mauritshuis

FIG. 114. GABRIEL METSU. *The Visit to the Nursery.* 1661. New York, Metropolitan Museum of Art, Gift of J. Pierpont Morgan, 1917

The extent to which our understanding of the implications of a storm painting within a picture must depend upon its context is made clear in Metsu's *Musical Party* (Fig. 113).[96] Here a shipwreck scene refers to the outcome of folly, but in this context the picture seems to warn not against the activity of the group, who are composing music, but against departing from the harmony they have achieved. The woman at center, who has apparently been writing musical notation, measures the beat with her hand, suggesting the positive powers of music to produce harmonious relatedness. In this case the shipwreck warns of the consequences of losing this measured concord. Metsu uses a similar picture to allude to the perils of this life in *The Visit to the Nursery* (Fig. 114), where the storm scene serves as a symbol of the tribulations of the voyage of life on which the newborn has just embarked rather than as an emblem of the outcome of folly.[97]

PENDANT PAINTINGS

The pairs of paintings within paintings seen in some genre interiors suggest that storm scenes could possess metaphorical significance in pendants. Unfortunately, very few pairs of paintings have survived, and it is usually difficult to prove that individual pictures once hung as pendants. Very likely more pairs were painted than we can now reconstruct. From views of interiors, moreover, it also seems likely that owners juxtaposed pictures that had not been painted as pendants but that nonetheless gained additional significance through such groupings. Pairs often involved, of course, opposition and reversal, as in the pairing of calm sea/stormy sea in Jan van Bijlert's *Prodigal Son* (Fig. 111). This pairing resonates not only with emblems on the sea's deceptiveness[98] but with the entire literary tradition in which the storm and its associated peril, disaster, and death exist in never-ending dialogue with fair weather, safety, prosperity, and life. As we saw in Chapter 2, thinking in terms of binary oppositions was a pervasive habit, and storm pictures in oppositional groupings reflect once again the tendency to conceptualize experience within generalized categories. In contemporary cosmology such polar tensions in human affairs echo sweeping oscillations between discord and harmony arising from the very fabric of the universe. Within this framework of ideas, every painting of a storm implies, at least conceptually, a calm harbor as its pendant, for the meaning of the tempest resides in large part in its relation to fair sailing and the harbor. Pairs of paintings make visually explicit what would have been implicit for seventeenth-century beholders.

Because the survival of pairs in general is so rare, few of storm and calm remain. An example by Matthys van Plattenberg has a calm Mediterranean harbor as pendant to a storm driving ships toward a lee shore (Figs. 115, 116).[99] Even this pair is known only in photographs. Other pairings of storm and calm occur as paintings within paintings. A pair strongly recalling Jan Peeters's work, for instance, hangs to either side of an arched doorway in a gallery scene by Hieronymus Janssens (Fig. 117).[100] More such pairings of these themes doubtless existed.

A related pairing consists of a storm scene and a calm, pastoral landscape, a juxtaposition evoking the recurrent theme of classical and Renaissance eclogue

FIG. 115. MATTHYS VAN PLATTENBERG. *Ships Driving Toward a Lee Shore.* Location unknown

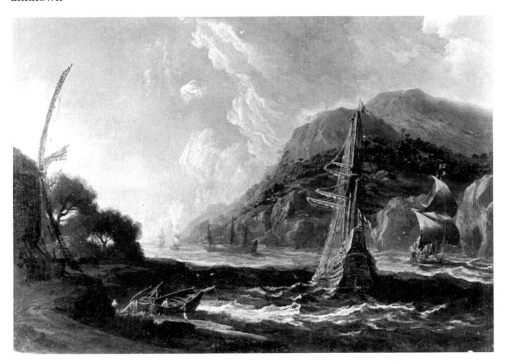

FIG. 116. MATTHYS VAN PLATTENBERG. *A Calm Harbor.* Location unknown

FIG. 117. HIERONYMUS JANSSENS. *A Picture Gallery*. Montargis, Musée Girodet

and georgic of the happy country life far from the raging sea. This pairing may well be suggested in Metsu's pendants in the Beit Collection (Figs. 106, 107), and it possibly explains the pendant to the storm in Palamedesz.'s *Musical Company* (Fig. 109), depicting two figures and an animal in what seems a hilly landscape at sunset. Actual pairs of pastoral and storm paintings do not survive in Dutch art, probably because most seascape specialists did not produce Italianate landscapes. Examples are known in Italian art, however, most notably in the work of Cavaliere Tempesta, who was Dutch by birth (Figs. 118, 119).[101]

Pairings of paintings could also be based upon conceptual parallels or, more accurately, correspondences, in view of the cosmology of macrocosm and microcosm. Tempests were paired especially with naval battles, conflict between men mirroring conflict in the greater world, as in Bolswert's engraving after Rubens. Vroom's pendants, *Ships in a Tempest* and *The Battle of Cadiz* (Figs. 54, 55) suggest another metaphor, for the battle scene functions as a symbol for the whole struggle, showing a battle between the English, Dutch, and Spanish admirals, who never actually closed for combat in this way. It is possible, therefore, that the foreground ship in Figure 54 is also a symbol, in this case of the Dutch state (her flags reveal her nationality) in the storms of war with Spain and perhaps of domestic controversy in the decade preceding the Twelve Years' Truce of 1609.[102]

A pair by Jan Porcellis, *Storm at Sea* and *Sea Battle by Night* (Figs. 120, 121) seems also to have a complex reference because the battle scene depicts the

conflict as taking place in the distance beyond a foreground group of fishermen at work.[103] There seems to be an implicit contrast between the industrious harmony of the foreground and the discord in the distance that gives the storm different connotations from that of Vroom, suggesting especially the theme of the vanity of human ambition in battle and in a struggle with nature.[104] The reference in Peeters's poem to sailors in the storm being like sailors in battle shows how such a moral could be expanded into a stoic meditation on the vanity of pleasure or ambition. Vroom's and Porcellis's pairs suggest the richness of interpretation that such juxtapositions made possible and indicate as well the loss we suffer because of the separation of most pendants.

In using pendants, emblems, and other symbolic sources to elucidate images of tempest, or indeed any landscape, it is important to keep in mind that the paintings are not diagrammatic, rebus-like arrangements of symbolic units. Though imaginary scenes based on conventions, they retain a high degree of realistic plausibility, and any symbolic interpretation of them must respect this realism. Furthermore, metaphorical readings derived from emblems and other sources must accord with patterns of significance inherent in the formal structures and narrative content of the pictures themselves. Choices of subject matter and narrative events, and the relationships between these thematic features revealed in the formal structure, have expressive consequences that are inherently meaningful. As Chapter 6 will make clear, these motifs and their relationships to each other conform to conventional patterns, or, as Fuchs terms them, "codes," communicating to beholders in a culture accustomed to looking for and finding details and patterns that fit conventional, universal categories.[105] In view of the existence of such "codes" in Dutch storm painting, symbolic readings can only be offered if they conform to the overall expressive structure and the particular details of an individual image. Historical sanction for this procedure exists in the many interpretive sources from the seventeenth century that seem also to have respected the character of the image being interpreted.

It is therefore arbitrary to apply a single marine metaphor to one feature of a painting as though thereby defining the meaning of either the motif itself or the image as a whole. Vroom's *Ships in a Tempest* (Fig. 54), for instance, if separated from its pairing with the scene of the Battle of Cadiz, cannot be read exclusively as the Dutch Ship of State with any more validity than it can be read as a metaphor for an individual's life. There are no corroborating symbols in the image itself.[106] Contemporary sources show, however, that it is appropriate to offer metaphorical readings that take into account the implications of the entire scene. Thus in Vroom's picture, any reading of the ship that sails onward, undaunted by a storm and monsters, must also include the threat embodied in a dismasted, helpless companion vessel at left (probably drifting to a sea anchor) and the ship smashing on the rocks at right. By the same principle, isolating a single feature such as the rocks and reading them as metaphors of endurance and virtue, a common motif in emblems, is not permissible given their dramatic role in the larger composition, where they function as a means of destruction.[107] Vergara, applying this line of reasoning, wisely suggests that Rubens's *Shipwreck* (Fig. 77) not be read solely as a Ship of State metaphor, though it may well have been inspired by such ideas, but as a more generalized metaphor of Fortune

FIG. 118. PIETER MULIER THE YOUNGER, called Pietro Tempesta. *Shipwreck on a Rocky Shore.* Geneva, Musée d'Art et d'Histoire

FIG. 119. PIETER MULIER THE YOUNGER, called Pietro Tempesta. *Pastoral Landscape with the Flight into Egypt.* 1696. Geneva, Musée d'Art et d'Histoire

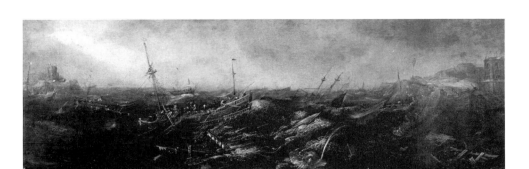

FIG. 120. JAN PORCELLIS. *Storm at Sea.* Hampton Court Palace

FIG. 121. JAN PORCELLIS. *A Sea Battle by Night.* Hampton Court Palace

and Fate. This reading perfectly suits the structure of the picture, which, as we read it from left to right, moves from destruction and death to salvation and life beginning anew.[108]

The multiplicity of symbolic readings in the sources and the quite unexpected character of many metaphors also require that we not make exclusive claims for the validity of a single interpretation. Land- and seascape were looked at in many contexts and for varying periods of time, from a brief glance to a prolonged meditation, and by people of varying backgrounds and dispositions, making it impossible to be dogmatic about how contemporary beholders perceived meaning. Our own interpretation, however, must be guided by the content of an individual picture itself and by the conventions through which it communicated. These conventions are, then, the last elements of interpretation we must consider.

6

Realism, Convention, and Meaning

The symbolic reading of storms in both literary and visual sources confirms the importance of grounding interpretation in a close attention to the narrative and formal elements of an image. Applying this insight to storm images means attending carefully to conditions of weather and the situations of vessels and crews: How severe is the storm? What is the degree of threat to the ship? What is the fate of other vessels shown? What is the response of the crew? And it requires examining how the formal structure—the size, prominence, clarity, location, color, and interrelationship of pictorial elements—affects the meaning of the situation shown.

The value of this approach to seventeenth-century tempest pictures becomes apparent when we recognize that their dramatized naturalism disguises their almost complete conformity to a limited number of formulas of narrative incident and formal expression. In adhering so closely to pictorial types, Dutch tempest scenes resemble the vast majority of seventeenth-century land- and seascapes, in part reflecting the artists' practice of painting not *en plein air*, recording an immediate apprehension of the world, but in the studio. It is a mode of working in which pictorial schemata assist the artist's drawings and memory in creating "uyt den gheest" ("from the imagination").[1] The virtually identical compositions used to render quite different incidents in several artists' works are evidence of this use of schemata (see, for example, Figs. 128, 129).

These conventions, however, are also one of the most important features of Dutch realism for interpretation because they reveal the limited range of reality that artists chose to depict. Rather than embracing all the situations ships and

men faced in storms, Dutch paintings portray but a small number of such events. This is not to say that all pictures of a given type are identical but that the range of variation is surprisingly limited. Tempest paintings neither illustrate specific voyages (except in rare instances) nor comprehensively survey the vicissitudes of seafaring. Rather, they portray human contention with the elements selectively, interpretively re-creating the experience of the storm in images that combine naturalistic accuracy with dramatic artifice. Although these paintings were thought of and valued as accurate imitations of nature in the seventeenth-century theory of art, the images themselves—and such literary responses to them as Oudaan's poetry—reveal that they were intended to arouse the viewer's empathic responses. Carefully describing the struggles and fates of human beings and vessels, they are dramatizations purposefully staged to engage us by their compelling immediacy. Reinforcing this narrative content, the formal structures of the pictures actively evoke our emotional participation as well.

This dramatic mode of representation is a further convention of the pictorial language of tempest painting. Its resemblance to the rhetorical tradition of storm description and allegory in literature suggests that the paintings can be best understood as visual analogues to this body of traditional ideas about nature at its most extreme and man's capacity *in extremis*. These pictorial conventions of narrative and form not only endow the works with an inherent significance and rhetorical power, they also strongly indicate that, like literary tempests, the paintings possessed the capacity for metaphorical interpretation. Conventionality depends on a predisposition to seek in a situation the typical pattern rather than the unique circumstance, a tendency of mind that underlies all metaphor in the seventeenth century. The conventionality of these pictures strongly argues that they too do not describe the specifics of history but articulate universal truths discernible in a purposeful cosmos.

Analyzing these conventions thus reveals a significant content that is not external to but inherent in the pictures. This significance is neither disguised nor concealed by the naturalism of the images—rather, it resides in their narrative and formal structures, where it is articulated by adherence to or divergence from typical patterns of representation. In this chapter, this significant narrative incident and affective content is described for each of the six types of Dutch storm painting. This content is further amplified through the application to each type of a variety of sources in which the narrative situations are interpreted metaphorically. These readings are attempts not to decipher a concealed symbolism but to allow the intrinsic symbolic potentials of an image to emerge and resonate with the culture of the seventeenth-century Netherlands.

NARRATIVE CONVENTIONS:
THE DRAMATIC ROLE OF SHIPS

In the seventeenth century the natural world is hardly ever—perhaps never—depicted in a finished image without man's presence, a characteristic that tem-

pest pictures share with land- and seascape in general.[2] Even in the brooding swamps of Jacob van Ruisdael huntsmen and travelers move freely. The world of seventeenth-century land- and seascape is accessible to man and proper to him—no matter how forbidding, vast, and perilous. Tempest paintings bear out the central role of humanity in land- and seascape through the accurate rendering of the appearances and tactics of vessels and more subtly through the careful integration of vessels into pictorial structures. Ships, in fact, acquire roles in these images akin to those of human beings in history painting. They serve as protagonists of the narratives and as subsidiary foils or chorus to the major actors. The role of ships as objects of sympathetic identification is inherent in the sixteenth-century compositional type from which seventeenth-century pictures descend, the distant view of the ship in a panorama. Ships, moreover, possess an intrinsic affective power, for they are not anonymous objects but manned vehicles that embody human ingenuity and presence in the world of movement and change. Their very complexity as achievements of human engineering gives them interest, while their role as harnessers of and combatants with the elements endows them with dramatic appeal. Every voyage has a temporal dimension like a story moving to an end, and a sailing ship moves through that story with a responsiveness to the natural forces around it that makes it seem alive and, indeed, human.[3] In view of the capacity of ships to serve as objects of sympathetic identification, it is all the more surprising—and ultimately revealing—that we can analyze the dramatic parts ships play in Dutch tempest scenes into a small number of formulas or types.

STORM ON THE OPEN SEA: STRUGGLE AND ENDURANCE

One type of tempest picture depicts vessels with no land in view, relying entirely on waves, clouds, patterns of light and dark, and the forms of ships for its expressive effects as well as its formal structure. Typical examples include a painting by C. C. Wou dated 1627 (Fig. 122)[4] and Willem van de Velde the Younger's *"Gust of Wind"* of about 1680 (Fig. 2).

In these images the diagonals of the waves establish a basic tone of instability that is amplified in the other forms. As the ships pitch and rise, the lines of their masts and rigging interact contrapuntally with slashing rays of light or sweeping clouds. The lack of solid earth in these pictures, though conceivably a blessing from a mariner's viewpoint, renders that instability absolute as it surrounds the vessels, threatening to overwhelm their struggles to hold their courses in the turmoil around them.

The focus on the effort to control the ships is, in fact, an essential characteristic of this type. In it vessels are hardly ever shown sinking or swamping or broaching to towering seas, all events that did occur. Willem IJsbrantsz. Bontekoe, for instance, in the famous account of his voyages published in 1646, describes the loss of two of the three ships under his command due to heavy storms.[5] In Dutch and Flemish storm paintings, however, ships sink almost exclusively on coasts. When no land is in view ships not only manage to stay afloat but in most cases are still under the control of their crews.

The importance of the theme of control in these images is evident from the

attention they give to the tactics used to maintain control.[6] Many depict ships scudding before the storm under reduced sail with the wind directly astern; only the forecourse and sometimes the mainsail or mizzen are set and half-lowered. A tactic frequently attempted in storms, its purpose was to keep the ship from being dismasted or the sails blown to shreds, and to prevent the ship from coming around and taking the waves broadside. Trimming the sails was ordinarily used to help steer these ships since the rudders could turn only through a limited arc. In heavy weather, as it became increasingly difficult to handle the rudder, setting at least one sail allowed a crew to alter a ship's course as necessary to take high waves directly astern when running before the wind. This seems to be what is depicted in a number of pictures where groups of sailors are shown hauling on the sheets and braces (Fig. 123).[7] Sailing close-hauled to windward under reduced sail, the alternative tactic to scudding before the wind, also appears in many storm scenes (Fig. 70).

Whatever courses these ships on the open seas follow, in almost all cases they are still under sail and to some degree under control, though the outcome of their struggle is usually not yet clear. Rarely does an artist depict ships scudding under bare poles, without any sail set, or lying to, drifting with the bow to windward, or sometimes with the forecourse set, which ships were forced to do once the strength of the storm became too great for the sails. This was again a common situation, familiar in the accounts of the Dutch voyagers, in which a typical entry reads: "On March 14 we had a very heavy storm from the s.s.e. so that we struck our foresail, and drifted without sail."[8] Bontekoe vividly describes lying to as "op Gods genade dryven," drifting at the mercy of God.[9] This

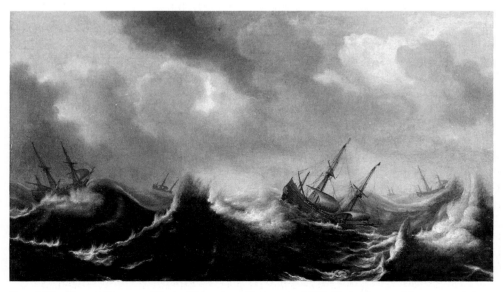

FIG. 122. CLAES CLAESZ. WOU. *Ships in a Tempest.* 1627. Providence, Museum of Art, Rhode Island School of Design

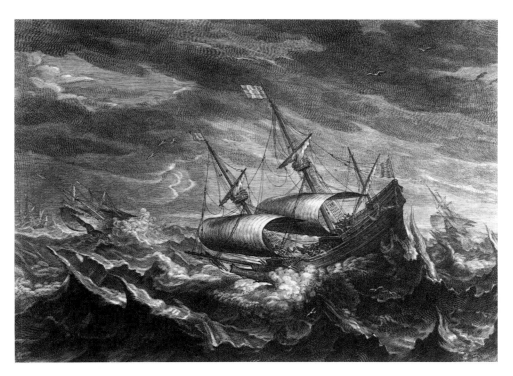

FIG. 123. SCHELTE ADAMS BOLSWERT, after Andries van Eertvelt. *Ships in a Tempestuous Sea.* Engraving

is exactly what most of these paintings do *not* show. They portray not the helplessness of ship and crew bowing before nature but rather continuing struggle in the storm (an outstanding exception is Van de Velde's painting in the National Gallery, London, dated 1673, depicting three Dutch ships lying to in a storm; Fig. 59).

This is not to say that these images imply a successful voyage. Safe arrival in port or passage from the storm to a region of fair weather cannot be assumed from what is depicted. The implicit need for continuing care and perseverance amid constant perils is further intensified by the varying degrees of damage vessels have suffered. Though many paintings like that by Wou (Fig. 122) depict vessels with little or no damage, many others show ships with sails blown from the bolt ropes by the wind. In Van de Velde's *"Gust of Wind"* (Fig. 2), the wildly flapping sail will soon be in shreds (a tear is already visible), and though this is not in itself a desperate situation, it greatly lessens the ship's maneuverability. This vessel has also lost the upper half of its main topmast and the whole topgallant mast and yard, and her mizzen yard is missing. Although not immediately serious, since such damage was common in heavy weather and appears frequently in this type of storm picture, these losses are, nevertheless, further steps in the direction of helplessness before wind and sea. They suggest the possibility of additional loss.

A still more battered ship fills the foreground of another painting by Van de

Velde dating also about 1680 (Fig. 124).[10] Not only has this ship's forecourse blown from the bolt ropes but most of her mainmast has also gone by the boards, her mizzen topmast has broken above the top and hangs in the rigging, and her spritsail and spritsail topmast have been lost as well. The wind in this picture, as in the Rijksmuseum painting, is apparently becoming too strong to allow any sail to be carried. Yet only occasionally do artists go beyond the extremity of this situation to depict ships that have struck all sail in order to try to ride out the tempest under bare poles or ships that are completely dismasted (Fig. 59).

The Storm on the Open Sea, then, portrays ships in situations that range from vessels sailing handily in the storm, through ships that show increasing levels of damage to sails and spars, to moments of crisis as sheets part and actual control of the ship is in question. What is virtually always chosen for illustration are ships holding courses or struggling to do so. Ships wrecked and ruined, or turned into helpless, dismasted hulks, or lying to, trying to ride out the storm, or castaways adrift in lifeboats at the mercy of the elements rarely appear in this type. The Storm on the Open Sea is not concerned with exploring all the possible forms of disaster and suffering that can and did occur, but rather human perseverance in a situation of great peril. Interestingly, Oudaan, in his reading of a painting by Porcellis, speaks in exactly these terms of maintaining control in the face of the storm.

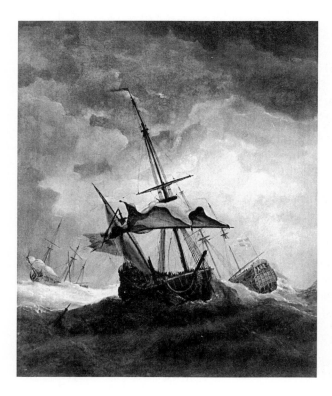

FIG. 124. WILLEM VAN DE VELDE THE YOUNGER. *English Ships in a Storm*. Formerly Vierhouten, Van Beuningen Collection

The narrative and expressive content revealed through the close reading of these paintings is fully in accord with emblematic interpretations of tempest-tossed ships on the open sea, which are often seen in terms of virtue—be it of a good man, a wise ruler, or a faithful Christian—persevering in adversity (Fig. 86). The barrels and bales floating in the waves in some pictures (Figs. 53, 56, 123) amplify on both narrative and allegorical levels this theme of struggle for control. Casting goods overboard to save the ship is a recurrent incident in literary storms and readily lends itself to metaphors of the voyage of life, of faith, and of the state: the necessity of giving up worldly goods to save greater goods, one's life or soul (Fig. 125),[11] or in the barrel trick, to elude powerful enemies of the state (Fig. 27). Interestingly, the barrel trick is rare in seventeenth-century imagery in which marine painters substituted the threat of purely natural disaster for the personified dangers of sea monsters.[12] Even the less specifically symbolic whales of Vroom, Segers, and Wou vanish during the 1630s.

Storms on the Open Sea can also be given a more ominous interpretation because the outcome of the struggle remains open, leaving room for a wide range of pathetic involvement. The tempest painting in Metsu's *Woman Reading a Letter* (Fig. 106) suggests that ships in storms on the high seas could be interpreted as symbols of love. It is, however, not the lover arriving in the port of the

FIG. 125. Emblem from *Afbeeldinghe van d'eerste eeuwe der Societeyt Iesu*, Antwerp, 1640

beloved's favor that is shown, as in Krul's emblem (Fig. 90), but the lover strug-
gling in the tempests of uncertainty and fear, as described by Daniel Heinsius:

> The waves of the sea, driven to the sky, frightfully assault the ship that you see
> here: it pitches, it gives way, it sinks; the sailors themselves tremble, and they no
> longer have the rudder under control. The heaven is clothed with clouds and with
> winds, the day is full of night. Light is all perished. In this darkness you will find
> hope yet, if you but look and see the eyes that there stand.[13]

A negative interpretation of the Storm on the Open Sea views this onward
struggle as vanity, for just as the ship rises to the stars in a storm and is cast into
the abyss, so God hurls the mighty into ruin (Fig. 126).[14] This reading is, how-
ever, exceptional, and the interpretation most emblems give of this type is in
sympathy with the struggle for survival depicted in the paintings. Geoffrey
Whitney's emblem "Constantia comes victoriae" ("constancy is the companion
of victory"; Fig. 127) epitomizes these interpretations:

> Thoughe master reste, thoughe Pilotte take his ease,
> Yet nighte, and day, the ship her course dothe keepe;
> So, whilst that man dothe saile theise worldlie seas,
> His voyage shortes: although he wake, or sleep.
> And if he keepe his course directe, he winnes
> That wished porte, where lastinge ioye beginnes.[15]

FIG. 126. Emblem from KORNELIS
ZWEERTS, *Zede-en zinnebeelden*,
Amsterdam, 1707

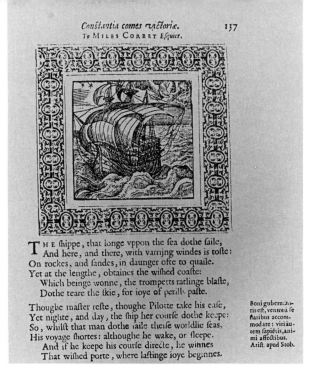

THE ſhippe, that longe vppon the ſea dothe ſaile,
And here, and there, with varijng windes is toſte:
On rockes, and ſandes, in daunger ofte to quaile.
Yet at the lengthe, obtaines the wiſhed coaſte:
 Which beinge wonne, the trompetts ratlinge blaſte,
 Dothe teare the ſkie, for ioye of perills paſte.

Thoughe maſter reſte, thoughe Pilotte take his eaſe,
Yet nighte, and day, the ſhip her courſe dothe keepe:
So, whilſt that man dothe ſaile theiſe worldlie ſeas,
His voyage ſhortes: althoughe he wake, or ſleepe.
 And if he keepe his courſe directe, he winnes
 That wiſhed porte, where laſtinge ioye beginnes.

Boni gubernato-
ris eſt, ventorū ſe
flatibus accom-
modare: viriau-
tem ſapiētis,ani-
mi affectibus.
Ariſt. apud Stob.

FIG. 127. Emblem from
GEOFFREY WHITNEY, *A
Choice of Emblems,* Leiden,
1586

SHIPWRECK ON A ROCKY COAST:
FORTUNE AND MORTALITY

Catastrophe and the immediate threat of it are the provinces of two other types
of tempest image in the seventeenth century: the Shipwreck on a Rocky Coast
and the Threatening Lee Shore. The actual distinction between these types
cannot be maintained too neatly since the former often includes vessels strain-
ing to escape the menacing shore and both types share the same kind of coast-
line and similar compositions. There is, however, a significant difference in the
narrative and emotional implications of these types. The Threat depicts vessels
facing a peril that remains implicit, that may or may not be eluded and whose
outcome is not portrayed (Fig. 129),[16] providing a tension that is distinct from
the overt dangers of the Shipwreck type (Fig. 128). Although the latter can also
include threatened ships, their peril is explicitly realized in the destruction of
other ships, giving a tone of greater urgency to their danger and enhancing the
mood of violence and desperation in the entire image. It seems appropriate,
therefore, to treat as a separate type pictures without shipwrecks or in which the
wreck is so insignificant that it does not intrude.

 Within the Shipwreck type itself the focus on the destruction of a vessel and
the fate of her crew can be to the point that threatened ships are either absent
(see Fig. 79) or remote from the center of attention. Sometimes the ship has
already sunk (Fig. 128), so that only the bow and the foremast are still visible,
pointing at steep angles as though reaching upward in torment as the vessel is
literally splintered by the pounding waves. The destruction is not always so
advanced. In his *Shipwreck on a Northern Coast* (Fig. 74), Bonaventura Peeters
portrays the ship dragging aground, but she is still in one piece, despite the
damage already done her stern. Not only do hulls smash on the rocks but the
means of propulsion, the complex mechanism of sails, masts, and rigging, also

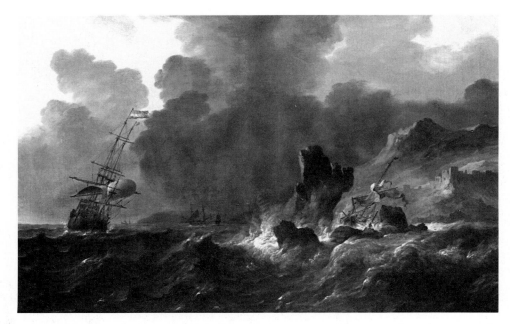

FIG. 128. LUDOLF BAKHUIZEN. *Ships in Distress on a Lee Shore.* Greenwich, National Maritime Museum

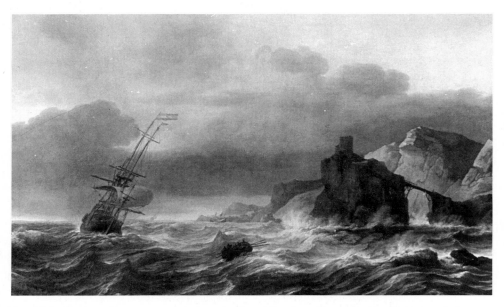

FIG. 129. LUDOLF BAKHUIZEN. *A Dutch Ship off a Lee Shore.* Berlin, P. Rosenthal, 1929

disintegrates as masts topple, spars break, and sails are shredded. The total helplessness of the vessels vividly engages our empathy.

The circumstantial description of the destruction of ships and of their impotence before the power of wind and wave seems intended to excite in the beholder a compassion of the kind we have seen in Linschoten's account (see page 45). But this emphasis on helplessness also evidently led seventeenth-century viewers to meditate on shipwreck as a figure for the man who has surrendered his self-

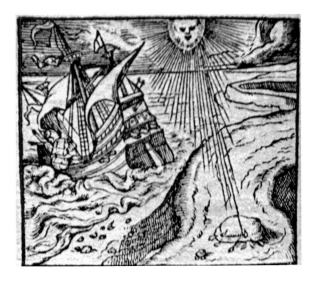

FIG. 130. Emblem from
JOHANNES SAMBUCUS,
Emblemata, Antwerp, 1566

control to passion, perhaps in drunkenness (Fig. 10), or in anger (Fig. 11), or in an unhappy marriage (Fig. 87). The vulnerability revealed in shipwreck could also allegorize a human being or the state rendered helpless and doomed by changes of Fortune, as in the medallion on the deaths of the De Witt brothers (Fig. 92) or in Sambucus's emblem "Res humanae in summo, declinant" ("the affairs of men at their height, decline"; Fig. 130), one of the most common themes of shipwreck emblems.[17] The sinking ship can also function emblematically as a kind of *vanitas*: Roemer Visscher allegorizes the folly of a man who dares disaster at sea twice (Fig. 9), recalling the text on the etching by Hoefnagel (Fig. 101): "Is he not a tributary of death, who seeks by death whence he might live?" Another emblem reads shipwreck as the outcome of worldly ambitions.[18]

In some paintings of the Shipwreck type, the wreck shares the stage with one or more vessels endangered by rocks, providing a harsh warning come as virtually a nautical *memento mori*. In paintings like Adam Willaert's *Shipwreck on a Northern Coast* (Fig. 131)[19] or Eertvelt's *Storm with the Wreck of a Turkish Galley* (Fig. 61), the wreck and the ships attempting to elude disaster receive about equal place, increasing the tension in the pictures by stressing the imminence of catastrophe. While the three ships beating to windward in Willaert's composition have a chance to escape, they are perilously near the rocks that have already claimed one vessel. A small miscalculation or a shift in the wind and they could easily end up in the situation of the small boat in the foreground manned by the shipwrecked crew, which is being blown back toward the rocks despite the sailors' efforts to bring the sail to the wind. In Eertvelt's picture the ship at left is also in a precarious position since her mainsail is beginning to blow out. Without sails she will inevitably be driven ashore to the horrible fate of the galley in the opposite corner of the painting. Another ship at center sailing close-hauled on the port tack may have a chance to escape, but the ship at far left and another in the distance are rushing before the wind to certain disaster.

In other paintings of this type, the wreck is distinctly subordinated to such threatened vessels, and our attention centers even more fully on their battle to avoid the rocks. In Vroom's *Ships in a Tempest* (Fig. 54), the ship at center, sailing with the wind astern, should have no difficulty avoiding the rocky outcropping in the middle distance, whereas two less fortunate vessels are being

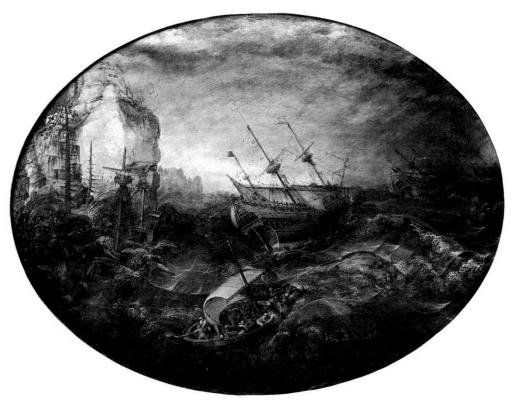

FIG. 131. ADAM WILLAERTS. *Shipwreck on a Northern Coast.* 1614. Amsterdam, Rijksmuseum

battered. In contrast, Porcellis's similar painting in Hampton Court (Fig. 120) shows the central ship in serious trouble as a lee shore looms at right, and the ship has lost her mainmast (which drifts beside her—her crewmen have been trying to chop it away) and has no other sail set to attempt to beat off the coast. Her anchor is lowered, but judging from the wreckage along the coast, it will afford little protection to the almost helpless vessel. A similar peril faces the dismasted ship with her anchor lowered in Bonaventura Peeters's *Ship in Distress off a Rocky Shoal* (Fig. 80), formerly in Rotterdam, where a large rock has snared one ship (her masts are visible around the natural arch) and a shift in the wind could send the drifting ship directly to the same fate. Between these extremes of relative safety and almost sure destruction are depictions of ships in critical moments in their attempted escapes. The English ship trying to claw off a lee shore in Van de Velde's painting of 1672 in Greenwich (Fig. 132) may have a chance of survival if she can work to windward.

These pairings of disaster and attempts to escape could be readily interpreted in terms of the vagaries of Fortune's favors, as in the painting-within-a-painting in Jan Steen's *"Soo gewonnen, soo verteert"* (Fig. 110). We also find this juxtaposition read as an emblem of life in the world, where a ship, weakened and poorly steered due to sin, suffers misfortune and wreck, while another, strengthened and guided by faith, escapes the threats of Fortune and reaches the harbor of eternal life. The icon of this emblem (Fig. 133) strongly recalls shipwreck scenes by Jan Abrahamsz. Beerstraten (Fig. 136).[20]

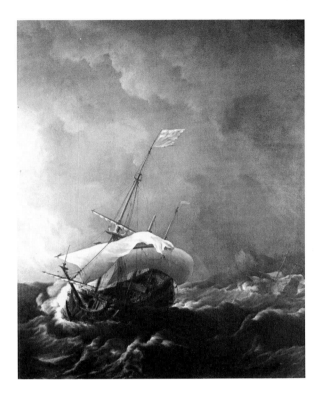

FIG. 132. WILLEM VAN DE VELDE
THE YOUNGER. *An English Ship
off a Lee Shore.* 1672.
Greenwich, National Maritime
Museum

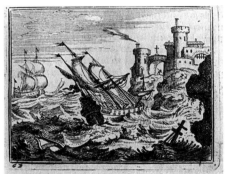

Door ftorm't een Schip licht onder-gaet,
Daer 't ander inde haef mé-flaet.

FIG. 133. Emblem from JOANNES A CASTRO,
Zedighe sinnebelden, Antwerp, 1694

 A distinct variant of these shipwreck scenes is a group of paintings depicting in addition to a wreck a small boat successfully sailing off the fatal coast. One of the earliest examples is Jan Porcellis's *Pink Approaching Shore* of about 1614–18 (Fig. 146). The *pink*, a small fishing boat, sails without evident difficulty in a strong gale past a bulwark against which a *jacht*, a larger, elegantly decorated pleasure craft, is sinking as her crew pull themselves ashore. Reading a moral in this narrative is almost irresistible: modest appearances and humble ambitions are less subject to the sudden alterations of Fortune than wealth and pride. The contrast between the humble workaday vessel and the ornate luxury ship is

made even bolder in pictures by Jacob Adriaensz. Bellevois (Fig. 134)[21] and Jan
Theunisz. Blankerhoff (Fig. 135).[22] Blankerhoff's painting is especially dramatic
as a *hoeker*, another small fishing boat, perhaps in a rescue attempt, approaches
the much larger Dutch ship, that, with her forecourse aback and mainsail flying
wildly, is helplessly driven onto the low rocky shore. All her size and power are

FIG. 134. JACOB ADRIAENSZ. BELLEVOIS. *Ships in Distress on a Rocky Coast.* 1664.
Braunschweig, Herzog-Anton-Ulrich Museum

FIG. 135. JAN THEUNISZ. BLANKERHOFF. *A Shipwreck.* Copenhagen, Statens Museum

FIG. 136. JAN ABRAHAMSZ. BEERSTRATEN. *Shipwreck with Castaways.* Munich, Bayerische Staatsgamäldesammlungen

useless in this extremity; in fact, they only make her plight worse. The diagonals of her masts and yards echo those of the *hoeker*, underscoring not just the contrast of tonnage and sail area but also the differing capacities of great size and might and smallness and handiness in this situation of mortal peril. Although no emblems or other seventeenth-century interpretations of this contrast are known to me, the frequency with which the shifts of Fortune are seen in interpretations of shipwrecks and the clarity and vividness of the narration make such a moral lesson plausible here.

The extremity of the situation shown in shipwreck images is frequently heightened by vividly circumstantial renderings of the crews of ships straining to work their vessels off threatening coasts and, when all is lost, abandoning ship. Though usually minute in scale, the crewmen can often be read in some detail as they furl the sails and haul on braces and sheets. Gesturing wildly at the shore and throwing their arms up in despair (Figs. 134, 161), the men, whose smallness adds to their pathos, become still more moving as their vessels drag aground and sailors clamber into the rigging and drop over the sides of the ships (Figs. 134, 136). Their horrifying predicament is to choose between being pounded to pieces with their ship or leaping from her or swinging on lines into the wild surf that could smash them into the rocks. Few could hope to survive raging seas on these rocky coasts, as Linschoten's account of the destruction in the storm of the Spanish fleet again reveals:

[The Witte Duyve] was on the side of the island where it was entirely sheer, precipitous, and high cliffs and rocks, like mountains, so that it is a horror to look at them; where already some inhabitants stood with ropes with cork tied at the end to throw to people so that they might get their hands on it. But few came so near, and most of them were already dead and in pieces before they drew near the shore.[23]

In these paintings castaways cling to spars, masts, and barrels (Fig. 134); others put off from their ships in boats and try to get into shore away from the rocks (Fig. 136).[24] Some boats make it ashore, as do individual castaways, who cling to rocks where they seem perilously close to being washed back to sea. In some scenes a few lucky survivors reach a stretch of beach between cliffs or a spot from which companions or the inhabitants of a town visible atop the cliffs can pull them to safety (Fig. 136). Coming ashore, the castaways show varied responses: desperation, terror, exhaustion; some hold their heads in their hands, others clasp their hands in prayer.

It is important to recognize that while these figures are often vividly characterized, they remain small: Close examination is required to decipher their affect, and in a number of cases (Fig. 155, for example), they are too minute or rendered in insufficient detail to allow precise interpretation. The figures, like the ships, are a means of engaging the viewer in the situation. Like the ships, some men escape the storm, but their pictorial context is the ultimate, mortal danger that all men at sea face from pounding waves on a rocky lee shore. Some are saved, some perish; but all are vulnerable.

Further enhancing this sense of helplessness and weakness is the affective value of the horribly rugged coastline depicted in the Shipwreck type. As noted in Chapter 4, these locales, even when populated by civilized rescuers, are remote from the flat beaches of the Netherlands, further enhancing our sense of the vulnerability of the vessels and castaways. Many such coasts are wild, savage places. Their inhospitality is essential to a grim irony in this situation, one that Vondel recognized when he wrote that a sailor in a storm "curses the longed-for land, although he fears the sea."[25] Indeed, the deadly cliffs that cause the wreck are the castaways' only hope of escape once a ship is aground; and the perilous open sea offers the only escape from the certain disaster of driving ashore. Human deliverance can be found only in places of desperate danger.

This emphasis on our frailty thoroughly governs the choice of situations in the Shipwreck type. These paintings do not depict all the ways a ship can wreck, nor all the places a vessel can go aground, nor all the sufferings possible for the shipwrecked. Castaways helplessly drifting in lifeboats or rafts, as in Géricault's *Raft of the "Medusa"* (Fig. 137), are conspicuously absent.[26] Painting at the beginning of the nineteenth century, Géricault emphasizes the physical and psychological effects of the prolonged agony of drifting at sea: death from starvation, thirst, and exposure; despair, madness, frenzies of hope, and he alludes to cannibalism.[27] Just listing the *affetti* in the *Raft of the "Medusa"* reveals how different its emotional charge is from that of Dutch shipwreck imagery. Looking at the *Raft* we are able to experience the most intense identification with and compassion for "the horror and anguish of the men on the raft," as the artist himself described their sufferings.[28]

The intensity of our empathy with the protagonists in their struggle with the natural world profoundly differentiates Géricault's scene from Dutch shipwreck pictures, even those with many figures. In the latter, we remain at a distance, observing mankind in a composition that locates action, suffering, and vulnerability within a wide natural context possessing an equally strong emotional value. We respond to the rhetorical drama of these Dutch pictures, but we are not ourselves overwhelmed by emotion and turned into near participants as we are when standing before the huge *Raft of the "Medusa"* with its boards and corpses seemingly a few feet from us.[29] Moreover, the Dutch scenes are generalized away from historical specificity and possess a binary structure that implies ultimate resolution. In the *Raft* Géricault does not permit a resolution of the conflict between man and nature; even the ship on the horizon will prove to be another disappointment.[30] Whereas Dutch shipwreck scenes lead ultimately to meditation on human life within a coherent, if turbulent, universe, Géricault's *Raft* serves as a highly personal symbol of the ceaseless conflict between human will and elemental forces.[31]

The emphasis in the Dutch tradition is not on our identification with human will and emotion in a grand conflict with nature. Even ships sinking due to collision, a disaster often caused by human error in contention with the elements, are not rendered, though collision was, in fact, always a serious danger

FIG. 137. THÉODORE GÉRICAULT. *The Raft of the "Medusa."* 1819. Paris, Louvre

for square-rigged ships. It could occur even in fair weather, needing only a slight miscalculation on a master's part. Ships wreck and men die in Dutch pictures not because of errors of seamanship—always a major cause of actual disaster at sea—but because of their insignificance and impotence in the face of the overwhelming destructiveness of elemental nature.

THREATENING LEE SHORES: MORTAL PERIL

In contrast to the immediate disaster consistently rendered in the Shipwreck type, a third variety of seventeenth-century storm scene depicts a potential disaster rather than a realized one (Fig. 129). Though the threatened vessels seek to escape coasts and jagged rocks familiar from shipwreck scenes, the tone of these pictures is in some ways more closely akin to the tensions of the Storm on the Open Sea. Like the ships holding to their courses on the high seas, vessels in the Threat type struggle for survival in a situation requiring perseverance if ultimate destruction is to be eluded. In other respects, however, the tone of the Threat type is more urgent than that of the Storm on the Open Sea precisely because of the physical presence of the lee shore. The juxtaposition of vessel and rocks and the implication of wind blowing onto the coast are elementary terrors for any sailor in any century.

The degree of peril and the sense of urgency, however, vary considerably among pictures of this type. One group of Threat scenes depicts vessels in such serious circumstances that shipwreck is virtually inevitable. The central ship in the large painting by Jan Peeters (Fig. 7) is almost certainly doomed to run aground, if she has not already, while her two companions, trying to avoid the same fate by beating upwind on crossing tacks, may be in danger of colliding. Similarly, the dismasted ship with her anchor dropped, drifting toward a nearby coast, in a picture by the unknown monogrammist J.P.C. (Fig. 138),[32] is in such desperate straits that the painting is hardly distinguishable from shipwreck scenes. Only an actual wreck and castaways are missing from these pictures, and yet they maintain the tension distinctive to the Threat type, for the calamity has not been consummated and the tension between vessel, wind, sea, and rocks is not released.

In another group of Threat paintings, however, the danger to the ships is much less overt. Typical examples are a pen-painting by Heerman Witmont (Fig. 139)[33] and a picture by Jacob van Ruisdael (Fig. 140).[34] In both, a gale is blowing, but the ships display no difficulty following courses away from looming rocky outcroppings or coastlines. These pictures possess nonetheless an emotional tension related to images of storm and shipwreck, since disaster is implicit in the visual tension between ships and rocks that is so reminiscent of shipwreck paintings. The very presence of the rocks makes it clear that these are not simply views of sailing in louring weather on the Dutch coast but, like shipwreck scenes, images of vessels in distant and dangerous places. The prominence of the rocks enhances their uncompromising menace. In a painting by De Vlieger (Fig. 75), they have an almost emblematic centrality, jaggedly silhouetted against the sky. If the rocks are less accentuated in Ruisdael's canvas (Fig. 140), they still dominate the foreground and balance the vessels in the middle distance at left. In their

enduring yet broken, active forms, eroded and beaten by foaming waves, they testify to the powers of nature that, quiescent for the moment, endanger all vessels.

The dangers of the situation are sometimes further intimated by the presence of bales and barrels in the waves (see Fig. 56), and fragments of annihilated ships also appear, as in a painting by Cornelis Verbeeck (Fig. 141), where a masthead and barrel float near upthrust rocks as reminders of past and potential disasters.[35] A giant fish with gaping mouth provides another source of danger, but this personification of nautical threat disappears from storm scenes in the 1620s, and it is completely absent from the work of De Vlieger and Ruisdael.

Such incidental features, if present, supplement the fundamental significance of the Threatening Lee Shore inherent in the juxtaposition of looming rocks and vessels. For these ships, sea and winds may be favorable, navigation is safe, and the cliffs are avoidable, but the danger, though latent, is there in the always-uncertain winds, the ever-changing sea, and potentially deadly shores.

These situations demanding vigilance and continuing effort to avoid catastrophe were, like shipwreck, intrinsically open to a variety of moral interpretations. The wisdom and constancy of the helmsman in the face of the threat is sometimes emphasized, as in the medallion of 1647 (Fig. 94), in which the ship of state is guided "cautiously and prudently" through a sea full of rocks. The successful avoidance of danger is usually the basis of symbolic readings of this

FIG. 138. MONOGRAMMIST J.P.C. *A Ship Dragging Aground.* Cologne, Lempertz sale, 1938

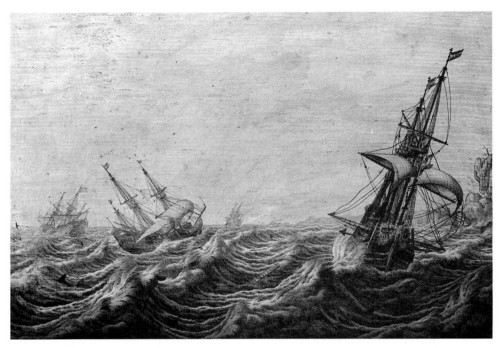

FIG. 139. HEERMAN WITMONT. *Ships off a Rocky Lee Shore.* Sharon, Massachusetts, Kendall Whaling Museum

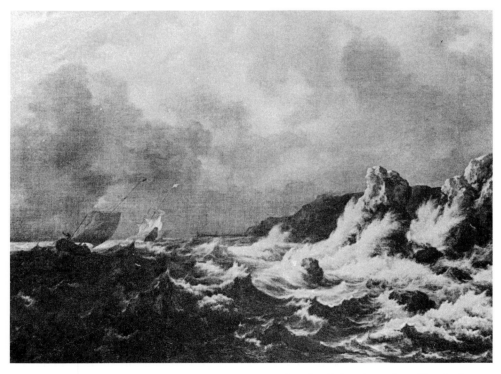

FIG. 140. JACOB VAN RUISDAEL. *Ships Near a Rocky Shoal.* London, Knoedler, before 1948

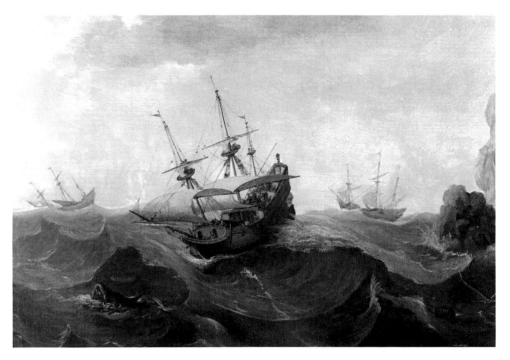

FIG. 141. CORNELIS VERBEECK. *Ships Sailing Near a Rocky Shore.* Greenwich, National Maritime Museum

type and agrees fully with the inherent content of such Threat scenes as Porcellis's picture (Fig. 56). A successful voyage is also assumed in emblems of the ship of life navigating deadly shoals or ironbound coasts, but as in Marnix van St. Aldegonde's personal impresa (Fig. 30), in these the success is due to God's guidance. Typotius's emblem "Custodi domine vigilantes" ("Lord, guard the watchful") depicts a ship sailing among rocks (Fig. 142); the epigram remarks that "they are prudent who, when pressed by misfortune, beseech the help of the divine."[36] Kornelis Zweerts reads a ship in these perilous straits in the same terms (Fig. 143):

> When a ship at sea gets out of all sorts of dangers, struggling before the current, through the deep waves, surrounded by sea monsters, and by cliffs, desolate and high, then one sees her sail [through] good steering into the harbor. He who hopes and prays and watches when it goes badly for him, finds himself saved by God, who never abandons his people.[37]

The rocks occupying such prominent positions in many Threat pictures and in Shipwreck scenes as well were also the subjects of symbolic interpretation. Particularly when these rocky outcroppings dominate the compositions (Fig. 75), they seem to call for a special reading. Rocks in the stormy sea were most frequently read as symbols of constancy—constancy in virtue, in love, in political principles, in faith, all embodied in the rocks' steadfast endurance.[38] Such readings are incongruous, however, with paintings where the shoals and cliffs

FIG. 142. Emblem from Jacobus Typotius, *Symbol divina et humana*, Prague, 1601–3

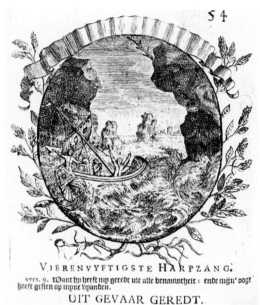

VIERENVYFTIGSTE HARPZANG.
vers. 9. Want hp heeft mp geredt ult alle benauwtheit : ende mijn' oogt heeft gesien op mpne vpanden.

UIT GEVAAR GEREDT.

FIG. 143. Emblem from Kornelis Zweerts, *Zede- en zinnebeelden*, Amsterdam, 1707

are a deadly danger to man.[39] More appropriate to the Threat type are other interpretations of rocks in terms of antagonism and destructiveness and of warning rather than simple endurance. Jacob Cats sees in the sea breaking on such rocks a lesson on meeting anger with anger (Fig. 144).[40] Strong resistance is like the effect of a steep shore on incoming breakers, making them still more violent, whereas a soft response produces results like waves breaking gently on a flat beach. Reading paintings with dramatic rock formations as allegories and warn-

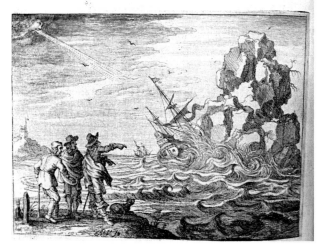

L. *Op 't geſichte van de Zee tegen een rotſſteen aengedreven.*

FIG. 144. Emblem from JACOB CATS, *Ouderdom, buyten leven, en hof- gedachten, op Sorgh-Vliet,* Amsterdam, 1656

93

DRIEENTNEGENTIGSTE HARPZANG.
vers. 4. (Doch) de HEERE in der hoogte is geweldiger / dan het bruysen van groote wateren / (dan) de geweldige baren der zee.
GEWELDIG.

FIG. 145. Emblem from KORNELIS ZWEERTS, *Zede- en zinnebeelden,* Amsterdam, 1707

ings of the passions fully accords with the metaphors of the literary tradition and with the expressive content of the pictures in which the antagonism of sea and land is vividly captured in eroded rock with natural arches hollowed out.

This power of the storm to undermine and destroy the seemingly immovable could be equally well interpreted, however, as an emblem on God's supreme power (Fig. 145):

> The horrid beating of the waves, the foaming violence of the sea, strike upon the rock through the rage of the waves. The rocks are hollowed out, where it serves as dike and dam. Each man fears the great disaster and utmost danger. Who sees God's fury or fearsome strength and is not then brought to fright and total anguish?[41]

STRANDINGS ON A BEACH:
LESSONS IN PRIDE AND HUMILITY

A fourth type of storm image, the Stranding on a Beach, initially seems to be little more than an uncommon variant on the theme of wreck. These images possess, however, a distinctive expressive character that owes much of its force to the location of the scene in home waters, on the beaches of the Netherlands coast.

The earliest picture depicting this locale as the setting for a wreck is Porcellis's *Pink Approaching Shore* (Fig. 146), a painting already mentioned in the context of a subgroup of shipwreck images portraying a humble vessel sailing handily near a larger, more ornate ship breaking up on shore.[42] Though this painting does not have the view from shore that typifies later Beach Strandings (Fig. 148), it deals with two motifs essential to the type: the local setting and the contrast between small, ordinary fishing vessels and larger, more powerful ships. The Budapest picture is apparently unique in Porcellis's oeuvre, but his preoccupation with ordinary Dutch vessels in the waters of the Netherlands is a constant feature of his work, so that his return to the beach as a setting for his *Stranding off a Beach* of 1631 (Fig. 1) is not surprising.[43]

FIG. 146. JAN PORCELLIS. *A Pink Approaching Shore.* Budapest, Szépmüvéczeti Múzeum

As we have seen, Porcellis paints here the aftermath of a storm, and in the distance a number of ships can be seen, dismasted or lying to. One at left has her anchor set, attempting to escape the fate of the stranded ship at center, her stern already submerged, her crew swinging into the surf trying to get ashore. Light just misses the wreck but falls on a lifeboat and on a crowd of onlookers on the beach who aid in the rescue of the castaways. The beach curves toward the foreground, where, after a dark interval, light falls again on three *pinks*, whose crews unload them and tend their gear. The fishermen are totally absorbed in their work, apparently unaware of the drama in the distance, except for one man gesturing at the wreck and running along the beach. He is poised at the edge of the darkness and visually links the light area of workaday calm with the tension and violence of the middle distance.

A couple, townspeople by their formal dress, observe the scene from the dune at lower right. Sharing the foreground with the fishermen, they are dark accents in a ray of late afternoon sun. Their prominent placement just below the knot of onlookers in the distance and subtly linked with the sinking ship by their poses and by small diagonals near them reveals the calculation that Porcellis gave the formal scheme of thematic oppositions visible to observers like the townsfolk—and to us.

Jacob Cats and, following him, Jan Luyken interpret stranded vessels as models of ways of life to be avoided. Cats's emblem titled "Een schip op sant is een baken in zee" ("a ship on a sandbar is a beacon in the sea") finds in a stranded *boeier* a lesson on using examples as guides to avoid moral and spiritual disaster (Fig. 147);[44] and virtually the same moral is pointed to in Luyken's emblem on a beached three-master, "Leerd uit allees. Een schip op strand is een baak in zee"

FIG. 147. Emblem from Jacob Cats, *Spiegel van den ouden ende nieuwen tijdt*, The Hague, 1632

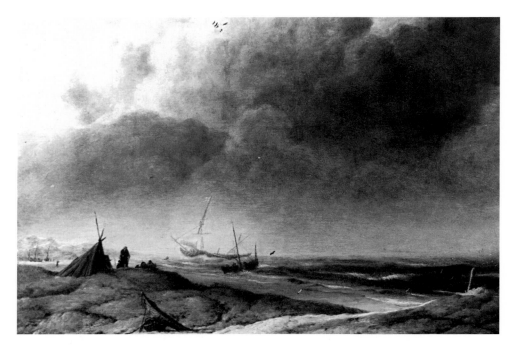

FIG. 148. HENDRICK VAN ANTHONISSEN. *A Ship Aground on a Beach.* Schwerin, Staatliches Museum

("Learn from everything. A ship on the beach is a beacon in the sea").[45] With this encouragement we can see in Porcellis's picture a more specific moral: Great size and ambition brought to ruin stand against smallness and humility pursuing everyday tasks in security; a place of desperate danger for large merchant ships that sail the world is the ordinary home and refuge for small boats with less exalted tasks. This opposition of high and low, the pride of wealth and power and the humility of poverty and simplicity, is familiar from the juxtaposition of a small boat sailing near a wrecked ship in some Shipwreck scenes, but the emphasis on the local Dutch coast in Porcellis's painting and the prominence of the fisherfolk and their boats gives this painting a reference to the immediate world of seventeenth-century Dutch society that never appears in the ordinary shipwreck type. It also seems to reflect an undercurrent of social criticism that occasionally surfaces in the first half of the century, expressed in contrasts between the virtues of the poor fisherfolk and the corruption of wealth. Jacob Cats, for instance, explains that his emblem on a fisherwoman was inspired by the refusal of the Schevenigen fisherfolk to send their children to wait upon the rich, preferring their poor but free lives.[46] Neither Cats's emblem nor Porcellis's painting can be construed as advocating social equality; they are moral lessons for the well-off, like those observing the scene in Porcellis's painting.

The setting on the Netherlands coast, however, did not become a widely used one for shipwreck in Dutch painting. Only a few other examples have survived, a picture dated 1630 by De Vlieger and a painting by Hendrick van Anthonissen (Fig. 148), the latter clearly relying on Porcellis's painting.[47]

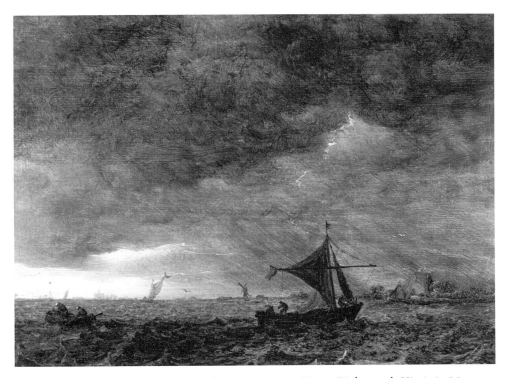

FIG. 149. JAN VAN GOYEN. *A Thunderstorm over a River.* Richmond, Virginia Museum of Fine Arts.

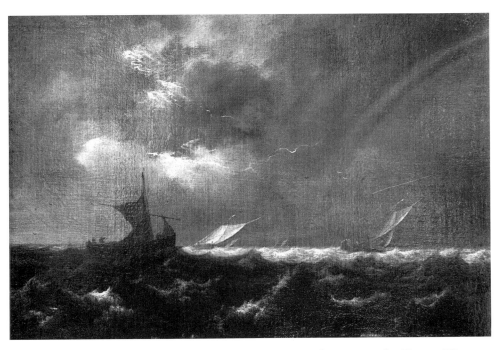

FIG. 150. JACOB VAN RUISDAEL. *A Thunderstorm Near the Coast.* The Hague, Dienst Verspreide Rijkscollecties

THUNDERSTORMS OVER LOCAL WATERS:
HUMILITY AND DIVINE WRATH

Stormy weather appears over local Netherlands waters in only two other subjects—the Thunderstorm over Local Waters and the Gathering Storm. Pictures of the former (Figs. 149, 150) depict not a full sea storm but less violent and shorter-lived rough weather over shallow coastal waters.[48] Typically, dark clouds fill at least two-thirds of the sky, and lightning, rendered in long fluid strokes of yellow or red, shines in the clouds and casts a lurid glare on land and sea. This depiction of lightning is one of this type's most distinctive features, for it is surprisingly rare in pictures of full-blown tempests. Aside from this dramatic outburst, these pictures convey none of the fury of a tempest; the waters generally have a low chop and the wind, sometimes with rain showers blowing in it, seems to be freshening but is not even gale force. Frequently a sprit-rigged boat is shown striking its sail, perhaps due to the rising wind, but other boats continue under way without significantly reducing sail and fishermen tend their nets. There is apparently no danger to the human beings busy at their workaday tasks in ordinary boats—large oceangoing ships are only exceptionally represented in this type. Yet the sharp contrasts of light and dark, the heavy clouds, and the flicker of lightning all seem weighted with brooding might.

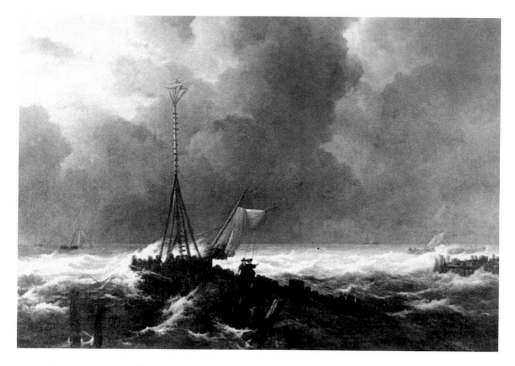

FIG. 151. JACOB VAN RUISDAEL. *A Looming Storm.* Private collection

The emotional suggestiveness of this type is enhanced when we realize how frequently the boat striking her sail is closely juxtaposed with lightning bolts. A recurrent emblematic reading of lightning as God's warning to and chastisement of the proud and ambitious acquires a distinctive tone in these scenes as humble fishermen and sailors reduce sail, figuratively bowing before the storm, but otherwise remain untroubled in their ordinary tasks.[49] This restrained sense of imminent drama probably explains why this type was favored not only by De Vlieger[50] but also by Jan van Goyen, Aelbert Cuyp,[51] and Jacob van Ruisdael, painters of subtle effects of atmosphere and illumination, who otherwise avoided the stormy sea.

THE GATHERING STORM: A GUIDE TO SALVATION

Related to the Thunderstorm and the Stranding on a Beach is the relatively rare theme of the Gathering Storm. Jacob van Ruisdael, who characteristically avoided full storm scenes in his work, preferred this more meditative subject, as we see in his *Looming Storm* (Fig. 151).[52] Ruisdael's picture is related to Allaert van Everdingen's *Snowstorm over Inland Waters* (Fig. 152).[53] Both dramatize a

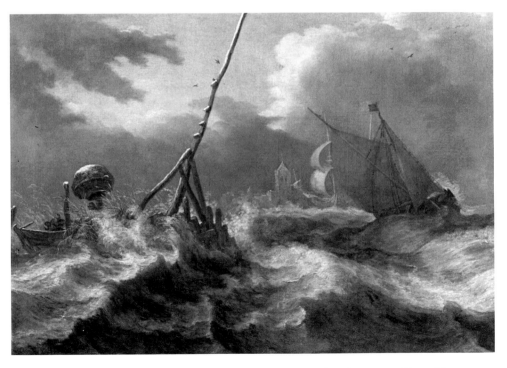

FIG. 152. ALLAERT VAN EVERDINGEN. *Snowstorm over Inland Waters*. Chantilly, Musée Condé

motif found occasionally in pictures by Van Goyen, Mulier, and Jan Peeters, and traceable back to Jan Brueghel the Elder.[54] Rather than depicting struggling vessels or dramatic disaster, these paintings suggest the menace of the elements through the ominous clouds and the boats running in for shore ahead of the storm. In both Ruisdael's and Van Everdingen's pictures the beacon, rather than the vessels, is the protagonist. It is a passive "hero" compared to boats but occupies center stage, rising into the light: a weathered survivor, slender, seemingly frail, yet erect and strikingly isolated against the piled-up masses of the gathering storm clouds. Such beacons were navigational signs, sometimes functioning as leading marks for use with another mark, like a beacon or a church tower, as guides to channel and harbor entrances. Given this function, their dramatic isolation as boats drive in to shore before the storm seems pregnant with significance.

The role of the beacon here is related to that seen in Jacob Cats's interpretation of a fire beacon blazing in the night guiding a ship to a harbor mouth (Fig. 153).[55] The lemma of Cats's emblem, "Luceat lux vestra coram hominibus" ("Let your light shine before men") is explicated by passages from Seneca, Pliny, and Ovid on the importance of a virtuous example for leading others to virtue, and by a citation from Gregory the Great to the effect that one who reveals the light of justice to others is like a torch that enlightens others as well as itself. Rembrandt used this metaphor in his *Staalmeesters*, where the chimney piece depicts a watchtower with a burning fire, surely intended here as an admonition to exemplary virtue for these citizens.[56] Ruisdael and Van Everdingen do not depict blazing beacons, of course, but the dramatic roles their beacons play seem not only analogous to that of Cats's and Rembrandt's fire beacons but even more urgent in tone.

FIG. 153. Emblem from JACOB CATS, *Proteus ofte minnebeelden verandert in sinnebeelden*, Rotterdam, 1627

FIG. 154. Emblem from ROEMER VISSCHER, *Sinnepoppen*, Amsterdam, 1614

Another line of meditation perhaps more suited to these pictures is suggested by Roemer Visscher's emblem on a beacon on a headland overlooking an anchorage (Fig. 154).[57] It is titled "Intelligentibus" ("For those who understand") and explains that such signs are understood by pilots, who use them to steer ships to safe harbors. Each trade or profession has similar signs whose meaning is known only to itself. In Ruisdael's and Van Everdingen's paintings the value of such understanding is dramatically amplified by the threatening tempest, which suggests that what the beacons represent is guidance to salvation in time of peril for the individual or the ruler or even the lover with the wit to recognize the means of deliverance.[58]

NARRATIVE CONVENTIONS:
THE DRAMATIC ROLE OF NATURE

The patterns of narrative incident in storm paintings reveal the clear distinctions between conventional types and their remarkable internal consistency. They also confirm the psychologically moving character of the paintings. These narratives are rendered not as symbolic diagrams but as staged dramas in which action and formal structure actively solicit the viewer's emotional participation. In one sense the natural world sets the stage for the dramas of struggle, misfortune, and salvation played by vessels and their crewmen. But in a more important sense nature is itself a protagonist, an active participant in the narratives.

These images belong to the Renaissance landscape tradition of depicting *natura naturans*, nature as a creative, dynamic process and one capable of interacting with human deeds and feelings. Far from dominating the scene, human beings are caught within a much broader conflict among the elements with which they contend and before which they are in large measure helpless. The elemental turmoil is characterized visually and compositionally in terms of thematic and formal polarities. The pictures do not show static balances of forces, but ever-changing equilibriums of constantly moving antagonists. This characterization of the natural world gives it an emotional charge as potent in some ways as the rendering of *affetti* in history painting, and like the *affetti* this characterization serves the purpose of psychological engagement in the narrative structures of the pictures. At the same time, the tensions animating nature reveal the place of the storm within the order of the cosmos.

ELEMENTAL DISCORD

The polarities in seventeenth-century tempest pictures are based on the common-place contemporary understanding of the storm as a conflict among the elements earth, water, air, and fire, whose characteristics, deriving from the four primary qualities, form a complex pattern of oppositions and concordances. The storm in this conception verges on the elemental confusion of primordial chaos, before each element took its assigned place in the spheres of the world. Pictorially we find that antithetical visual qualities dramatize these cosmological oppositions. In De Vlieger's painting in the Fitzwilliam Museum (Fig. 155), for example, the elements are contrasted in both form and motion.[59] De Vlieger composes waves in long, rolling curves mounting to peaks that scatter into spray as the wind hits their crests or as they crash against the rocks. The latter are blocky masses, marked by sharp edges and rifts; their emphatically three-dimensional, upright forms are accentuated by the fluid waves and spraying foam that are hurled against them. In many other pictures (Figs. 57, 75), the rocks, isolated from the land mass, rise firm and immovable from engulfing spray, while waves seemingly seek to penetrate and undermine the cliffs, which show the scars of these assaults. The two elements become mingled in their conflict. Painters also tend to apply paint differently to render antagonistic elements. The complexity and energy of waves are suggested in numerous long sweeps and small strokes and touches, with spray rendered by tiny dabs and spatters; the cliffs are painted more simply, with fewer touches and less buildup of paint, suggesting a simple firmness. The forces of air in turn oppose earth and sea as billowing clouds and driving rain showers, giving visible form to the dynamism and might of wind, the element air in motion. The typical treatment of clouds is again well represented in De Vlieger's work (Figs. 58, 155). Dark cumulus clouds usually dominate half to two-thirds or more of the sky, while horizontal bands of clouds, reaching from and moving before their rounded cumulus masses, extend across the image and recede into depth, sometimes in layers, other times as a single cloudbank. From the horizontal cloudbanks other clouds rise in vertical masses of swelling curves modeled by light that gives them density and bulk and muscular energy.

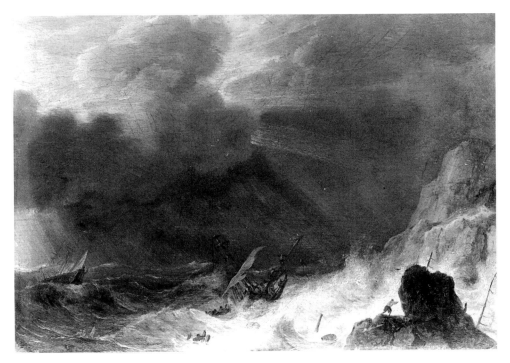

FIG. 155. SIMON DE VLIEGER. *Shipwreck on a Rocky Coast.* Cambridge (England), Fitzwilliam Museum

Another means of demonstrating the power of atmospheric forces is the use of diagonal brush strokes to render rain showers blowing in the wind (Figs. 58, 155). These insistent diagonals depict not just rain but the direction and energy of the wind, something visible only in its effects and yet essential to communicating the role of the element air in the tempest. Wind blasts produce the heeling of the ships, the set of their sails, the billowing of flags and torn sails, and the direction of waves.

In a majority of storm images of all types another visual principle of subtle affective power is the articulation of the direction of the storm wind: the ships and waves are driven from left to right, exploiting our tendency to scan images this way. Though this left-to-right movement is by no means a universal compositional principle for storm pictures (numerous exceptions exist; see Figs. 69, 89, 91), it augments the violence of stormy blasts on the open sea, and in shipwreck and threat scenes it implies a kind of inevitability as sea and wind drive vessels toward cliffs and disaster on the right side of the image.

The repeated diagonals of rain and the rounded, swelling masses of clouds form a vital, elementary contrast to the curving sweep of the waves and the dense, battered solidity of the shore. Each of these distinctive formal qualities expresses the capacity for violent motion or resistance to it in an elemental force. By their oppositions they charge the world around men with the capacity for movement, change, and conflict that produces human crises on the high

seas. Central to this dynamic juncture of elemental antagonisms is a fourth polarity, that of light and dark, further intensifying this interpretation of the world.

The natural origin of these chiaroscuro contrasts is logically the fourth element, fire, but the luminous rays in the sky and pools of light scattered on land and sea result from elemental fire not, as we might expect, in the form of lightning but in that of daylight. Lightning is typically rendered in Dutch and Flemish marine painting by long, fluid streaks of yellow and orange; it rarely appears in images of sea storms as such (an exception is Figure 83) but typifies a distinct theme, the Thunderstorm over Local Waters.

In full-blast tempests the light that animates the heavy darkness of the storm usually results from bursts of sunlight through gaps in the clouds (Figs. 146, 156, 162). Billowing white clouds lit by the sun and sometimes a patch of blue sky suggest the hope of fair weather and change, providing a dramatic foil to the deep leaden gray of the storm. The sharp chiaroscuro creates fields of opposing forces, an effect heightened in many paintings by diagonal beams of light that seem to rend the tempest. Whereas lightning would participate in and reinforce the totally hostile and destructive conflict of the elements, these bursts of sunlight expressively charge the image with the psychological weight of light and dark as symbols of good and evil, hope and despair, salvation and death, clarity and obscurity, order and disorder. The light, however, is not simply positive, for it sharply illuminates the fury of the elements and the plight of ships and men. In contemporary meteorology, moreover, fire in the sun was held to be the cause of all weather, which the sun's heat induced by the formation and circulation of vapors and exhalations and their interaction with heat and cold in the region of the air.[60] Sunlight in tempest images thus has an equivocal expressive role, acting dramatically as both ultimate instigator of the crisis and a beacon of hope in the darkness.

Light and the patches of clearing skies associated with it also serve to make tempest images comprehensive in the way Fuchs shows that Ruisdael's *Wheatfield* (Fig. 76) includes pairings of opposed objects and themes in a kind of embracing, universal whole. Similarly, storm pictures are not solely negative but tensional; they contain the full potential of the universe, including calm and harmony, in the active give-and-take between opposing principles. It is as much this dynamic rendering of a world permeated by conflicts and tensions as the emotional interest of the ships and men that draws the beholder into the tempestuous pictorial space. In this natural drama we find also parallels and echoes of the verbal evocation of the storm: Intense oppositions, extremes of violence, elemental antagonism are basic to the rhetoric of tempest narratives. And as in the literary tradition, these antagonistic conflicts also contain the suggestion of a larger order beyond the chaos and deadliness of the storm.

NATURE AND MAN

If the storm is a mobile and expressive complex of forces actually participating in the actions of ships and men, the human protagonists, for their part, are always carefully integrated compositional constituents. They at once focus at-

tention as centers of sympathetic identification and work within the ensemble to engage the beholder in the larger drama of natural discord and harmony.

In the real world vessels occupy by their very nature places where the elements converge; in pictures they are depicted just at the boundaries of wind, wave, and shore where the ships must respond to conflicting pressures. From the time of Porcellis onward, the low viewpoint lets the vessels overlap the horizon, visually juxtaposing them with the forces that drive and imperil them. They appear at once in the grip of the waves and silhouetted against the clouds and the driving gales (Fig. 156),[61] or they struggle between foaming breakers and solid cliffs (Figs. 155, 162).

In almost every case ships function as accents of complicated form that articulate the composition. Imagined without vessels, most of these paintings become inert, for the intricate lines of hull, masts, rigging, and sails—and the implied motion of the entire ship—both reinforce and counter the diagonals and curves of the natural world. This creates a visual impression of interaction that enhances the role of the storm in the narrative, since the ships' every movement—their tactics, the sail they carry, the way they heel, pitch, and rise, the damage they suffer, and the destruction they undergo—are responses to the tempest.

Yet, while vessels play an integral role in the staging of storm scenes, they are also subordinated to a larger pattern of movement and meaning. After the time

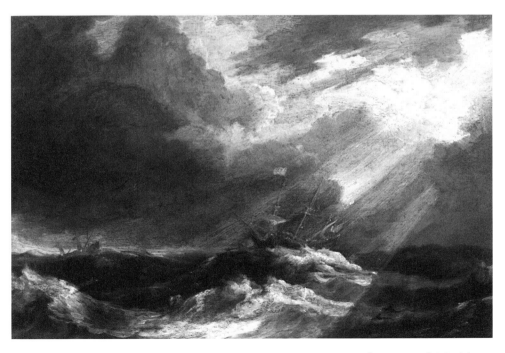

FIG. 156. BONAVENTURA PEETERS. *Ships in a Tempest.* Greenwich, National Maritime Museum

of Porcellis, ships are rarely depicted exactly at the center of the compositions, a development that gives images a much more spontaneous, psychologically open-ended character. The distribution of light is still more subtle in effect, for rather than acting as focused spotlights, pools of light frequently just miss or partly touch the protagonists, whether ships, men, breakers, or rocks. The light sometimes falls between viewer and vessel (Fig. 156) or glows just beside (Fig. 1) or just behind a ship (Fig. 2). In some paintings a ship, rock, or lifeboat occupies the edge of the illuminated area (Figs. 74, 135). This lighting heightens tensions in the picture by frustrating the expected focus of emotional sympathy, but even more, this displaced illumination suggests that light falls by chance as the result of surging movements independent of man. The lighting of every part of these images is, of course, as carefully contrived as the illumination in a genre painting by Vermeer or Metsu (Figs. 105, 106) or a history painting by Rembrandt (Fig. 81). Its distribution has the same effect as in these images, appearing to catch fortuitously a moment in ongoing time, while integrating the partially lit elements into a larger drama.

The distinctive character of this interpretation of man's relation to nature becomes still more apparent if alternative approaches to rendering our encounter with the stormy sea are considered. Human beings, for instance, are rarely solitary in these images. A few examples depicting a single vessel exist, but two or more ships are far more common. The voyagers' accounts show, however, that in the seventeenth century ships did lose sight of all other vessels, so that the presence of more than one ship is yet another convention revealing a fundamental attitude to man's place in the storm. It is not an occasion on which the isolated individual—or vessel—confronts the overwhelming vastness of nature, as in Caspar David Friedrich's *Monk by the Sea* (1809; Fig. 157) or *The Polar Sea* (1824).[62] The storm remains an experience men share.

Dutch painters of storms also never eliminate mediating human beings completely. Such nineteenth-century artists as Turner, Courbet, Winslow Homer, and Thomas Moran, however, painted stormy seas that the beholder seems to confront personally from a shore or the deck of a vessel (Figs. 3, 4, 158).[63] Boats are either absent or tiny and remote or else beached and crewless. The viewer in effect takes the place of Friedrich's monk and alone faces the enormous otherness of nature, experiencing through art the tensions arising from man's identification with and separation from the world outside the self.

In Dutch pictures of storm, human beings neither disappear nor totally dominate. In Segers's etching (Fig. 159)[64] and Bonaventura Peeters's sketch in Greenwich (Fig. 156), we see one extreme of man's relation to nature in Netherlandish tempest scenes. In one of these etchings Segers painted the paper black before printing it in yellow-green (Fig. 159). His remarkable technique renders the vessels in the same light tones as waves and clouds and against such dark grounds that the ships appear to be near dissolving into a spectral, luminescent flux around them. Peeters also uses illumination to enhance the smallness of his vessel, as light rays strike the waves between viewer and ship but not the ship itself, almost concealing it. As in Segers's etchings, human vulnerability is intensified by the distance of ships from the picture plane and their near-isolation from all other ships. These works, however, are as close as these

seventeenth-century storm scenes come to isolating or eliminating man.

Segers's and Peeters's treatment of man is typical of the diminution of man's scale in seascapes in the first half of the seventeenth century. In the later decades of the century, this trend was reversed, notably in such paintings by Willem van de Velde the Younger as *"Gust of Wind"* in Amsterdam (Fig. 2). This painting represents, however, the furthest degree to which ships dominate the scene in Dutch storms. Van de Velde's vessels are large enough to permit a detailed reading of ships' rigging, structure, and response to the storm, and, to some extent, the actions and reactions of crewmen are visible also. Nonetheless, the viewpoint is not nearly so proximate as in such religious subjects as Rembrandt's *The Storm on the Sea of Galilee* (Fig. 48) or in the extremely popular eighteenth-century type, the Drama on the Deck.

This new type depicts primarily scenes from real, contemporary sea disasters, something virtually unknown in storm pictures of the previous century.[65] It closely renders human action and sufferings on endangered vessels, depicting the widest possible range of extreme emotion in a group confronted with the storm and their own ends. The degree to which these images adapted not Dutch marine art but older religious iconography of the sea to current events may be seen by comparing John Singleton Copley's *Watson and the Shark* (Fig. 160) to Dirck Barendsz.'s design for *Jonah Cast to the Whale* (Fig. 44).[66] Géricault's *Raft of the "Medusa"* (Fig. 137) is probably the most brilliant and compelling image of this type. As in the sixteenth-century closeup type, the depiction of human

FIG. 157. CASPAR DAVID FRIEDRICH. *A Monk by the Sea.* 1809. Berlin, Schloss Charlottenburg

FIG. 158. GUSTAVE COURBET. *The Wave.* Berlin-Dahlem, Gemäldegalerie

FIG. 159. HERCULES SEGERS. *A Storm at Sea.* Etching. Vienna, Albertina

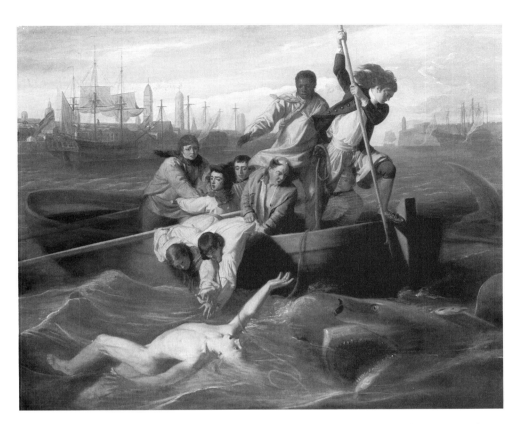

FIG. 160. JOHN SINGLETON COPLEY. *Watson and the Shark.* 1778. Washington, D.C., National Gallery of Art, Ferdinand Lammot Belin Fund

feeling and action and the viewer's identification with them are primary in this kind of image, and the storm, though the cause of the figures' responses, does not appear as an equal actor in the drama.

In Dutch paintings, in contrast, men and vessels are depicted as participants in a huge conflict raging around them in which men are neither reduced to total insignificance, tiny and remote in the expanse of the world, nor elevated to heroic dimensions, the absolute foci of attention. They are, rather, actors in a drama of elemental strife that surpasses in scale their individual misfortunes, disasters, and salvation. Yet their actions, embodied in ships, are essential to the meaningful coherence of both the pictorial structure and the underlying natural order implicit in that formal order. The pictures, it seems, are conceived with man as the means by which the storm is made fully articulate and comprehensible.

This human role is rooted in the same cosmology of macrocosm and microcosm that underlies all symbolic interpretation, for the little world of man is not in essence alien to the great world of the universe. Nature is not an "other," apart from man and reachable only by intuition, as in the eighteenth and nineteenth centuries. Nature and humanity in the seventeenth century still participate in a cosmos, a coherent, multilayered order in which their actions and essential, elemental structures echo and articulate each other.

NARRATIVE CONVENTIONS:
DISCORD AND RESOLUTION

The imaginatively compelling rendering of the peril and destruction that men experience in the tempest—and the vivid capturing of the very discordance of the storm itself—constitute one major and enduring source of the popularity of this subject. As Lucretius observes, "Suave, mari magno turbantibus aequora ventis, / e terra magnum alterius spectare laborem" ("What a joy it is, when out at sea the stormwinds are lashing the waters, to gaze from the shore at the heavy stress some other man is enduring").[67] For seventeenth-century viewers, however, the pictorial coherence of the human and the natural underlying the conflict of the storm was another source of the imaginative power of this subject. As in the literary storm, paintings render the elemental conflicts that produce storms and kill men as components of a larger, cosmic tension with elemental harmony. It is an embracing, universal order in which the storm and the discord of the elements oscillate in tension with calm and elemental concinnity. From this dialogue of opposing forces, the pictures derive a sense of unfolding dramatic coherence, a distinctively Baroque expression of unity, whose character corresponds to the interacting oppositions of tempest and music that Knight finds in Shakespeare.[68]

FIG. 161. LUDOLF BAKHUIZEN. *Ships in Distress on a Lee Shore.* 1667. Washington, D.C., National Gallery of Art, Ailsa Mellon Bruce Fund

The presence of sunlight and blue skies in the great majority of tempest pictures holds out the possibility of clearing skies and calm weather, however remote they may be from the present or imminent catastrophe (Figs. 161, 162). These features give the scenes a universality, a sense of including all potentialities. That some vessels escape and some castaways survive likewise suggests pictorially a hope in the kind of comprehending order found in literary storms in which the tempest is one pole in tension with fair sailing and a secure harbor.

The paintings further intimate this larger cosmos in their formal structures. Light, for instance, as in any pictures with pronounced chiaroscuro structure, serves as a means of unifying the image. A kind of unity is implicit in the very tensions of chiaroscuro, but light also draws the parts of the picture together, linking them by providing foci of attention, and balancing the composition dynamically by playing off areas of illumination and darkness of varying sizes. Although this sort of asymmetric compositional equilibrium typifies seventeenth-century imagery in general, dismissing it as conventional would be to ignore the sense of order that underlies both the antipathy of the elements and the transience and violent change pervading the scene.

Diagonals are fundamental to this constantly shifting coherence as well. They define the forms of coastlines, rocks, waves, clouds, and light rays; and these opposing forces frequently meet along such diagonals. Crisscrossing the pic-

FIG. 162. SIMON DE VLIEGER. *Shipwreck with Castaways.* 1642. Roermond, private collection

tures, diagonals shape the larger compositional structures, linking the elements by intertwining all areas of the picture surface and providing points of attention at their intersections. This active linear structure, functioning closely with the distribution of light, activates and unifies the apparent discord and random movement of nature.

Still another source of coherence are echoes of form among different natural elements, a feature especially common in the rocks and clouds of the Shipwreck and Threat types. These echoing configurations usually appear as a direct repetition of shapes in radically different and otherwise antagonistic substances (Figs. 161, 162). While less common in the Storm on the Open Sea, echoing forms are also exploited there in the diagonal sweeps of waves and clouds (Fig. 2). Like the play of light and dark and the diagonals, these repeated shapes are a typical feature of seventeenth-century land- and seascape, but again they cannot be regarded simply as conventions ensuring the formal integrity of the composition, for their unifying function fundamentally fashions order in the chaotic turbulence of the storm.

The pictorial structures of storm scenes are thus essentially dynamic, for the chiaroscuro is irregular, the favored diagonal forms threaten imbalance, and the formal and thematic expression is restless and potentially disrupted. Yet the pictures remain formally ordered and nature is ultimately concordant, despite the dissension and dissonance racking the world. The elements appear as antagonists with opposing capabilities rendered by differing forms and textures, but still in the end they possess an essential kinship and a harmony deeper than the discord that sends them crashing against each other.

The pictorial expression of this embracing harmony of paired oppositions reflects habits of thought rooted in a cosmology of polarities that resolve in a larger unity. While few original pairs of storm images survive intact, the very expressive structures of the pictures imply the alternative and complement of the storm and wreck—the calm seas, prosperous harbors, and fish markets on the beach typical of other Dutch marine paintings (Figs. 163, 164). Scenes of man's vessels and enterprise filling the waters of the Netherlands with bustling prosperity and scenes of tranquil simplicity and exquisite subtlety of mood complement images of storm whether or not the individual paintings were ever pendants. Fair weather and storm, sure navigation and the lee shore, a safe harbor and shipwreck—these form the larger pattern of meaning in which the seventeenth-century mind located pictures of both storm and calm. Though conventional categories, they also imply a dynamic of conflict and ultimate resolution that is essentially in accord with Baroque style.

The formal integration of tempest images—in effect, the imposition of pictorial order on natural discord—clearly indicates that these paintings result from acts of the imagination rather than from a copying of appearances. Nature is the artists' model, to be sure, but their approach to nature is summed up in Van Hoogstraeten's characterization of Porcellis's art as possessing a "keurlijke natuerlijkheyt," a selective naturalism.[69] This might as aptly be called a rhetorical naturalism. It engages our interest in the vessels themselves and their crews, in their tactics, and in their fates and activates the natural stage on which the human actors perform in order to engage us in the pictorial space. It is rhetorical

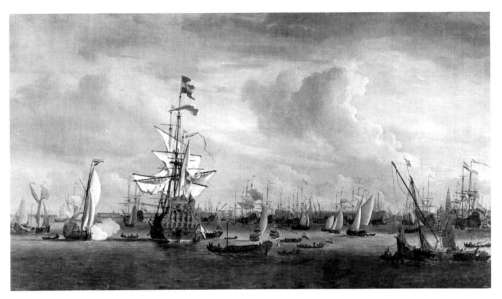

FIG. 163. WILLEM VAN DE VELDE THE YOUNGER. *"De Gouden Leeuw" off Amsterdam.*
1686. Amsterdams Historisch Museum

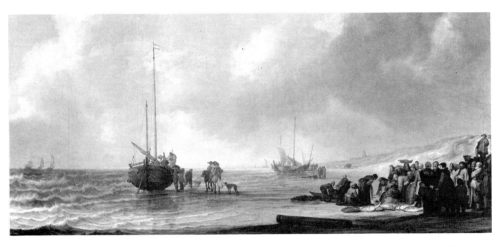

FIG. 164. SIMON DE VLIEGER. *Fish Market on the Beach near Scheveningen.* 1633.
Greenwich, National Maritime Museum

in emphasizing the opposition of the elements and enhances their distinctive
characteristics and their eternal conflict. And it is rhetorical in selecting from
nature incidents and forms that give the images a universal reference rather than
an impression of split-second randomness. For all their verisimilitude, these
pictures are types, formed by conventions that permit the recognition of pat-
terns of meaning. Ultimately all interpretations of these paintings must be
based on the recognition of this conventionalized naturalism, in which the
compelling drama and comprehensiveness and formal integration make these
works images of a meaningful cosmos.

Dutch tempest paintings thus intimate a cosmos. They depict a world where discord, horror, and death are at once harsh realities and implicitly resolved into a comprehending wholeness. Like Ruisdael's *Wheatfield*, they witness the power, wisdom, and goodness of God and of his creation for viewers who could find in the tragedy and dangers of this disorder divinely ordained metaphors, lessons for individuals, institutions, and societies. The ominous power of nature that is only adumbrated in Ruisdael's picture, however, is in a painting of a storm the main protagonist of the image. Conversely, the concordance of opposites in *The Wheatfield* is only hinted at in the storm. In storm pictures we find narrative dramas and in *The Wheatfield* a more subdued meditation, but both conform to an essentially dramatic conception of the world and of human existence, since both are comprised of irresoluble tensions. If order and plenty can only be conceived in relation to turmoil and loss, so the storm can only be understood in relation to fair weather, its opposite, counterpart, and fulfillment, just as evil makes good knowable and light is perceived through darkness. In the world of seventeenth-century land- and seascapes the storm exists in intense and ever-moving reciprocation with calm and prosperity. The transience, conflict, and turmoil implicit in every aspect of the pictures are in the end not a sign of final meaninglessness and loss but of an ever-changing order like that of dance and music, in which oppositions balance in moving and coherent concord.

Notes

PREFACE

1. E. de Jongh, *Zinne- en minnebeelden in de schilderkunst van de zeventiende eeuw*, Amsterdam, 1967. See also De Jongh's essay "Realisme en schijnrealisme in de Hollandse schilderkunst van de zeventiende eeuw," in *Rembrandt en zijn tijd*, Brussels, Palais des Beaux-Arts, 1971, and his introduction to *Tot lering en vermaak*, Amsterdam, Rijksmuseum, 1976.

2. *Gods, Saints, and Heroes: Dutch Painting in the Age of Rembrandt*, exhibition catalogue, Washington, D.C., National Gallery, 1980.

3. Alison McNeil Kettering, *The Dutch Arcadia: Pastoral Art and Its Audience in the Golden Age*, Montclair, New Jersey, 1983; and David R. Smith, *Masks of Wedlock: Seventeenth-Century Dutch Marriage Portraiture*, Ann Arbor, 1982.

4. Gary Schwartz, *Rembrandt: His Life, His Paintings*, Harmondsworth, 1985.

5. De Jongh, "Realisme en schijnrealisme," pp. 143–46. De Jongh, p. 185, n. 3, expresses dissatisfaction with the term "schijnrealism" but uses it for want of a better word.

6. De Jongh, *Tot lering en vermaak*, pp. 27–28.

7. De Jongh, "Realisme en schijnrealisme," p. 143.

8. Svetlana Alpers, *The Art of Describing: Dutch Art in the Seventeenth Century*, Chicago, 1983.

9. Ibid., pp. xxiv–xxvii.

10. Ibid., chap. 4.

11. See the excellent discussion by Peter C. Sutton of these issues as they bear on genre painting in *Masters of Seventeenth-Century Dutch Genre Painting*, exhibition catalogue, Philadelphia Museum of Art, 1984, esp. pp. XIX–XXV, LIX–LXI.

CHAPTER 1

1. H. R. Hoetink, *Mauritshuis, the Royal Cabinet of Paintings: Illustrated General Catalogue*, The Hague, 1977, no. 969.

2. P. J. J. van Thiel et al., *All the Paintings of the Rijksmuseum in Amsterdam*, Amsterdam and Maarssen, 1976, p. 562, no. A1848.

3. *Northeaster*, 1895. Gordon Hendricks, *The Life and Work of Winslow Homer*, New York, 1979, no. CI–517.

4. Martin Butlin and Evelyn Joll, *The Paintings of J. M. W. Turner*, New Haven and London, 1977, no. 398. The full title of the painting is *Snow Storm—Steam-Boat off a Harbour's Mouth making Signals in Shallow Water, and going by the Lead. The Author was in this Storm on the Night the Ariel left Harwich.*

5. On the sublime and its relation to eighteenth- and nineteenth-century landscape, see Samuel H. Monk, *The Sublime*, New York, 1935, esp. pp. 1–17, 203–32. See also Marie-Antoinette Tippetts, *Les Marines des peintres vues par les littérateurs de Diderot aux Goncourt*, Paris, 1966, pp. 42–52, 75–77; Andrew Wilton, *Turner and the Sublime*, exhibition catalogue (Toronto, Art Gallery of Ontario), London, 1980, esp. pp. 65–105, 145–64; and Roger B. Stein, *Seascape and the American Imagination*, New York, 1975, pp. 40–51, 111–23.

6. W. H. Auden, *The Enchafèd Flood or the Romantic Iconography of the Sea*, New York, 1967, p. 12.

7. Denis Diderot, *Salons*, vol. III, 1787, ed. Jean Seznec, 2d ed., Oxford, 1983, p. 165. Tippetts, *Les Marines des peintres*, p. 48.

8. Gauging the popularity of a specific subject in seventeenth-century painting is difficult. Compared to the sixteenth century and the first two decades of the seventeenth, the period 1620–70 witnessed a dramatic increase in the number of storm paintings, though compared to all landscape it remained a relatively infrequent subject. I have notes on more than 300 extant Dutch and Flemish tempest paintings, and my research was by no means exhaustive, which gives some idea of the number of pictures involved. A somewhat more objective sense of the marked increase in the popularity of seascape (though not specifically storm scenes) is provided by John Michael Montias's census of inventories of Delft art collections, in which he finds seascapes accounting for 3.75 percent of all identified paintings between 1610 and 1639; about 6 percent in the decades 1640–70; and rising to 11 percent in the 1670s. See Montias, *Artists and Artisans in Delft: A Socio-Economic Study of the Seventeenth Century*, Princeton, 1982, p. 242, Table 8.3, and p. 245 for seascape.

9. Cf., for example, Eugène Fromentin, *Les Maîtres d'autrefois* (1882), trans. M. C. Robbins, New York, 1963, pp. 146–56, 184–202; Wilhelm von Bode, *Die Meister der holländischen und vlämischen Malerschulen*, Leipzig, 1917, pp. 165–68, 173–78, 242–62; and Jakob Rosenberg, Seymour Slive, and E. H. ter Kuile, *Dutch Art and Architecture, 1600 to 1800*, Baltimore and Harmondsworth, 1966, pp. 162–67.

10. On the identification of ships and the accuracy of ship-handling in paintings, see Chapter 5.

11. Klaus Demus, ed., *Kunsthistorisches Museum, Wien, Verzeichnis der Gemälde*, Vienna, 1973, p. 132.

12. On landscape in Italian painting, see Wolfgang Kallab, "Die toscanische Landschaftsmalerei im XIV. und XV. Jahrhundert, ihre Entstehung und Entwicklung," *Jahrbuch der kunsthistorischen Sammlungen des allerhöchsten Kaiserhauses*, 21, 1900, pp. 1–90, and A. Richard Turner, *The Vision of Landscape in Renaissance Italy*, Princeton, 1966, and Götz Pochat, *Figur und Landschaft: Eine historische Interpretation der Landschaftsmalerei von der Antike bis zur Renaissance*, Berlin and New York, 1973, chapters 3 and 4.

13. Fern Rusk Shapley, *Catalogue of the Italian Paintings*, Washington, D.C., 1979, I, no. 267, pp. 277–80, and Giordana Maria Canova, *L'opera completa del Lotto*, Milan, 1975, no. 9, pp. 87–88. On moralized landscape, see Erwin Panofsky, *Herkules am Scheidewege* (*Studien der Bibliothek Warburg*, 18), Leipzig, 1930, pp. 43–49, 63ff.; idem, *Studies in Iconology*, New York, 1939, pp. 64–65, 150–53; Patricia Egan, "Poesia and the Fête Champêtre," *The Art Bulletin*, 41, 1959, pp. 303–13; and E. Tietze-Conrat, "Titian as a Landscape Painter," *Gazette des beaux-arts*, 45–46, 1955, pp. 14–15.

14. Creighton Gilbert, "On Subject and Not-Subject in Italian Renaissance Pictures," *The Art Bulletin*, 34, 1952, pp. 202–16.

15. Ibid., pp. 212–13.

16. Lisa Vergara, *Rubens and the Poetics of Landscape*, New Haven and London, 1982, p. 20, n. 11. For a fuller argument of this position, see Linda Nochlin, *Realism*, Harmondsworth and Baltimore, 1971, pp. 51–56.

17. "Jan and Julius Porcellis: Dutch Marine Painters," Dissertation: Columbia University, 1971, pp. 114–15.

18. R. H. Fuchs, *Dutch Painting*, New York and Toronto, 1978, pp. 107–9.

19. M. Russell, *Visions of the Sea: Hendrick C. Vroom and the Origins of Dutch Marine Painting*, Leiden, 1983, pp. 78–82, asserts that since the iconography of realistic seascapes originates in symbolic images, realistic seascapes too are symbolic. Even granting the primacy of a separate symbolic tradition in the formation of seventeenth-century seascape, a doubtful contention, there

remains the problem of knowing with any confidence that the symbolic content persisted in images lacking a clearly symbolic structure or context.

20. E. H. Gombrich, "The Renaissance Theory of Art and the Rise of Landscape," in *Norm and Form*, London, 1966, p. 107; and Vergara, *Rubens*, p. 42. The use of landscape as the setting of a history painting and the variety and verisimilitude of landscape as testimony to the mimetic powers of painting are recurrent themes in the literature of art from antiquity onward: see the texts cited in Gombrich, pp. 110–14. This is essentially the level at which landscape is discussed by such seventeenth-century Dutch writers as Philips Angel, *Het Lof der schilderkunst*, Leiden, 1642, reprint Utrecht, 1969, pp. 25–26, 42, and Samuel van Hoogstraeten, *Inleydinge tot de hooge schoole der schilderkonst*, Amsterdam, 1678, pp. 123–25, 135–40, 231–32. On landscape and the theory of art, see also Chapter 5 above.

21. T. Krielaart, "Symboliek in zeegezichten," *Antiek*, 8, 1973–74, pp. 568–69.

22. Amsterdams Historisch Museum, on loan from the Rijksmuseum (no. C449). The painting bears the signature of Simon de Vlieger and the date 1640, but Jan Kelch personally informs me that he considers the signature false and attributes the painting to Jan Peeters, which is very likely correct.

23. "Verbeeldende een Schipbreuk en de dus als de oorsprong der armoede die in desen huyse wordt te gemoet gekoomen." Krielaart, "Symboliek in zeegezichten," p. 568.

24. J. R. Judson, "Marine Symbols of Salvation in the Sixteenth Century," in *Essays in Memory of Karl Lehmann* (*Marsyas*, Supplement I), New York, 1964, pp. 151–52. See now Peter C. Sutton, in *Masters of Seventeenth-Century Dutch Genre Painting*, exhibition catalogue, Philadelphia Museum of Art, 1984, pp. LX–LXI and note 133, and Linda Stone-Ferrier, *Dutch Prints of Daily Life: Mirrors of Life or Masks of Morals?* exhibition catalogue, Lawrence, Kansas, Spencer Museum of Art, 1983, pp. 22–24. See also E. de Jongh's criticism of Lyckle de Vries's concept of "iconographic erosion" in a review of Peter Sutton, *Peter de Hooch*, in *Simiolus*, 11, 1980, p. 184.

25. The best survey of emblem literature is William S. Heckscher and Karl-August Wirth, "Emblem, Emblembuch," in *Reallexikon zur deutschen Kunstgeschichte*, Stuttgart, 1967, V, 85–228. A more detailed study is K. Porteman, *Inleiding tot de Nederlandse emblemataliteratuur*, Groningen, 1977. See also E. de Jongh, *Zinne- en Minnebeelden in de schilderkunst van de zeventiende eeuw*, Amsterdam, 1967, pp. 8–22; and Mario Praz, *Studies in Seventeenth-Century Imagery*, Rome, 1964. A selection from this vast literature has been compiled by Arthur Henkel and Albrecht Schöne, *Emblemata: Handbuch zur Sinnbildkunst des XVI. und XVII. Jahrhunderts*, Stuttgart, 1967; supplement, Stuttgart, 1976. Emblems used in this study will be cited with the original publication and the Henkel and Schöne reference if available there.

26. "Jacob van Ruisdael, 'Die Mühle von Wijk bei Duurstede,'" in *Festschrift für Otto von Simson*, ed. L. Grisebach and K. Renger, Frankfurt, 1977, pp. 379–97. The same variety is evident in the compilation of emblems and texts in Anna Bentkowska, "*Navigatio vitae*: Elements of Emblematic Symbolism in 17th Century Dutch Seascapes," *Bulletin du Musée National de Varsovie*, 23, 1982, pp. 25–43.

27. Roemer Visscher, *Sinnepoppen*, Amsterdam, 1614; reprint, ed. L. Brummel, The Hague, 1949, no. XLVII, p. 108.

28. J. J. Deutel, *Huwelijckx weegh-schael*, Hoorn, 1641, pp. 41–42.

29. Mattheus Broverius van Niedek, *Zederyke zinnebeelden der tonge*, Amsterdam, 1716, pp. 52–59.

30. Joannes a Castro, *Zedighe sinne-beelden*, Antwerp, 1694, no. 80, pp. 245–47.

31. Jacob Cats, *Spiegel van den ouden ende nieuwen tijdt*, The Hague, 1632, Part III, no. xxix, p. 88, "Een schip op sant is een baken in zee."

32. Johannes Sambucus, *Emblemata*, Antwerp, 1566, p. 42; Henkel and Schöne, col. 114.

33. The naturalism of many Dutch emblem illustrations reflects the high quality of the artists responsible for them. Claes Jansz. Visscher provided the engravings for Roemer Visscher's *Sinnepoppen* (see note 27), and Adriaen van de Venne illustrated many of Jacob Cats's volumes. Both artists were important figures in the development of Dutch realism. On this specifically Dutch type of emblem, see Porteman, *Inleiding*, pp. 117–39.

34. For the history of this approach to the interpretation of Dutch realism, see Konrad Renger, "Zur Forschungsgeschichte der Bilddeutung in der holländischen Malerei," in *Die Sprache der Bilder: Realität und Bedeutung in der niederländischen Malerei des 17. Jahrhunderts*, exhibition catalogue, Braunschweig: Herzog-Anton-Ulrich Museum, 1978, pp. 34–38. For De Jongh's method, see *Zinne- en minnebeelden*, and his essay, "Realisme en schijnrealisme in de Hollandse schilderkunst van de zeventiende eeuw," in *Rembrandt en zijn tijd*, exhibition catalogue, Brussels, Palais des Beaux-Arts, 1971; and the exhibition catalogue *Tot lering en vermaak*, Amsterdam, Rijksmuseum, 1976, with an introductory essay by De Jongh.

35. De Jongh, "Realisme en schijnrealisme," pp. 143–46. "Disguised symbolism" is a concept

developed by Erwin Panofsky, "Jan van Eyck's Arnolfini Portrait," *Burlington Magazine*, 64, 1934, pp. 117–27 (cf. idem, *Early Netherlandish Painting*, Cambridge, Mass., 1953, I, pp. 140–44), and by Charles de Tolnay, *Le Maître de Flémalle et les frères Van Eyck*, Brussels, 1938.

36. Marjorie Hope Nicolson, *The Breaking of the Circle*, rev. ed., New York and London, 1962, p. 19.

37. De Jongh discusses the multiple possibilities of interpretation and the principle of reinforcing symbolism in "Realisme en schijnrealisme," pp. 144–46; *Zinne- en minnebeelden*, pp. 31–34; and especially *Tot lering en vermaak*, pp. 24–27. Cf. Panofsky, *Early Netherlandish Painting*, pp. 142–43.

38. "Realisme en schijnrealisme," pp. 150–51.

39. Ibid., pp. 150–52.

40. Examples of this tendency are the symbolic interpretations of Jacob van Ruisdael's landscapes in Wilfried Wiegand, "Ruisdael-Studien: Ein Versuch zur Ikonologie der Landschaftsmalerei," Dissertation: University of Hamburg, 1971. Wiegand applies emblematic readings to paintings detail by detail rather than to an entire image, and he insists that all motifs in a painting must share a single meaning, despite his analysis of formal oppositions in Ruisdael's pictures. See esp. Wiegand, pp. 38–56, 82–85. See also the interpretation of the *Storm at Sea* formerly attributed to Pieter Bruegel the Elder (Fig. 39) using as the basis of the interpretation solely the barrel tossed to the threatening whale, discussed in Chapter 3. See, as well, Bentkowska, "*Navigatio vitae*," pp. 25–43.

41. For an exception to this, see De Jongh's study, "Bol vincit amorem," in *Simiolus*, 12, 1981–82, pp. 147–61.

42. The strengths and weaknesses of the iconographic method in studying Dutch genre painting are judiciously assessed by Sutton, *Masterpieces*, pp. XIX–XXV, LX–LXI, and Stone-Ferrier, *Dutch Prints*, pp. 3–28.

43. De Jongh, in *Tot lering en vermaak*, pp. 26–27, explicitly warns against an overly rationalized, systematic approach to interpretation. Cf. E. H. Gombrich's insistence upon a single isolated meaning to Renaissance pictures ("Introduction: Aims and Limits of Iconology," in *Symbolic Images: Studies in the Art of the Renaissance*, London and New York, 1972, pp. 1–25), which seems needlessly restrictive. It is evident that Renaissance artists—while perhaps in some cases consciously intending a single symbolic reference based on a text—gave such references visual forms that in themselves modify or amplify content in ways not necessarily determined by or fully congruent with the text or commission. Not all symbols and metaphors were necessarily commissioned. Renaissance society found the world charged with meaning. The issue may not be so much whether any artist ever tried to paint with the fourfold method of exegesis in mind, as whether an artist would have been at all surprised at the possibility of multiple interpretations of his work.

44. The focus on Dutch art in Laurens J. Bol, *Die holländische Marinemalerei des 17. Jahrhunderts*, Braunschweig, 1973, leads Bol to neglect the importance of developments in Flanders and Italy, and a similar criticism can be addressed to Wolfgang Stechow, *Dutch Landscape Painting of the Seventeenth Century*, 2d ed., London, 1968.

45. For the character of *ekphrasis* and its history from antiquity to the seventeenth century, see Jean H. Hagstrum, *The Sister Arts: The Tradition of Literary Pictorialism in English Poetry from Dryden to Gray*, Chicago, 1958, pp. 3–128. See also Chapter 5 above. I am grateful to Patricia Wirthlin for stimulating my interest in the subject of *ekphrasis*.

46. Svetlana Alpers, "*Ekphrasis* and Aesthetic Attitudes in Vasari's *Lives*," *Journal of the Warburg and Courtauld Institutes*, 23, 1960, p. 196.

47. For the deep influence of Horace's comment, "ut pictura poesis" (*Ars poetica* II.361), and its relation to *ekphrasis*, see Hagstrum, *The Sister Arts*, pp. 57–70, and Rensselaer W. Lee, *Ut pictura poesis: The Humanistic Theory of Painting*, New York, 1967, pp. 3–48. Plutarch attributes the dictum that painting is mute poetry, poetry a speaking picture, to Simonides of Ceos (c. 556–467 B.C.); see Hagstrum, pp. 10–11.

48. R. H. Fuchs, "Over het landschap: Een verslag naar aanleiding van Jacob van Ruisdael, *Het Korenveld*," *Tijdschrift voor Geschiedenis*, 86, 1973, pp. 281–92.

49. See note 10 above.

50. H. David Brumble, III, "Peter Brueghel the Elder: The Allegory of Landscape," *Art Quarterly*, n.s. 2, 1979, pp. 125–39; Justus Müller Hofstede, "Zur Interpretation von Pieter Bruegels Landschaft: Äesthetischer Landschaftsbegriff und stoische Weltbetrachtung," in *Pieter Bruegel und seine Welt*, ed. Otto von Simson and Matthias Winner, Berlin, 1979, pp. 73–142.

51. For what follows on Dutch trade, shipping, and overseas expansion in the late sixteenth and seventeenth centuries, see C. R. Boxer, *The Dutch Seaborne Empire, 1600–1800*, New York, 1965, and L. M. Akveld et al., eds., *Maritieme Geschiedenis der Nederlanden*, II, *Zeventiende eeuw, van 1585 tot ca. 1680*, Bussum, 1977. A useful short study is D. W. Davies, *A Primer of Dutch Seventeenth-Century Overseas Trade*, The Hague, 1962. See also Fernand Braudel, *The Mediterra-*

nean and the Mediterranean World in the Age of Philip II, trans. S. Reynolds, New York, 1972, I, pp. 629–40.

52. On the connection between Dutch seascape and seafaring, see Chapter 4.

53. Audrey M. Lambert, *The Making of the Dutch Landscape: An Historical Geography of the Netherlands*, 2d ed., London, 1985, chap. 7.

54. Boxer, *Dutch Seaborne Empire*, p. 27.

55. Ibid., p. 20; J. van Beylen in *Maritieme Geschiedenis*, II, pp. 28–32.

56. For the important role of the Dutch in map-making and navigation, see G. Schilder and W. F. J. Morzer Bruyns in *Maritieme Geschiedenis*, II, pp. 159–99.

57. See P. Geyl, *The Revolt of the Netherlands, 1555–1609*, 2d ed., London, 1958, pp. 233–38; idem, *The Netherlands in the Seventeenth Century*, I, pp. 158–208; and Boxer, *Dutch Seaborne Empire*, pp. 1–30. The connection between national identity, prosperity, and seafaring was explicitly recognized by many Dutch writers in the early seventeenth century. For example, Hugo Grotius, while urging in his *Bewys van den waren godsdienst*, 2d ed., Leiden, 1622, p. 1, that voyaging be used to spread the Christian faith as well as to accumulate profits, begins by describing how the Dutch people have carried their flag and fame around the globe through their courageous seafaring and acquired riches in Africa and the East. Joost van den Vondel's "Hymnus, ofte Lof-gesangh over de wijd-beroemde scheeps-vaert der Vereenighde Nederlanden" ("Hymn or paean on the celebrated navigation of the United Netherlands") recounts the history of seafaring and the power and wealth it has brought the Netherlands; see *De Werken van Vondel*, I, Amsterdam, 1927, pp. 427–45. The poem was written about 1613; its earliest known publication was 1622. This poem refers in part to an anonymous print (illustrated in the modern edition) allegorizing "s' Lands Welvaren" ("the prosperity of the land") by means of a view of the harbor of Amsterdam filled with ships flying flags with the arms of the Dutch provinces. See page 140 above.

58. On the *rederij*, see S. Hart, in *Maritieme Geschiedenis*, II, pp. 106–11, and Boxer, *Dutch Seaborne Empire*, pp. 6–7.

59. On the accounts of Dutch voyagers, see G. A. van Es, "Reisverhalen," in F. Baur, ed., *Geschiedenis van de letterkunde der Nederlanden*, IV, s'Hertogenbosch and Antwerp, 1948, pp. 220–41, and bibliography in P. A. Tiele, *Mémoire bibliographique sur les journaux des navigateurs néerlandais*, Amsterdam, 1867. Many of the voyagers' journals have been reprinted in modern editions by the Linschoten Vereeniging. For a discussion of the voyagers within a broad and ambitious interpretation of Dutch culture, see Simon Schama, *The Embarrassment of Riches*, New York, 1987, pp. 28–34.

60. Van de Velde the Younger's *A Gale with Ships Wrecked on a Rocky Coast* (on loan to the National Maritime Museum, Greenwich) of about 1685 has been linked to a disaster in December 1653; see David Cordingly, in *The Art of the Van de Veldes*, exhibition catalogue, Greenwich, National Maritime Museum, 1982, no. 123, and Chapter 4 above for further examples and a discussion of the problem of identification.

CHAPTER 2

1. This discussion is in large part based on M. P. O. Morford, *The Poet Lucan: Studies in Rhetorical Epic*, Oxford, 1967, pp. 20–36. For Homer's storms, see *The Odyssey*, trans. A. T. Murray (Loeb Classical Library), Cambridge, Mass., and London, 1974, pp. 191–99, 461–63.

2. *Aeneid*, trans. H. Rushton Fairclough (Loeb Classical Library), Cambridge, Mass., and London, 1974, pp. 246–53.

3. *Metamorphoses*, trans. F. J. Miller (Loeb Classical Library), Cambridge, Mass., and London, 1951, II, pp. 154–73.

4. *Seneca's Tragedies*, trans. F. J. Miller (Loeb Classical Library), London and New York, 1917, II, pp. 40–49.

5. *Pharsalia*, IV.48–120; V.504–677; IX. 319–47; IX.445–92. The last of these is a dust storm in the Libyan desert. See *The Civil War*, trans. J. D. Duff (Loeb Classical Library), Cambridge, Mass., and London, 1928, pp. 176–83, 276–91, 528–31, 538–41. See also Morford, *The Poet Lucan*, pp. 20, 37–50.

6. *The Adventures of Leucippe and Clitophon*, trans. S. Gaselee (Loeb Classical Library), London and New York, 1917, book III, pp. 134–45.

7. H. Lausberg, *Handbuch der literarischen Rhetorik*, Munich, 1960, I, pp. 399–401. See also Morford, *The Poet Lucan*, pp. 32–36, and S. F. Bonner, *Roman Declamation in the Late Republic and Early Empire*, Liverpool, 1949, pp. 58–60. See also the discussion of *enargeia* in Quintilian, *Institutio oratoria*, IV.ii.63; VI.ii.29–36; VIII.iii.61–82 (trans. H. E. Butler [Loeb Classical Library],

Cambridge, Mass., and London, 1921, vol. 2, pp. 82–85, 432–39; vol. 3, pp. 244–57).

8. *De rerum natura* II.551–61; *On the Nature of the Universe,* trans. R. E. Latham, Baltimore, 1951, p. 76.

9. Morford, *The Poet Lucan,* pp. 33–34.

10. Ernst Robert Curtius, *European Literature and the Latin Middle Ages,* trans. Willard R. Trask, New York, 1953, p. 69.

11. Samuel Purchas, *Hakluytus Posthumus, or Purchas His Pilgrimes,* London, 1625; Glasgow and New York, 1906, XIX, pp. 5–8. Strachey's report was written in 1610. For its relationship to Shakespeare, see Frank Kermode's introduction to *The Tempest* (The Arden Shakespeare), Cambridge, Mass., 1954, pp. xxv–xxx.

12. Ibid., pp. 6–7.

13. Ibid., pp. 6–8.

14. "Het Lof der zeevaert," ll.265–314, in *De Werken van Vondel,* Amsterdam, 1929, II, pp. 445–47:

265 Als onverwacht de wind versucht langs't sandige oever,
De locht betreckt, en dooft de sterren langs hoe droever.
En steeckt syne ooren op, en gaet den Oceaen
Met dicken nevelen bevatten, en beslaen:
Mengt Zee, en Hemel t'saem, plasregenen, en buyen.

270 Het Oost is tegen't West, en't Noorden tegen't Zuyen.
Den Opgang d'Ondergang al bulderende ontseyt.
De Middagh huylt en raest. de Middernacht die schreyt.
De berning woed aen't strand, op Syrten, en op platen.
De Winter is ontboeyt. de stormen uytgelaten,

275 Vermeestren AEolus; die twijffelt of't Geval
Van Hemel, Aerde, en Zee een Chaos brouwen sal.
De vloed weerstreeft den wind. de winden aen het hollen
Omwentelen den vloed, en doen de golven rollen.
Waer waendy blijft mijn schip ghedreven vanden Nood,

280 Geworpen inden muyl, en kaecken vande dood?
Men isser drock in't werck met strijcken, pompen, hoosen,
Met kerven, klutsen, slaen, met binden, klimmen, loosen.
Nu lydet achter last, nu voren, nu ter sy.
De Zee vergeet haer perck, en Nereus eb en ty.

285 Nu hanget aen een berg. nu breeckt de mast de wolcken.
Nu slickt den Hel het op door't slorpen vande kolcken.
Men vloeckt 'tgewenschte land al schricktmen voor den plas.
't Schip luystert nae geen roer, na Stuurman, nocht kompas.
De kunst is overheert. gelijk wanneer door tooren

290 't Ianitser schuym verhit, wil na geen Sultan hooren,
En schuymbeckt, dreyght, en driescht, en stampt, en huylt, en woelt,
Tot met der Bassen bloed sijn wraecklust word ghekoelt:
Mijn Tiphys vaeck aldus, sijns ondancx, de ghemoedren
Der Watergoon versoent, met d'ingeladen goedren,

295 En licht ter nood scheeps last, en sijne masten kerft,
Smackt willigh over boord het gene hy noode derft,
En worstelt by den tast, en hoort de touwen gieren,
Verneemt geen hemels licht, nocht siet geen baeckens vieren:
Of soo hem licht gebeurt, 't zijn blixemen met kracht

300 Geslingert van Iuppijn in't droefste vanden nacht:
Tot traegh de dagh aenbreeckt: die hem te moet gaet voeren
't Geen met medoogen soude een steenen hert beroeren:
d'Ontrampeneerde vloot, verbaest, en afgeslooft,
Van seyl van treyl, van roer van snoer, van mast berooft,

305 Gesloopt, versand, gestrand, op riffen, en op scheeren:
Wanhopige die hulp in't uyterste begeeren,
En hangen van een roots, of swemmen op een planck,
d'Een levend, d'ander dood, versopen, flaeu, en kranck,
En andere die stijf van vreese sijn gekrompen,

310 En wachten op het jongste, en houden't op met pompen,
En smeecken noch van verre om bystand met een schoot,
En and're die gepropt sieltoogen in een boot.

Help Proteus! wonder is't dat sterffelijcke menschen
Noch smalen op den ploegh, en om een Zeelucht wenschen.

15. The book or poem as a metaphorical sea voyage is a familiar classical *topos.* See Curtius, *European Literature,* pp. 128–30.

16. G. Wilson Knight, *The Shakespearian Tempest,* 3d ed., Oxford, 1953, esp. the preface and pp. 1–74, 169–217, and 267–92.

17. Ibid., pp. 15–16, 288–92.

18. Ibid., p. 292.

19. My discussion of the *locus amoenus* and pastoral is based primarily on Curtius, *European Literature,* pp. 185–200; Thomas G. Rosenmeyer, *The Green Cabinet: Theocritus and the European Pastoral Lyric,* Berkeley and Los Angeles, 1969, pp. 3–44, 179–203; and Donald M. Friedman, *Marvell's Pastoral Art,* Berkeley and Los Angeles, 1970, pp. 4–14. On landscape description in Dutch seventeenth-century poetry, see T. H. Beening, "Het Landschap in de Nederlandsche letterkunde van de Renaissance," Dissertation: University of Nijmegen, 1963, pp. 452–67. On georgic poetry in the Netherlands, see P. A. F. van Veen, "De Soeticheydt des buyten-levens, vergheselschapt met de boucken." Dissertation: University of Leiden, The Hague, 1960, esp. pp. 5–15, 115–21, 205–22.

20. Curtius, *European Literature,* p. 186.

21. The ancient *topos* of the evil of seafaring first appears in Hesiod's *Works and Days,* 236–37 (trans. Hugh G. Evelyn-White, London and New York, 1914, pp. 20–21). See Morford, *The Poet Lucan,* pp. 29–30. Cf. Revelation 21:1 ("and there was no more sea"). In antiquity the perils of navigation were also the subject of a standard *thesis,* a rhetorical exercise on a question of philosophy. See Bonner, *Roman Declamation,* pp. 2–5, 163–64.

22. Virgil, *Georgics,* trans. H. Rushton Fairclough (Loeb Classical Library), Cambridge, Mass., and London, 1974, p. 151.

23. Horace, *The Odes and Epodes,* trans. C. E. Bennett (Loeb Classical Library), Cambridge, Mass., and London, 1927, pp. 364–65.

24. The dangers of the storm and a condemnation of seafaring appear in the first Dutch *hofdicht,* Philibert van Borsselen's *Den Binckhorst* (1613), and recur throughout the seventeenth century: see Van Veen, "De Soeticheydt des buyten-levens," pp. 15–77.

25. *Georgics* (trans. Fairclough), pp. 102–3. See also the storm in *Georgics* I.356–72; pp. 104–7. Concerning the first of these passages, see Michael C. J. Putnam, *Virgil's Poem of the Earth: Studies in the Georgics,* Princeton, 1979, pp. 50–53, and Gary B. Miles, *Virgil's Georgics: A New Interpretation,* Berkeley, 1980, pp. 98–99.

26. A concise, comprehensive discussion of Renaissance cosmology is S. K. Heninger, *The Cosmographical Glass,* San Marino, California, 1977, esp. pp. 106–15. See also Nicolson, *The Breaking of the Circle,* pp. 1–46, and E. M. W. Tillyard, *The Elizabethan World Picture,* New York, 1941. For a parallel discussion of the relation of landscape to cosmological conceptions, see Lisa Vergara, *Rubens and the Poetics of Landscape,* New Haven and London, 1982, pp. 48–55.

27. For a contemporary explication of this worldview, see Guillaume Salluste du Bartas's famous *Première Sepmaine ou création du monde* (1578), a work widely available in numerous French editions and in English (1605) and Dutch (1609) translations: *The Works of Guillaume Salluste Sieur du Bartas,* ed. Urban Tigner Holmes et al., Chapel Hill, North Carolina, 1938, vol. I, esp. "Le second jour," pp. 222–65, for a full account of the elements and meteorology. The English translation is by Joshua Sylvester, *Bartas: His Devine Weekes and Works,* London, 1605; ed. Francis C. Haber, Gainesville, Florida, 1965.

28. Nicolson, *The Breaking of the Circle,* pp. 81–165, esp. pp. 125ff.

29. Ignaz Matthey, "De Betekenis van de natuur en de natuurwetenschappen voor Constantijn Huygens," in *Constantijn Huygens: Zijn plaats in geleerd Europa,* Amsterdam, 1973, pp. 334–459, esp. pp. 392–412, and for Huygens's response to the storm of 1675, pp. 400–401.

30. Nicolson, *The Breaking of the Circle,* pp. 132–33.

31. For the elements and qualities, see Heninger, *The Cosmographical Glass,* pp. 106–7, and Gerhard Frey, "Elemente," in *Reallexikon zur deutschen Kunstgeschichte,* IV, 1256–61.

32. Heninger, *The Cosmographical Glass,* p. 107.

33. Ibid., pp. 107–15. Nicolson, *The Breaking of the Circle,* pp. 1–46. C. S. Lewis, *The Discarded Image,* Cambridge, 1964, p. 92, observes that "in medieval science the fundamental concept was that of certain sympathies, antipathies, and strivings inherent in matter itself."

34. S. K. Heninger, *A Handbook of Renaissance Meteorology,* Durham, North Carolina, 1960, is fundamental to my discussion. For what follows on Aristotle, see Heninger, pp. 4–13, 37–44.

35. Ibid., pp. 42, 119.

36. Edmund Spenser, *Poetical Works,* ed. J. C. Smith and E. de Selincourt, London, 1912, p. 59.

37. *Natural History,* trans. Harris Rackham (Loeb Classical Library), Cambridge, Mass., 1938, I, 246–47.

38. Heninger, *The Cosmographical Glass*, pp. 108–15. See also Nils Erik Enkvist, "The Seasons of the Year: Chapters on a Motif from Beowulf to the Shepherd's Calendar," *Societas Scientiarum Fennica, Commentationes Humanarum Litterarum*, 22, no. 4, 1957, esp. chap. III, and Rosemund Tuve, *Seasons and Months: Studies in a Tradition of Middle English Poetry*, Paris, 1933, pp. 11–52.

39. For seasons in pastoral, see Enkvist, "The Seasons of the Year," chap. IV. On seasons in georgic, see Van Veen, *De Soeticheydt des buyten-levens*, pp. 117–20.

40. Fernand Braudel, *The Mediterranean and the Mediterranean World in the Age of Philip II*, trans. S. Reynolds, New York, 1972, pp. 246–56.

41. *De rerum natura* VI.356–78 (*On the Nature of the Universe*, trans. R. E. Latham, Baltimore, 1951, p. 228). For equinoctial storms, see also Aratus, *Phaenomena* 744–47; trans. G. R. Mair (Loeb Classical Library), London and Cambridge, Mass., 1955, pp. 264–65 and note a, with other examples. See also Virgil's first *Georgic* 311–34 (Loeb Classical Library, pp. 102–5).

42. Nicolson, *The Breaking of the Circle*, p. 126. Cf. Nicolson, p. 7: "What once seemed 'identicals' have become in our modern world only 'similars'. Metaphor, based upon accepted truth, inscribed by God in the nature of the universe, has given way to simile." Nicolson's emphasis upon the reality of metaphor in the pre-enlightenment worldview is one of the most important contributions of her study.

43. Nicolson, *The Breaking of the Circle*, pp. 16–17.

44. Jacob Cats, *Ouderdom, buyten-leven, en hof-gedachten op Sorgh-Vliet*, Amsterdam, 1656, "Invallende gedachten," XIII, p. 85.

45. "Daer is niet ledighs of ydels in de dinghen." Roemer Visscher, *Sinnepoppen*, Amsterdam, 1614; reprint, ed. L. Brummel, The Hague, 1949, p. 1. Van Veen, *De Soeticheydt des buyten-levens*, pp. 211–15, rightly stresses the importance of nature as a form of divine revelation in seventeenth-century Holland, but in seeking to link this concept solely to Protestantism does not recognize the degree to which this was a commonplace of European culture from the Middle Ages onward. See Curtius, *European Literature*, pp. 319–26, for a discussion of the *topos* of the book of nature.

46. Friedman, *Marvell's Pastoral Art*, p. 14. Pastoral, unlike storm narratives, is a distinct literary genre that could serve as a vehicle for complex allegorical considerations of society, human nature, and art. But the tempest clearly possesses an almost irresistible capacity for metaphorical interpretation in which man's relationship to nature and to his fellow travelers is easily allegorized in ways similar to the subject matter of pastoral.

47. The basis for my discussion is Johannes Kahlmeyer, *Seesturm und Schiffbruch als Bild im antiken Schrifttum*, Dissertation: Ernst-Moritz-Arndt Universität, Greifswald; Hildesheim, 1934.

48. Ibid., pp. 3–8. Among Homer's numerous images of battle as sea and storm are *Iliad* IV.422ff.; XI.305ff.; XIII.795ff.

49. Ovid, *Metamorphoses* XI.525–32.

50. Kahlmeyer, "Seesturm und Schiffbruch," p. 7.

51. Ibid., pp. 8–11; *Iliad* II.144ff.; II.207ff.

52. Kahlmeyer, pp. 11–12, 19–22. *Iliad* IX.4ff.; XV.624ff.

53. Kahlmeyer, pp. 22–26.

54. Ibid., pp. 23–24.

55. Ibid., p. 23.

56. Ibid., pp. 26–39.

57. G. L. Boxhoorn, *Nieuw liedt-boeck 't Maes-sluysche tydt-verdryff*, Delft, 1671, p. 130; in D. F. Scheurleer, ed., *Onze mannen ter zee in dicht en beeld*, II, The Hague, 1912–14, pp. 165–66.

58. Adrianus Valerius, *Neder-landtsche gedenck-clank*, Haarlem, 1626; reprint, New York, 1974, p. 253:

> Een stierman, die daer seyld na wyd' gelegen Landen,
> Neemt altydt oogen-merck op Caap, en klip, en stranden,
> En bakens van de locht, neemt mede boog en kaert,
> Compas, en wat hem al mocht dienen op de vaert.
>
> Op dat hy schip en volck te beter mochte vueren
> End' door Gods hulp in een behouden haven stueren.
> O mensch! saegt g'oock soo toe voor uwe diere siel,
> Sulcks dat sy toch door sond tot schip-breuck niet verviel!

59. Kahlmeyer, pp. 26–39, treats metaphors of human life, sufferings, and misfortune as a single general motif, but Fortune has a distinct identity, however closely related it is to metaphors of human life in general. See A. Doren, "Fortuna im Mittelalter und in der Renaissance," *Vorträge der Bibliothek Warburg*, 1922–23, pp. 71–144, and Samuel H. Chew, *The Pilgrimage of Life*, New Haven and London, 1962, pp. 38–69.

60. "Waerlijck, de Zee is't reghte Sinnebeeld der onbestandigheyd; sijnde nu stil, dan woedend: Nu ebbende, stracks weer vloeyende. Op den gantschen Aerdbodem is alles onbestandigh . . . bestaet

in een bestandigheyt van onbestandigheyd. . . . Dat oock ons leven, en de Staet onses Levens, seer bequaemlijck by de Zee werd vergeleecken, is yeder bekend. Laet ons dan bysonderlijck hier nae traghten, dat wy in al de hobbelingen, hooghstijgende golven, en gevaeren des selven mogen uytwerpen een verseeckerd Ancker: Door't Geloof . . . door de Hoop . . . door de Liefde." Simon de Vries, *Wonderen soo aen als in, en wonder-gevallen soo op als ontrent de zeeën . . .* , Amsterdam, 1687, p. 12.

61. Kahlmeyer, *Seesturm und Schiffbruch*, pp. 39–47.

62. For Alcaeus's poem, see *Lyra Graeca*, trans. J. M. Edmonds, London and New York, 1922, I, pp. 344–45. Plato uses this image repeatedly (e.g., *Republic*, VI.488); see Kahlmeyer, *Seesturm und Schiffbruch*, p. 43. For the many references to the Ship of State in Plutarch and Cicero, see Kahlmeyer, pp. 45–46.

63. Steele Commager, *The Odes of Horace: A Critical Study*, New Haven and London, 1962, pp. 163–69.

64. Horace, *The Odes and Epodes* (Loeb Classical Library), pp. 42–43.

65. J. A. Worp, *De Gedichten van Constantijn Huygens, naar zijn handschrift uitgegeven*, Gronigen, 1893, II, pp. 126–28; first published in Huygens's *Korenbloemen* in 1650.

66. See the commentary on the gospel narrative of Christ calming the storm in D. E. Nineham, *The Gospel of St. Mark: The Pelican New Testament Commentaries*, rev. ed., Baltimore, 1969, pp. 146–47; and the discussion of the storm as theophany with reference to Job 38:1, "Then Yahweh answered Job / From out of the storm," in *The Anchor Bible: Job*, New York, 1955, p. 249, note 1b (I am grateful to Ruth Eisenstein for this reference).

67. The symbolism of the ship in antiquity and its incorporation into patristic theology has been exhaustively studied in a series of articles by Hugo Rahner, "Antenna Crucis," in *Symbole der Kirche: Die Ekklesiologie der Väter*, Salzburg, 1964, pp. 239–564. For concise discussions of both the Ship of Human Life and the Ship of the Church, see U. Weber, "Schiff," in *Lexicon der christlichen Ikonographie*, ed. E. Kirschbaum, Freiburg im Bresgau, 1972, IV, 61–67, and Franz Joseph Dolger, *Sol salutis: Gebet und Gesang im christlichen Altertums*, Marburg, 1920; 3d ed., Münster, 1972, pp. 272–86. For the iconography of the Ship of the Church, see also John B. Knipping, *Iconography of the Counter Reformation in the Netherlands: Heaven on Earth*, Nieuwkoop and Leiden, 1974, II, 355–59.

68. Augustine, *De beata vita*, chap. 1; in J.-P. Migne, *Patrologiae cursus completus, series latina*, Paris, 1845, vol. 32, 959–62.

69. Rahner, *Symbole der Kirche*, pp. 260–71.

70. For the following, in addition to the literature cited in note 67, see H. Hohl, "Arche Noe," in *Lexikon der christlichen Ikonographie*, I, 178–79.

71. Tertullian, *De baptismo*, 12; in August Reifferscheid and Georg Wissowa, eds., *Corpus scriptorum ecclesiasticorum latinorum*, Vienna, 1890, 20, p. 212.

72. Hippolytus, *De Christo et Antichristo*, 59; in J.-P. Migne, ed., *Patrologiae cursus completus, series graeca*, Paris, 1857, vol. 10, 777–80.

73. Clemens Romanus, *Epistola ad Jacobum*, xiv–xv; in Migne, *Patrologia graeca*, vol. 2, 49–52.

74. Rahner, *Symbole der Kirche*, pp. 473–503. See also U. Weber, "Schiff," in *Lexikon der christlichen Ikonographie*, IV, 63–67.

75. D. Bax, *Hieronymus Bosch: His Picture-Writing Deciphered*, Rotterdam, 1979, pp. 244–55.

76. Sebastian Brant, *Narrenschiff*, ed. Friedrich Zarnke, Leipzig, 1854; reprint, Darmstadt, 1964. For the origins of Brant's conception of the ship as a community of folly, see Zarnke's edition, pp. xliv–xlvi, liii–lxiii. Reiner Gruenter, "Das Schiff: Ein Beitrag zur historischen Metaphorik," in *Tradition und Ursprünglichkeit: Akten des III. Int. Germanistenkongresses 1965 in Amsterdam*, Bern, 1966, pp. 86–101, discusses the relation of Brant's allegory to the patristic tradition.

77. *Colloquia*, Basel, 1523; *The Colloquies of Erasmus*, trans. and ed. Craig R. Thompson, Chicago and London, 1965, pp. 138–46.

78. *Le Quart Livre*, 1551, chaps. XVIII–XXII; *The Five Books of Gargantua and Pantagruel*, trans. Jacques Le Clercq, New York, 1936, pp. 556–70.

79. Ibid., p. 557.

80. Ibid., p. 558.

81. See *Maritieme Geschiedenis der Nederlanden*, II, p. 150. In addition to Udemans's *Geestelick Compas* (see note 82), such texts include A. Westermans, *Groote christelyke zeevaert in XXVI predikanten*, Amsterdam, 1635; and N. S. van Leeuwaarden, *De Godvrezende zeeman, ofte de nieuwe christelyke zeevaert*, Amsterdam, 1748.

82. Godefridus Cornelis Udemans, *Geestelick Compas, dat is nut ende nootwendigh bericht voor alle zee-varende ende reysende luyden om te ontgaen de steen-klippen ende zantplaten der sonde ende des toorns Godts . . .* , 4th ed., Dordrecht, 1647. The dedication is dated 1617.

83. Ibid., p. [A3r].

84. Ibid., p. 22.

85. "Wy oock daer inne hebben een figure ende af-beeldinghe van de werelt. . . . Want gelijck de zee nimmermeer soo gherust en is / of sy doet de schepen altijt drijven ende tobbelen herrewaerts en derwaerts; soo en is de werelt nimmermeer soo stil / of de menschen ghevoelen dat sy vol onrusten is: Gelijck de zee lichtelick wordt onstelt door de winden ende tempeesten; soo wordt oock de werelt in roere gestelt door den duyvel ende de boose menschen / . . ." Ibid., pp. 31–32.

86. "In de Schepen in de zee liggen in tobbelen, hebben wy oock eene figure van de strijdende Kercke Christi op de aerden." Ibid., pp. 32–33.

87. "Want de beschrijvinghe is soo levendigh ende aerdigh / als of wy den noodt voor onsen ooghen saghen / . . ." Ibid., p. 25.

88. ". . . ghelijck dan in sware tempeesten het water als met een dicke duysternisse bedeckt wordt / ghelijck dien gheleerden Poeet dat seer aerdigh heeft uyt-ghedruckt met weynighe woorden / seggende van een seker tempeest *Ponto nox incubat atra . . .*" Ibid., pp. 253–54, quoting *Aeneid* I.89.

89. My discussion is based on Garrett Mattingly, *The Armada*, Boston, 1959.

90. Ibid., pp. 389–91, 397–402. Ironically, the gales that blew the Armada into the North Sea actually saved the Spanish fleet from almost total annihilation on the Zeeland sands, where the fleet was being driven, when the wind veered around the compass in the nick of time to send it out to sea. Ibid., pp. 335–38.

91. Gerard van Loon, *Beschryving der nederlandsche historie penningen*, The Hague, 1723, I, pp. 390–91. The inscriptions on the reverse read "TU DEUS MAGNUS ET MAGNA FACIS TU SOLUS DEUS" and "VENI. VIDE. VIVE, 1588." The obverse depicts a council of pope, emperor, king of Spain, and cardinals, their eyes blindfolded, their feet on a bed of nails. The legends read "DURUM EST CONTRA STIMULOS CALCITRARE" ("It is hard for thee to kick against the pricks"—quoting the message Paul received on the road to Damascus in Acts 9:5); and "O COECAS HOMINUM MENTES O PECTORA COECA" ("O blind minds of men, O blind sinners").

92. Ibid., p. 392. Another Armada medallion depicts on the obverse a family praying with the inscription "HOMO PROPONIT DEUS DISPONIT 1588" ("man proposes, God disposes"); and on the reverse, a ship breaking up with the text, "HISPANI FUGIUNT ET PEREUNT NEMINE SEQUENTE" ("The Spaniards flee and perish pursued by no one"). See ibid., p. 392.

93.
't is de onbedachte sond
Die ons door het water wond,
Die de baren, end'haar slaan
Doet als hooghe berghen gaan,
'Hoe de sond ons meer verdwaast,
Hoe de wind te stercker blaast,
Hoe de sonde meerder groeyt
Hoe de zee te hoogher vloeyt,
't is de sonde die ons plaaght
Die ons uyt het Land verjaaght. . . .

Adrianus Hofferus, *Nederduytsche poemata*, Amsterdam, 1635, pp. 287–92; the quotation is from p. 290. Hubert Korneliszoon Poot similarly interprets the inundation of 1717; see his *Gedichten*, 2d ed., Amsterdam, 1729, pp. 385–88. Johannes Vollenhove's poem "Op de gruwzamen nachtstorm in Wintermaant des jaars 1660" ("On the horrible night-storm in December 1660") identifies the wind as the breath of God, able to overthrow all human security and pride: *J. Vollenhoves Poëzy*, 1686, p. 188ff.; *Nederlandse dicht- en prozawerken*, ed. Georg Penon, Groningen, 1888, IV, pp. 359–62.

94. Worp, *De Gedichten van Constantijn Huygens*, VIII, p. 130:
Op het stille weder vanden biddagh 6.en Nov.1675
naer veler dagen storm

De Donder, Blixem, Storm van winden allerhand
Zijn grouwelick geweest in Oogen en in Ooren:
Van daegh is 't schielijck still: Bidt neerstigh, Vaderlandt
't Schijnt dat den Hemel swijght, om uw gebed te hooren.
6 nov.1675

95. "Noch dese beschrijvinghe is niet van hooren segghen . . . maer komt uyt selfs-ondervindinghe, verhalende wat wonderen dat Godt aen den autheur self, als oock aen dieghene, die by hem waren, bewesen heeft. Want wie en sal sich niet op het hoochste verwonderen, wanneer hy leest, hoe dat een mensch . . . door soo veel ghevaer en teghenspoedt, jae soodanighe waerin het hopen nae eenighe uytkomste scheen te zijn als wanhopen, door des Heeren genade is ter behouder plaets ghebracht." Willem IJsbrantsz. Bontekoe, *Journael ofte gedenckwaerdige beschrijvinghe van de oost-indische reyse . . .*, Hoorn, 1646; ed. G. J. Hoogewerff, The Hague, 1952 (De Linschoten Vereeniging, no. 54), p. 5. Bontekoe's account went through twenty-five printings between 1648 and 1680 and more than seventy by 1800; see the introduction to the modern edition, p. xlix.

96. "... *want dese dagh was de laetste*, nae welcke het volck ghesolveert waren de jonghens aen te tasten en op te eten: Hier bleeckt dat de Heere de beste Stierman was, die ons gheleyde en stierde dat wy het landt kreghen als verhaelt is." Ibid., p. 38.

97. "Ses glasen in de nacht begon het soo schrickelijck te waeyen, dat het dieghene, die 't noyt ghehoort noch gesien heeft, onmooghelijck sou schijnen dat de windt sulcken kracht kan bybrengen.... Het schip sackte door de windt soo laegh in 't water alsof de windt recht van boven neer quam, dat het scheen dat de anckers, die op de boegh stonden, by 't water quamen; jae, meende dat het schip sonck. Ten lasten waeyde onse groote mast over boordt en brack ontrent drie vadem boven 't bovenet, waerdoor het schip doen weder rees. Wy stonden by malkander met de hoofden teghen malkander aen, maer konden niet roepen noch spreecken dat wy malkander konden verstaen, te weten die boven waren." Ibid., pp. 173–74.

98. Samuel H. Monk, *The Sublime*, New York, 1935, pp. 216–20, discusses the vogue that appeared from the 1760s onward for observing storms from the safety of shore as a means of experiencing sublimity.

99. "... eenen gheduerighen tempeest ende onweer, dat het een verschricken om hooren was van wy, die op het land stonden, hoe veel te meer die in de schepen op de zee swermden, so dat alleenlijck op de custe ende clippen rontom van het eylandt Tercera bleven over die twaelf schepen, ende dat niet alleenlijck van d'een zyde ofte een plaets van het eylandt, maer rontom op alle hoecken ende plaetsen, soo datmen anders niet en hoorden dan claghen, cryten en kermen, ende segghen: daer is een schip aen de clippe aen stucken geloopen, ende daer een ander, ende alle het volck verdroncken...." Jan Huygen van Linschoten, *Itinerario*, Amsterdam, 1596; ed. H. Kern and H. Terpstra, The Hague, 1957 (De Linschoten Vereeniging, no. 60), III, p. 136.

100. "... soo datter van alle het volck maer veerthien oft vijfthien af quamen, ende die noch armen en beenen half ghebroken en uyt haer leden, ... die reste van de Spaengiaerts ende zee-volck, capiteijn en schipper zijn daer ghebleven." Ibid., p. 137.

CHAPTER 3

1. For brief surveys of the development of storm imagery from the fourteenth to the seventeenth century, see J. Richard Judson, "Marine Symbols of Salvation in the Sixteenth Century," *Essays in Memory of Karl Lehmann* (*Marsyas*, Supplement I), New York, 1964, pp. 136–52; Eduard Hüttinger, "Der Schiffbruch: Deutungen eines Bildmotivs im 19. Jahrhundert," in *Beiträge zur Motivkunde des 19. Jahrhunderts* (Studien zur Kunst des 19. Jahrhunderts, vol. 6), Munich, 1970, pp. 216–26; and Werner Timm, *Schiffe und ihre Schicksale: Maritime Ereignisbilder*, Rostock, 1976. Both Hüttinger's and Timm's studies are most useful for the development of this motif in the late eighteenth and nineteenth centuries.

2. Judson, "Marine Symbols of Salvation," pp. 136–52.

3. See the *Jonah* (Fig. 15) from the circle of Patinir in the S. Simon Collection in Belgium (Max J. Friedländer, *Early Netherlandish Painting*, vol. IXb, *Joos van Cleve, Jan Provost, Joachim Patenir*, New York, 1973, no. 255), and a drawing by Matthijs Cock dated 1540 in the Victoria and Albert Museum (Hans Gerhard Franz, *Niederländische Landschaftsmalerei im Zeitalter des Manierismus* [Forschungen und Berichte der Kunsthistorischen Instituts der Universität Graz, II], Graz, 1969, I, 141).

4. *The Voyage of St. Julian* and *The Prayer on the Shore* were in the now-destroyed section of the manuscript formerly in Turin (Paul Durrieu, *Les Heures de Turin*, Paris, 1902; ed. Albert Châtelet, Turin, 1967, nos. XXX, XXXVII). On the difficult problem of attributing these miniatures, see James Marrow's review of Châtelet's edition, in *The Art Bulletin*, 50, 1968, pp. 203–9; and Millard Meiss, *French Painting in the Time of Jean de Berry: The Limbourg Brothers*, New York, 1974, pp. 242–43. On the tradition of marine subject matter in Netherlandish painting, see F. C. Willis, *Die niederländische Marinemalerei*, Leipzig, 1911; Laurens J. Bol, *Die holländische Marinemalerei des 17. Jahrhunderts*, Braunschweig, 1973, pp. 2–7; John Walsh, "Jan and Julius Porcellis: Dutch Marine Painters," Dissertation: Columbia University, 1971, pp. 60–88; and M. Russell, *Visions of the Sea: Hendrick C. Vroom and the Origins of Dutch Marine Painting*, Leiden, 1983, pp. 3–87.

5. For Master ⚒'s ship engravings, see Max Lehrs, *Der Meister* ⚒, Dresden, 1895; idem, *Geschichte und kritischer Katalog des deutschen, niederländischen, und französischen Kupferstichs im XV. Jahrhundert*, VII, Vienna, 1930, nos. 34–41. For Bruegel's series, see Louis Lebeer, *Catalogue raisonné des estampes de Bruegel l'Ancien*, Brussels, 1969, nos. 41–51.

6. Lehrs, *Geschichte und kritischer Katalog*, VII, no. 40, pp. 66–67.

7. Aldo di Rinaldis, *Pinacoteca del Museo Nazionale de Napoli*, Naples, 1928, p. 198, inv. no. 84459.

8. See, for example, the versions of Patinir's *St. Jerome* in the Prado, Madrid, and in the National Gallery, London; Friedländer, *Early Netherlandish Painting*, IXb, nos. 240, 243a.

9. John Oliver Hand and Martha Wolff, *Early Netherlandish Painting*, Washington, D.C., 1986, pp. 2–6. Hand's tentative attribution to Matthys Cock and date about 1540 are much more plausible than the attribution to Pieter Bruegel the Elder proposed by Gustav Glück, *Das Bruegel Buch*, Vienna, 1936, no. 2.

10. On *La Navicella*, see J. Poeschke, "Navicella," in *Lexikon der christlichen Ikonographie*, Rome, 1971, III, 319–20; Lionello Venturi, "La Navicella di Giotto," *L'arte*, 25, 1922, pp. 49–69; Wilhelm Paeseler, "Giottos Navicella und ihr spätantikes Vorbild," *Römisches Jahrbuch für Kunstgeschichte*, 5, 1941, pp. 49–162. The reversed reproduction of Nicolaus Beatrizet's engraving of 1559 (Fig. 20) is from Paeseler, fig. 75. For the probable influence of *La Navicella* through model books, see Bernhard Degenhart and Annegrit Schmitt, *Corpus der italienischen Zeichnungen 1300–1450, Teil I, Süd und Mittelitalien*, Berlin, 1968, I, 2, no. 181, pp. 278–80.

11. Cf., for example, Gentile da Fabriano's *St. Nicholas Calming a Storm* from the Quaretesi Polyptych of 1425: Keith Christiansen, *Gentile da Fabriano*, Ithaca, New York, 1982, pp. 43–47, and E. Micheletti, *L'opera completa di Gentile da Fabriano*, Milan, 1976, no. 38.

12. Max Seidel, "Wiedergefundene Fragmente eines Hauptwerks von Ambrogio Lorenzetti," *Pantheon*, 36, 1978, pp. 119–27; see also George Rowley, *Ambrogio Lorenzetti*, Princeton, 1958, I, 91–93.

13. *Het Schilder-Boeck*, Amsterdam, 1618, p. 34r.

14. Julius von Schlosser, ed., *Lorenzo Ghiberti's Denkwürdigkeiten (I commentarii)*, vol. 1, Berlin, 1912, pp. 40–41. The translation is from Rowley, *Ambrogio Lorenzetti*, p. 92. Cf. Bernardus Facius's description in 1455–56 of a now-lost *Tempest* by Gentile da Fabriano: "Pinxit item in eadem urbe turbinem arbores caeteraque id genus radicitus evertentem, cuius est ea facies, ut vel prospicientibus horrorem ac metum incutiat." See Michael Baxandall, *Giotto and the Orators*, Oxford, 1971, pp. 164–65, and Micheletti, *L'opera completa di Gentile da Fabriano*, no. 18. Degenhart and Schmitt, *Corpus*, I, 2, p. 280, note 9, suggest that this tempest is one known to have been in the Doge's Palace, and also suggest its possible relation to manuscript illuminations and cassone panels illustrating the *Aeneid*. See ibid., pls. 377a, 379c; figs. 802, 804.

15. *The Notebooks of Leonardo da Vinci*, ed. Edward MacCurdy, New York, 1954, p. 734. For the importance of time in Leonardo's thought, see V. P. Zubov, *Leonardo da Vinci*, trans. David H. Kraus, Cambridge, Mass., 1968, p. 221ff. See also the discussion of Leonardo's fascination with transformation and its relation to the concept of the incomplete in Joseph Gantner, *Leonardos Visionen von der Sintflut und vom Untergang der Welt: Geschichte einer künstlerischen Idee*, Bern, 1958, pp. 36–45, and E. H. Gombrich's discussion of Leonardo's studies of motion: "The Form of Movement in Water and Air," in *The Heritage of Apelles*, Ithaca, New York, and Oxford, 1976, pp. 39–56.

16. MacCurdy, *Notebooks*, p. 72.

17. MacCurdy, *Notebooks*, p. 646. For Leonardo's concern with water, see MacCurdy, *Notebooks*, pp. 643–770; Gantner, *Leonardos Visionen*, pp. 62–71; Zubov, *Leonardo da Vinci*, pp. 74–78, 226–36; Kenneth Clark, *Leonardo da Vinci*, Harmondsworth and Baltimore, 1967, p. 148; and Gombrich, "The Form of Movement," pp. 39–56.

18. Zubov, *Leonardo da Vinci*, p. 226ff.; Gombrich, "The Form of Movement," pp. 39–56.

19. See Gantner, *Leonardos Visionen*, pp. 168–82, and the collection of texts pp. 227–49. For English translations, see MacCurdy, *Notebooks*, esp. pp. 870, 909, 914–20.

20. The famous drawing juxtaposing an old man in meditation with studies of flowing water (Windsor Castle, Royal Library, no. 12,579 recto; A. E. Popham, *The Drawings of Leonardo da Vinci*, New York, 1945, no. 282) includes a note observing the similarity between the movements of water and of plaited hair. See Clark, *Leonardo*, p. 148, and Gantner, *Leonardos Visionen*, pp. 62–63. Compare such famous drawings as Popham, nos. 209, 211, 273, 279–81.

21. Windsor Castle, Royal Library, no. 12,383; Popham, no. 295.

22. For Leonardo's deluge series, see Popham, nos. 290–96; Gantner, *Leonardos Visionen*, esp. pp. 192–222; and Clark, *Leonardo*, pp. 148–53.

23. Windsor Castle, Royal Library, no. 12,409; Popham, no. 261.

24. E. H. Gombrich, "Leonardo's Method for Working Out Compositions," in *Norm and Form: Studies in the Art of the Renaissance*, London, 1966, pp. 58–63.

25. On the development of "painterly" styles and their implications for the beholder's imaginative engagement in the art work, see E. H. Gombrich, *Art and Illusion: A Study in the Psychology of Pictorial Representation*, 2d ed., Princeton, 1961, pp. 181–202. See also the discussion of tonal structure in David Rosand, *Painting in Cinquecento Venice: Titian, Veronese, Tintoretto*, New Haven and London, 1982, pp. 43–46.

26. Jan Białostocki, "The Renaissance Concept of Nature and Antiquity," in *The Renaissance and Mannerism: Studies in Western Art* (Acts of the Twentieth International Congress on the History of

Art), Princeton, 1963, II, 19–30; the quotation is from p. 27. The terms *natura naturans* and *natura naturata* themselves originate in scholastic philosophy, but Białostocki shows that the concepts derive from antiquity and became matters of great importance for Renaissance art.

27. Vasari-Milanesi, IV, 11, 92. See the discussion of this relationship in Rosand, *Painting in Cinquecento Venice*, pp. 18–19 and the literature cited there in note 73.

28. Clark, *Leonardo*, p. 102.

29. David Rosand, *Titian*, New York, 1978, pp. 27–29.

30. On Bosch's influence in Italy, see Leonard J. Slatkes, "Hieronymus Bosch and Italy," *The Art Bulletin*, 57, 1975, pp. 335–45, and Michael Jacobsen, "Savoldo and Northern Art," *The Art Bulletin*, 56, 1974, pp. 530–34.

31. The three paintings in the Grimani Collection were seen by Marcantonio Michiel; see *Der Anonimo Morelliano (Marcantonio Michiel's Notizia d'opera del disegno)*, ed. Theodor Frimmel, Vienna, 1888 (Quellenschriften für Kunstgeschichte und Kunsttechnik des Mittelalters und der Neuzeit, n.f. 1), p. 102. See also Slatkes, "Bosch and Italy," pp. 339, 344.

32. Bosch, like Leonardo, was interested in storm clouds. The impressive clouds in the outer wings of the *Garden of Earthly Delights* are among the most convincingly realized of the early sixteenth century. See Friedländer, *Early Netherlandish Painting*, vol. V, *Geertgen tot Sint Jans and Jerome Bosch*, New York, 1969, no. 110, pl. 100.

33. The interpretation of Giorgione's *Tempesta* remains intriguing and problematic, in large measure due to the essentially allusive and poetic character of Giorgione's art and Venetian *colorito* in general; see Rosand, *Painting in Cinquecento Venice*, pp. 26–27. Creighton Gilbert, "On Subject and Not-Subject in Italian Renaissance Pictures," *The Art Bulletin*, 34, 1952, pp. 202–16, despite his conception of subjectless landscape (discussed above, Chapter 1), remains fundamental to a consideration of these issues. See also the most recent sustained interpretation, Salvatore Settis, *La "Tempesta" interpretata: Giorgione, i committenti, il soggetto*, Turin, 1978.

34. Venice, Scuola Grande di S. Marco, now the Ospedale Civile. Vasari first attributed the painting to Giorgione in the first edition of *Le Vite* (1550; ed. Rosanna Bettarini and Paola Barocchi, Florence, 1976, text vol. IV, p. 45), but to Palma Vecchio in the second edition with no mention of Giorgione (ibid., pp. 550–51). Sandra Moschini Marconi, *Gallerie dell'Accademia de Venezia, opere d'arte del secolo XVI*, Rome, 1962, no. 275, concludes first that there is no clear sign of Giorgione's participation, though the picture could well reflect an original idea of Giorgione giving rise to the tradition of his authorship, and second that it was primarily executed by Palma, except for the large piece of canvas with the saints in the boat added at right by Paris Bordone. Rosand, *Painting in Cinquecento Venice*, p. 254, note 138, observes that "the very *concetto* of the image bespeaks [Giorgione's] inspiration," and discusses recent bibliography, including Philip L. Sohm's attempt to fix the commission in 1513: "Palma Vecchio's *Sea Storm*: A Political Allegory," *Revue d'art canadienne/Canadian Art Review*, 6, 1979–80, pp. 85–96.

35. See page 126 above.

36. This woodcut is printed from twelve blocks and measures 1225 by 2215 mm. David Rosand and Michelangelo Muraro, *Titian and the Venetian Woodcut*, exhibition catalogue, Washington, D.C., National Gallery, 1976, no. 4, pp. 70–73.

37. Arthur M. Hind, *Early Italian Engraving*, London, 1938, E.III.12, pl. 405.

38. Rosand and Muraro, *Titian and the Venetian Woodcut*, pp. 72–73.

39. Sohm, "Palma Vecchio's *Sea Storm*," pp. 90–96, argues that the commission of *La Burrasca* by the Scuola Grande di San Marco was intrinsically political and specifically commemorated events in the conflict with the League of Cambrai, probably in 1513.

40. For other examples, see my dissertation, "Tempest and Shipwreck in the Art of the 16th and 17th Centuries: Dramas of Peril, Disaster, and Salvation," New York, Columbia University, 1984, pp. 135–38.

41. Figure 27 is from a medallion of 1552 illustrated in Joannes Luckius, *Sylloge numismatum elegantiorum*, Augsburg, 1620, p. 147. The device appears in emblems in Joachim Camerarius, *Symbolorum et emblematum ex aquitatibus et reptilibus desumptorum centuria quarta*, Nuremberg, 1604, no. II, pp. 4–5 (Henkel and Schöne, col. 680), and in Jacobus Typotius, *Symbola divina et humana*, Prague, 1601–3, II, viii, pp. 88–89.

42. For Cardinal Granvelle, see Pieter Geyl, *The Revolt of the Netherlands*, 2d ed., London, 1958, pp. 69–75. Concerning his numerous portrait medallions, see Max Bernhart, "Die Granvella-Medaillen des XVI. Jahrhunderts," *Archiv für Medaillen- und Platten-kunde*, 2, 1920–21, pp. 101–19. See also Gerard van Loon, *Beschryving der nederlandsche historie-penningen*, The Hague, 1723, I, 48–50, 59–61, and Liliane Wellens–De Donder, *Medailleurs en numismaten van de Renaissance in de Nederlanden*, exhibition catalogue, Brussels, Koninklijke Bibliotheek, 1959, nos. 110–11, who reproduces a medallion dated 1561.

43. Luckius, *Sylloge numismatum*, p. 150, illustrates a medallion struck in 1568; Van Loon,

Historie-penningen, I, 108–9, 240–41, lists six medallions with this device, one dated 1577. The halcyon appears frequently in emblem books beginning with Andrea Alciati, *Viri clarissimi*, Milan, 1531, p. [Blv.] and subsequent editions. See also Henkel and Schöne, cols. 840–41. The halcyon was a well-known inhabitant of natural-history books, including Aristotle, *De historia animalium* V.8.542b, and Pliny, *Natural History* II.125; X.89ff. The origins of the bird are dramatically recounted in Ovid, *Metamorphoses* XI.478–572.

44. William S. Heckscher, "Sturm und Drang: Conjectures on the Origin of a Phrase," *Simiolus*, I, 1966–67, pp. 95, 98–102, esp. p. 100, and note 8, with specific reference to William's device.

45. A portrait drawing of Marnix with this device by Jacques de Gheyn the Younger is in the Fodor Collection, Amsterdam; see Judson, "Marine Symbols," pp. 144–45. For the engraving after this drawing, see Hollstein, VII, 14. Figure 30 is from the *album amicorum* of Abraham Ortelius in the Pembroke College Library, Cambridge; facsimile ed., *Album amicorum Abraham Ortelius*, ed. J. Puraye, Amsterdam, 1969, fol. 42, with a French translation. Marnix's entry is dated 7 March 1579. See also Judson, "Marine Symbols," pp. 145–46, and Claus Kreuzberg, "Zur Seesturm-Allegorie Bruegels," *Zwischen Kunstgeschichte und Volkenkunde: Festschrift für Wilhelm Fraenger*, Berlin, 1960, pp. 46–48, with a German translation. Shorter entries by Marnix with similar pictures and texts can be found in the *album amicorum* of Quirine de Hornes, dated 1579 (The Hague, Archief van den Hoogen Raad van Adel, published in Judson, p. 146, fig. 10), and in the *album* of Janus Douza (Jan van der Does) dated 2 February 1578 (Leiden University Library, published by J. J. van Toorenenbergen, "Bij eene pen-teekening van Philips van Marnix van St. Aldegonde," *Oud Holland*, 11, 1893, pp. 149–53). See also M. Russell, *Visions of the Sea: Hendrick C. Vroom and the Origins of Dutch Marine Painting*, Leiden, 1983, pp. 77–78. Russell reproduces Marnix's collector's mark, which uses the same device.

46. An exceptionally elaborate text accompanies the illustration in the Ortelius album (Fig. 30). The epigram reads "Vela dato atque alibi requiem tibi quare repositam certa evangelii quo cynosura vocat" ("set sail and seek elsewhere a place of rest, whither the North Star of the Gospel calls"), ideas amplified by scriptural passages relating to the impermanence of man's state in this life.

47. Bruegel's relation to Venetian landscape drawing was first observed by Pierre-Jean Mariette in 1741: see *Abecedario*, ed. Ph. de Chennevières and A. de Montaiglon, Paris, 1851–53; reprint, Paris, 1966, I, 189. See also Franz, *Niederländische Landschaftsmalerei*, I, 157–59; and Matthias Winner in *Pieter Bruegel d. Ä. als Zeichner*, exhibition catalogue, Berlin, Staatliche Museen, 1975, p. 7, and cat. nos. 30, 32, 40, 41.

48. *Pieter Bruegel als Zeichner*, no. 32. Compare such woodcuts after Titian as *Saint Jerome in the Wilderness* and *Landscape with a Milkmaid*, both generally ascribed to the cutter Nicolò Boldrini (Rosand and Muraro, *Titian and the Venetian Woodcut*, nos. 21, 22).

49. For these paintings and prints, see F. Grossman, *Bruegel: The Paintings*, 3d ed., London, 1973, fig. 18, p. 190; fig. 20, p. 190; fig. 57, pp. 193–94; and Lebeer, *Catalogue raisonné*, no. 40, pp. 109–10. Two other marine paintings by Bruegel are now lost: a tempera painting of small ships listed in the inventory of Rubens's collection, and a Jonah scene in the collection of Pieter Stevens in Antwerp. See Glück, *Bruegels Gemälde*, no. 68, p. 109; no. 73, p. 111. Charles de Tolnay, "Newly Discovered Miniatures by Pieter Bruegel the Elder," *Burlington Magazine*, 107, 1965, pp. 110–14, proposes that a *bas-de-page* in The Towneley Lectionary (New York Public Library), fol. 23, is by Bruegel. The miniature depicts a naval battle before a burning harbor city, not a storm as Tolnay says. The manuscript was illuminated by Giulio Clovio, with whom Bruegel is known to have collaborated while in Rome about 1553–54; the frame and Last Judgment scene of the miniature Tolnay discusses are by Clovio. While Tolnay's attribution is tantalizing in view of the high quality of the tiny scene and the similarity of motifs in the miniature to those in Bruegel's marine paintings and prints, it is difficult to see Bruegel's hand with any certainty in the miniature. Though clearly by an artist familiar with the conventions of the Netherlandish panoramic tradition, the Towneley scene could well be by the anonymous (presumably Netherlandish) painter who produced the harbor and sea-coast views with sailing ships in the margins of another Clovio manuscript, *The Farnese Hours*, fols. 20v–21r, 60v–61r, 90v–91r; facsimile, ed. Webster Smith, New York, 1976. These also strikingly resemble Bruegel's views of harbors, but the date of *The Farnese Hours*, begun about 1537, completed by 1546, precludes Bruegel's participation. *The Towneley Lectionary* is dated to 1550–60 by Webster Smith. For additional attributions to Bruegel in *The Towneley Lectionary*, see Tolnay, "Further Miniatures by Pieter Bruegel the Elder," *Burlington Magazine*, 122, 1980, pp. 616–23.

50. Lebeer, *Catalogue raisonné*, nos. 41–51, p. 110ff. For the ship types in each print, see F. Smekens, "Het Schip bij Pieter Bruegel de Oude: Een authenticiteitscriterium?" *Jaarboek van het Koninklijk Museum voor Schone Kunsten Antwerpen*, 14, 1961, pp. 18–19, note 16, which also summarizes earlier attempts to identify the vessels. On the accuracy of Bruegel's ships, see, in addition, J. van Beylen, "De Uitbeelding en de documentaire waarde van schepen bij enkele oude meesters," *Bulletin Koninklijke Musea voor Schone Kunsten, Brussel*, 10, 1961, pp. 125–29.

51. Bruegel's ship series is in some respects closer to this group of Venetian engravings than it is to Northern precedents: see Hind, *Early Italian Engraving*, pls. 401–4; and Louis Lebeer, "Nog enkele wetenswaardigheden in verband met Pieter Bruegel den Oude," *Gentsche bijdragen tot de kunstgeschiedenis*, 9, 1943, pp. 227–35.

52. Grossman, *Bruegel*, figs. 32, 37, pp. 191–92.

53. Lebeer, *Catalogue raisonné*, no. 48, p. 118.

54. Lebeer, *Catalogue raisonné*, no. 32, pp. 95–96, attributed to Philippe Galle. The preparatory drawing, dated 1559, is in the Kupferstichkabinett, Berlin-Dahlem: Ludwig Münz, *Pieter Bruegel the Elder: The Drawings*, trans. L. Hermann, New York and London, 1961, no. 145, fig. 142. My discussion of the iconography of *Spes* depends mostly on Charles de Tolnay, *Die Zeichnungen Pieter Bruegels*, Munich, 1925, p. 28; translated and revised as *The Drawings of Pieter Bruegel the Elder*, New York, 1952, pp. 26–27. For the specific iconographic tradition to which Bruegel's *Spes* belongs, see Ingvar Bergström, "The Iconological Origins of *Spes* by Pieter Bruegel the Elder," *Nederlands Kunsthistorisch Jaarboek*, 7, 1956, pp. 53–63.

55. Carnegie Institute Museum of Art, no. 54.6.1, woven in Brussels. A related tapestry from a series of the Seven Virtues woven in Brussels is dated by Ludwig Baldass to the second quarter of the sixteenth century (*Die wiener Gobelinsammlung*, Vienna, 1920, I, no. 47). In the background it too depicts three wind gods blowing with bellows on a ship at sea, but no shipwreck.

56. Anne Lowenthal pointed out to me Bruegel's conflation of *Spes* and *Fortuna/Occasio*. On the iconography of *Fortuna*, see A. Doren, "Fortuna im Mittelalter und in der Renaissance," *Vorträge der Bibliothek Warburg*, 1922–23, pp. 71–144, esp. pp. 134–37, where Doren discusses the reappearance in the Renaissance of *Fortuna* with a sail; Doren does not discuss tempests or sinking ships as attributes of Fortune, though the sea is associated with *Fortuna* from antiquity onward. For the confusion of *Fortuna* and *Occasio* as concepts and iconographic types, see ibid., pp. 135–36, and note 133. Seascapes sometimes accompany the figure of *Fortuna/Occasio* in the first half of the sixteenth century (e.g., Andrea Alciati, *Viri clarissimi*, Lyon, 1550, p. 133, "In Occasionem"), but storms and shipwrecks are less common as attributes until later in the century. The tempest by itself was a common allegory of *Fortuna*, however. See, for example, the emblems in Gilles Corrozet, *Hecatongraphie*, Paris, 1543, "Peril Incogneu" (Henkel and Schöne, col. 1467); and Johannes Sambucus, *Emblemata*, Antwerp, 1566, p. 42, "Res humanae in summo declinant" (Fig. 130; Henkel and Schöne, col. 114). In Italian the word "fortuna" was synonymous with "tempest" in the sixteenth century: Edgar Wind, *Giorgione's Tempesta*, Oxford, 1969, p. 3 and note 7.

57. Iucundissima est spei persuasio, et vitae imprimis
Necessaria, inter tot aerumnas peneque intolerabiles.

Stridbeck, *Bruegelstudien*, pp. 143–48, amplifies Tolnay's discussion by interpreting Bruegel's *Spes* as formed by Erasmian ideas of Hope as a foolish illusion necessary to a happy life on earth.

58. Of this series, five pictures survive of what was probably a set of six. The original number of paintings and which months to associate with each are among the most vexed questions in the study of Bruegel's work. Whether the original cycle comprised six or twelve pictures is the issue, and the documents for the series are equivocal on this point. In addition, the pictorial tradition of the labors of the months is inconsistent, and numerous different identifications of the months depicted and of the first picture in the series have been proposed. Klaus Demus has provided the most important and complete assessment of these problems and an overview of the literature. See Klaus Demus, Friderike Klauner, and Karl Schütz, eds., *Flämische Malerei von Jan van Eyck bis Pieter Bruegel D. Ä.*, Vienna, Kunsthistorisches Museum, 1981, pp. 86–94. I do not, however, entirely agree with Demus's findings. See also F. Novotny, *Die Monatsbilder Pieter Bruegels d. Ä.*, Vienna, 1948. Assessing the available evidence leads me to conclude that the cycle was probably six-part as Demus also believes, but contrary to Demus, that *The Dark Day* was the second picture in the set, and that in conformity with iconographic tradition, *The Dark Day* depicts the months March and April. The reasons for these conclusions are complicated and will be published as a separate note. The identification of *Hunters in the Snow* and *The Dark Day* as pendants depends upon unpublished lectures by Howard McP. Davis. The analysis and interpretation of *The Dark Day* is also based on Davis's lectures and on Charles de Tolnay, *Pierre Bruegel l'Ancien*, Brussels, 1935, I, 39–40.

59. Bruegel's relation to the manuscript tradition is stressed by Tolnay, *Pierre Bruegel l'Ancien*, p. 38ff., and 69, note 85. The entire tradition of labors of the months, calendars, and seasons in the Renaissance has not received adequate monographic treatment; manuscript calendar cycles have received the most attention. See Raimond van Marle, *Iconographie de l'art profane*, The Hague, 1931–32, I, 373ff. The tradition in the Middle Ages has been better studied: Alois Riegl, "Die mittelalterliche Kalenderillustration," *Mitteilungen des Instituts für oesterreichische Geschichtsforschung*, 10, 1889, pp. 1–74; and J. C. Webster, *The Labors of the Months in Antique and Medieval Art*, Princeton, 1938, esp. the comparative table, pp. 175–79, an inventory of the labors in twelfth-century calendar cycles. See also the following articles in the *Lexikon der christlichen Ikonographie:*

O. Holl, s.v., "Kalendrium, Kalenderbild," II, cols. 482–89; "Monate, Monatsbilder," III, cols. 274–79; and B. Kerber and O. Holl, s.v., "Jahreszeiten," II, cols. 364–70. The tradition in tapestries especially needs further study.

60. Erwin Panofsky, *Early Netherlandish Painting*, Cambridge, Mass., 1953, I, 33–34; II, figs. 13, 15. The calendar miniatures by Pucelle in the Belleville Breviary (Bibliothèque National ms. lat. 10483) are lost but known from other manuscripts produced in Pucelle's shop.

61. Munich, Staatsbibliothek, cod. lat. 23638. G. Leidinger, *Flämischer Kalender des XVI. Jahrhunderts gemalt von Simon Bening dem Hauptmeister des Breviarium Grimani*, Munich, 1936.

62. Landscapes thematically related to zodiacal signs are not a constant feature of the calendar tradition; January and February miniatures could also depict courtly celebrations or outdoor snow scenes. An inventory of the labors and landscape types in fifteenth- and sixteenth-century manuscript calendars similar to that in Webster, *Labors of the Months*, pp. 175–79, would be very useful.

63. Both Tolnay, *Pierre Bruegel l'Ancien*, p. 69, note 5, and Novotny, *Die Monatsbilder*, p. 32, call the flood in *The Dark Day* an attribute of February, but the manuscript precedents they cite contain no images with floods. For winter and the equinoxes as times of storm, see Chapter 2 above.

64. Münz, *Pieter Bruegel: The Drawings*, no. 151. The storm and shipwreck are less clearly represented in the engraving: see Lebeer, *Catalogue raisonné*, no. 77.

65. Antoine Seilern, *Flemish Paintings and Drawings at 5 Princes Gate London SW7*, London, 1955, no. 11, pp. 17–18; Münz, *Bruegel: The Drawings*, no. 50.

66. In the Patinir tradition, gallows sometimes stand near harbor cities on islands or promontories, and Bruegel repeatedly introduces this motif in his landscapes, usually as a small detail in the distance—but in *The Magpie on the Gallows* of 1568 (Darmstadt, Hessisches Landesmuseum; Grossman, *Bruegel*, fig. 147, p. 203) as the protagonist of the image.

67. For Hoefnagel's print, see Chapter 5, pp. 000–00. While the gallows is clearly an affective means of enhancing the impression of nature's constant change and the threatening character of this for man (and suggests the theme of fortune as well), the frequency with which this motif recurs in Northern landscape painting suggests that it then possessed connotations that have not as yet been fully discovered. On gallows, see also Brumble, "The Allegory of Landscape," pp. 130–35.

68. For the literature on this much-discussed painting, see Klaus Demus, in *Flämische Malerei*, pp. 128–38.

69. Ibid., p. 135. On dendrochronology, see M. G. L. Baillie, *Tree-Ring Dating and Archaeology*, London and Canberra, 1982, esp. pp. 241–47. The problem of the origin of the oak panels used in Netherlandish painting before 1650, which has cast doubt on the tree-ring chronology, has been resolved by the discovery that they are from Poland. See M. G. L. Baillie et al., "Re-Dating the English Art-Historical Tree-Ring Chronologies," *Nature*, 315, 23 May 1985, pp. 317–19; D. Eckstein et al., "New Evidence for the Dendrochronological Dating of Netherlandish Paintings," *Nature*, 320, 3 April 1986, pp. 465–66; and Peter Klein, "Age Determinations Based on Dendrochronology," *PACT*, 13, 1986, pp. 225–37. The statistical method used to establish master chronologies and to correlate specific panels with those chronologies continues to be troubling, especially when the dendrochronological dating is so close to the lifetime of the artist, as in the case of the Vienna *Storm*. I am grateful to Maryan Ainsworth of the Metropolitan Museum for her help with this subject.

70. Demus, *Flämische Malerei*, pp. 133–36, and Claus Ertz, *Josse de Momper der Jüngere (1564–1635): Die Gemälde mit kritischem Oeuvrekatalog*, Freren, 1986, pp. 365–90, argue for an attribution to De Momper, a distinct possibility, especially in view of the dendrochronological dating. One basic obstacle to resolving the debate is that the painting is not obviously by either Bruegel or De Momper, as Ertz observes (p. 373). The arguments Demus advances against Bruegel's authorship are not fully convincing, particularly his account of the expressive character of the picture, which he terms that of a capriccio-fantasy, and his assertion that the picture is not really comparable to works by Bruegel or his followers. The treatment of nature in the Vienna *Storm*, however, does not seem more fantastic than in *The Dark Day*, for example, or in the *View of Naples* (cited in note 49 above), while the similarities between the Vienna picture and works of both Pieter Bruegel and Jan Brueghel are clear and will be discussed presently in the text. Even the breadth of touch, while exceptional for Bruegel, is not inconceivable in the context of his late work.

More persuasive is Ertz's detailed formal comparison of the Vienna *Storm* to aspects of De Momper's landscape style of the period 1610–20 (Ertz, pp. 371–88). Yet as Ertz implies (p. 373), the painting as a whole does not really look like a De Momper. Aside from the works of Pieter Bruegel himself, its compositional structure most closely resembles pictures by Jan Brueghel the Elder. Moreover, the only known storm scenes by De Momper (Figs. 42, 43), like his landscapes in general, are characterized by a more fussily elaborate execution and more diffused treatment of incident than is found in the concentrated form and simple, direct execution of the *Storm*. Ertz accounts for these differences by dating the Vienna painting later in De Momper's career, in the decade 1610–20. De Momper's design for an engraving by Theodor Galle depicting shipwrecks in a storm (Fig. 42;

Hollstein, VII, no. 431, p. 88), however, appears to be considerably later than Ertz's dating of it before 1600 (see Ertz, p. 389). Its somewhat lower horizon and vigorous bursts of light, the exaggeratedly curled waves, the frantic castaways, and the ships derive from Jan Brueghel's shipwreck scenes of the 1590s and conceivably reflect still later works of about 1610–20 by Adam Willaerts and Andries van Eertvelt (see Figs. 61, 131).

The other comparable picture by De Momper, a large painting in Stockholm, *Destruction of the Greek Fleet Returning from Troy* (Fig. 43), is dated by Ertz to about 1590 (Ertz, no. 548; see also the articles by Kjell Boström, who first attributed the Vienna *Storm* to De Momper: "Är 'Stormen' verkligen en Bruegel," *Konsthistorisk Tidskrift*, 20, 1951, pp. 1–19, and "Joos de Momper och det tidiga marin-måleriet i Antwerpen," ibid., 23, 1954, pp. 45–66). Neither the composition nor the detail of this painting resembles the Vienna painting. The ships in the Stockholm picture are largely fantasies, contrasting with the basically accurate and much earlier ships in the *Storm*, and the wind blows from every corner in the Stockholm image, unlike the more naturally consistent *Storm*, in which the ships also ride in the water more convincingly (see Smekens, "Het Schip bij Pieter Bruegel," p. 48). One of the ships in the Stockholm painting is based on a ship that appears in both Jan Brueghel's *Shipwreck with Castaways* (Fig. 40) and the *Shipwreck on the Netherlands Coast* (Fig. 41), reinforcing the impression that the Stockholm picture is an additive, derivative image. The vessels in the Vienna *Storm*, in contrast, would seem to tell against an attribution of the picture to De Momper because though old-fashioned for De Momper's time, they are generally accurate sixteenth-century vessels, following accepted contemporary tactics, with the exception of the vessel at center, which has crowded on too much sail for a storm: see Smekens, "Het Schip bij Pieter Bruegel," pp. 50–53 (Smekens's conclusion that the lack of greater detail in the ships precludes Bruegel's authorship seems to me unwarranted).

71. B. Langercrantz, "Pieter Bruegel und Olaus Magnus," *Konsthistorisk Tidskrift*, 18, 1949, p. 76, suggests that this lighter area results from a deterrent against whales, pouring oil on the waves, mentioned by Olaus Magnus in *Historia de gentibus septentrionalibus*, Rome, 1555, book XXI, chap. xxxii, p. 761. Though this has been widely accepted, the sea does not look particularly calmer there, and nothing confirms that oil produces this patch rather than sunlight.

72. Lebeer, *Catalogue raisonné*, nos. 41–42.

73. Although generally described as unfinished due to the breadth of touch, the fine white lines of foam on wave crests and the flocks of birds surely indicate that the painting is completed or nearly so; such details are not applied in the preparatory paint layers. See Demus, *Flämische Malerei*, pp. 133–34.

74. For Jan's *Shipwreck with Castaways* (Fig. 40) and the *Jonah*, see Klaus Ertz, *Jan Brueghel der Ältere (1568–1625): Die Gemälde*, Cologne, 1979, no. 22–23, pp. 108–14; cf. nos. 12, 13, 31, 139, figs. 5, 108–9, 114. Ertz attributes the *Shipwreck on the Netherlands Coast* (Fig. 41) to Jan Brueghel the Younger: *Jan Breughel der Jüngere: Die Gemälde mit kritischem Oeuvre-Katalog*, Freren, 1984, no. 39. Judging from reproductions of this badly damaged painting, however, this picture may well have been similar in quality to the *Shipwreck with Castaways*, so that an attribution to Jan the Elder still seems tenable. The novel setting of the scene off the Netherlands coast as indicated by the buildings and the bulkheads along the shore would also suggest his authorship. Ertz refers to the image as "Jonah Cast to the Whale," but while a figure with a white beard in the wave beside the ship could conceivably be Jonah, the only threatening leviathan is far from this figure in the lower-right corner, a most unusual iconographic configuration for this theme. It seems like a typical Bruegelian displacement of focus and possibly reflects the lost *Jonah* by Pieter the Elder (see above, note 49).

75. Teréz Gerszi, "Pieter Bruegels Einfluss auf die Herausbildung der niederländischen See- und Kustenlandschaftsdarstellung, *Jahrbuch der Berliner Museen*, 24, 1982, pp. 152–64, gives additional examples of the relation between the marines of Pieter the Elder and Jan Brueghel.

76. Ertz, *Josse de Momper*, pp. 389–90, stresses the relationship of the Vienna picture to a developing tradition of stormscape. The chronology he proposes, however, puts the Vienna *Storm* in the decade 1610–20, much later than the paintings of Jan Brueghel of the 1590s that it most resembles. Ertz, pp. 388–89, also suggests that the Vienna painting may well reflect the lost *Jonah* by Pieter Bruegel the Elder (see above, note 49). His proposal that the Vienna panel is somehow a Jonah scene, however, is unwarranted. It seems more likely that *Shipwreck on the Netherlands Coast* (Fig. 41), which may be a Jonah scene, reflects the lost Bruegel in view of its unusual iconography; see above, note 74.

77. Burchard's interpretation was first cited in Glück, *Bruegels Gemälde*, 2d ed., Vienna, 1932, p. 75. Burchard's own discussion ("Bruegel's Parable of the Whale and the Tub," *Burlington Magazine*, 91, 1949, p. 224) was amplified by Guy de Tervarent, "Bruegel's Parable of the Whale and the Tub," *Burlington Magazine*, 91, 1949, p. 293, which first cited Maurice of Saxony's device. Tervarent also pointed out George Marlier's discussion of a contemporary reference to the barrel trick by the

chronicler Marcus van Vaernewyck: "Le vrai sujet de la Tempête de Bruegel," *Beaux-Arts*, 3 February 1939, p. 5.

78. Burchard based his interpretation on J. H. Zedler, *Grosses vollständiges Universal-Lexikon aller Wissenschaften und Künste*, Halle and Leipzig, III, 1733, col. 175.

79. For sixteenth-century interpretations of the barrel trick, see the articles by Tervarent and Marlier cited in note 77.

80. For a survey of such interpretations, see Demus, *Flämische Malerei*, pp. 128–33.

81. The relation between Bruegel's work and the revolt of the Netherlands has not been systematically studied. Attempts to relate his works to particular events (for example, Irving Zupnick, "Bruegel and the Revolt of the Netherlands," *Art Journal*, 23, 1964, pp. 283–89; and Jeremy D. Bangs, "Pieter Bruegel and History," *The Art Bulletin*, 60, 1978, pp. 704–5) have been unpersuasive in various respects. Other studies, however, seem to confirm a more generalized comment on aspects of religious and secular conflicts of the late 1550s and 1560s: see, for example, Howard McP. Davis, "Fantasy and Irony in Pieter Bruegel's Prints," *Metropolitan Museum of Art Bulletin*, 1, 1943, pp. 291–95; and Margaret A. Sullivan, "Madness and Folly: Peter Bruegel the Elder's *Dulle Griet*," *The Art Bulletin*, 59, 1977, pp. 55–66. For the situation in the Low Countries, see Pieter Geyl, *The Revolt of the Netherlands, 1555–1609*, 2d ed., London, 1958, and Geoffrey Parker, *The Dutch Revolt*, Ithaca, New York, 1977.

82. This discussion essentially follows the development sketched out in Judson, "Marine Symbols of Salvation," pp. 136–39, 148–52.

83. Hollstein, I, 102, no. 9. J. Richard Judson, *Dirck Barendsz., 1534–1592*, Amsterdam, 1970, pp. 38–39.

84. Judson, "Marine Symbols of Salvation," pp. 138–39; and idem, "Martin de Vos' Representations of 'Jonah Cast over the Side,' " in *Miscellanea I. Q. van Regteren Altena*, Amsterdam, 1969, pp. 82–87. See also Armin Zweite, *Marten de Vos als Maler: Ein Beitrag zur Geschichte der Antwerpner Malerei in der zweiten Hälfte des 16. Jahrhunderts*, Berlin, 1980, no. 75, pp. 200–202.

85. Tintoretto painted the *St. Mark* as part of a series executed about 1562–66 for the Scuola Grande di San Marco; it is now in the Accademia. See Moschini Marconi, *Gallerie dell'Accademia*, no. 408, pp. 235–36. Dirck Barendsz. was in Titian's shop from 1555 to 1562. Judson, *Dirck Barendsz.*, p. 39, observes the resemblance of Barendsz.'s *Jonah* to Tintoretto's *St. Mark* and points out that the pose and heroic nudity of Jonah are inspired by the slave in Tintoretto's *St. Mark Freeing a Christian Slave* of 1548, also in the Accademia; Moschini Marconi, no. 394, pp. 221–23, fig. 394. De Vos's familiarity with Tintoretto's *Rescue of a Saracen* is uncertain. Zweite, *Marten de Vos*, p. 22, suggests he may have returned from Italy as early as 1556. Zweite, p. 27 and note 44, also doubts that De Vos painted landscapes in Tintoretto's shop and believes De Vos's putative second trip to Italy is improbable.

86. Judson, "Marine Symbols of Salvation," pp. 149–50.

87. Examples of tempest images dating before about 1610 depicting classical history and allegory include the following: *The Shipwreck of Aeneas* by Frederick van Valckenborch, dated 1603, Museum Boymans–van Beuningen, Rotterdam (Fig. 50); *The Destruction of the Greek Fleet*, attributed to Joos de Momper (Fig. 43); a *Fortuna* by Goltzius in the Stuttgart Museum, illustrated in F. Wurtenberger, *Mannerism*, New York, 1963, p. 233; and an *Arion Saved by the Dolphin*, engraved by Jan Muller after the design of Cornelis Cornelisz. van Haarlem (Hollstein, XIV, 107, no. 48). On Rubens's *Shipwreck of Aeneas*, see Lisa Vergara, *Rubens and the Poetics of Landscape*, New Haven and London, 1982, pp. 23–43; see also Jan Kelch, *Peter Paul Rubens: Kritischer Katalog der Gemälde im Besitz der Gemäldegalerie Berlin*, Berlin-Dahlem, 1978, pp. 38–42, with a discussion of the various subjects proposed for this picture. For the engraving after it, see Hollstein, III, 88, no. 300. See also Hella Robels, "Die Rubens-Stecher," in *Peter Paul Rubens, 1577–1640, Maler mit dem Grabstichel: Rubens und die Druckgraphik*, exhibition catalogue, Wallraf-Richartz-Museum, Cologne, 1977, p. 59, discussing the dating and the origin of the inscriptions on the set of engravings after Rubens's landscapes.

88. Rubens's *Jonah* formed the predella to the left wing of the triptych of *The Miraculous Draught of the Fishes* in the church of Notre-Dame-de-la-Dyle in Mechelen. See F. Heilbrun in *Le Siècle de Rubens*, no. 125, pp. 172–74. Heilbrun observes that Rubens's *Jonah* closely resembles De Vos's design for a *Christ Asleep in the Storm* engraved by Adriaen Collaert, for which there is a preparatory drawing in the Louvre (Fritz Lugt, *Inventaire général des dessins des écoles du Nord: Maîtres des anciens Pays-Bas né avant 1550*, Paris, 1968, no. 407, p. 97, pl. 145). Rubens used essentially the same composition, but pitching the vessel to obtain a view of the entire deck, in *The Miracle of St. Walburga* (Leipzig, Museum der Bildenden Künste), formerly a predella for the triptych of *The Raising of the Cross*, commissioned in 1610. See R. A. d'Hulst et al., *P. P. Rubens: Paintings—Oilsketches—Drawings*, exhibition catalogue, Koninklijk Museum voor Schone Kunste, Antwerp, 1977, no. 21, pp. 64–65.

89. Bredius, no. 547. Rembrandt's composition is directly based on Collaert's engraving of *Christ Asleep in the Storm* after De Vos's design; see note 88.

90. Kelch, *Simon de Vlieger*, pp. 58–70. Examples of this subject by De Vlieger include the painting in the collection of the University of Göttingen, signed and dated 1637 (catalogue, 1926, no. 188); the version from the late 1630s in the collection of the Earl of Plymouth in Oakley Park, Shropshire; and the painting of about 1640 in the Bildersaal der Prälatur of the monastery at Melk (photo RKD), engraved in reverse by Jan Ossenbeeck (Hollstein, XIV, 207, no. 30).

91. Narrative paintings using typical Netherlandish storm types include the following: *Jonah Cast to the Whale* by Eertvelt, sold at the Galerie Koller, Zürich, 22 September 1975, no. 2724, with illustration; another *Jonah* by Adam Willaerts, in the National Maritime Museum, Greenwich (Fig. 49; inv. no. 27:223; reversed color illustration in D. MacIntyre, *The Adventure of Sail*, London, n.d., pl. 11); a *Jonah* by Jan Peeters sold at Sotheby's, New York, 1–2 July 1986, no. 347; Bakhuizen's *Shipwreck of St. Paul*, in the collection of Ir. C. Th. F. Thurkow, The Hague; the same subject by J. A. Bellevois, known in three versions (the collection of J. F. Treling, Amsterdam, 1963, photo RKD; in the Museum at Tours; and a painting sold at Christie's, 22 May 1936, no. 84); and a *Shipwreck of St. Paul* by Adam Willaerts in the Centraal Museum, Utrecht, no. 343.

92. N. van der Blom, "Van Valckenborch's Schipbreuk," *Bulletin Museum Boymans–van Beuningen*, 18, 1967, pp. 54–67.

93. Keith Andrews, *Adam Elsheimer: Paintings, Drawings, Prints*, New York, 1977, no. 11, p. 143. Andrews, pp. 19, 24–25, discussing the varied sources of Elsheimer's night light, correctly rejects the influence of Caravaggio but suggests the influence of Cristoforo Sorte's treatise, *Osservazioni nella pittura*, Venice, 1580; 2d ed., 1594; ed. Paola Barocchi, *Trattati d'arte del cinquecento*, I, Bari, 1960, pp. 273–301. Sorte's instructions for rendering storms, burning towns, and night pieces, and for using two sources of light, the moon and torches, should, however, be seen as a summation of current Venetian artistic practice, which is the actual origin of these pictorial ideas in Elsheimer's work. The basic composition, on the other hand, derives from Bril.

94. Judson, "Marine Symbols of Salvation," pp. 137–38; A. Mayer, *Das Leben und die Werke der Brüder Mattheus und Paul Bril*, Leipzig, 1910, p. 27; Giuseppe Scavizzi, "Paolo Bril alla Scala Santa," *Commentari*, 10, 1959, pp. 196–200. Fritz Lugt attributes a drawing in the Louvre of the same composition but without the figure of Jonah or the whale to Mattheus Bril and suggests it is the model for Paul's fresco (*Inventaire général des dessins des écoles du Nord, école flamande*, Paris, 1949, I, no. 355, pl. XVIII). Justus Sadeler engraved a version of Bril's *Jonah* that almost exactly reproduces a very fine painting by Bril of about 1600 in the Musée des Beaux-Arts, Lille. For the engraving, see Hollstein, XXI, 201, no. 33; XXII, p. 176; for the painting, see H. Oursel, in *Le Siècle de Rubens dans les collections publiques françaises*, Paris, Louvre, 1977, exhibition catalogue, no. 10, pp. 46–47. Other painted versions of this composition include the painting in the Wawel Museum, Cracow (Marcel Roethlisberger, *Cavalier Pietro Tempesta and His Time*, Newark, 1970, fig. 66); a picture in the Ca'd'Oro, Venice (Giorgio T. Faggin, "Per Paolo Bril," *Paragone*, 185, 1965, pl. 15); and what appears in reproduction to be an inferior version in the Musées Royaux des Beaux-Arts, Brussels (Russell, *Visions of the Sea*, fig. 26). There is also a drawing of the subject by Bril in the British Museum (A. E. Popham, *Catalogue of Drawings by Dutch and Flemish Artists*, London, 1932, V, 137, no. 1, pl. XLV); and in 1976 a similar drawing from the circle of Bril was with the dealer Brian Koetser, London.

95. J. C. J. Bierens de Haan, *L'Oeuvre gravée de Cornelis Cort, graveur hollandais, 1533–1578*, The Hague, 1948, nos. 246–47, pp. 215–16. The etchings after Cort's designs are by Joris Hoefnagel. For their date and inscriptions, see below, Chapter 5, note 80. The landscapes in the drawings and prints of Cornelis Cort, combining characteristics of the Northern and Venetian traditions, were very likely important models for Bril's landscapes. Even closer to the craggy cliffs with picturesque ruins and straggly trees in Bril's *Jonah* is a seascape fresco by Lodewijk Toeput in the Abbey at Praglia, dating about 1575. See Gerszi, "Pieter Bruegel's Einfluss," pp. 145–52, fig. 2.

96. While this development is not exclusive to storm scenes but extends to all areas of landscape imagery, in depictions of storm the natural world is given an especially dramatic role.

97. Albert Blankert, review of Wolfgang Stechow, *Dutch Landscape Painting*, in *Simiolus*, 2, 1967–68, p. 108, discusses several paintings by Jan Brueghel anticipating developments in landscape painting in the North Netherlands after 1615. See also Gerszi, "Pieter Bruegels Einfluss," pp. 158–64.

98. Jan knew Bril's work firsthand from his stay in Rome about 1592–94. For the relationship between Bril and Jan Brueghel, see Ertz, *Jan Brueghel der Ältere*, pp. 92–94, and Gerszi, "Pieter Bruegels Einfluss," pp. 164–71. Works related to Bril's *Jonah* include a *Jonah* of 1595 by Jan in the Herbert Girardet Collection, Kettwig (Ertz, no. 13, fig. 5); a *Christ Asleep in the Storm*, also dated 1595, in the Ambrosiana, Milan (Ertz, no. 12, fig. 108); and another dated 1596 in the Silvano Lodi Collection, Campione (Ertz, no. 31, fig. 109).

99. Judson, "Marine Symbols of Salvation," pp. 151–52, points out the influence of Jan Brueghel's

rocks and whales on Adam Willaerts and other seventeenth-century seascape painters, but Jan's contribution is not adequately assessed in the major surveys of marine painting in the Netherlands: F. C. Willis, *Die niederländische Marinemalerei*, Leipzig, 1911, p. 12; Laurens J. Bol, *Die holländische Marinemalerei des 17. Jahrhunderts*, Braunschweig, 1973, p. 7. More suggestive are comments in Russell, *Visions of the Sea*, pp. 15, 185, and Gerszi, "Pieter Bruegels Einfluss," pp. 162–71. Jan's *Shipwreck* (Fig. 40) could not have been known in the North, since it remained in the Palazzo Colonna in Rome. It is the only independent storm by Jan in Ertz's catalogue raisonné, but others most likely existed in addition to the *Shipwreck on the Netherlands Coast* attributed by Ertz to Jan the Younger (Fig. 41).

100. Karel van Mander, *Het Schilder-Boeck*, Amsterdam, 1604; 2d ed., Amsterdam, 1618, fols. 202r–202v, reports that the artist's first marine painting depicted his own experiences in a shipwreck on the Portuguese coast; the successful sale of the painting encouraged him to paint more marines. On Vroom's storm paintings, see Bol, p. 16, which includes a list of references to pictures no longer traceable. See also George Keyes's dissertation (Utrecht) on Vroom's son, *Cornelis Vroom: Marine and Landscape Artist*, Alphen aan den Rijn, 1975, pp. 24–27; and Russell, *Visions of the Sea*, pp. 114–15, 154.

101. The fragment formerly in the P. H. A. Martini Buys Collection, Rotterdam, was auctioned at Christie's Amsterdam, 29 May 1986, no. 137 with color illus. See also Bol, p. 16, and Russell, *Visions of the Sea*, p. 114. The engraving after Vroom by Petrus Kaerius (Pieter van der Keere) is not listed in Hollstein; see Keyes, *Cornelis Vroom*, p. 123, note 25, and pl. VIII. The same composition was also engraved by Claes Jansz. Visscher; see Russell, fig. 130a. Keyes, pp. 25–26 and note 25, also attributes to Hendrick Vroom a drawing in the Museum Boymans–van Beuningen, Rotterdam, a scene of five ships in a storm on the open sea (Bol, fig. 41).

102. See Bol, pp. 15–16, and Eric C. Palmer, " 'The Battle of the Armada' and 'The Great North Sea Storm,' " *Connoisseur*, 149, 1962, pp. 154–55. John Walsh, "Jan and Julius Porcellis: Dutch Marine Painters," Dissertation: Columbia University, 1971, p. 73, note 1, observes that the Dutch flags of the ship at center make Palmer's identification of the picture as the destruction of the Armada impossible. The basis for Palmer's hypothesis is the pendant battle scene (Fig. 55), but this depicts not the Armada but the Battle of Cadiz, as identified by F. C. van Oosten: see Russell, *Visions of the Sea*, pp. 154, 210–11. This painting is datable before 1608 on the basis of a smaller, dated copy by Aert Antum in the Rijksmuseum (Bol, pp. 15–16, fig. 35). Keyes, *Cornelis Vroom*, p. 123, note 26, correctly rejects Bol's view that the version by Aert Antum is the original.

103. On Vroom's relation to Bruegel, see Gerszi, "Pieter Bruegels Einfluss," pp. 176–86.

104. Vroom's compositional structures seem to derive fundamentally from Bruegel's marine prints, but other aspects of Vroom's style are similar to contemporary landscape; see Bol, pp. 9, 12, 25. On Mannerist landscape, see Franz, *Niederländische Landschaftsmalerei*; and idem, "Meister der spätmanieristischen Landschaftsmalerei in den Niederlanden," *Jahrbuch des Kunsthistorischen Institutes der Universität Graz*, 3–4, 1968/69, pp. 19–71. See also the still-useful dissertation by J. A. Raczynski, *Die flämische Landschaft vor Rubens*, Frankfurt am Main, 1937.

105. See, for example, Paolo Fiammingho's *Diana and Nymphs* in Berlin and Coninxloo's *Forest* of 1598, in the collection of Prince Liechtenstein, Vaduz, both illustrated in Wolfgang Stechow, *Dutch Landscape Painting of the Seventeenth Century*, 2d ed., London and New York, 1968, figs. 121–22.

106. For Porcellis's earliest storms, see page 87 above. Segers produced two extraordinary etchings of vessels in storms, both known in only one impression; E. Haverkamp-Begemann, *Hercules Segers: The Complete Etchings*, Amsterdam and The Hague, 1973, no. 48 (Amsterdam, Rijksmuseum) and no. 49 (Vienna, Albertina; Fig. 159). Willaerts's earliest dated storm scene is *Shipwreck on a Northern Coast* of 1614 in the Rijksmuseum (Fig. 131). Another, dated 1616, is in the Hermitage, Leningrad. A signed drawing by Cornelis Claesz. van Wieringen in the Kupferstichkabinett, Dresden, depicting ships in distress on a rocky coast is clearly dependent on Vroom. E. K. J. Reznicek, *Die Zeichnungen von Hendrick Goltzius*, Utrecht, 1961, I, 179, pl. XXXIII, dates this drawing about 1600. See also George S. Keyes, "Cornelis Claesz. van Wieringen," *Oud Holland*, 93, 1979, pp. 1–46.

107. On Porcellis, see Walsh, "Jan and Julius Porcellis"; and idem, "The Dutch Marine Painters John and Julius Porcellis," *Burlington Magazine*, 116, 1974, pp. 653–62, 734–45. See also Bol, pp. 91–102. For the Hampton Court *Storm* and its pendant, *Sea Battle by Night*, see above, Chapter 5, pages 158–59.

108. Walsh, "The Dutch Marine Painters Jan and Julius Porcellis," p. 658.

109. Ibid., p. 737.

110. On De Vlieger, see the unpublished dissertation by Jan Kelch, "Simon de Vlieger als Marinemaler," Berlin, 1968, esp. pp. 95–114 for his storm paintings. I am grateful to Dr. Kelch for allowing me to consult his work. See also Bol, pp. 177–90; and Walsh, "Jan and Julius Porcellis," pp.

136–40. Kelch, pp. 99–103, places De Vlieger's shipwreck scenes later than most scholars. On the basis of style he dates *Ships in Distress on a Rocky Shore*, formerly in Dresden (Fig. 57), to 1635–40, and to 1640 the painting sold in Mannheim from the Lanz Collection, 14 May 1928, no. 263 (photographs: RKD). Bol, pp. 178–79, in contrast, believes De Vlieger's shipwreck scenes to be a development of the early 1630s. Bonaventura Peeters's picture in Prague dated 1632 takes precedence over any dated work with a rocky coast by De Vlieger. A *Stranding on a Beach* by De Vlieger, signed and dated 1630 (Swiss art market, 1942, present location unknown; Stechow, *Dutch Landscape Painting*, p. 104, fig. 204), does not have the rocks that mark the Peeters–De Vlieger wreck type. Kelch, p. 100 and note 172, observes that Peeters was a precocious artist and could well have developed these motifs before the more gifted De Vlieger. Peeters was a master of the Antwerp guild at age twenty in 1634, and signed and dated paintings by him exist from 1629 onward.

111. Kelch, *Simon de Vlieger*, pp. 106–7, sees Bonaventura Peeters again as the innovator in the expansion of the earlier, isolated craggy rocks into massive ridges and cliffs in the 1640s. The earliest dated painting of this fully developed type by Peeters, however, is *Ships in Danger off a Rocky Coast*, in the Museum in Kortrijk, monogrammed and dated 1645 or 1648, whereas De Vlieger signed and dated such a wreck scene in 1642 (Fig. 162; private collection, Roermond). His shipwreck scene in the National Maritime Museum, Greenwich, signed and dated 1640 (Fig. 58), is clearly moving in the direction of the Roermond picture.

112. See in addition to Figure 1, *Single-Masters in a Rough Sea* (Alte Pinakothek, Munich) and *Single-Masters in a Light Breeze* (De Lakenhal, Leyden), both dated 1629; Walsh, "Jan and Julius Porcellis," II, figs. 28, 29.

113. For these artists, see Bol, *Die holländische Marinemalerei:* On Van Everdingen, pp. 203–5; Blankerhoff, pp. 205–9; Van de Velde, pp. 231–44; Jacob van Ruisdael, pp. 276–82; Bakhuizen, pp. 301–7. On Van Everdingen, see also Alice I. Davies, *Allaert van Everdingen*, Dissertation: Harvard, 1973; New York and London, 1978, pp. 61–98; and on Van de Velde, see David Cordingly and Westby Percival-Prescott, *The Art of the Van de Veldes*, exhibition catalogue, Greenwich, National Maritime Museum, 1982 (the catalogue entries are based on the research of M. S. Robinson).

114. Bol, pp. 230–44. On Figure 59, see Neil Maclaren, *The Dutch School*, London, 1960, no. 981, p. 431. On Figure 60, see Bol, p. 302.

115. On Smit's painting in the Karlsruhe Kunsthalle, see Rupert Preston, *The Seventeenth-Century Marine Painters of the Netherlands*, Leigh-on-Sea, 1974, fig. 63.

116. On the sublime, see Chapter 1.

117. G. Reynolds, "Turner and Dutch Marine Painting," *Nederlands Kunsthistorisch Jaarboek*, 21, 1970, pp. 383–90. See also David Cordingly, *Marine Painting in England, 1700–1900*, London, 1974, pp. 16, 65–71, 117–21; and idem, *Painters of the Sea*, exhibition catalogue, Brighton Art Gallery and Museum, 1979, pp. 13–15, 25–29.

118. While the Dutch tradition was not Vernet's major source of inspiration, his paintings confirm his awareness of it. On De Loutherbourg, see Rüdiger Joppien, *Philippe-Jacques de Loutherbourg, RA, 1740–1812*, exhibition catalogue, London, Kenwood House, 1973; and Cordingly, *Marine Painting in England*, pp. 113–15.

119. On tempest images in the eighteenth century, see T. S. R. Boase, "Shipwrecks in English Romantic Painting," *Journal of the Warburg and Courtauld Institutes*, 22, 1959, pp. 332–46.

120. On Van Eertvelt, see Willis, *Die niederländische Marinemalerei*, pp. 12, 23–25; idem, in Thieme-Becker, X, 360–61; Alfred Wurzbach, *Niederländisches Künstler-Lexikon*, Vienna and Leipzig, 1906, I, 495; and Russell, *Visions of the Sea*, pp. 182–85. He was listed as a master in the Antwerp St. Luke's Guild by 1609–10. His master is unknown, but the strong ties of Jan Porcellis and his family to Antwerp suggest the means of his early awareness of Porcellis's work. See Erik Duverger, "Nadere gegevens over de Antwerpse periode van Jan Porcellis," *Jaarboek van het Koninklijke Museum voor Schone Kunsten Antwerpen*, 16, 1976, pp. 269–79.

121. Ghent, Museum van Schone Kunsten, catalogue, 1938, p. 54, no. S–88. The forecastle deck of the ship in the left foreground is inscribed "GODT SY MET ONS ALLEN ANNO 1523" ("God be with us all"). The poop deck bears the words "VAN EERTVELT 1623[2?]." The first inscription has probably been strengthened. I have not been able to identify a specific incident of the 1520s or 1620s that the painting might illustrate. While the galleys would suggest an incident in the Mediterranean Sea or conceivably in the Indian Ocean or Red Sea, the (apparently) Netherlandish ships are unlikely in such locales in the 1520s. The ship types seem typical of the period 1590–1630. Possibly the inscription was misunderstood by a restorer.

122. Compare Hendrick Vroom's *Battle of Gibraltar*, dated 1617, in the Rijksmuseum, depicting a Dutch ship running down a sinking galley; illustrated in Walther Bernt, *The Netherlandish Painters of the Seventeenth Century*, trans. P. S. Falla, London, 1970, vol. III, fig. 1363.

123. Dated paintings documenting Eertvelt's later work are lacking, but a portrait of him dated

1632 depicting Eertvelt at work on a storm painting confirms his development of a less mannered but still highly dramatized representation of tempests. This painting from the Van Dyck shop is in the Bayerischen Staatsgemäldesammlungen, Munich; it was formerly in the Königlichen Gemälde-galerie, Augsburg; catalogue, 1912, no. 2471. See E. Schaeffer, *Van Dyck: Des Meisters Gemälde* (Klassiker der Kunst, XIII), Stuttgart and Leipzig, 1909, p. 250; the painting is correctly eliminated as a work by Van Dyck in later editions.

124. A *Shipwreck on a Rocky Coast* by Bonaventura Peeters in the Galerie Sint Lucas, The Hague, in 1962 (photo RKD), and another in a Rotterdam private collection in 1942, *Ship in Distress off a Rocky Shoal* (Fig. 80; photo RKD), both probably date from the mid-1630s. The Rotterdam painting bears the signature of Simon de Vlieger and the date 1635, but Kelch, *Simon de Vlieger*, pp. 99–100, observes that though the date is acceptable the signature must be false. He plausibly attributes the painting to Bonaventura Peeters, and a similar unpublished painting in the Dienst Verspreide Rijkscollecties, The Hague, inv. no. E 37, signed "BP," supports Kelch's attribution. On Peeters, see also Willis, *Die niederländische Marinemalerei*, pp. 77–79.

125. On Kasper or Gaspard van Eyck, see K. Zoege von Manteuffel, in Thieme-Becker, XI, 133–34. On Plattenberg, see T. H. Fokker, in Thieme-Becker, XXVII, 141–42; and Roethlisberger, *Pietro Tempesta*, p. 28, figs. 74–83.

126. Russell, *Visions of the Sea*, pp. 102, 185.

127. Recent scholarship on Tassi is usefully summarized and evaluated in Teresa Pugliatti, *Agostino Tassi: Tra conformismo e libertà*, Rome 1977, pp. 9–13.

128. For Tassi's early career as a painter, see Pugliatti, *Tassi*, pp. 17–19, 27–29, 147–49. Pugliatti's rejection of Bril's influence on the formation of Tassi's style (p. 19) is unwarranted.

129. Poggio Imperiale. M. Chiarini, *Artisti alla corte granducale*, exhibition catalogue, Florence, Palazzo Pitti, 1969, no. 25, fig. 22.

130. For Claude's two etchings of storms, see H. Diane Russell, *Claude Lorrain, 1600–1682*, exhibition catalogue, Washington, D.C., National Gallery, 1983, no. E4 (dated 1630) and E44 (about 1638–39). A preparatory drawing for the former is in the British Museum: Marcel Roethlisberger, *Claude Lorrain: The Drawings*, Berkeley and Los Angeles, 1968, no. 46, vol. I, pp. 90–91, vol. II, fig. 46. No surviving paintings correspond to the three tempest drawings in the *Liber veritatis* dating from 1638–44: Michael Kitson, *Claude Lorrain: Liber veritatis*, London, 1978, nos. 33, 72, 74, pp. 73, 96–99. See also Russell, no. D9. Eckhart Knab, "Die Anfänge des Claude Lorrain," *Jahrbuch der Kunsthistorischen Sammlungen in Wien*, 56, 1960, p. 131, observes that the figures in the fore-ground of Claude's etching of 1630 are derived from the work of Pieter van Laer and possibly directly from the figures in a signed *Shipwreck* by Van Laer in the Galleria Spada in Rome.

131. Tempests by Tassi include canvases in a Roman private collection and in the Galleria Corsini, Rome: Pugliatti, *Tassi*, pp. 111–15, figs. 162–63. Leonart Bramer signed a similar storm piece (Hamburg, Kunsthalle; Bol, fig. 206), his only known treatment of the theme. Because Bramer had left Rome by 1627, Pugliatti, p. 112, suggests that Tassi's storms of the 1630s show the influence of Bramer. It seems more likely, however, that earlier storms of this kind by Tassi existed, as the picture probably by Filippo Napoletano at Poggio Imperiale would suggest, and that Bramer's paint-ing reflects such works.

132. Roethlisberger, *Pietro Tempesta*, pp. 27–28.

133. Although it is generally assumed that Rosa painted sea storms, none in fact is known, as Roethlisberger, *Pietro Tempesta*, p. 28, correctly observes.

134. Roethlisberger's discussion of Tempesta's influence on later Italian painting (*Pietro Tempesta*, pp. 56–63) is sound except for his assertion of "no significant contact" between Tempesta and Magnasco, who in fact worked simultaneously in Milan for a decade. Magnasco's marine imagery resembles Tempesta's in composition, choice of landscape elements, and treatment of ships. See Antonio Morassi, *Mostra di Magnasco*, exhibition catalogue, Genoa, Palazzo Bianco, 1949, nos. 21, 28; figs. 24, 33. For Marco Ricci's tempest scenes, see Giuseppe Maria Pilo, *Marco Ricci*, exhibition catalogue, Bassano del Grappa, Palazzo Sturm, 1963, nos. 14–15, 23–24.

135. On Manglard, see André Rostand, "Adrien Manglard et la peinture de marines au XVIIIe siècle," *Gazette des Beaux-Arts*, 12, 1934, pp. 263–72. For Vernet, see Florence Ingersoll-Smouse, *Joseph Vernet, peintre de marine, 1714–1789*, 2 vols., Paris, 1926; and Philip Conisbee, *Claude-Joseph Vernet, 1714–1789*, exhibition catalogue, London, Kenwood House, 1976. While the influ-ence of Claude Lorrain is usually cited as the inspiration of the storm pieces of Manglard and Vernet (Ingersoll-Smouse, p. 11), Rostand, p. 268, and Roethlisberger, *Pietro Tempesta*, p. 57, correctly emphasize the importance of Tempesta's paintings for these artists' storm images. The influence of Rosa on Vernet's conception of this subject is perceptively discussed by Philip Conisbee, "Salvator Rosa and Claude-Joseph Vernet," *Burlington Magazine*, 115, 1973, pp. 789–94.

CHAPTER 4

1. On flags, see J. van Beylen, in L. M. Akveld et al., *Maritieme geschiedenis der Nederlanden, II, zeventiende eeuw, van 1585 tot ca 1680*, Bussum, 1977, pp. 69–71 and 358 with further bibliography; Rupert Preston, *The Seventeenth-Century Marine Painters of the Netherlands*, Leigh-on-Sea, 1974, pp. 88–93; and M. S. Robinson, *Van de Velde Drawings: A Catalogue of Drawings in the National Maritime Museum*, Cambridge, 1958, I, 28–29, 227–231. For the differences in structural features and rigging between Dutch and English ships, see Robinson, pp. 28–29.

2. See, for example, Figure 59, produced just after the Van de Veldes moved to England in the winter of 1672–73, and Figures 2, 70, produced in later years.

3. On the relative accuracy of various marine artists, see J. van Beylen, "De Uitbeelding en de dokumentaire waarde van schepen bij enkele oude meesters," *Bulletin Koninklijke Musea voor Schone Kunsten, Brussel*, X, 1961, pp. 123–50. John Walsh, "Jan and Julius Porcellis: Dutch Marine Painters," Dissertation, Columbia University, 1971, uses the accurate rendering of vessels, their correct foreshortening and diminution, and their responses to the elements as points on which to discriminate the works of Porcellis from imitators. On the accuracy of the Van de Veldes, see David Cordingly and Westby Percival-Prescott, *The Art of the Van de Veldes*, exhibition catalogue, Greenwich, National Maritime Museum, 1982. For ship types and points of dating, see Van Beylen, in *Maritieme Geschiedenis*, II, 11–68, and for more detail, idem, *Schepen van de Nederlanden: Van de late middeleeuwen tot het einde van de 17de eeuw*, Amsterdam, 1970. Also helpful are Robinson, *Van de Velde Drawings*, I, 227–48, and R. Anderson and R. C. Anderson, *The Sailing Ship: Six Thousand Years of History*, London, 1926; rev. ed., New York, 1963, pp. 140–62. Because of the difficulty involved in identifying larger ship types, I will refer to them as three-masters or simply as ships unless they are clearly distinguishable as warships, flutes, pinnaces, frigates, *jachten*, etc.

4. Amsterdam, Gebr. Douwes, 1927; photo RKD.

5. Robert Vorstman of the Nederlands Historisch Scheepvaart Museum, Amsterdam, showed me a manuscript list of ships sailing from Amsterdam in the seventeenth century to demonstrate the frequency with which ship names appear in documents and the difficulty of relating ships in paintings to those named in contemporary sources. The same problem is evident in using the lists of voyages, helpfully indexed by ship, in J. R. Bruijn et al., *Dutch-Asiatic Shipping in the 17th and 18th Centuries*, vols. II and III, The Hague, 1979. Many wrecks are noted, but I have been able to link none with a painting.

6. Ibid., no. 5547, lists the wreck of the *Wapen van Amsterdam* on 19 September 1667, south of Iceland. No painting known to me illustrates this disaster.

7. Cordingly and Percival-Prescott, *The Van de Veldes*, no. 119.

8. Ibid., no. 123.

9. On the inscription, see p. 212. Bruijn, *Dutch-Asiatic Shipping*, vol. I, nos. 0021, 1060, describes two vessels named *De Liefde* that wrecked in the seventeenth century. One wrecked after reaching Japan in 1600 with the voyage of Mahu and De Cordes around the world, the other at Baios de Padua, coming from Persia on 5 July 1668. Nothing in Dubbels's painting seems to refer to either ship. Another picture probably depicting a specific incident is Van Eertvelt's painting in Ghent (Fig. 61).

10. H. van de Waal, *Drie eeuwen vaderlandsche geschied-uitbeelding, 1500–1800*, The Hague, 1952, I, 1–17 and, with reference to land- and seascape, 50–52.

11. On the problems of navigating the passages to Dutch harbors, see J. P. Sigmond, in *Maritieme Geschiedenis*, II, 78–105. Sigmond, p. 83, quotes Sir William Temple's observation in 1676 that "the entrance of the Tessel and passage over the Zudder-Sea is more dangerous than a voyage from there to Spain, lying all in blind and narrow channels," from *Observations upon the United Provinces of the Netherlands*, 1673 (ed. G. N. Clark, Oxford, 1972, p. 108).

12. This distinctive Mediterranean environment is analyzed by Fernand Braudel, *The Mediterranean and the Mediterranean World in the Age of Philip II*, trans. Sian Reynolds, New York, 1972, I, 25–162.

13. For defensive coastal towers, see ibid., II, 849–54.

14. On the galley as a Mediterranean vessel, see Anderson and Anderson, *The Sailing Ship*, pp. 133–35, and Braudel, *The Mediterranean*, I, 250–52. The Dutch used southern-style galleys for a brief period at the turn of the seventeenth century; see Van Beylen, *Maritieme Geschiedenis*, II, 20–23.

15. Braudel, *The Mediterranean*, I, 629–42. See also J. R. Bruijn in *Maritieme geschiedenis*, II, 235–41.

16. For seaport paintings, see Christine Skeeles Schloss, *Travel, Trade, and Temptation: The Dutch Italianate Harbor Scene, 1640–1680*, Ann Arbor, 1982. Schloss, pp. 47–53, discusses the imaginary character of these harbor views.

17. A useful survey of European attitudes to and images of American Indians is Hugh Honour, *The New Golden Land: European Images of America from the Discoveries to the Present Time*, New York, 1975, pp. 3–27, 53–85. The collection of illustrated voyagers' accounts begun by Theodore de Bry, generally known by the title *Collectiones peregrinationum in Indiam Orientalem et Indiam Occidentalem*, 25 parts, Frankfurt, 1590–1634, helped perpetuate earlier European views of Indians. For De Bry, see E. D. Church, *A Catalogue of Books Relating to the Discovery and Early History of North and South America*, New York, 1907, I, 316ff.

18. For Peeters's picture, see Jacques Foucart in *Le Siècle de Rubens dans les collections publiques françaises*, exhibition catalogue, Paris, Grand Palais, 1977, no. 99.

19. On trade to the north and east, see Bruijn in *Maritieme geschiedenis*, II, 215–29.

20. On Eckhout, see T. Thomsen, *Albert Eckhout ein niederländischer Maler*, Copenhagen, 1938, and Honour, *The New Golden Land*, pp. 78–83.

21. Sale Zürich, Koller, 28/29 May 1976, no. 5397.

22. *Het Schilder-Boeck*, p. 288r. See also Willis, *Die niederländische Marinemalerei*, pp. 1–4; and more recently Jakob Rosenberg et al., *Dutch Art and Architecture: 1600 to 1800* (Pelican History of Art), Baltimore and Harmondsworth, 1966, pp. 162–63; and Bol, pp. 8–10.

23. Keyes, *Cornelis Vroom*, pp. 18–20. For details of these commissions, see M. Russell, *Visions of the Sea: Hendrick C. Vroom and the Origins of Dutch Marine Painting*, Leiden, 1983, pp. 116–73. Russell, p. 91, sees Vroom himself as the primary factor in the sudden popularity of seascape, since he began producing sea pieces more than a decade before the founding of the Dutch East India Company (1602), before the Dutch achieved maritime supremacy. Nonetheless, the basis of that supremacy was laid during the years in question, and institutional or official patronage seems to have played a crucial role in Vroom's career, beginning soon after his return to Haarlem in 1592. This patronage was surely in part responsible for Vroom's becoming the first specialist in seascape. The influence of this patronage on the development and content of seascape requires further study.

24. On the accounts of Dutch voyagers, see Chapter 2.

25. Numerous Portuguese accounts of sea disasters, published between 1554 and 1651 in cheap pamphlet form, were compiled by Bernardo Gomes de Brito and published as the *História trágico-marítima* in 1735–36. C. R. Boxer translated a selection of these texts: *The Tragic History of the Sea*, Cambridge, 1959, 1966 (The Hakluyt Society, ser. 2, nos. 112, 132). See also James Duffy, *Shipwreck and Empire*, Cambridge, Mass., 1955.

26. Van Mander's "Den Grondt der edel vry schilder-const" is part of *Het Schilder-Boeck*, Haarlem, 1604. The "Grondt" has been edited and translated into modern Dutch by Hessel Miedema, 2 vols., Utrecht, 1973. For Chapter VIII, on landscape, and its historical significance, see Miedema's edition, I, 202–19, and his commentary, II, 534–58, esp. 534–39. See also E. K. J. Reznicek's useful comments moderating some of Miedema's conclusions in a review of Miedema's edition in *Oud Holland*, 89, 1975, pp. 118–19.

27. Keyes, *Cornelis Vroom*, pp. 10–11. Miedema, in his commentary on Van Mander's "Grondt," II, 343–44, discussing the "Voor-reden," l. 43, suggests that Van Mander's biography of Vroom is possibly ironical in tone, since drawings of little boats were regarded at that time as typical of a child's earliest scribblings, and Van Mander in addition did not esteem simple copying from nature. Miedema's own arguments for and against this interpretation, however, would seem to confirm Van Mander's esteem for Vroom's work.

28. On the complex development of naturalism in landscape and in other subjects in Dutch art between 1590 and 1630, see Stechow, *Dutch Landscape Painting*, pp. 15–27; J. G. van Gelder, *Jan van de Velde, 1593–1641, teekenaar-schilder*, The Hague, 1933; E. K. J. Reznicek, *Die Zeichnungen von Hendrick Goltzius*, Utrecht, 1961, esp. pp. 177–84 for landscape; idem, "Realism as a 'Side Road or Byway' in Dutch Art," in *The Renaissance and Mannerism: Studies in Western Art* (Acts of the Twentieth International Congress of the History of Art, 1961), Princeton, 1963, II, 247–53; E. Haverkamp-Begemann, *Willem Buytewech*, Amsterdam, 1959; and David Freedberg, *Dutch Landscape Prints of the Seventeenth Century*, London, 1980, pp. 9–44.

29. The relationship of naturalism in landscape, as well as the new realism in Dutch art in general to political, economic, and cultural developments, needs much more careful study. See Van Gelder, *Jan van de Velde*, pp. 42–46; and Reznicek, *Hendrick Goltzius*, pp. 211–15; and Freedberg, *Dutch Landscape Prints*, pp. 9–20. While many aspects of contemporary society and culture seem to have played some part in the development of the new realism, their exact contributions are extremely difficult to substantiate. For example, Åke Bengtsson, *Studies in the Rise of Realistic Landscape Painting in Holland*, Stockholm, 1952, analyzes a large body of historical and statistical data, but cannot demonstrate a direct connection between the development of realism in Haarlem painting and the strong structure of the Haarlem painters' guild and the Arminian sympathies of the upper classes. And yet he is doubtless correct in seeing these as important factors affecting contemporary attitudes and tastes. Hessel Miedema, "Over het realisme in de Nederlandsche schilderkunst van de

zeventiende eeuw," *Oud Holland*, 89, 1975, pp. 9–10, suggests that a variety of factors involving politics, economics, literary theory, and national pride functioned simultaneously in the creation of a realistic style; all deserve careful scrutiny.

30. The illustrations in Roemer Visscher's *Sinnepoppen* were designed in 1608 by Claes Jansz. Visscher, who, as a draftsman and publisher of prints, was one of the central figures in the development of the new landscape style. See Van Gelder, *Jan van de Velde*, pp. 27–29. The depiction of emblems in realistic form became increasingly common in seventeenth-century Dutch emblem books. See K. Porteman, *Inleiding tot de Nederlandse emblemataliteratuur*, Groningen, 1977, pp. 123–39.

31. Cf., for example, the opening forty-four lines of *Griane* (Amsterdam, 1616; ed. Fokke Veenstra, Culemborg, 1973, pp. 119–22) in rural dialect, and the street scenes of *Moortje* (Amsterdam, 1615; ed. J. A. N. Knuttel, II, Amsterdam, 1924), a play in which Bredero transposes Terence's *Eunuchus* into a totally contemporary Amsterdam setting.

32. Haverkamp-Begemann, *Willem Buytewech*, nos. CP34, CP38, pp. 197, 199; the latter is from a series of the Four Elements dated 1622.

33. Miedema, "Over het realisme," p. 9. Miedema, "Realism and the Comic Mode: The Peasant," *Simiolus*, 9, 1977, p. 208, note 11, refers to Hendrick Laurensz. Spieghel's "diatribes against allegorical poetry." See also, in a totally different vein, Bredero's robustly self-confident sarcasm against classicism in the introduction to *Moortje*, "Reden aande Latynsche-Geleerde," ed. Knuttel, II, 102–4.

34. See the discussion of the new empiricism and the thought of Francis Bacon and Thomas Browne in Basil Willey, *The Seventeenth-Century Background* (1934), Garden City, New York, 1953, pp. 11–64.

CHAPTER 5

1. For the theory of art and landscape, see E. H. Gombrich, "The Renaissance Theory of Art and the Rise of Landscape," in *Norm and Form*, London, 1966, pp. 107–21, and Hessel Miedema's commentary to Karel van Mander's chapter on landscape in *Den Grondt der edel vry schilder-const*, Haarlem, 1604; Utrecht, 1973, II, 534–58. Michelangelo's generally disparaging views on Northern landscape are recorded by Francisco de Hollanda; see *Francisco de Hollanda's Gespräche über die Malerei*, ed. J. de Vasconcellos (Quellenschriften für Kunstgeschichte, 9), Vienna, 1899, p. 29. On the debate over the reliability of De Hollanda as a source, see now David Summers, *Michelangelo and the Language of Art*, Princeton, 1981, pp. 26–27, 289–91.

2. Van Mander–Miedema, *Grondt*, II, 536 and note 11, and 545, note 75. See also Lisa Vergara, *Rubens and the Poetics of Landscape*, New Haven and London, 1982, pp. 42–43.

3. Francesco Lancilotti, *Trattato di pittura*, ed. Filippo Raffaelli, Recanati, 1885, p. 4.

4. Benedetto Varchi, *Due lezzioni*, Florence, 1549; in *Trattati d'arte del Cinquecento*, ed. Paola Barocchi, I, Bari, 1960, p. 61.

5. Pliny, *Natural History* XXXV.96; see *The Elder Pliny's Chapters on the History of Art*, trans. K. Jex-Blake; ed. E. Sellers, Chicago, 1968, pp. 132–33.

6. Cristoforo Sorte, *Osservazioni nella pittura*, Venice, 1580; in *Trattati d'arte del Cinquecento*, I, 292–93.

7. Gian Paolo Lomazzo, *Trattato dell'arte della pittura, scoltura et archittetura*, Milan, 1584, book VI, chap. xxxix; in *Scritti sulle arti*, ed. Roberto Paolo Ciardi, Florence, 1974, pp. 326–29.

8. Van Mander–Miedema, *Grondt*, I, chap. VIII, 12–13, pp. 206–7:

> 12 Doch t'hardtwindich weder hier uytghesondert /
> Als beroert zijn Zee / en Beken fonteynich:
> Nu maeckt my t'bedencken somtijts verwondert /
> Hoe soo gheblixemt hebben en ghedondert
> *Appellis* verwen / wesende soo weynich /
> Daer wyder nu hebben seer veel en reynich /
> Bequamer t'uytbeelden soo vreemde dinghen /
> Hoe comt ons lust tot naevolgh oock niet dringhen?

The marginal note:

> Appelles schilderde maer met vier verwen, soo Plinius seght, en maecte blixem, donder, en sulcke ander dinghen: wy die soo veel verwen hebben, mosten oock lust hebben de natuere in alles te volghen.

> 13 Laet somtijts dan rasende golven vochtich
> Naebootsen / beroert door *Eolus* boden /
> Zwarte donders wercken / leelijck ghedrochtich /

En cromme blixems / door een doncker-lochtich
Stormich onweder / comende ghevloden
Wt de handt van den oppersten der Goden /
Dat de sterflijcke Siel-draghende dieren
Al schijnen te vreesen door sulck bestieren.

9. For the idea of the power of both a work of art and a poem describing it to rival nature itself, see Jean H. Hagstrum, *The Sister Arts: The Tradition of Literary Pictorialism and English Poetry from Dryden to Gray*, Chicago, 1958, pp. 9–12, 20–24, 62–70.

10. Virgil, *Georgics*, I.328–31; trans. H. Rushton Fairclough (Loeb Classical Library), Cambridge, Mass., and London, 1974, pp. 102–3.

11. Wolfgang Stechow, *Dutch Landscape Painting of the Seventeenth Century*, 2d ed., London, 1968, p. 9.

12. Samuel van Hoogstraeten, *Inleydinge tot de Hooge Schoole der Schilderkonst*, Amsterdam, 1678, pp. 77, 87.

13. Ibid., pp. 134–35.

14. Ibid., p. 140: "Maer lust u, zat van vermaeklijkheden, de woedende Zee, van een veyligen oever aen te zien, laet de golven vry hol gaen, en de donkere wolken de Schepen dreygen. Protogeen, zegtmen, was tot zijn vijftich jaer toe een Zee- en Scheep Schilder; maer laet ons aen de wal blijven."

15. Ibid., p. 125. The only storms without historical subjects that Hoogstraeten refers to are by Rubens.

16. Ibid., p. 125:

Indien't u lust een stormwindt te verbeelen,
Zoo buig't geboomt, en laet de takken speelen,
 Laet regenen, laet vry den blixem slaen,
 En masteloos een Schip te gronde gaen:
Dat ongeluk en zal toch niemand schaeden,
Maer liever zach ik dartle Nimfjes baeden,
 By Zomerdagh, in een Kristalle bron:
 Een schoon Paleis staen blikren in de Zon:
Het wit gewolkt in't schoon Lazuer verspreyen:
En aerdich volk zich in een beemd vermeyen.
 Want al wat in natuer het oog vernoegt,
 Heeft ook al't geen een Schildery best voegt.

17. Gérard de Lairesse, *Groot Schilderboek*, Amsterdam, 1707; reprint of Haarlem, 1740, ed., 1969, pp. 121, 418–34.

18. Vergara, *Rubens*, p. 43.

19. R. H. Fuchs, "Over het landschap: Een verslag naar aanleiding van Jacob van Ruisdael, *Het Korenveld*," *Tijdschrift voor geschiedenis*, 86, 1973, pp. 281–92. I am grateful to David R. Smith for bringing this study to my attention. For Vergara's study, see note 2 above.

20. Fuchs, "Over het landschap," p. 289. The painting is in the Museum Boymans–Van Beuningen, Rotterdam.

21. Ibid., pp. 290–91.

22. Ibid., pp. 291–92.

23. Vergara, *Rubens*, esp. pp. 15–71; the quotation is from p. 56.

24. Ibid., pp. 154–92.

25. Ibid., pp. 33–43.

26. On the history and character of *ekphrasis*, see Hagstrum, *The Sister Arts*, pp. 3–128. See also Michael Baxandall, *Giotto and the Orators*, Oxford, 1971, pp. 85–96. Cornelis Hofstede de Groot, *Arnold Houbraken und seine 'Groote Schouburgh'*, The Hague, 1893, pp. 404–32, provides a list arranged by author of Dutch poems quoted by Houbraken praising or describing works of art. The great majority of the paintings described are portraits, with history paintings next in frequency, though far fewer than portraits. The *ekphraseis* on storm paintings I will examine are conspicuously unusual in Hofstede de Groot's list, as they are when compared with the concordance of Italian and French *ekphraseis* in Marianne Albrecht-Bott, *Die bildende Kunst in der italienischen Lyrik der Renaissance und des Barock: Studie zur Beschreibung von Portraits und anderen Bildwerken unter besonderer Berücksichtigung von G. B. Marino's Galleria*, Wiesbaden, 1976 (Mainzer Romanistische Arbeiten, XI), pp. 200–242. Again most paintings described are portraits and histories.

27. Joachim Oudaan, *Poezy*, Amsterdam, 1712, II, 115–16, 136–38.

28. Ibid., pp. 115–16:

Op een Onweer, door PORCELLIS
De wind steekt hooger op, het seil swelt langs hoe ronder,
Pas, Stierman, op de schoot, veel' bragt het roemen onder,

Die in den nood, met't hart van hovaerdye vol,
Sig schaemden van een reef: hier gaen de stroomen hol;
Matroos en Schippers-gast arbeyen, dat sy swoegen,
Aen't roer en aen de plegt, om't klotsen op de boegen
Te breken soo men kost; de Stiermans py verdrinkt,
Terwyl een waterbaer, die op de steven klinkt,
Naer achter-over springt, en valt in knikker-droppen,
En mackt Matroosjes hair als waterhonde-koppen;
Van boven komt een wolk, die, lang door sy'el-wint
Gedreven a'n, en a'n, te storten plots begint,
En klatert op het boort, en boort zoo veel te stranger
Door't blauwe tobbers-hoed, door hoos en bollik-vanger,
Tot op het naekte lyf, des hy sig niet en kreunt,
Maer roept (terwyl de wint uitbuldert dat het dreunt)
't Roer wil benede wint, het schip aen lager oever,
Set by; set manne-kracht: noch sit een koelen troever
Deurgaens op d'overloop, en siet het speeltgen aen,
Schoon winden gispelen, en regen-buijen slaen;
Porcellis desgelyks en kruipt niet in't voor-onder,
Maer siet (spyt water-draf, spyt regen, hagel, donder)
Den storrem rustig in, dienge in gedagte prent,
Om levend na te gaen dit woedend element.

29. E. H. Gombrich, *Art and Illusion: A Study in the Psychology of Pictorial Representation*, 2d ed., Princeton, 1961, pp. 135–38.

30. Hagstrum, *The Sister Arts*, pp. 9–12, 20–24, 62–70, discusses the importance in *ekphraseis* of the imitation of nature and the power of both the art work and the poem describing it to rival reality. The imitation of nature is a fundamental critical doctrine of Renaissance artistic theory, and as Rensselaer W. Lee, *Ut pictura poesis: The Humanistic Theory of Painting*, New York, 1967, pp. 9–16, shows, the doctrine of ideal imitation, of reproducing nature as it ought to be, coexisted with and often in later Renaissance theory superseded the notion of strict verisimilitude. Writers of pictorial literature exploited both concepts of imitation, but the examples discussed in this chapter are concerned exclusively with the older concept of a close rendering of nature. Albrecht-Bott, *Die bildende Kunst*, pp. 192, 196–97, provides a list of motifs in the *ekphraseis* of Marino, including nature and art and the vitality of the art work.

31. For Van de Velde's "going a skoying," see David Cordingly in *The Art of the Van de Veldes*, p. 20. For Bakhuizen, see Arnold Houbraken, *De groote schouburgh der nederlantsche konstschilders en schilderessen*, Amsterdam, 1718–21; The Hague, 1753, II, 238.

32. George Levitine, *"Vernet Tied to a Mast in a Storm:* The Evolution of an Episode of Art Historical Romantic Folklore," *The Art Bulletin*, 49, 1967, pp. 93–101. Levitine observes that in the earliest accounts of this episode, which presumably occurred on Vernet's trip to Italy in 1734, the artist's motive for enduring the storm was to observe nature as directly as possible, exactly the purpose Oudaan and Houbraken ascribe to Porcellis and Bakhuizen. In nineteenth-century reports of Vernet's adventure, however, interest shifts from the traditional concept of the artist as faithful imitator of nature to the artist as a romantic hero confronting the sublime might of the enraged sea. The actions of these two Dutch painters are closer precedents for Vernet's exploit than those Levitine cites: Ulysses tied to a mast to hear the Sirens and the Van de Veldes sketching actual naval battles. Although it is most unlikely that Vernet was familiar with either Dutch text, the similarity of these three anecdotes suggests that the idea of a marine specialist directly observing a storm for the sake of greater naturalism was available among seascape painters in the early eighteenth century, perhaps in a verbal studio tradition that could have made Vernet aware of such Dutch exemplars. Gérard de Lairesse's protests against sending young artists out to draw in thundery and windy weather (*Groot Schilderboeck*, I, 433–34) also suggest that the idea of an artist's observing foul weather firsthand was widespread in the late seventeenth and early eighteenth centuries.

33. In antiquity the concept of *enargeia*, a pictorial vividness that verbally sets an object or scene before a hearer, originated in rhetorical theory and gradually became applied to literary criticism as "the concept of imitation came to be understood as a rendering of natural objects, social details and psychological effects" (Hagstrum, *The Sister Arts*, pp. 11–12). This critical idea was revived and widely known in the Renaissance (ibid., pp. 63–65).

34. Oudaan, *Poezy*, pp. 134–36:

Op een STORM
Het bloot gesigt,
Schynt, in den storm (soo levend is de kunst)

Ons ook te wikkelen;
Het drabbig ligt,
Der dik-bewolkte son, gesaeidt op't dunst',
Schynt ons te prikkelen,
Met innerlyken anxst, en harte-wee;
Bedaer! bedaer! bedaer onstuime zee!
Of uw' verbolgentheden rukken mee'
'␣t Gevoel
Door't koel
Gewoel.

Daer ploft de hulk
(Begruist van moerig nat, en driftig sandt)
Diep in den afgront:
Geen dobber kulk
En rees soo ligt, door starke wint, van't landt,
Als hy uit 't graf stont:
Wyl't heir der woede winden samen-brult:
Dus raekt het schip ligt op een stenen bult,
En stoot en barst aen spaenders, nu vervult
Van wolk',
Dan kolk,
Steeds volk.

De flaeuwe stem
Der hopelose barst, in't eind', dus uit:
Heer! hoed' het splinteren!
Eer gaeft gy klem
De winden, door uw goddelyk geluidt!
Ey! laet het winteren,
Gelyk, wanneer Halcion 't jong brengt voort!
Ach bind dees water-wolf eer hy ons smoort!
Ach Heer! (eer hy de afgestormde boordt,
Der schulp,
Bestulp)
Doe hulp!

Leg ne'er; leg ne'er;
Geleerde hand, uw konstelyk pinceel,
Gedoopt in tranen;
Uw' fyne ve'er
Verspreid, en leit haer trekjes veel te e'el
Om druk te spanen;
En hoe sig't leeds indruxel hoger heft,
Hoe d'ingedrukte smarte dieper treft;
Uw konst geen ongenugt weg-neemt, maer g'eft,
Door't klaer,
Gevaer-
Verklaer.

35. *Aeneid* I.81–124, *Metamorphoses* XI.479–532, Psalm 107:23–30, and Acts 27:14–44 exemplify numerous texts that Oudaan could have drawn upon for such details as the sailors' actions, their shouted orders, the sudden onslaught of the clouds, wind, and rain, the darkness of the storm, the ship rising from the abyss, the laments of the sailors, and the wreck itself. Even the metaphor of the "rushed board of the shell" ("de afgestormde boordt, / Der schulp") echoes Ovid's extended simile of the ship as a fortress beleaguered by the waves (*Metamorphoses* XI.525–32).

36. *De groote schouburgh*, I, 213–14; II, 12–13.

37. Ibid., II, 12–13:

Bonaventura Peeters . . . schilderde Zeestormen, en schepen door velerhande droevige Zeerampen in nood van vergaan. Hoe Eoöl in grammen moede door zyne stormwinde de Wolken van vier oorden perst, en tot een drukt, dat zy met een vervaarlyk geloei van Blixemen en Donderen uitbarsten, met slag op slag de Zeilen, Masten, Stengen en de romp der Zeehulken rammeyen, dat de splinters den Matrozen om de ooren stuiven, die in dien nood hun veege sterfuur met beklemde lippen voorspellen. Dan weer hoe Neptuin gestoort op den trots der Zeerotsen het pekel beroert, en uit der onmeetelyke diepten tegen dezelve met zyn drietan-

dige gaffels aandryft, de bovenste toppen met het schuim bespat; en hoe de Schepen in die branding vervallen, gints en herwaard geschokt, eindelyk zig te barsten stooten: volk en goed in gevaar van omkomen gebragt word, vertoonende zig menigten van menschen op eenig gesloopt wraak; terwyl andere weer door 't zwemmen hunne lyfsberginge zoeken. Of ook welweer hoe de schipbreukelingen aan eenig bevolkt strand, hun wedervaren met opgeschorte schouderen verhalen, en om bystand bidden enz. Deze en diergelyke droevige voorwerpen heeft hy in hunne vertoonselen zoo eigentlyk weten uit te beelden; als ook Lucht, Water, Klippen, en Stranden zoo natuurlyk te schilderen, dat hy geoordeelt wierd de beste in zyn tyd, in die wyze van schilderen, te wezen.

38. Poseidon appears in the first storm in the *Odyssey* V.291–386 and both Neptune and Aeolus in *Aeneid* I.76–141. In *Metamorphoses* XI, Aeolus is the father of Alcyone, who becomes a halcyon when her lover Ceyx is drowned in a storm. Ovid's account of that storm is also a classic example of sailors lamenting their fates (XI.537–43).

39. See above, Chapter 1, note 47.

40. Svetlana Alpers, *"Ekphrasis* and Aesthetic Attitudes in Vasari's *Lives,"* *Journal of the Warburg and Courtauld Institutes*, 23, 1960, p. 196.

41. Giorgio Vasari, *Le vite de' più eccellenti pittori scultori e architettori nelle redazioni del 1550 e 1568*, ed. Rosanna Bettarini, Florence, 1976, IV, 45 (for 1550 ed.) and 550–51 (1568 ed.). The translation for the edition of 1568 is by Gaston du C. de Vere, London, 1911–12; New York, 1979, III, 1152–53.

42. A. H. Kan, *De jeugd van Constantijn Huygens door hemself beschreven*, Rotterdam and Antwerp, 1946, p. 79; trans. from J. Bruyn et al., *A Corpus of Rembrandt Paintings, Vol. I, 1625–1631*, The Hague, 1982, p. 193.

43. Compare an emblem in Jan Harmensz. Krul's *Minne-Spiegel der Deughden*, Amsterdam, 1639, pp. 60–65: "Treft u op Zee onstuymigh weer / Soo strijck in tijdts u zeyltjen neer" ("If you encounter stormy weather at sea, strike your sail in time"). The epigram warns a lover to strike his sails if he foresees unfavorable weather on the sea of love, particularly opposition from the beloved's parents. The picture illustrates a young man shortening sail on a *jacht* carrying a young woman and steered by Amor; the sheets have already parted in the rising wind. For a related emblem on the wisdom of shortening sail when a storm approaches, see Kornelis Zweerts, *Zede- en zinnebeelden over Koning Davids Harpzangen*, Amsterdam, 1707, no. 62, p. 124.

44. A. J. J. Delen, *Cabinet des estampes de la ville d'Anvers (Musée Plantin Moretus): Catalogue des dessins anciens, écoles flamande et hollandaises*, Brussels, 1938, vol. I, no. 432. Pieces of paper have been added to the edges of the drawing. The inscription is partly on the drawing and partly on the added pieces of paper.

45. Gelijk een Schip in zee gedreven door de Baaren
 dan hoogh, en dan weer leegh, onseker waer't sal vaaren,
 door't felle zeetempeest, soo gaet het met den staet
 der menschen, die veel meer geneygen sijn tot quaet
 als tot de deught waerdoor sy niet als quellingh lijden,
 als bootsgesellen die ter zee gaen om te strijden
 die hebben somwijl vreught door veel vercreghen buijt
 toch selden valt de reijs wel tot hun voordeel uijt;
 als hun de dootsschricks vol van dusent ijslijckheden
 op zee verrassen comt, en dringht soo inde leden
 dat niemant weet waer heen de vuijtkomst wesen sal:
 siet of het leven anders is als ongeval,
 en of niet beter is de wellust te ontvluchten
 als hier te leven in cleijn vreught, die baert veel suchten,
 dan sterft den mensch gerust, en hopt het sielsprofijt
 te crijgen naer de doodt van sijne salicheijt,
 en waeght dan niet te licht u Lijf om veel te winnen
 die't doet en is niet wijs: men dient eerst te versinnen
 en volghen goeden Raet am wel te varen, want
 daer is te veel aen vast alsmen sonder verstandt
 sijn selven alte licht betrouwt int Avonturen.
 Wee die het doen en't ongeluck te laet besuuren—
 'T is al moij weer wanneer men seijlen can voor windt
 soo langh men geene klip (die't schip doet bersten) vindt.

46. Stockholm Nationalmuseum, no. 398. L. J. Bol, *Die holländische Marinemalerei des 17. Jahrhunderts*, Braunschweig, 1973, p. 215, publishes the painting but does not discuss the inscription. I am very grateful to Jeremy D. Bangs, who deciphered this badly abraded inscription for me.

47. John Landwehr, *Emblem Books in the Low Countries, 1554–1949: A Bibliography*, Utrecht, 1970.

48. Herman Hugo, *Pia desideria emblematis elegiis et affectibus SS. Patrum illustrata*, Antwerp, 1624. This popular book had gone through forty-two editions by 1757.

49. Florentius Schoonhovius, *Emblemata*, Gouda, 1618; facsimile ed., Hildesheim and New York, 1975, pp. 15–17. Henkel and Schöne, col. 1801.

50. Julius Wilhelm Zincgreff, *Emblematum ethico-politicorum centuria*, Heidelberg, 1619, no. 44; Henkel and Schöne, col. 1465.

51. Bartholomeus Hulsius, *Emblemata sacra*, n.p., 1631, no. XIX, pp. 65–68.

52. Jan Jansz. Deutel, *Huwelijckx weegh-schael*, Hoorn, 1641, pp. 41–44.

53. See, for example, the interpretations of shipwreck cited in Chapter 1, page 53.

54. Warsaw, Muzeum Narodowe, no. 130870. I am grateful to George Keyes for directing me to this picture and Dr. Janina Michalkowa for a detail photograph of the figures.

55. On pastoral costume, see Alison McNeil Kettering, *The Dutch Arcadia: Pastoral Art and Its Audience in the Golden Age*, Montclair, New Jersey, 1983, pp. 45–48, 55–58, 114–19.

56. Jan Harmenszoon Krul, *Minne-beelden: Toe-ghepast de lievende ionckheyt*, Amsterdam, 1634, pp. 2–3:

> De liefd' is als een Zee, een Minnaer als een schip,
> V gonst de haven lief, u af-keer is een Klip;
> Indien het schip vervalt (door af-keer) komt te stranden,
> Soo is de hoop te niet van veyligh te belanden:
> De haven uwes gonst, my toont by liefdens baeck,
> Op dat ick uyt de Zee van liefdens vreese raeck.

57. Jan Harmenszoon Krul, *Pampiere wereld, ofte wereldse oeffeninge*, Amsterdam, 1644, p. 109:

> O Min! hoe zal mijn hert uw heete brand uyt smooren?
> Nu my zoo schielijk slaet een donder in mijn ooren,
> Een blixem in mijn Ziel, een onweer in het hert,
> Waer door ik als een Schip op strand gesmeten werd,
> Van levens hoop berooft, door kracht van woeste golven.
> 'k Ly Schip-breuk aen mijn min, zoo dat ik gansch bedolven,
> Bedompeld in een Zee, van woeste Baren, smoor;
> Indien ik Philida niet anders spreken hoor.

58. Deutel, *Huwelijckx weegh-schael*, p. 41.

59. C. P. Biens, *Handt-boecxken der christelijcke gedichten, sinne-beelden ende liedekens*, 2d ed., Hoorn, 1635, pp. 69–71.

60. G. van Loon, *Beschryving der nederlandsche historie-penningen*, The Hague, 1723, III, 87, no. IV.

61. Ibid., II, 24, no. I.

62. Ibid., II, 306–7, no. I.

63. Ibid., II, 55. Van Loon gives the date as 1609, but the piece in the Scheepvaart Museum, Amsterdam (Fig. 95), is dated 1617.

64. On the cow as a political symbol of the Netherlands, see Amy L. Walsh, "Paulus Potter: His Works and Their Meaning," Dissertation: Columbia University, 1985, pp. 352–82. On the Hollandse Tuin, see P. J. Winter, "De Hollandse Tuin," *Nederlands Kunsthistorisch Jaarboek*, 8, 1957, pp. 29–122.

65. Van Loon, *Beschryving*, II, 80, no. I.

66. Koninklijke Bibliotheek, Brussels; not in Hollstein. A. D. de Vries, "Het Portret van Willem Barentsen," *Oud Holland*, 1, 1883, pp. 114–17, finds this engraving similar to but not of the same quality as those of De Baudous. Vondel's "Hymnus, ofte lof-gesangh over de wijd-beroemde scheeps-vaert der Vereenighde Nederlanden" refers to this print, which is reproduced in the modern edition, *De Werken van Vondel*, Amsterdam, 1927, I, facing p. 432. It is also reproduced in *Maritieme geschiedenis*, II, 14–15, with a description of flags and ship types.

67. ". . . Hanc prosperrimi Foederatum Belgij Provinciarum status, graphicam per naves delineationem."

68. "Zoo bouwt men hier aan't Scheepryk Y / De Moerbalk van den Staat en Steeden, / Ten besten van't gemeen en Leeden / Van de Indiaansche Maatschappy: / Zoo brengt men peerlen, wyd vant een en't ander Landt; / Daar Kristus Leer, geleert, gesticht werd, en geplant." The translation is from Clifford S. Ackley, *Printmaking in the Age of Rembrandt*, exhibition catalogue, Boston, Museum of Fine Arts, 1981, nos. 207–8.

69. B. 230; Walter L. Strauss, ed., *The Illustrated Bartsch*, vol. 4, *Netherlandish Artists: Matham, Saenredam, Muller*, New York, 1980, p. 207.

70. November
Pleiades, en, turbant totum mare mense Novembri,
Et dubiam raptat saeva procella ratem,
Quam cernens dicas, quis tam discordia junxit,
Hoc uno est coelum tartaraque atra loco.
I am deeply indebted to Mark Morford for advice on this and the following translations from Latin.

71. For this series, see Irene de Groot and Robert Vorstman, *Sailing Ships: Prints by Dutch Masters from the Sixteenth to the Nineteenth Centuries*, New York, 1980, nos. 13–16.

72. Autumnus
Sic Neptunicolas Batavos juvat ire per altum,
Agminaque horrisono velorum expandere Cauro.

73. B. 21; Otto Naumann, ed., *The Illustrated Bartsch*, vol. 6, *Netherlandish Artists*, New York, 1980, p. 127.

74. Hollstein, VII, 88, no. 431. The set of four seasons was published by Theodor Galle. The storm scene and a winter landscape (Hollstein, VII, no. 432) were engraved by Galle; the summer scene by Egbert van Panderen (Hollstein, XV, 102, no 54); and the spring by Claes Jansz. Visscher (Maria Simon, "Claes Jansz. Visscher," Dissertation: Albert-Ludwig-Universität, Freiburg im Bresgau, 1958, no. 146).

75. Sic ubi praecipites quatiunt freta nota procellae,
Et saevo mixtus fulmine ventus agit
Commissae pelago tabulae feriuntur ab undis,
Velaque et antennas excutit ira maris.
Anxia in immenso iactantur corpora Ponto,
Et mox congestas Tenarus haurit opes.
Lines 3 and 5 paraphrase Ovid, *Tristia* I.2.47 and 39. On this print, see also above, Chapter 3, note 70.

76. "En quo discordia cives"
Et Coelum et Terram turbat "bella horrida bella"
Nubibus in mediis ignis et unda gerens
Ast ubi dissimiles agitat discordia mentes
Plus nocitura aliis et Sibi bella gerunt.
The title is from Virgil, *Eclogues* I.71–72. "Bella horrida bella" is from the *Aeneid* 6.86.

77. Hella Robels in *Peter Paul Rubens, 1577–1640, Maler mit dem Grabstichel: Rubens und die Druckgraphik*, exhibition catalogue, Cologne, Wallraf-Richartz-Museum, 1977, pp. 59, 61.

78. Paul Alpers, *The Singer of the Eclogues: A Study of Virgilian Pastoral*, Berkeley, 1979, pp. 65–71.

79. A. Bredius, *Rembrandt: The Complete Edition of the Paintings*, 3d ed., rev. H. Gerson, London and New York, 1969, p. 441.

80. J. C. J. Bierens de Haan, *L'Oeuvre gravé de Cornelis Cort, graveur hollandais, 1533–1578*, The Hague, 1948, nos. 246–47, pp. 215–16. The prints form a series with two etchings after Pieter Bruegel the Elder, also by Joris Hoefnagel: *A River Landscape with Mercury and Psyche* and *A River Landscape with the Fall of Icarus*, both dated in Rome in 1553 (Louis Lebeer, *Catalogue raisonné des estampes de Bruegel l'Ancien*, Brussels, 1969, nos. 81–82). The date must derive from Bruegel's drawings made during his Italian journey, since Hoefnagel (1542–1600) probably did not execute the prints until about 1590. A related drawing by Jacob Hoefnagel with the same iconography as Figure 102 is dated 12 August 1599. See Terész Gerszi, *Netherlandish Drawings in the Budapest Museum: Sixteenth-Century Drawings*, Amsterdam and New York, 1971, I, 50, no. 101; II, 101. On the iconography of these and related works, see idem, "Die humanistischen Allegorien der rudolfinischen Meister," in *Evolution générale et développements régionaux en histoire de l'art* (Actes du XXIIe Congrès International d'Histoire de l'Art, Budapest, 1969), Budapest, 1973, I, 755–62.

81. Bierens de Haan, *Cornelis Cort*, no. 247.

82. Nonne ille est mortis stipendiarius, qui morte
quaerit unde vivat?
O mortale lutum et ventis obiecta lucerna,
"I nunc et ventis animam committe, dolato
Confisus ligno, digitis a morte remotis
Quatuor, aut septem si sit latissima taeda."
The last three lines quote Juvenal, *Satires* 12.57–59. I would like to thank George Keyes for locating these prints and transcribing the inscriptions for me.

83. Gerszi, "Die humanistischen Allegorien," pp. 755–58.

84. Tales opes sunt comparandae, quae navi fracta una cum domino
queant enatare.

Res est multa omnium pretiosissima
omnibus hominibus ad vivendum, ARS.
Caetera enim et tempus, et mutationes
Fortunae absumunt, Ars autem conservatur.

85. On paintings within paintings, see Wolfgang Stechow, "Landscape Paintings in Dutch Seventeenth Century Interiors," *Nederlands Kunsthistorisch Jaarboek*, 11, 1960, pp. 165–84. On the symbolic interpretation of paintings within paintings, see E. de Jongh, *Zinne- en minnebeelden in de schilderkunst van de zeventiende eeuw*, Amsterdam, 1967, and De Jongh et al., *Tot lering en vermaak*, exhibition catalogue, Amsterdam, Rijksmuseum, 1976.

86. De Jongh, *Zinne- en minnebeelden*, pp. 50–55; and *Tot lering en vermaak*, nos. 25, 39, 71.

87. Amsterdam, Rijksmuseum. See De Jongh, *Zinne- en minnebeelden*, pp. 50–52, and *Tot lering en vermaak*, no. 71. Stechow, "Landscape Paintings in Interiors," pp. 180–81, finds the picture "suggestive of Jacob van Ruisdael."

88. *Tot lering en vermaak*, no. 39. For this painting and its pendant, both in the collection of Sir Alfred Beit, Blessington, see Franklin W. Robinson, *Gabriel Metsu (1629–1667)*, New York, 1974, pp. 59–61. Stechow, "Landscape Paintings in Interiors," p. 183, suggests the picture resembles the work of De Vlieger.

89. Stechow (ibid., p. 183) suggests a resemblance to the pictures of Willem Romeyn.

90. See De Jongh, *Zinne- en minnebeelden*, pp. 6–8, and idem, *Tot lering en vermaak*, no. 23. The association of the Deluge with such a merry company derives from the iconography of Mankind Before the Flood and Mankind Awaiting the Last Judgment, especially as developed by Dirck Barendsz. See J. Richard Judson, *Dirck Barendsz., 1534–1592*, Amsterdam, 1970, pp. 94–98.

91. H. R. Hoetink, *Mauritshuis, the Royal Cabinet of Paintings: Illustrated General Catalogue*, The Hague, 1977, no. 615.

92. See Chapter 1.

93. *The Oyster Meal*, dated 1660, is in the collection of the Earl of Lonsdale, Askham Hall, Penrich; *Soo gewonnen, soo verteert*, dated 1661, is in the Museum Boymans–van Beuningen, Rotterdam. The title of the latter, derived from an inscription on the mantelpiece in the painting, means more literally "thus won, thus lost." See Stechow, "Landscape Paintings in Interiors," p. 183 and note 40, and *Tot lering en vermaak*, pp. 102, 110. See also Robert Keyselitz, "Zur Deutung von Jan Steens 'Soo gewonnen, soo verteert,' " *Zeitschrift für Kunstgeschichte*, 22, 1959, pp. 40–45.

94. G. J. Hoogewerff, "Jan van Bijlert, Schilder van Utrecht (1598–1671), *Oud Holland*, 80, 1965, nos. 16, 16a, lists the picture in the Museum der bildenden Künste, Leipzig, no. 995 (Fig. 111), as a copy after a version in the Charpentier Collection, sold by N. Katz, Paris, 25 April 1951, no. 11. I am grateful to George Keyes for referring me to this picture.

95. John Walsh, "Jan and Julius Porcellis: Dutch Marine Painters," Dissertation: Columbia University, 1971, no. A5, datable about 1617–19.

96. See *Mauritshuis: Dutch Painting of the Golden Age*, exhibition catalogue (Washington, D.C., National Gallery), The Hague, 1982, no. 22.

97. See John Walsh, "The Dutch Marine Painters Jan and Julius Porcellis," *Burlington Magazine*, 116, 1974, p. 657, note 21. Stechow, "Landscape Paintings in Interiors," p. 183, note 40, believes that the shipwreck scenes in this picture and in *Musical Party* in the Mauritshuis (Fig. 113) are the same painting, a view endorsed by Robinson, pp. 64–65. From what little I can see of the shipwreck in *Visit to the Nursery*, I am not convinced of this. Stechow doubts the presence of allegorical meaning in these seascapes, since the same painting is used in two such different subjects. It is exactly this contextual element, however, that is the means of refining the more general Voyage of Life theme present in the pictures.

98. See, for example, Deutel's emblem on marriage (Fig. 87) in *Huwelijckx weegh-schael*, pp. 41–44, and Felix Egger, *Elegantissimorum emblematum corpusculum*, Leiden, 1696, no. 2: "Subito mutabile coelum est. . . . 'T kan schielyk verkeeren."

99. Location unknown; photo RKD. Van de Velde the Younger's *"Gust of Wind"* and *Cannon Shot*, both in the Rijksmuseum, are often said to be pendants. The fact that the former depicts English and the latter Dutch ships makes this unlikely.

100. See Jacques Foucart, in *Le Siècle de Rubens*, no. 63.

101. For the pair in the Musée d'Art et d'Histoire, Geneva, see Marcel Roethlisberger, *Cavalier Pietro Tempesta and His Time*, Newark, 1970, nos. 116, 322. Another pair is in the collection of Prince Borromeo at Isola Bella, Lago Maggiore (ibid., nos. 114, 294).

102. George Keyes, *Cornelis Vroom: Marine and Landscape Artist*, Alphen aan den Rijn, 1975, pp. 25–27. For the identification of the battle, see M. Russell, *Visions of the Sea: Hendrick C. Vroom and the Origins of Dutch Marine Painting*, Leiden, 1983, p. 154. Russell also sees the central ship in the storm scene as possibly a ship of state.

103. Walsh, "The Dutch Marine Painters," pp. 654–57 and note 17. Russell, *Visions of the Sea*,

pp. 162–64, argues unconvincingly for Vroom's authorship of these paintings.

104. Walsh, "Jan and Julius Porcellis," no. A2, suggests this moral reading. Russell, *Visions of the Sea*, p. 154, proposes identifying the event as the battle of the Revenge, commanded by Sir Richard Grenville, against the Spanish fleet in 1591. While this was indeed a night battle, this identification does not explain the presence of the fishing boats.

105. Fuchs, "Over het landschap," pp. 291–92.

106. Contrast Russell, *Visions of the Sea*, p. 115: "Such [storm] scenes mostly assumed a symbolic character. They often represent one ship (Ship of State), well under control, while others are being wrecked against the rocky shores. Sea monsters and spouting whales symbolize the dangers of the sea and the powers of hell."

107. See this interpretation of rocks applied to a shipwreck by Jacob Adriaensz. Bellevois, *Ships in Distress on a Rocky Coast* (Fig. 134), in *Die Sprache der Bilder*, exhibition catalogue, Braunschweig, 1978, p. 46.

108. Vergara, *Rubens*, pp. 39–40.

CHAPTER 6

1. On creating "uyt den gheest," see E. K. J. Reznicek, "Realism as a 'Side Road or a Byway' in Dutch Art," in *The Renaissance and Mannerism: Studies in Western Art* (Acts of the Twentieth International Congress of the History of Art, 1961), Princeton, 1963, III, 247–53, and Hessel Miedema's commentary on Karel van Mander, *Den Grondt der edel vry schilder-const*, Haarlem, 1604; Utrecht, 1973, II, 437–39.

2. Wolfgang Stechow, *Dutch Landscape Painting of the Seventeenth Century*, 2d ed., London and New York, 1968, pp. 7–8.

3. George Keyes, *Cornelis Vroom: Marine and Landscape Artist*, Alphen aan den Rijn, 1975, p. 17.

4. Attributed to Wou by John Walsh, "Jan and Julius Porcellis: Dutch Marine Painters," Dissertation: Columbia University, 1971, pp. 144–45.

5. Willem IJsbrantsz. Bontekoe, *Journael ofte gedenckwaerdige beschrijvinghe van de Oost-Indische Reyse*, Hoorn, 1646; ed. G. J. Hoogewerff, The Hague, 1952 (De Linschoten Vereeniging, no. 54), pp. 175–76.

6. On ship-handling, see Alan Villiers, *The Way of a Ship*, New York, 1970, pp. 97–163. Though Villiers's book deals with the five-masted full-rigged iron ships of the late nineteenth and early twentieth centuries, his discussion of handling square-rigged ships is basically applicable to seventeenth-century vessels. M. S. Robinson, *Van de Velde Drawings: A Catalogue of Drawings in the National Maritime Museum*, Cambridge, 1958, I, 237–48, has a useful glossary and descriptions of tactics in the drawings. See also F. L. Diekerhoff, *De oorlogsvloot in de zeventiende eeuw*, Bussum, 1967, pp. 92–98; F. Smekens, "Het schip bij Pieter Bruegel de Oude: Een authenticiteitscriterium?" *Jaarboek van het Koninklijk Museum voor Schone Kunsten Antwerpen*, 74, 1961, pp. 5–57; and J. van Beylen, "De uitbeelding en de dokumentaire waarde van schepen bij enkele oude meesters," *Bulletin Koninklijke Musea voor Schone Kunsten, Brussel*, 10, 1961, pp. 123–50. Also useful is Peter Kemp, ed., *The Oxford Companion to Ships and the Sea*, Oxford, 1976.

7. This is suggested by Smekens, "Het Schip bij Pieter Bruegel," p. 51. For Schelte Bolswert's engraving (Fig. 123), see Hollstein, III, p. 87; cf. the painting in Düsseldorf published by Boström, "Joos de Momper," fig. 20.

8. *Beschryvinghe vande voyagie om den geheelen werelt cloot/ ghedaen door Olivier van Noort*, Rotterdam and Amsterdam, 1602; ed. J. W. IJzerman, The Hague, 1926 (De Linschoten Vereeniging, no. 27), I, 15–16: "Den 14 Marty cregen seer harde storm uyten z.z.o. sodat wy ons Foc in nemen, en dreven zonder zeyl. . . ."

9. Bontekoe, *Journael*, pp. 143–44.

10. Vierhouten, Van Beuningen Collection; photo RKD.

11. *Afbeeldinghe van d'eerste eeuwe der Societeyt Iesu*, Antwerp, 1640, pp. 90–91, "D'armoede is voorsichtig" ("poverty is prudent"; Fig. 125). This emblem icon derives from an anonymous engraving of about 1600. See Irene de Groot and Robert Vorstman, *Sailing Ships: Prints by Dutch Masters from the Sixteenth to the Nineteenth Centuries*, New York, 1980, no. 39. See also Otto van Veen, *Emblemata sive symbola*, Brussels, 1624, no. 128, "Si desit, prodest" ("if it is gone, it does good").

12. A rare seventeenth-century depiction of the barrel trick is an etching by Monogrammist A.B. See De Groot and Vorstman, *Sailing Ships*, no. 58.

13. Daniel Heinsius, *Nederduytsche poemata*, Amsterdam, 1616, no. 11, pp. 74–75, "In tenebris lucem" ("light in the darkness"):
De baren van de Zee tot aen de locht ghedreven,

Bestormen vreesselick het schip dat ghy hier siet:
Het helt, het wijckt, het sinckt, de schippers selve beven,
En hebben nu het roer niet meer in haer ghebiedt.
Den hemel is becleet met wolcken en met winden,
Den dach is vol van nacht. het licht is al vergaen.
In dese duysternis sult ghy noch hope vinden,
So ghy maer aen en siet die ooghen die daer staen.

14. Kornelis Zweerts, *Zede- en zinnebeelden over Koning Davids Harpzangen*, Amsterdam, 1707, no. 48, pp. 96–97.

15. Geoffrey Whitney, *A Choice of Emblemes, and Other Devises*, Leiden, 1586; ed. H. Green, London, 1866, p. 137. The icon is taken from Andrea Alciati, *Viri clarissimi*, Antwerp, 1581, pp. 188–90, but is interpreted not as the ship of state as in Alciati but as the ship of life. A similar reinterpretation of Alciati's emblem occurs in an Italian translation, *Diverse imprese accommodate a diverse moralità*, Lyon, 1551, p. 44. Alciati's emblem is largely concerned with the belief that two lights of St. Elmo's fire are a portent of salvation. Though deriving from antiquity (cf. Pliny, *Natural History* II.101) and well known to the Renaissance, this conception of St. Elmo's fire does not figure in tempest imagery of the sixteenth and seventeenth centuries.

16. Berlin, Dealer P. Rosenthal, April 1929; photo RKD.

17. Johannes Sambucus, *Emblemata*, Antwerp, 1566, p. 42 (Henkel and Schöne, col. 114).

18. *Afbeeldinghe van d'eerste eeuwe der Societeyt Iesu*, pp. 130–31, "Eer-ghierigheyt is sorghe-lijck" ("ambition is precarious").

19. Bol, p. 65.

20. The emblem is in Joannes a Castro, *Zedighe sinne-belden ghetrocken uyt den on-geschreven boeck van den aerdt der schepselen*, Antwerp, 1694, no. XXI, p. 61.

21. Bellevois's painting is dated 1664. In the exhibition catalogue, *Die Sprache der Bilder*, Braunschweig, 1978, no. 2, p. 47, it is proposed that the central ship be read as a ship of state, perhaps with reference to the Second English War, which began in 1664. This interpretation does not deal with the entire picture, particularly the wreck and the small boat at left, which are essential to the inherent meaning of the image.

22. Copenhagen, Statens Museum, Catalogue, 1951, no. 61.

23. Jan Huygen van Linschoten, *Itinerario*, Amsterdam, 1596; ed. H. Kern and H. Terpstra, The Hague, 1957 (De Linschoten Vereeniging, no. 60), III, 137:

[De Witte Duyve] was aen de zyde van het eylandt, daer't altemael louter steylen ende hooghe clippen en steenrootsen zijn, als berghen, soo dat het een grouwel is om af te sien, alwaer sommighe inwoonders stonden met koorden ende aen het eijnde curck ghebonden, om alsoo het volck toe te werpen, dat zy daer die handen aen mochten slaen, maer quamen weynich soo naer, waren al meest doot ende in stucken eer zy aende wal ghenaeckten.

24. The painting by Beerstraten (Fig. 136) is in the Bayerischen Staatsgemäldesammlungen, Munich, inv. no. 370.

25. Joost van den Vondel, "Het lof der zeevaert," l. 287; see Chapter 2.

26. Lorenz Eitner, *Géricault's Raft of the Medusa*, London, 1972.

27. Ibid., pp. 43–46.

28. Ibid., p. 53.

29. Ibid., pp. 30–31.

30. Ibid., pp. 146–47.

31. Ibid., pp. 54–56.

32. Sold at Lempertz, Cologne, 12 November 1938, no. 318; photo RKD.

33. Kendall Whaling Museum, Sharon, Massachusetts, inv. no. 0–159.

34. Jakob Rosenberg, *Jacob van Ruisdael*, Berlin, 1928, no. 593, pl. 102.

35. Bol, p. 49.

36. Jacobus Typotius, *Symbola divina et humana pontificum imperatorum regum*, Prague, 1601–3, III, 150, 153: "Prudentes illi, qui dum adversis premuntur, numinis auxilium implorant. . . ."

37. Zweerts, *Zede- en zinnebeelden*, no. 54, pp. 108–9, "Uit gevaar geredt" ("saved from danger") referring to Psalm 54:9 (verse 7 in the English Bible):

Wanneer een Schip in zee, uit veelerhande nood
Geredt, voor wind, voor stroom, streeft door de holle baaren,
Omringt van zeegedrogt en klippen, woest en groot,
Dan ziet men't, door bestier, ter haven binnen vaaren.
Wie hoopt en bidt, en waakt, wanneer 't hem qualyk gaat,
Vindt zich geredt, door God, die nooit zyn volk verlaat.

38. Typotius, *Symbola divina et humana*, I, 108–9. E. De Jongh, *Zinne- en minnebeelden in de schilderkunst van de zeventiende eeuw*, Amsterdam, 1967, pp. 60–62, discusses this symbolism.

39. The reading of the rocks in Bellevois's *Ships in Distress on a Rocky Coast* (Fig. 134) as metaphors of virtuous endurance seems inappropriate to an image in which the viewer's empathy is engaged by figures and ships struggling for survival against the elements. See *Die Sprache der Bilder*, no. 2, p. 46.

40. Jacob Cats, *Ouderdom, buyten-leven, en hof-gedachten, op Sorgh-Vliet*, Amsterdam, 1656, pp. 122–23: "Op't gesichte van de Zee tegen een rotzsteen aengedreven" ("on the sight of the sea driven against a rock").

41. Zweerts, *Zede- en zinnebeelden*, no. 93, pp. 286–87 (pages misnumbered, actually pp. 186–87), referring to Psalm 93:4:

> Het akkelig geklots, het bruischend zeegewelt,
> Stoot op de rotsen aan, door't woeden van de baaren,
> De rots wordt uitgeholt, daar 't dyk en damme gelt.
> Elk vreest voor groote nood, en uiterste gevaren.
> Wie zag uit Gods gewelt of vreeselyke kracht,
> En wierdt dan niet tot schrik en allen angst gebragt.

42. Bol, p. 94. The moral interpretation is suggested by Walsh, "Jan and Julius Porcellis," no. A4.

43. My interpretation follows that of Walsh, "Jan and Julius Porcellis," pp. 114–15.

44. Jacob Cats, *Spiegel van den ouden ende nieuwen tijdt*, The Hague, 1632, part III, no. xxix, p. 88.

45. Jan Luyken, *Het overvloeijende herte*, Haarlem, 1767, no. I, pp. 2–5.

46. Cats, *Ouderdom*, pp. 74–75; cited by Seymour Slive, *Frans Hals*, London, 1970, I, 144.

47. For De Vlieger's painting, see Stechow, *Dutch Landscape Painting*, p. 104, fig. 204. For Anthonissen's painting, see Bol, p. 109.

48. For Van Goyen's painting (Fig. 149), see Hans Ulrich Beck, *Jan van Goyen*, Amsterdam, 1973, vol. II, no. 833; cf. nos. 803–4, 806–7, 811, 827. On Ruisdael's painting (Fig. 150), see Rosenberg, *Jacob van Ruisdael*, no. 587.

49. See, for example, emblems of lightning striking towers as symbols of overweening ambition: Cats, *Spiegel*, part II, xv, p. 60, and Adrianus Hofferus, *Nederduytsche poemata*, Amsterdam, 1635, p. 140.

50. Thunderstorms by De Vlieger include the painting in the collection of Lord Leconfield, Petworth, no. 306 (Walsh, "Jan and Julius Porcellis," fig. 238), and another formerly in the collection of Sir Bruce Ingram, London (photo RKD).

51. For example, Aelbert Cuyp's *Thunderstorm over the Maas at Dordrecht*, London, National Gallery. See J. M. de Groot in *Aelbert Cuyp en zijn familie: Schilders te Dordrecht*, exhibition catalogue, Dordrechts Museum, 1977, no. 28.

52. Rosenberg, *Jacob van Ruisdael*, no. 579. Seymour Slive and H. R. Hoetink, *Jacob van Ruisdael*, exhibition catalogue, Cambridge, Mass., Fogg Art Museum, 1982, no. 27. I am much indebted to Seymour Slive for a photograph of this painting. A less dramatic version of this theme by Ruisdael is in the City Art Gallery, Manchester, inv. 1955, no. 124.

53. For these two paintings, see Stechow, *Dutch Landscape Painting*, pp. 121–22.

54. Earlier versions of this theme include a picture by Pieter Mulier the Elder in Osnabrück (Hildegard Kayser, *Niederländische und flämische Malerei des 16. und 17. Jahrhunderts*, Osnabrück, 1983, inv. no. 3628/30, pp. 82–83) and another by Jan Peeters in the F. C. Butôt Collection, St. Gilgen (Laurens J. Bol et al., *Netherlandish Paintings and Drawings from the Collection of F. C. Butôt*, London, 1981, no. 88). The latter is pendant to a stolen painting by Peeters depicting ships in distress off a rocky coast. For Jan Brueghel's drawing of this theme in Berlin dated 1 December 1614, see *Pieter Bruegel d. Ä. als Zeichner*, exhibition catalogue, Berlin-Dahlem, 1975, no. 124, pp. 102–3. Paintings of this type should possibly be considered dramatized versions of the beacon theme, which is frequently found in calm seascapes. See such seascapes by Van Goyen as Beck, *Jan Van Goyen*, II, nos. 792–96, 798, 805, 819, 823, 825. In two cases Van Goyen combines the beacon motif with the thunderstorm: Beck, nos. 807, 811.

55. Jacob Cats, *Proteus ofte minne-beelden verandert in sinne-beelden, emblemata moralia et aeconomica*, Rotterdam, 1627, pp. 26–27. On this emblem, see De Jongh, *Zinne- en minnebeelden*, p. 63.

56. Ibid., p. 63.

57. Roemer Visscher, *Sinnepoppen*, Amsterdam, 1614; reprint, ed. L. Brummel, The Hague, 1949, p. 239.

58. Jacob Cats gave his beacon emblem an amorous interpretation in *Maechden-plicht ofte ampt der ionck-vrouwen, in eerbaer liefde, aen ghewesen door sinnebeelden*, Middelburgh, 1618, no. xiii, pp. 42–43: "Monstrat, non ducit" ("it shows but does not lead"). Just as a beacon shows the sailor where the harbor is but does not move, leaving the initiative to the sailor, so a young woman should in beauty, dress, and behavior attract but not actively entice men. Ruisdael's painting (Fig. 151) may

have an amorous content if the two figures in the foreground are, as they seem, a man and a woman (there appear to be leaves in one figure's hair). The staffs they carry cannot be read with certainty; they seem to be boat hooks.

59. Bol, p. 176; Kelch, *Simon de Vlieger*, no. 46.

60. See Chapter 2.

61. Walsh, "Jan and Julius Porcellis," pp. 330–31, attributes the painting to Peeters.

62. On Friedrich's paintings and Romanticism, see Robert Rosenblum, *Modern Painting and the Northern Romantic Tradition: Friedrich to Rothko*, New York, 1975, pp. 1–40. On shipwreck in Romantic paintings, see also Eduard Hüttinger, "Der Schiffbruch": Deutungen eines Bildmotivs im 19. Jahrhundert," in *Beiträge zur Motivkunde des 19. Jahrhunderts*, Munich, 1970 (*Studien zur Kunst des neunzehnten Jahrhunderts*, VI), pp. 211–16, 226–44, and T. S. R. Boase, "Shipwrecks in English Romantic Painting," *Journal of the Warburg and Courtauld Institutes*, 22, 1959, pp. 332–46.

63. For the paintings by Homer (Fig. 3) and Turner (Fig. 4), see Chapter 1, notes 3, 4. For Courbet's *The Wave* (Fig. 158), see Hélène Toussaint in *Gustave Courbet (1819–1877)*, exhibition catalogue, Paris, Grand Palais, 1977, no. 117. For Moran's *Seascape* of 1906 in the Brooklyn Museum, see Roger B. Stein, *Seascape and the American Imagination*, New York, 1975, pp. 112, 117.

64. E. Haverkamp-Begemann, *Hercules Segers: The Complete Etchings*, Amsterdam and The Hague, 1973, no. 49. The sole impression is in the Albertina, Vienna.

65. On the surge of interest in this subject matter in the second half of the eighteenth century, see Boase, "Shipwrecks in English Romantic Painting," esp. pp. 332–36. This obsession with shipwreck and a fascination with the historical circumstances of real events are also evident in the bibliography in Keith Huntress, *Narratives of Shipwreck and Disasters, 1586–1860*, Ames, Iowa, 1974, pp. 221–42, where the dramatic increase in the number of narratives devoted exclusively to sea disasters begins in the 1730s. Collections of shipwreck accounts also begin to be much more common at that time. Bernardo Gomes de Brito's *História trágico marítima* of 1735–36 is an example of this development. See Chapter 4, note 25.

66. On *Watson and the Shark*, see Stein, *Seascape*, pp. 18–20.

67. Lucretius, *De rerum natura* II.1–4; trans. R. E. Latham, Baltimore, 1951, p. 60.

68. John Rupert Martin, *Baroque*, New York, 1977, chap. V, esp. pp. 175–81. For G. Wilson Knight on Shakespeare, see chap. II.

69. Samuel van Hoogstraeten, *Inleydinge tot de hooge schoole der schilderkonst*, Amsterdam, 1678, pp. 237–38. H. van de Waal, *Jan van Goyen* (Palet Serie), Amsterdam, 1941, p. 27, observes the applicability of the term "keurlijke natuurlijkheid" to the seventeenth-century conception of landscape.

Bibliography

PRIMARY SOURCES

Afbeeldinghe van d'eerste eeuwe der Societeyt Iesu. Antwerp, 1640.
Album amicorum Abraham Ortelius. Ed. J. Puraye. Amsterdam, 1969.
Alciati, Andrea. *Diverse imprese accommodate a diverse moralità.* Lyon, 1551.
———. *Emblematum liber.* Augsburg, 1531. Antwerp, 1581.
Angel, Philips. *Het lof der schilderkunst.* [Leiden, 1642.] Reprint Utrecht, 1969.
Beschryvinghe vande voyagie om den geheelen werelt cloot/ ghedaen door Olivier van Noort.
 [Rotterdam and Amsterdam, 1602.] Ed. J. W. IJzerman. De Linschoten Vereeniging, no. 27.
 The Hague, 1926.
Biens, C. P. *Handt-Boecxken der christelijcke gedichten, sinne-beelden ende liedekens.* 2d ed.
 Hoorn, 1635.
Bontekoe, Willem IJsbrantsz. *Journael ofte gedenckwaerdige beschrijvinghe van de Oost-Indische
 reijse.* [Hoorn, 1646.] Ed. G. J. Hoogewerff. De Linschoten Vereeniging, no. 54. The Hague,
 1952.
Brant, Sebastian. *Das Narrenschiff.* [1494.] Ed. Friedrich Zarnke. Reprint, Darmstadt, 1964.
Broverius van Niedek, Mattheus. *Zederyke zinnebeelden der tonge.* Amsterdam, 1716.
Brune, Johan de. *Emblemata of zinne-werck.* Amsterdam, 1624.
Burke, Edmund. *A Philosophical Enquiry into the Origin of Our Ideas of the Sublime and Beautiful.*
 [1757.] Ed. J. T. Boulton. London, 1958.
Camerarius, Joachim. *Symbolorum et emblematum ex aquatilibus et reptilibus desumptorum
 centuria quarta.* Nuremberg, 1604.
Castro, Joannes a. *Zedighe sinne-belden ghetrocken uyt den on-gheschreven boeck van den aerdt
 der schepselen.* Antwerp, 1694.
Cats, Jacob. *Maechden-plicht ofte ampt der ionck-vrouwen, in eerbaer liefde, aen ghewesen door
 sinnebeelden.* Middelburgh, 1618.
———. *Ouderdom, buyten-leven, en hof-gedachten, op Sorgh-Vliet.* Amsterdam, 1656.
———. *Proteus ofte minnebeelden verandert in sinne-beelden, emblemata moralia et aeconomica.*
 Rotterdam, 1627.
———. *Spiegel van den ouden ende nieuwen tijdt.* The Hague, 1632.

Coornhert, Dirck Volkertsz. *Zedekunst dat is wellevenskunst.* [1586.] Ed. B. Becker. Leiden, 1942.

Corrozet, Gilles. *Hecatongraphie.* Antwerp, 1566.

Deutel, Jan Jansz. *Huwelijckx weegh-schael.* Hoorn, 1641.

Diderot, Denis. *Salons,* vol. III, *1787.* Ed. Jean Seznec. 2d ed. Oxford, 1983.

Du Bartas, Guillaume Salluste. *Bartas: His Devine Weekes and Works.* Trans. Joshua Sylvester. [London, 1605.] Ed. Francis C. Haber. Gainesville, Fla., 1965.

——. *The Works of Guillaume Salluste Sieur du Bartas.* Ed. Urban Tigner Holmes et al. 2 vols. Chapel Hill, N.C., 1938.

Egger, Felix. *Elegantissimorum emblematum corpusculum.* Leiden, 1696.

Erasmus. "Naufragium." [1523.] In *The Colloquies of Erasmus.* Trans. and ed. Craig R. Thompson. Chicago and London, 1965, pp. 138–65.

Ghiberti, Lorenzo. *I commentarii.* Ed. Julius von Schlosser. 2 vols. Berlin, 1912.

Gomes de Brito, Bernardo, ed. *The Tragic History of the Sea.* [1735–36.] Trans. and ed. C. R. Boxer. The Hakluyt Society, ser. 2, nos. 112, 132. Cambridge, 1959–68.

Grotius, Hugo. *Bewys van den waren godsdienst.* 2d ed. Leiden, 1622.

Heinsius, Daniel. *Emblemata amatoria nova.* Leiden, 1613.

——. *Nederduytsche poemata.* Amsterdam, 1616.

Heyns, Zacharias. *Emblemata, emblèmes chrestienes, et morales, Sinne-Beelden.* Rotterdam, 1625.

Hofferus, Adrianus. *Nederduytsche poemata.* Amsterdam, 1635.

Hollanda, Francisco de. *Vier Gespräche über die Malerei.* [1548.] Ed. J. de Vasconcellos. Quellenschriften für Kunstgeschichte, 9. Vienna, 1899.

Hoogstraeten, Samuel van. *Inleydinge tot de hooge schoole der schilderkonst.* Amsterdam, 1678.

Houbraken, Arnold. *De groote schouburgh der nederlantsche konstschilders en schilderessen.* 2d ed. 3 vols. The Hague, 1753.

Hugo, Herman. *Pia desideria emblematis elegiis et affectibus SS. Patrum illustrata.* Antwerp, 1624.

Hulsius, Bartholomeus. *Emblemata sacra, dat is, eenighe geestelicke sinnebeelden.* N.p., 1631.

Huygens, Constantijn. *De Gedichten van Constantijn Huygens, naar zijn handschrift uitgegeven.* Ed. J. A. Worp. Groningen, 1893– .

——. *De jeugd van Constantijn Huygens door hemzelf beschreven.* Trans. and ed. A. H. Kan. Rotterdam and Antwerp, 1946.

Krul, Jan Harmenszoon. *Minne-beelden: Toe-ghepast de lievende jonckheyt.* Amsterdam, 1634.

——. *Pampiere wereld ofte wereldsche oeffeninge.* Amsterdam, 1644.

Lairesse, Gérard de. *Groot schilderboek.* Amsterdam, 1707.

Lancilotti, Francesco. *Trattato di pittura.* [1509.] Ed. Filippo Raffaelli. Recanati, 1885.

Leeuwaarden, N. S. van. *De godvrezende zeeman, ofte de nieuwe christelyke zeevaert.* 7th printing. Amsterdam, 1748.

Linschoten, Jan Huygen van. *Itinerario.* [Amsterdam, 1596.] Ed. H. Kern and H. Terpstra. De Linschoten Vereeniging, no. 60. The Hague, 1957.

Lomazzo, Gian Paolo. *Trattato del'arte della pittura, scoltura et architettura.* [Milan, 1584.] In *Scritti sulle arti.* Ed. Roberto Paolo Ciardi. Florence, 1974.

Loon, Gerard van. *Beschryving der nederlandsche historie-penningen . . . van Keyzer Karel den Vyfden . . . tot het sluyten van den Uytrechtschen Vreede.* 4 vols. The Hague, 1723.

Luckius, Joannes. *Sylloge numismatum elegantiorum.* Augsburg, 1620.

Luyken, Jan. *Het overvloeijende herte.* Haarlem, 1767.

Olaus Magnus. *Historia de gentibus septentrionalibus.* Rome, 1555.

Mander, Karel van. *Den grondt der edel vry schilder-const.* [Haarlem, 1604.] Ed. Hessel Miedema. 2 vols. Utrecht, 1973.

Michiel, Marcantonio. *Notizia d'opere del disegno.* Ed. Theodor Frimmel. Quellenschriften für Kunstgeschichte und Kunsttechnik des Mittelalters und der Neuzeit, n.f. 1. Vienna, 1888.

Oudaan, Joachim. *Joachim Oudaans Poëzy.* 3 vols. Amsterdam, 1712.

Poot, Hubert Korneliszoon. *Gedichten.* 2d ed. 3 vols. Amsterdam, 1722–35.

——. *Het groot natuur en zedekundigh werelttoneel.* Delft, 1743.

Rabelais, François. *The Five Books of Gargantua and Pantagruel.* Trans. Jacques le Clercq. New York, 1936.

Ripa, Cesare. *Iconologia, of uytbeeldingen des verstands.* Trans. D. P. Pers. Amsterdam, 1644.

Sambucus, Johannes. *Emblemata.* 3d ed. Antwerp, 1569.

Schoonhovius, Florentius. *Emblemata.* Gouda, 1618.

Sorte, Cristoforo. *Osservazioni nella pittura.* [Venice, 1580.] In *Trattati d'arte del Cinquecento.* Ed. Paola Barocchi. Bari, 1960, vol. I.

Spenser, Edmund. *Poetical Works.* Ed. J. C. Smith and E. de Selincourt. London, 1912.

Strachey, William. "A True Repertory of the Wracke, and Redemption of Sir Thomas Gates,

Knight." In Samuel Purchas, *Hakluytus Postumus, or Purchas His Pilgrimes.* [1625.] Glasgow and New York, 1906, vol. XIX, p. 5ff.

Typotius, Jacobus. *Symbola divina et humana pontificum imperatorum regum.* Prague, 1601–3. Facsimile, Graz, 1972.

Udemans, Godefridus Cornelis. *Geestelick compas, dat is nut ende nootwendigh bericht voor alle zee-varende en reysende luyden om te ontgaen de steen-klippen ende zantplaten der sonde ende des toorns Gods.* 4th ed. Dordrecht, 1647.

Vaernewyck, Marcus van. *Troubles réligieux en Flandre et dans les Pays-Bas au XVIe siècle.* Trans. H. van Duyse. 2 vols. Ghent, 1905.

Valerius, Adrianus. *Neder-landtsche gedenck-clanck.* Haarlem, 1626. Facsimile ed., New York, 1974.

Varchi, Benedetto. *Due lezzioni.* [Florence, 1549.] In *Trattati d'arte del Cinquecento.* Ed. Paola Barocchi. Bari, 1960, vol. I.

Vasari, Giorgio. *Le vite de più eccellenti pittori scultori e architettori nelle redazioni del 1550 e 1568.* Ed. Rosanna Bettarini and Paola Barocchi. 6 vols. Florence, 1966–76.

———. *Lives of the Most Eminent Painters Sculptors and Architects.* Trans. Gaston du C. de Vere. New ed., 3 vols. New York, 1979.

Veen, Otto van. *Emblemata sive symbola a principibus, viris ecclesiasticis, ac militaribus, aliisque usurpanda.* Brussels, 1624.

Visscher, Roemer. *Sinnepoppen.* [Amsterdam, 1614.] Reprint, ed. L. Brummel. The Hague, 1949.

Vondel, Joost van den. "Hymnus, ofte lof-gesangh over de wijd-beroemde scheeps-vaert der Vereenigde Nederlanden." [1622.] In *De Werken van Vondel,* vol. I. Amsterdam, 1927, pp. 427–545.

———. "Het lof der zeevaert." [1623.] In *De Werken van Vondel,* vol. II. Amsterdam, 1929, pp. 431–55.

Vries, Simon de. *Wonderen soo aen als in, en wonder-gevallen soo op als ontrent de zeeën, rivieren, meiren, poelen, en fonteynen: Historischer, ondersoeckender, en redenvoorstellender wijs verhandeld.* Amsterdam, 1687.

Westerman, A. *Groote christelyke zeevaert in XXVI predikaten.* Amsterdam, 1635.

Whitney, Geoffrey. *A Choice of Emblemes, and Other Devises.* [Leiden, 1586.] Facsimile, ed. H. Green. London, 1866.

Zedler, J. H. *Grosses vollständiges Universal-Lexikon aller Wissenschaften und Künste.* 68 vols. Halle and Leipzig, 1732–54.

Zincgreff, Julius Wilhelm. *Emblematum ethico-politicorum centuria.* Heidelberg, 1619.

Zweerts, Kornelis. *Zede- en zinnebeelden over Koning Davids Harpzangen.* Amsterdam, 1707.

SECONDARY SOURCES

Akveld, L. M., et al., eds. *Maritieme geschiedenis der Nederlanden,* vol. II. *Zeventiende eeuw, van 1585 tot ca 1680.* Bussum, 1977.

Albrecht-Bott, Marianne. *Die bildende Kunst in der italienischen Lyrik der Renaissance und des Barock: Studie zur Beschreibung von Portraits und anderen Bildwerken unter besonderer Berücksichtigung von G. B. Marinos Galleria.* Mainzer Romanistische Arbeiten, XI. Wiesbaden, 1976.

Alpers, Svetlana. "*Ekphrasis* and Aesthetic Attitudes in Vasari's *Lives.*" *Journal of the Warburg and Courtauld Institutes,* 23, 1960, pp. 190–215.

———. *The Art of Describing: Dutch Art in the Seventeenth Century.* Chicago, 1983.

Amsterdam, Rijksmuseum. *Tot lering en vermaak.* Exhibition catalogue. Amsterdam, 1976.

Anderson, R., and R. C. Anderson. *The Sailing Ship: Six Thousand Years of History.* Rev. ed., New York, 1963.

Andrews, Keith. *Adam Elsheimer: Paintings, Drawings, and Prints.* London, 1977.

Antwerp, Koninklijke Museum voor Schone Kunsten. *P. P. Rubens: Paintings—Oilsketches—Drawings.* Exhibition catalogue. Antwerp, 1977.

Auden, W. H. *The Enchafèd Flood or the Romantic Iconography of the Sea.* New York, 1967.

Baldass, Ludwig. *Die wiener Gobelinsammlung.* Vienna, 1920.

Bangs, Jeremy D. "Pieter Bruegel and History." *The Art Bulletin,* 60, 1978, pp. 704–5.

Barocchi, Paola, ed. *Trattati d'arte del Cinquecento fra manierismo e controriforma.* 3 vols. Bari, 1960–62.

Bax, D. *Hieronymus Bosch: His Picture-Writing Deciphered.* Rotterdam, 1979.

Baxandall, Michael. *Giotto and the Orators.* Oxford, 1971.

Beening, Th. J. "Het landschap in de Nederlandse letterkunde van de Renaissance." Dissertation:

University of Nijmegen, 1963.

Begemann, E. Haverkamp. *Hercules Segers: The Complete Etchings*. Amsterdam and The Hague, 1973.

──────. *Willem Buytewech*. Amsterdam, 1959.

Bengtsson, Åke. *Studies on the Rise of Realistic Landscape Painting in Holland, 1610–1625*. Figura, 3. Stockholm, 1952.

Bentkowska, Anna. "*Navigatio vitae:* Elements of Emblematic Symbolism in 17th Century Dutch Seascapes." *Bulletin du Musée National de Varsovie*, 23, 1982, pp. 25–43.

Bergström, Ingvar. "The Iconological Origins of *Spes* by Pieter Bruegel the Elder." *Nederlands Kunsthistorisch Jaarboek*, 7, 1956, pp. 53–63.

Berlin, Staatlichen Museen. *Pieter Bruegel d. Ä. als Zeichner: Herkunft und Nachfolge*. Exhibition catalogue. Berlin, 1975.

Bernhart, Max. "Die Granvella-Medaillen des XVI. Jahrhunderts." *Archiv für Medaillen- und Platten-kunde*, 2, 1920–21, pp. 101–19.

Bernt, Walther. *The Netherlandish Painters of the Seventeenth Century*. Trans. P. S. Falla. 3 vols. London, 1970.

Beylen, J. van. *Schepen van de Nederlanden: Van de late Middeleeuwen tot het einde van de 17de eeuw*. Amsterdam, 1970.

──────. "De uitbeelding en documentaire waarde van schepen van enkele oude meesters." *Bulletin van de Koninklijke Musea voor Schone Kunsten, Brussel*, 10, 1961, pp. 123–50.

Białostocki, Jan. "The Renaissance Concept of Nature and Antiquity." *The Renaissance and Mannerism: Studies in Western Art*. Acts of the Twentieth International Congress of the History of Art, 1961, vol. II. Princeton, 1963, pp. 19–30.

Blankert, Albert. Review of Wolfgang Stechow, *Dutch Landscape Painting of the Seventeenth Century*. In *Simiolus*, 2, 1967–68, pp. 103–8.

Blom, N. van der. "Van Valckenborch's Schipbreuk." *Bulletin Museum Boymans–van Beuningen*, 18, 1967, pp. 54–67.

Boase, T. S. R. "Shipwrecks in English Romantic Painting." *Journal of the Warburg and Courtauld Institutes*, 22, 1959, pp. 332–46.

Bode, Wilhelm von. *Die Meister der holländischen und vlämischen Malerschulen*. Leipzig, 1917.

Bol, Laurens J. *Die holländische Marinemalerei des 17. Jahrhunderts*. Braunschweig, 1973.

Bonner, S. F. *Roman Declamation in the Late Republic and Early Empire*. Liverpool, 1949.

Boström, Kjell. "Är 'Stormen' verkligen en Bruegel?" *Konsthistorisk Tidskrift*, 20, 1951, pp. 1–19.

──────. "Joos de Momper och det tidiga marin-måleriet i Antwerpen." *Konsthistorisk Tidskrift*, 23, 1954, pp. 45–66.

Boxer, C. R. *The Dutch Seaborne Empire*. London, 1965.

Braudel, Fernand. *The Mediterranean and the Mediterranean World in the Age of Philip II*. Trans. by Siân Reynolds. 2 vols. New York, 1972.

Braunschweig, Herzog-Anton-Ulrich Museum. *Die Sprache der Bilder: Realität und Bedeutung in der niederländischen Malerei des 17. Jahrhunderts*. Exhibition catalogue. Braunschweig, 1978.

Broos, Ben, Robert Vorstman, and Willem L. van de Watering. *Ludolf Bakhuizen: 1631–1708: Schrijfmeester—teyckenaer—schilder*. Exhibition catalogue. Amsterdam, Nederlands Scheepvaart Museum, 1985.

Bruijn, J. R., et al. *Dutch-Asiatic Shipping in the 17th and 18th Centuries*, vols. II–III. The Hague, 1979.

Brumble, H. David, III. "Pieter Bruegel the Elder: The Allegory of Landscape." *Art Quarterly*, n.s. 2, 1979, pp. 125–39.

Burchard, Ludwig. "Bruegel's Parable of the Whale and the Tub." *Burlington Magazine*, 91, 1949, p. 224.

Butlin, Martin, and Evelyn Joll. *The Paintings of J. M. W. Turner*. New Haven, 1977.

Canova, Giordana Maria. *L'opera completa del Lotto*. Milan, 1975.

Chew, Samuel C. *The Pilgrimage of Life*. New Haven and London, 1962.

Chiarini, M. *Artisti alla corte granducale*. Exhibition catalogue. Florence, Palazzo Pitti, 1969.

Church, E. D. *A Catalogue of Books Relating to the Discovery and Early History of North and South America*. 5 vols. New York, 1907.

Clark, Kenneth. *Leonardo da Vinci*. Harmondsworth and Baltimore, 1967.

Cologne, Wallraf-Richartz-Museum. *Peter Paul Rubens, 1577–1640*. Cologne, 1977.

──────. *Peter Paul Rubens, 1577–1640, Maler mit dem Grabstichel: Rubens und die Druckgraphik*. Exhibition catalogue. Cologne, 1977.

Commager, Steele. *The Odes of Horace: A Critical Study*. New Haven and London, 1962.

Conisbee, Philip. *Claude-Joseph Vernet, 1714–1789*. Exhibition catalogue. London, Kenwood House, 1976.

——. "Salvator Rosa and Claude-Joseph Vernet." *Burlington Magazine*, 115, 1973, pp. 789–94.

Cordingly, David. *Marine Painting in England, 1700–1900*. London, 1974.

——. *Painters of the Sea*. Exhibition catalogue. Brighton Art Gallery and Museum, 1979.

——, and Westby Percival-Prescott. *The Art of the Van de Veldes*. Exhibition catalogue. Greenwich, National Maritime Museum, 1982.

Curtius, Ernst Robert. *European Literature and the Latin Middle Ages*. Trans. Willard R. Trask. New York, 1953.

Davies, Alice I. "Allaert van Everdingen." Dissertation: Harvard University, Cambridge, Mass., 1973.

Davies, D. W. *A Primer of Dutch Seventeenth-Century Overseas Trade*. The Hague, 1962.

Davis, Howard McP. "Fantasy and Irony in Pieter Bruegel's Prints." *Metropolitan Museum of Art Bulletin*, 1, 1943, pp. 291–95.

Degenhart, Bernhard, and Annegrit Schmitt. *Corpus der italienischen Zeichnungen, 1300–1450*, vol. I. *Süd und Mittelitalien*, Berlin, 1968.

Delen, A. J. J. *Cabinet des Estampes de la Ville d'Anvers (Musée Plantin Moretus): Catalogue des dessins anciens, écoles flamandes et hollandaises*. 2 vols. Brussels, 1938.

Demus, Klaus, ed. *Kunsthistorisches Museum, Wien, Verzeichnis der Gemälde*. Vienna, 1973.

Demus, Klaus, Friderike Klauner, and Karl Schutz. *Flämische Malerei von Jan van Eyck bis Pieter Bruegel d. Ä. Kunsthistorisches Museum Wien*. Vienna, 1981.

Diekerhoff, F. L. *De oorlogsvloot in de zeventiende eeuw*. Bussum, 1967.

Dolger, Franz Joseph. *Sol salutis: Gebet und Gesang im christlichen Altertums*. 3d ed. Münster, 1972.

Dordrecht, Dordrechts Museum. *Aelbert Cuyp en zijn familie: Schilders te Dordrecht*. Dordrecht, 1977.

——. *Zee- rivier- en oevergezichten: Nederlandse schilderijen uit de 17de eeuw*. Dordrecht, 1964.

Doren, A. "Fortuna in Mittelalter und in der Renaissance." *Vorträge der Bibliothek Warburg*, 1, 1922–23, pp. 77–144.

Duffy, James. *Shipwreck and Empire, Being an Account of Portuguese Maritime Disasters in a Century of Decline*. Cambridge, Mass., 1955.

Durrieu, Paul. *Les Heures de Turin*. Ed. Albert Châtelet. Turin, 1967.

Duverger, Erik. "Nadere gegevens over de Antwerpse periode van Jan Porcellis." *Jaarboek van het Koninklijk Museum voor Schone Kunsten Antwerpen*, 16, 1976, pp. 269–79.

Egan, Patricia. "Poesia and the Fête Champêtre." *The Art Bulletin*, 41, 1959, pp. 303–13.

Eitner, Lorenz. *Géricault's Raft of the Medusa*. London, 1972.

——. "The Open Window and the Storm-Tossed Boat: An Essay in the Iconography of Romanticism." *The Art Bulletin*, 37, 1955, pp. 281–90.

Enkvist, Nils Erik. "The Seasons of the Year: Chapters on a Motif from Beowulf to the Shepherd's Calendar." *Societas Scientiarum Fennica, Commentationes Humanarum Litterarum*, 22, no. 4, 1957.

Ertz, Claus. *Jan Brueghel der Ältere (1568–1625): Die Gemälde*. Cologne, 1979.

——. *Jan Breughel der Jüngere: Die Gemälde*. Freren, 1984.

Es, G. A. van. "Reisverhalen." In *Geschiedenis van de letterkunde der Nederlanden*, vol. IV. Ed. F. Baur. s'Hertogenbosch and Antwerp, 1948, pp. 220–41.

Faggin, Giorgio T. "Per Paolo Bril." *Paragone*, 185, 1965, pp. 21–35.

Franz, Heinrich Gerhard. "Meister der spätmanieristischen Landschaftsmalerei in den Niederlanden." *Jahrbuch des Kunsthistorischen Instituts der Universität Graz*, 3–4, 1968–69, pp. 19–71.

——. *Niederländische Landschaftsmalerei im Zeitalter des Manierismus*. Forschungen und Berichte des Kunsthistorischen Instituts der Universität Graz, II. 2 vols. Graz, 1969.

Frey, Gerhard, Ellen J. Beer, and Karl-August Wirth. "Elemente." In *Reallexikon zur deutschen Kunstgeschichte*, vol. IV, Stuttgart, 1958, cols. 1256–88.

Friedländer, Max J. *Early Netherlandish Painting*, vol. V. *Geertgen tot Sint Jans and Jerome Bosch*. New York, 1969. vol. IXb; *Joos van Cleve, Jan Provost, Joachim Patenir*. New York, 1973.

Friedman, Donald M. *Marvell's Pastoral Art*. Berkeley and Los Angeles, 1970.

Fromentin, Eugene. *The Old Masters of Belgium and Holland*. [1882.] Trans. M. C. Robbins. New York, 1963.

Fuchs, R. H. *Dutch Painting*. New York and Toronto, 1978.

——. "Over het landschap: Een verslag naar aanleiding van Jacob van Ruisdael, *Het Korenveld*." *Tijdschrift voor geschiedenis*, 86, 1973, pp. 281–92.

Gantner, Joseph. *Leonardos Visionen von der Sintflut und vom Untergang der Welt.* Bern, 1958.

Gelder, J. G. van. *Jan van de Velde, 1593–1641, teekenaar-schilder.* The Hague, 1933.

Gerszi, Terész. "Die humanistischen Allegorien der rudolfinischen Meister." In *Evolution générale et développements régionaux en histoire de l'art.* Actes du XIIIe Congrès International d'Histoire de l'Art, Budapest, 1969, vol. I. Budapest, 1973, pp. 755–62.

———. *Netherlandish Drawings in the Budapest Museum: Sixteenth-Century Drawings.* 2 vols. Amsterdam and New York, 1971.

———. "Pieter Bruegels Einfluss auf die Herausbildung der niederländischen See- und Kustenland-schaftsdarstellung." *Jahrbuch der Berliner Museen,* 24, 1982, pp. 143–87.

Geyl, Pieter. *The Netherlands in the Seventeenth Century,* Part One, *1609–1648.* Trans. S. T. Bindoff. Rev. ed. London, 1961.

———. *The Revolt of the Netherlands.* 2d ed. London, 1958.

Gilbert, Creighton. "On Subject and Not-Subject in Italian Renaissance Pictures." *The Art Bulletin,* 34, 1952, pp. 202–16.

Glück, Gustav. *Bruegels Gemälde.* 6th ed. Vienna, 1953.

Gombrich, E. H. *Art and Illusion: A Study in the Psychology of Pictorial Representation.* 2d ed. Princeton, 1961.

———. "The Form of Movement in Water and Air." In *The Heritage of Apelles.* Ithaca, N.Y., and Oxford, 1976, pp. 39–56.

———. "Leonardo's Method for Working Out Compositions." *Norm and Form: Studies in the Art of the Renaissance.* London, 1966, pp. 58–63.

———. "The Renaissance Theory of Art and the Rise of Landscape." In *Norm and Form: Studies in the Art of the Renaissance.* London, 1966, pp. 107–21.

Groot, Irene de, and Robert Vorstman. *Sailing Ships: Prints by Dutch Masters from the Sixteenth to the Nineteenth Century.* Trans. Michael Hoyle. New York and Maarssen, 1980.

Grossman, F. *Bruegel: The Paintings.* 3d ed. London, 1973.

Gruenter, Reiner. "Das Schiff: Ein Beitrag zur historischen Metaphorik." In *Tradition and Ursprung-lichkeit: Akten des III. Internationalen Germanistenkongresses 1965 in Amsterdam.* Bern, 1966, pp. 86–101.

Hagstrum, Jean H. *The Sister Arts: The Tradition of Literary Pictorialism and English Poetry from Dryden to Gray.* Chicago, 1958.

Hand, John Oliver, and Martha Wolff. *Early Netherlandish Painting* (The Collections of the National Gallery of Art: Systematic Catalogue). Washington, D.C., 1986.

Heckscher, William S. "Sturm und Drang: Conjectures on the Origin of a Phrase." *Simiolus,* 1, 1966–67, pp. 94–105.

———, and Karl-August Wirth. "Emblem, Emblembuch." In *Reallexikon zur deutschen Kunstges-chichte,* vol. V, Stuttgart, 1967, cols. 85–228.

Hendricks, Gordon. *The Life and Work of Winslow Homer.* New York, 1979.

Heninger, S. K. *The Cosmographical Glass.* San Marino, Calif., 1977.

———. *A Handbook of Renaissance Meteorology, With Particular Reference to Elizabethan and Jacobean Literature.* Durham, N.C., 1960.

Henkel, Arthur, and Albrecht Schöne. *Emblemata: Handbuch zur Sinnbildkunst des XVI. und XVII. Jahrhunderts.* Stuttgart, 1967; supplement, Stuttgart, 1976.

Hilgert, Earle. *The Ship and Related Symbols in the New Testament.* Assen, 1962.

Hind, Arthur M. *Early Italian Engraving.* 7 vols. London, 1938–48.

Hoetink, H. R. *Mauritshuis, the Royal Cabinet of Paintings: Illustrated General Catalogue.* The Hague, 1977.

Hofstede de Groot, Cornelis. *Arnold Houbraken und seine "Groote Schouburgh."* The Hague, 1893.

Hohl, H. "Arche Noa." In *Lexikon der christlichen Ikonographie,* vol. I, Freiburg im Bresgau, 1968, cols. 178–99.

Holl, O. "Kalendrium, Kalenderbild." In *Lexikon der christlichen Ikonographie,* vol. II, Freiburg im Bresgau, 1970, cols. 482–89.

———. "Monate, Monatsbilder." In *Lexikon der christlichen Ikonographie,* vol. III, Freiburg im Bresgau, 1971, cols. 274–79.

Honour, Hugh. *The New Golden Land: European Images of America from the Discoveries to the Present Time.* New York, 1975.

Hoogewerff, G. J. "Jan van Bijlert, Schilder van Utrecht (1598–1671)." *Oud Holland,* 80, 1965, pp. 2–33.

Huntress, Keith. *Narratives of Shipwrecks and Disasters, 1586–1860.* Ames, Iowa, 1974.

Hüttinger, Eduard. "Der Schiffbruch: Deutungen eines Bildmotivs im 19. Jahrhundert." *Beiträge zur Motivkunde des 19. Jahrhunderts.* Studien zur Kunst des 19. Jahrhunderts, vol. 6. Forschungs-unternehmen der Fritz-Thyssen-Stiftung. Munich, 1970, pp. 211–44.

Ingersoll-Smouse, Florence. *Joseph Vernet: Peintre de marine, 1714–1789.* 2 vols. Paris, 1926.

Jacobsen, Michael. "Savoldo and Northern Art." *The Art Bulletin,* 56, 1974, pp. 530–34.

Jongh, E. de. "Bol vincit amorem." *Simiolus,* 12, 1981–82, pp. 147–61.

———. "Inleiding." In *Tot lering en vermaak.* Exhibition catalogue. Amsterdam, Rijksmuseum, 1976, pp. 14–28.

———. "Realisme en schijnrealisme in de Hollandse schilderkunst van de zeventiende eeuw," in *Rembrandt en zijn tijd,* Exhibition catalogue. Brussels, Palais des Beaux-Arts, 1971.

———. Review of Peter Sutton, *Pieter de Hooch: Complete Edition.* In *Simiolus,* 11, 1980, pp. 181–85.

———. *Zinne- en minnebeelden in de schilderkunst van de zeventiende eeuw.* Amsterdam, 1967.

Joppien, Rüdiger. *Philippe-Jacques de Loutherbourg, RA 1740–1812.* Exhibition catalogue. London, Kenwood House, 1973.

Judson, J. Richard. *Dirck Barendsz., 1534–1592.* Amsterdam, 1970.

———. "Marine Symbols of Salvation in the Sixteenth Century." *Essays in Memory of Karl Lehmann. Marsyas,* Supplement I. New York, 1964, pp. 136–52.

———. "Martin de Vos' Representations of 'Jonah Cast Over the Side.' " In *Miscellanea I. Q. van Regeteren Altena.* Amsterdam, 1969, pp. 82–87.

Kahlmeyer, Johannes. "Seesturm und Schiffbruch als Bild im antiken Schrifttum." Dissertation: Greifswald, Ernst-Moritz-Arndt-Universität, 1934.

Kallab, Wolfgang. "Die toscanische Landschaftsmalerei im XIV. und XV. Jahrhundert, ihre Entstehung und Entwicklung." *Jahrbuch der kunsthistorischen Sammlungen des allerhöchsten Kaiserhauses,* 21, 1900, pp. 1–90.

Kauffmann, Hans. "Jacob van Ruisdael, 'Die Mühle von Wijk bij Duurstede.' " In *Festschrift für Otto von Simson.* Ed. L. Grisebach and K. Renger. Frankfurt, 1977, pp. 379–97.

Kelch, Jan. *Peter Paul Rubens: Kritischer Katalog der Gemälde im Besitz der Gemäldegalerie, Berlin.* Berlin, 1970.

———. "Simon de Vlieger als Marinemaler." Dissertation: Berlin, 1968.

Kemp, Peter, ed. *The Oxford Companion to Ships and the Sea.* Oxford, 1976.

Kerber, B., and O. Holl. "Jahreszeiten." In *Lexikon der christlichen Ikonographie,* vol. II, Freiburg im Bresgau, 1970, cols. 364–70.

Kettering, Alison McNeil. *The Dutch Arcadia: Pastoral Art and Its Audience in the Golden Age.* Montclair, N.J., 1983.

Keyes, George. "Cornelis Claesz. van Wieringen." *Oud Holland,* 93, 1979, pp. 1–46.

———. *Cornelis Vroom: Marine and Landscape Artist.* Alphen aan den Rijn, 1975.

———. "Hendrick and Cornelis Vroom: Addenda." *Master Drawings,* 20, 1982, pp. 115–24.

Keyselitz, Robert. "Zur Deutung von Jan Steens 'Soo gewonnen, soo verteert.' " *Zeitschrift für Kunstgeschichte,* 22, 1959, pp. 40–45.

Kitson, Michael. *Claude Lorrain: Liber Veritatis.* London, 1978.

Knab, Eckhart. "Die Anfänge des Claude Lorrain." *Jahrbuch der Kunsthistorischen Sammlungen, Wien,* 56, 1960, pp. 63–164.

Knight, G. Wilson. *The Shakespearian Tempest.* Oxford, 1932.

Kreuzberg, Claus. "Zur Seesturm-Allegorie Bruegels." In *Zwischen Kunstgeschichte und Volkenkunde: Festschrift für Wilhelm Fraenger.* Berlin, 1960, pp. 33–49.

Krielaart, T. "Symboliek in zeegezichten." *Antiek,* 8, 1973–74, pp. 568–69.

Lambert, Audrey M. *The Making of the Dutch Landscape: An Historical Geography of the Netherlands.* 2d ed. London, 1985.

Landwehr, John. *Emblem Books in the Low Countries, 1554–1949: A Bibliography.* Utrecht, 1970.

Langercrantz, B. "Pieter Bruegel and Olaus Magnus." *Konsthistorisk Tidskrift,* 18, 1949, pp. 71–76.

Lausberg, Heinrich. *Handbuch der literarischen Rhetorik: Eine Grundlegung der Literaturwissenschaft.* 2 vols. Munich, 1960.

Lebeer, Louis. *Catalogue raisonné des estampes de Bruegel l'Ancien.* Brussels, 1969.

———. "Nog enkele wetenswaardigheden in verband met Pieter Bruegel den Oude." *Gentsche bijdragen tot de kunstgeschiedenis,* 1943, pp. 217–36.

Lee, Rensselaer W. *Ut pictura poesis: The Humanistic Theory of Painting.* New York, 1967.

Lehrs, Max. *Der Meister ꝏ ⚹ : Ein Kupfersticher der Zeit Carel des Kühnen.* Dresden, 1895.

Leidinger, G. *Flämischer Kalender des XVI. Jahrhunderts gemalt von Simon Bening dem Hauptmeister des Breviarium Grimani.* Munich, 1936.

Levitine, George. "*Vernet Tied to a Mast in a Storm:* The Evolution of an Episode of Art Historical Romantic Folklore." *The Art Bulletin,* 49, 1967, pp. 93–101.

Lewis, C. S. *The Discarded Image.* Cambridge, 1964.

Lugt, Fritz. *Musée du Louvre. Inventaire général des dessins des écoles du Nord: École flamande.* 2 vols. Paris, 1949.

———. *Musée du Louvre. Inventaire général des écoles du Nord: Maîtres des anciens Pays-Bas nés*

avant 1550. Paris, 1968.

MacCurdy, Edward, ed. *The Notebooks of Leonardo da Vinci.* New York, 1954.

Maclaren, Neil. *National Gallery Catalogues: The Dutch School.* London, 1960.

Marle, Raimond van. *Iconographie de l'art profane en moyen-âge et à la Renaissance et la decoration des demeures.* 2 vols. The Hague, 1931–32.

Marlier, Georges. "Le Vrai sujet de la Tempête de Bruegel." *Beaux-Arts,* 3 February 1939, p. 5.

Marrow, James. Review of P. Durrieu, *Les Heures de Turin,* ed. A. Châtelet. *The Art Bulletin,* 50, 1968, pp. 203–9.

Martin, John Rupert. *Baroque.* New York, 1977.

Matthey, Ignaz. "De Betekenis van de natuur en de natuurwetenschappen voor Constantijn Huygens." In *Constantijn Huygens: Zijn plaats in geleerd Europa.* Amsterdam, 1973, pp. 334–459.

Mattingly, Garrett. *The Armada.* Boston, 1959.

Mayer, A. *Das Leben und die Werke der Brüder Mattheus und Paul Bril.* Leipzig, 1910.

Meiss, Millard. *French Painting in the Time of Jean de Berry: The Limbourg Brothers.* New York, 1974.

Micheletti, E. *L'opera completa di Gentile da Fabriano.* Milan, 1976.

Miedema, Hessel. "Over het realisme in de Nederlandse schilderkunst van de zeventiende eeuw." *Oud Holland,* 89, 1975, pp. 2–18.

Monk, Samuel H. *The Sublime.* New York, 1935.

Montias, John Michael. *Artists and Artisans in Delft: A Socio-Economic Study of the Seventeenth Century.* Princeton, 1982.

Morassi, Antonio. *Mostra di Magnasco.* Exhibition catalogue. Genoa, Palazzo Bianco, 1949.

Morford, M. P. O. *The Poet Lucan: Studies in Rhetorical Epic.* Oxford, 1962.

Moschini Marconi, Sandra. *Gallerie dell'Accademia di Venezia, opere d'arte del secolo XVI.* Rome, 1962.

Müller Hofstede, Justus. "Zur Interpretation von Pieter Bruegels Landschaft: Ästhetischer Landschaftsbegriff und stoische Weltbetrachtung." In *Pieter Bruegel und seine Welt.* Ed. Otto von Simson and Matthias Winner. Berlin, 1979, pp. 73–142.

Münz, Ludwig. *Pieter Bruegel the Elder: The Drawings.* Trans. L. Hermann. New York and London, 1961.

Nicolson, Marjorie Hope. *The Breaking of the Circle.* Rev. ed. New York and London, 1962.

Nochlin, Linda. *Realism.* Harmondsworth and Baltimore, 1971.

Novotny, F. *Die Monatsbilder Pieter Bruegels d. Ä.* Vienna, 1948.

Pächt, Otto. *The Master of Mary of Burgundy.* London, 1948.

Paeseler, Wilhelm. "Giottos Navicella und ihr spätantikes Vorbild." *Römisches Jahrbuch für Kunstgeschichte,* 5, 1941, pp. 49–162.

Palmer, Eric C. " 'The Battle of the Armada' and 'The Great North Sea Storm,' " *Connoisseur,* 149, 1962, pp. 154–55.

Panofsky, Erwin. *Early Netherlandish Painting: Its Origins and Character.* 2 vols. Cambridge, Mass., 1953.

———. *Herkules am Scheidewege und andere Bildstoffe in der neueren Kunst. Studien der Bibliothek Warburg,* 18. Leipzig, 1930.

———. "Jan van Eyck's Arnolfini Portrait." *Burlington Magazine,* 64, 1934, pp. 117–27.

———. *Studies in Iconology.* New York, 1939.

Paris, Grand Palais. *Gustave Courbet (1819–1877).* Exhibition catalogue. Paris, 1977.

———. *Le Siècle de Rubens dans les collections publiques françaises.* Exhibition catalogue. Paris, 1977.

Parker, Geoffrey. *The Dutch Revolt.* London, 1977.

Penon, Georg, ed. *Nederlandse dicht- en prosawerken.* Groningen, 1888.

Pilo, Giuseppe Maria. *Marco Ricci.* Exhibition catalogue. Bassano del Grappa, Palazzo Sturm, 1963.

Popham, A. E. *Catalogue of Drawings by Dutch and Flemish Artists in the British Museum.* London, 1932.

———. *The Drawings of Leonardo da Vinci.* New York, 1945.

———. "Pieter Bruegel and Abraham Ortelius." *Burlington Magazine,* 59, 1931, pp. 184–88.

Porteman, K. *Inleiding tot de Nederlandse emblemataliteratuur.* Groningen, 1977.

Praz, Mario. *Studies in Seventeenth-Century Imagery.* Rome, 1964.

Preston, Rupert. *The Seventeenth-Century Marine Painters of the Netherlands.* Leigh-on-Sea, 1974.

Pugliatti, Teresa. *Agostino Tassi: Tra conformismo e libertà.* Rome, 1977.

Raczynski, J. A. *Die vlämische Landschaft vor Rubens.* Frankfurt, 1937.

Rahner, Hugo. "Antenna crucis." In *Symbole der Kirche: Die Ekklesiologie der Väter.* Salzburg, 1964, pp. 239–564.

Renger, Konrad. "Zur Forschungsgeschichte der Bilddeutung in der holländischen Malerei." In *Die*

Sprache der Bilder: Realität und Bedeutung in der niederländischen Malerei des 17. Jahrhunderts. Exhibition catalogue. Braunschweig, Herzog-Anton-Ulrich Museum, 1978, pp. 34–38.

Reynolds, G. "Turner and Dutch Marine Painting." *Nederlands Kunsthistorisch Jaarboek*, 21, 1970, pp. 383–90.

Reznicek, E. K. J. "Realism as a 'Side Road or Byway' in Dutch Art." In *Studies in Western Art, the Renaissance and Mannerism.* Acts of the Twentieth International Congress of the History of Art, 1961. Princeton, 1963, vol. 2, pp. 247–53.

——. *Die Zeichnungen von Hendrick Goltzius.* 2 vols. Utrecht, 1961.

——. Review of Karel van Mander, *Den grondt der edel vry schilder-const,* ed. Hessel Miedema. *Oud Holland*, 89, 1975, pp. 102–28.

Riegl, Alois. "Die mittelalterliche Kalenderillustration." *Mitteilungen des Instituts für österreichische Geschichtsforschung*, 10, 1889, pp. 1–74.

Rinaldis, Aldo di. *Pinacoteca del Museo Nazionali de Napoli.* Naples, 1928.

Robinson, M. S. *Van de Velde Drawings: A Catalogue of Drawings in the National Maritime Museum.* 2 vols. Cambridge, 1958–74.

Robinson, Franklin W. *Gabriel Metsu (1629–1667).* New York, 1974.

Rosand, David. *Painting in Cinquecento Venice: Titian, Veronese, Tintoretto.* New Haven and London, 1982.

——, and Michelangelo Muraro. *Titian and the Venetian Woodcut.* Exhibition catalogue. Washington, D.C., National Gallery of Art, 1976.

Rosenberg, Jakob. "The Wreckers by Simon de Vlieger." *Annual Report of the Fogg Art Museum, Harvard University*, 1953–54, p. 8.

——, Seymour Slive, and E. H. ter Kuile. *Dutch Art and Architecture, 1600 to 1800.* The Pelican History of Art. Harmondsworth and Baltimore, 1966.

Rosenblum, Robert. *Modern Painting and the Northern Romantic Tradition: Friedrich to Rothko.* New York, 1975.

Rosenmeyer, Thomas G. *The Green Cabinet: Theocritus and the European Pastoral Lyric.* Berkeley and Los Angeles, 1969.

Rostand, André. "Adrien Manglard et la peinture de marines au XVIIIe siècle." *Gazette des Beaux-Arts*, 12, 1934, pp. 263–72.

Röthlisberger, Marcel. *Cavalier Pietro Tempesta and His Time.* Newark, 1970.

——. *Claude Lorrain: The Paintings.* 2 vols. London, 1961.

Rotterdam, Museum Boymans–van Beuningen. *Tentoonstelling van Nederlandsche zee en riviergezichten uit de XVIIe eeuw.* Exhibition catalogue. Rotterdam, 1946.

Rowley, George. *Ambrogio Lorenzetti.* 2 vols. Princeton, 1958.

Russell, H. Diane. *Claude Lorrain, 1600–1682.* Exhibition catalogue. Washington, D.C., National Gallery of Art, 1982.

Russell, M. *Visions of the Sea: Hendrick C. Vroom and the Origins of Dutch Marine Painting.* Leiden, 1983.

Scavizzi, Giuseppe. "Paolo Bril alla Scala Santa." *Commentari*, 10, 1959, pp. 196–200.

Schama, Simon. *The Embarrassment of Riches: An Interpretation of Dutch Culture in the Golden Age.* New York, 1987.

Scheurleer, D. F., ed. *Onze Mannen ter zee in dicht en beeld.* 3 vols. The Hague, 1912–14.

Schloss, Christine Skeeles. *Travel, Trade, and Temptation: The Dutch Italianate Harbor Scene, 1640–1680.* Ann Arbor, 1982.

Seidel, Max. "Wiedergefundene Fragmente eines Hauptwerks von Ambrogio Lorenzetti." *Pantheon*, 36, 1978, pp. 119–27.

Seilern, Antoine, *Flemish Paintings and Drawings at 5 Princes Gate London SW7.* 2 vols. London, 1955.

Shapley, Fern Rusk. *National Gallery, Washington, D.C., Catalogue of the Italian Paintings.* 2 vols. Washington, D.C., 1979.

Simson, Otto von, et al., eds. *Pieter Bruegel und seine Welt.* Berlin, 1979.

Slatkes, Leonard J. "Hieronymus Bosch and Italy." *The Art Bulletin*, 57, 1975, pp. 335–45.

Slive, Seymour, and H. R. Hoetink. *Jacob van Ruisdael.* Exhibition catalogue. Cambridge, Mass., Fogg Art Museum, 1982.

Smekens, F. "Het schip bij Pieter Bruegel de Oude: Een authenticiteitscriterium?" *Jaarboek van het Koninklijk Museum voor Schone Kunsten Antwerpen*, 14, 1961, pp. 5–57.

Sohm, Philip L. "Palma Vecchio's *Sea Storm:* A Political Allegory." *Revue d'art canadienne/ Canadian Art Review*, 6, 1979–80, pp. 85–96.

Stechow, Wolfgang. *Dutch Landscape Painting of the Seventeenth Century.* London, 1966.

——. "Landscape Paintings in Dutch Seventeenth Century Interiors." *Nederlands Kunsthis-*

torisch Jaarboek, 11, 1960, pp. 165–84.

Stein, Roger B. *Seascape and the American Imagination.* New York, 1975.

Stone-Ferrier, Linda. *Dutch Prints of Daily Life: Mirrors of Life or Masks of Morals?* Exhibition catalogue. Lawrence, Kansas, Spencer Museum of Art, 1983.

Stridbeck, Carl Gustav. *Bruegelstudien.* Stockholm, 1956.

Sullivan, Margaret A. "Madness and Folly: Peter Bruegel the Elder's *Dulle Griet.*" *The Art Bulletin,* 59, 1977, pp. 55–66.

Summers, David. *Michelangelo and the Language of Art.* Princeton, 1981.

Sutton, Peter C. *Masters of Seventeenth-Century Dutch Genre Painting.* Exhibition catalogue. Philadelphia Museum of Art, 1984.

Tervarent, Guy de. "Bruegel's Parable of the Whale and the Tub." *Burlington Magazine,* 91, 1949, p. 293.

Thiel, P. J. J. van, et al. *All the Paintings in the Rijksmuseum in Amsterdam.* Amsterdam and Maarssen, 1976.

Tiele, P. A. *Mémoire bibliographique sur les journaux des navigateurs néerlandais.* Amsterdam, 1867.

Tietze-Conrat, Erica. "Titian as a Landscape Painter." *Gazette des Beaux-Arts,* 45–46, 1955, pp. 11–20.

Tillyard, E. M. W. *The Elizabethan World Picture.* New York, 1941.

Timm, Werner. *Schiffe und ihre Schicksale: Maritime Ereignisbilder.* Rostock, 1976.

Tippetts, Marie-Antoinette. *Les Marines des peintres vues par les littérateurs de Diderot aux Goncourt.* Paris, 1966.

Tolnay, Charles de. *The Drawings of Pieter Bruegel the Elder.* New York, 1952.

———. "Further Miniatures by Pieter Bruegel the Elder." *Burlington Magazine,* 122, 1980, pp. 616–23.

———. "Newly Discovered Miniatures by Pieter Bruegel the Elder." *Burlington Magazine,* 107, 1965, pp. 110–14.

———. *Pierre Bruegel l'Ancien.* 2 vols. Brussels, 1935.

Toorenenbergen, J. J. van. "Bij eene pen-teekening van Philips van Marnix van St. Aldegonde." *Oud Holland,* 11, 1893, pp. 149–53.

Turner, A. Richard. *The Vision of Landscape in Renaissance Italy.* Princeton, 1966.

Tuve, Rosemund. *Seasons and Months: Studies in a Tradition of Middle English Poetry.* Paris, 1935.

Veen, P. A. F. van. "De soeticheydt des buyten-levens, vergheselschapt met de boucken: Het hofdicht als tak van een georgische literatuur." Dissertation: Leiden, 1960.

Venturi, Lionello. "La Navicella de Giotto." *L'arte,* 25, 1922, pp. 49–69.

Vergara, Lisa. *Rubens and the Poetics of Landscape.* New Haven and London, 1982.

Villiers, Alan. *The Way of a Ship.* New York, 1970.

Waal, H. van de. *Drie eeuwen vaderlandsche geschied-uitbeelding, 1500–1800: Een iconologische studie.* 2 vols. The Hague, 1952.

———. *Jan van Goyen.* Amsterdam, 1941.

Walsh, Amy L. "Paulus Potter: His Works and Their Meaning." Dissertation: Columbia University, 1985.

Walsh, John, Jr. "The Dutch Marine Painters Jan and Julius Porcellis—I: Jan's Early Career; II: Jan's Maturity and 'de jonge Porcellis.' " *Burlington Magazine,* 116, 1974, pp. 653–64, 734–45.

———. "Jan and Julius Porcellis: Dutch Marine Painters." Dissertation: Columbia University, New York, 1971.

Washington, D.C., National Gallery of Art. *Summary Catalogue of European Painting and Sculpture.* Washington, D.C., 1965.

Weber, U. "Schiff." In *Lexikon der christlichen Ikonographie,* vol. IV, Freiburg im Bresgau, 1974, cols. 61–67.

Webster, J. C. *The Labors of the Months in Antique and Medieval Art.* Princeton, 1938.

Wellens–De Donder, Liliane. *Medailleurs en numismaten van de Renaissance in de Nederlanden.* Exhibition catalogue. Brussels, Koninklijke Bibliotheek, 1959.

Wiegand, Wilfried. "Ruisdael-Studien: Ein Versuch zur Ikonologie der Landschaftsmalerei." Dissertation: University of Hamburg, 1971.

Willis, F. C. *Die niederländische Marinemalerei.* Leipzig, 1911.

Wilton, Andrew. *Turner and the Sublime.* Exhibition catalogue. Toronto, Art Gallery of Ontario. London, 1980.

Wind, Edgar. *Giorgione's Tempesta.* Oxford, 1969.

Winter, P. J. "De hollandse Tuin." *Nederlands Kunsthistorisch Jaarboek,* 8, 1957, pp. 29–122.

Wurzbach, Alfred. *Niederländisches Künstler-Lexikon.* 3 vols. Vienna and Leipzig, 1906–11.

Zubov, V. P. *Leonardo da Vinci.* Trans. David H. Kraus. Cambridge, Mass., 1968.

Zupnik, Irving. "Bruegel and the Revolt of the Netherlands." *Art Journal,* 23, 1964, pp. 283–89.

Zweite, Armin. *Marten de Vos als Maler: Ein Beitrag zur Geschichte der Antwerpner Malerei in der zweiten Hälfte des 16. Jahrhunderts.* Berlin, 1980.

Index